PUBLIC PAINTING AND VISUAL CULTURE IN EARLY REPUBLICAN FLORENCE

Street corners, guild halls, government offices, and confraternity centers contained paintings that made the city of Florence a visual jewel at precisely the time of its emergence as an international cultural leader. This book considers the paintings that were made specifically for consideration by lay viewers as well as the way they could have been interpreted by audiences who approached them with specific perspectives. Their belief in the power of images, their understanding of the persuasiveness of pictures, and their acceptance of the utterly vital role that art could play as a propagator of civic, corporate, and individual identity made lay viewers keenly aware of the paintings in their midst. Those pictures affirmed the piety of the people for whom they were made in an age of social and political upheaval as the city experimented with an imperfect form of republicanism that often failed to adhere to its declared aspirations.

George R. Bent is the Sydney Gause Childress Professor of the Arts at Washington and Lee University, where he has taught in the Department of Art and Art History since 1993. A Fulbright scholar, Bent has written about the art of Lorenzo Monaco, Florentine painting of the Late Middle Ages and Early Renaissance, and manuscript production in the fourteenth century.

PUBLIC PAINTING AND VISUAL CULTURE IN EARLY REPUBLICAN FLORENCE

GEORGE R. BENT

Washington and Lee University

CAMBRIDGE
UNIVERSITY PRESS

CAMBRIDGE
UNIVERSITY PRESS

One Liberty Plaza, 20th Floor, New York, NY 10006, USA

Cambridge University Press is part of the University of Cambridge.

It furthers the University's mission by disseminating knowledge in the pursuit of
education, learning, and research at the highest international levels of excellence.

www.cambridge.org
Information on this title: www.cambridge.org/9781107139763

First published 2016

Printed in the United States of America by Sheridan Books, Inc.

A catalogue record for this publication is available from the British Library.

Library of Congress Cataloging–in–Publication Data
Names: Bent, George R., author.
Title: Public painting and visual culture in early republican Florence / George R. Bent.
Description: New York : Cambridge University Press, 2016. | Includes bibliographical
 references and index.
Identifiers: LCCN 2016021810 | ISBN 9781107139763 (hardback)
Subjects: LCSH: Painting, Italian – Italy – Florence – Themes, motives. | Public art – Italy –
 Florence – History – To 1500. | Art and society – Italy – Florence – History – To 1500. |
 Florence (Italy) – Civilization. | BISAC: HISTORY / Europe / General.
Classification: LCC ND621.F7 B47 2016 | DDC 701/.03–DC23
LC record available at https://lccn.loc.gov/2016021810

ISBN 978-1-107-13976-3 Hardback

CONTENTS

List of Illustrations *page* vi

Acknowledgments xiii

INTRODUCTION: PUBLIC PAINTING AND VISUAL
CULTURE IN EARLY REPUBLICAN FLORENCE, 1282–1434 I

1 PAINTINGS IN THE STREETS: TABERNACLES, PUBLIC
 DEVOTION, AND CONTROL 17

2 IMAGES OF CHARITY: CONFRATERNITIES, HOSPITALS,
 AND PICTURES FOR THE DESTITUTE 65

3 ART AND THE COMMUNE: POLITICS, PROPAGANDA, AND
 THE BUREAUCRATIC STATE 105

4 PICTURES FOR MERCHANTS: THE GUILDS, THEIR
 PAINTINGS, AND THE STRUGGLE FOR POWER 135

5 PUBLIC PAINTING IN SACRED SPACES: PIERS AND
 PILASTERS IN FLORENTINE CHURCHES 185

6 MURALS FOR THE MASSES: PAINTINGS ON NAVE WALLS 221

7 MASACCIO'S *TRINITY* AND THE TRIUMPH OF PUBLIC
 PAINTING FOR COMMON PEOPLE IN EARLY REPUBLICAN
 FLORENCE 273

Notes 289

Bibliography 311

Index 325

ILLUSTRATIONS

COLOR PLATES APPEAR BETWEEN PAGES 158 AND 159

 I. Giottino, *Lamentation of Christ*, ca. 1360, Uffizi Galleries, Florence

 II. Giottino, *Madonna della Sagra*, 1356, Accademia, Florence

 III. Andrea del Bonaiuto, *Madonna of Humility*, ca. 1375, Via San Gallo, Florence

 IV. *Madonna dei Malcontenti*, ca. 1385, Via dei Malcontenti, Florence

 V. Jacopo del Casentino, *Madonna della Tromba*, ca. 1335–1340, Palazzo Arte della Lana, Florence

 VI. *Santa Maria della Tromba*, *Codice Rustici*, fol. 22, 1442–1447, Biblioteca Seminario Maggiore, Florence

 VII. Bernardo Daddi, *Madonna of Orsanmichele*, 1347, Orsanmichele, Florence

 VIII. Bernardo Daddi, *Crucifix* (recto), ca. 1345, Museo Poldi Pezzoli, Milan

 IX. Bernardo Daddi, *Crucifix* (verso), ca. 1345, Museo Poldi Pezzoli, Milan

 X. Niccolò di Pietro Gerini, *Flagellation of Christ*, ca. 1390, private collection

 XI. Workshop of Bernardo Daddi, *Allegory of Mercy*, 1342, Museo del Bigallo, Florence

 XII. Niccolò di Pietro Gerini and Ambrogio di Baldese, *Abandonment of Children and the Reunification of Families*, 1386, Museo del Bigallo, Florence

 XIII. Reconstruction, *Abandonment of Children and the Reunification of Families*, 1386, Museo del Bigallo, Florence

 XIV. Jacopo di Cione, *Madonna Lactans*, ca. 1375, National Gallery of Art, Washington, D.C.

 XV. Workshop of Lorenzo Monaco, *Double Intercession*, ca. 1400, Metropolitan Museum of Art (The Cloisters), New York

 XVI. Giotto (?), *Enthroned Madonna with Symbols of the City*, 1334–1336, Museo Nazionale del Bargello, Florence

 XVII. Andrea di Cione (?), *Expulsion of the Duke of Athens*, ca. 1345, Palazzo Vecchio, Florence

XVIII. Jacopo di Cione, *Coronation of the Virgin*, 1373, Accademia, Florence

XIX. Fra Angelico, *Madonna and Child*, 1435, Museo di San Marco, Florence

XX. Mariotto di Nardo, *Madonna and Child with Saints Stephen and Reparata*, ca. 1385, Accademia, Florence

XXI. *Incipit Page, Arte della Lana 4*, fol. 6, ca. 1335, Archivio di Stato, Florence

XXII. Sala d'Udienza, Palazzo Arte della Lana, Florence

XXIII. *Madonna della Lana*, ca. 1315, Palazzo Arte della Lana, Florence

XXIV. Nardo di Cione (?), *Judgment of Brutus*, ca. 1345, Palazzo Arte della Lana, Florence

XXV. Bernardo Daddi, *Saint Paul*, 1333, National Gallery of Art, Washington, D.C.

XXVI. Giovanni del Biondo, *Martyrdom of Saint Sebastian*, ca. 1376, Museo dell'Opera del Duomo, Florence

XXVII. Jacopo di Cione and Giovanni del Biondo, *Saint Zenobius*, ca. 1390, Santa Maria del Fiore, Florence

XXVIII. Nardo di Cione, *Madonna and Child with Saints John the Baptist, John the Evangelist, Zenobius, and Reparata*, ca. 1360, Brooklyn Museum of Art, Brooklyn, New York

XXIX. Giovanni del Biondo, *Saint John the Evangelist*, ca. 1380, Accademia, Florence

XXX. Andrea di Cione and Jacopo di Cione, *Saint Matthew and Scenes from His Life*, 1369, Uffizi, Florence

XXXI. Lorenzo Monaco, *Agony in the Garden*, ca. 1396, Accademia, Florence

XXXII. *Saints Mary Magdalene, Nicholas, Miniato, Andrew, and Christopher*, ca. 1380–1390, San Miniato al Monte, Florence

XXXIII. *Coronation of the Virgin*, ca. 1300, Santa Maria del Fiore, Florence

XXXIV. *Last Judgment and Biblical Scenes*, detail, *Last Judgment* (southwest, west, and northwest vaults), ca. 1275–1300, San Giovanni, Florence

XXXV. *Last Judgment and Biblical Scenes*, detail, east vault, *John the Baptist Imprisoned*, ca. 1275–1300, San Giovanni, Florence

XXXVI. Andrea di Cione, *Triumph of Death*, ca. 1345, Santa Croce, Florence

XXXVII. Masaccio, *Holy Trinity*, 1427, Santa Maria Novella, Florence

XXXVIII. Pulpit, Santa Maria Novella, Florence

XXXIX. View of the *Trinity* from the east portal, Santa Maria Novella, Florence

BLACK AND WHITE FIGURES

1. Fra Angelico, *Deposition of Christ*, 1435, Museo San Marco, Florence *page* 3

2. Bernardo Daddi, *Madonna del Bagnuolo*, ca. 1335, Museo dell'Opera del Duomo, Florence 7

3. Isometric project of Santa Croce with *tramezzo*, before Vasari's renovation 10

4. Sketch of Santa Croce with *tramezzo* 11

5. Niche, Piazza Santo Spirito, Florence 19

6. Taddeo Gaddi, *Madonna and Child*, ca. 1340, Via Antonino, Florence 20

7. Niccolò di Tommaso, *Saint Sixtus*, ca. 1385, Via del Sole, Florence 21

8. Maestro di San Martino a Mensola, *Madonna and Child*, ca. 1395, Piazza Piattellina, Florence 23

9. Lorenzo di Bicci, *Madonnone*, ca. 1390, Via di San Salvi, Florence 25

10. Giovanni del Biondo (?), *Renunciation of Worldly Goods*, ca. 1390, Orsanmichele, Florence 26

11. Giovanni del Biondo (?), *Miracle of the Ordeal by Fire at the Grain Market*, ca. 1390, Orsanmichele, Florence 27

12. Giovanni del Biondo (?), *Miracle of the Hanged Thief*, ca. 1390, Orsanmichele, Florence 29

13. Mercato Vecchio before its demolition, Florence 33

14. Giuseppe Moricci, *Santa Maria della Tromba*, ca. 1860, Galleria d'Arte Moderna, Florence 35

15. Johannes Stradanus, *Mercato Vecchio*, Palazzo Vecchio, Florence 36

16. Jacopo del Casentino, *Madonna and Child with Saints Benedict and Peter*, ca. 1345, Borgo degli Albizzi (Via dei Giraldi), Florence 37

17. Orsanmichele, Florence 47

18. *Supplicants before the Madonna of Orsanmichele, Chigi L VIII 296*, fol. 152, ca. 1342–1348, Vatican Library, Vatican City 49

19. *Riot at Orsanmichele, Biadaiolo Manuscript*, fol. 79, ca. 1340, Biblioteca Laurenziana, Florence 53

20. *Saint Anne*, ca. 1345, Orsanmichele, Florence 57

21. Andrea di Cione, *Tabernacle of Orsanmichele*, 1352–1359, Orsanmichele, Florence 59

22. Duccio di Buoninsegna, *Rucellai Madonna*, ca. 1290, Uffizi Galleries, Florence 67

23. Cimabue, *Santa Trinita Madonna*, ca. 1295, Uffizi, Florence 69

24. Mariotto di Nardo, *Coronation of the Virgin*, 1408, Minneapolis Institute of Art, Minneapolis, Minnesota 73

25. Niccolò di Pietro Gerini, *Vir Dolorum*, ca. 1400, Accademia, Florence 76

26. Jacopo del Casentino, *Saint Agatha*, ca. 1335, Museo dell'Opera del Duomo, Florence 80

27. Anonymous, *Saint Agatha*, ca. 1290, Museo dell'Opera del Duomo, Florence 81

28. *Flagellants, Chigi L VIII 296*, fol. 197v, ca. 1342–1348, Vatican Library, Vatican City — 82

29. Loggia del Bigallo, Florence — 85

30. Alberto Arnoldi, *Madonna and Child*, ca. 1365, Museo del Bigallo, Florence — 86

31. Nardo di Cione, *Christ in Judgment with Angels*, ca. 1364, Museo del Bigallo, Florence — 87

32. Workshop of Bernardo Daddi, *Allegory of Mercy* (detail, roundels), 1342, Museo del Bigallo, Florence — 89

33. Workshop of Bernardo Daddi, *Allegory of Mercy* (detail, bread and wine), 1342, Museo del Bigallo, Florence — 90

34. Workshop of Bernardo Daddi, *Allegory of Mercy* (detail, funeral bier), 1342, Museo del Bigallo, Florence — 91

35. Copy, *Abandonment of Children and the Reunification of Families*, 1386, Museo del Bigallo, Florence — 93

36. Pseudo Don Silvestro dei Gherarducci, *Madonna Lactans*, ca. 1380, Accademia, Florence — 97

37. Workshop of Giotto, Chapel of the Magdalene with *Last Judgment*, ca. 1321, Museo Nazionale del Bargello, Florence — 110

38. Workshop of Giotto, Chapel of the Magdalene with *Hell*, ca. 1321, Museo Nazionale del Bargello, Florence — 111

39. Giovanni Toscani, *Incredulity of Saint Thomas*, ca. 1420, Accademia, Florence — 115

40. Ambrogio Lorenzetti, *Allegory of Bad Government*, 1339, Palazzo Pubblico, Siena — 121

41. *Stemmi*, Uffizi, Florence — 124

42. Jacopo di Cione, *Coronation of the Virgin* (detail, Virgin), 1373, Accademia, Florence — 125

43. Jacopo di Cione, *Coronation of the Virgin* (detail, Victor and Zenobius), 1373, Accademia, Florence — 130

44. Gold florins — 131

45. Bernardo Daddi, *Madonna and Child*, ca. 1340, Accademia, Florence — 136

46. Fra Angelico, *Madonna and Child (Saints Mark and Peter)*, detail, 1435, Museo di San Marco, Florence — 139

47. Taddeo Gaddi, *Madonna and Child*, ca. 1350–1355, Accademia, Florence — 141

48. Jacopo del Casentino, *Madonna and Child with Saints Stephen and Philip*, ca. 1340, Palazzo Arte della Lana, Florence — 143

49. Palazzo Arte dei Giudici e Notai, Via del Proconsolo, Florence — 145

50. Palazzo Arte dei Giudici e Notai, Sala d'Udienza, Via del Proconsolo, Florence — 146

51. Ambrogio di Baldese, *Cleric*, ca. 1406, Palazzo Arte dei Giudici e Notai, Florence — 147

52. Ambrogio di Baldese, *Allegorical Women*, ca. 1406, Palazzo Arte dei Giudici e Notai, Florence — 148

53. Ambrogio di Baldese, *Uomini Famosi*, ca. 1406, Palazzo Arte dei Giudici e Notai, Florence — 149

54. Ambrogio di Baldese, *Allegorical Winged Figure*, ca. 1406, Palazzo Arte dei Giudici e Notai, Florence — 151

55. Palazzo Arte della Lana, Via Calimala, Florence — 155

56. Bottega, Palazzo Arte della Lana, Via Calimala, Florence — 157

57. Vault, Palazzo Arte della Lana, Florence — 158

58. *Annunciation of the Virgin*, ca. 1315, Palazzo Arte della Lana, Florence — 159

59. *Saints Martin, Pancras, Peter, and Frediano*, ca. 1370–1380, Palazzo Arte della Lana, Florence — 161

60. Ambrogio Lorenzetti, *Allegory of Good Government*, 1338–1339, Palazzo Pubblico, Siena — 165

61. *Judgment of Brutus*, detail (dado), ca. 1345, Palazzo Arte della Lana, Florence — 167

62. Nardo di Cione, *Paradise*, ca. 1357, Santa Maria Novella, Florence — 168

63. Andrea di Cione, *Strozzi Altarpiece*, 1357, Santa Maria Novella, Florence — 169

64. *Judgment of Brutus*, detail (left figures), ca. 1345, Palazzo Arte della Lana, Florence — 177

65. *Judgment of Brutus*, detail (right figures), ca. 1345, Palazzo Arte della Lana, Florence — 179

66. Giovanni del Biondo, *Scenes from the Life of Saint Sebastian*, left panel, ca. 1376, Museo dell'Opera del Duomo, Florence — 188

67. Giovanni del Biondo, *Scenes from the Life of Saint Sebastian*, right panel, ca. 1376, Museo dell'Opera del Duomo, Florence — 189

68. Bernardo Daddi, *Saint Catherine*, ca. 1335, Museo dell'Opera del Duomo, Florence — 193

69. Giovanni del Biondo, *Saint Catherine with Noferi Bischeri*, ca. 1380, Museo dell'Opera del Duomo, Florence — 195

70. Jacopo di Cione, *Saint Zenobius*, 1394, Museo dell'Opera del Duomo, Florence — 197

71. Bernardo Daddi, *Madonna and Child with Saints* ("San Pancrazio Altarpiece," ex–Santa Maria del Fiore), 1342, Uffizi, Florence — 199

72. Lorenzo di Niccolò, *Saint Reparata*, ca. 1408, Museo dell'Opera del Duomo, Florence — 200

73. Jacopo del Casentino, *Enthroned Madonna Lactans*, ca. 1335, Museo dell'Opera del Duomo, Florence — 201

74. Jacopo del Casentino, *Saint Bartholomew Enthroned*, ca. 1335, Accademia, Florence — 203

75. Circle of Andrea di Bonaiuto, *Annunciation of the Virgin*, ca. 1380, Accademia, Florence — 205

76. Lorenzo di Bicci, *Saint Martin*, ca. 1395, Accademia, Florence — 209

77. *Vision of Saint Bernard*, ca. 1360, Accademia, Florence — 212

78. *Saint Mary Magdalene*, ca. 1275, Accademia, Florence — 213

79. Niccolò di Pietro Gerini, *Saint Bartholomew*, 1408, Orsanmichele, Florence — 215

80. *Christ with the Virgin and Saint Miniato*, facade, ca. 1240, San Miniato
 al Monte, Florence 222

81. *Christ Enthroned*, apse, 1297, San Miniato al Monte, Florence 223

82. *Saints on the South wall*, ca. 1380–1410, San Miniato al Monte,
 Florence 224

83. *Saints John the Baptist, Reparata, Zenobius, and Benedict*, ca. 1400–1410,
 San Miniato al Monte, Florence 227

84. *Christ with the Instruments of the Passion and Saints Julian, Miniato, and
 Catherine with Female Donors*, ca. 1409–1410, San Miniato al Monte,
 Florence 228

85. *Christ with the Instruments of the Passion*, ca. 1409–1410, San Miniato
 al Monte, Florence 229

86. *Vir Dolorum*, ca. 1340–1350, Santa Maria del Fiore, Florence 233

87. *Last Judgment and Biblical Scenes*, detail, *Heaven* (southwest vault),
 ca. 1275–1300, San Giovanni, Florence 242

88. *Last Judgment and Biblical Scenes*, detail, *Hell* (northwest vault),
 ca. 1275–1300, San Giovanni, Florence 243

89. *Last Judgment and Biblical Scenes*, detail, north vault, ca. 1275–1300,
 San Giovanni, Florence 245

90. *Last Judgment and Biblical Scenes*, detail, northeast vault,
 ca. 1275–1300, San Giovanni, Florence 246

91. *Last Judgment and Biblical Scenes*, detail, east vault, ca. 1275–1300, San
 Giovanni, Florence 247

92. *Last Judgment and Biblical Scenes*, detail, southeast vault, ca.
 1275–1300, San Giovanni, Florence 248

93. *Last Judgment and Biblical Scenes*, detail, south vault, ca. 1275–1300,
 San Giovanni, Florence 249

94. Andrea Pisano, *Scenes from the Life of John the Baptist*, ca. 1336, San
 Giovanni, Florence 251

95. Lorenzo Ghiberti, *Baptism of Christ*, ca. 1407–1424, San Giovanni,
 Florence 256

96. Lorenzo Ghiberti, *Scenes from Genesis (Gates of Paradise)*, ca.
 1430–1452, San Giovanni, Florence 257

97. Santa Croce, nave and pulpit, Florence 259

98. *Crucifixion, Noli me Tangere, Ascension*, Santa Croce, Florence 260

99. *Triumph of Death*, ca. 1333, Camposanto, Pisa 261

100. Andrea di Cione, *Hell*, detail, earthquake, ca. 1345, Santa Croce,
 Florence 262

101. Andrea di Cione, *Hell*, detail, eclipse, ca. 1345, Santa Croce, Florence 263

102. Andrea di Cione, *Last Judgment*, detail, beaked torturers, ca. 1345,
 Santa Croce, Florence 264

103. Andrea di Cione, *Last Judgment*, detail, LU(SS)VRIA, ca. 1345, Santa
 Croce, Florence 265

104. West side wall, with bay containing *Trinity*, Santa Maria Novella,
 Florence. 279

105. Cemetery, east cloister, Santa Maria Novella, Florence 281

106. Giotto, *Crucifix*, ca. 1310–1312, Santa Maria Novella, Florence 283

107. Filippo Brunelleschi, *Crucifix*, ca. 1415, Santa Maria Novella,
Florence 284

108. *Lamentation of Christ*, ca. 1340, Santa Maria Novella, Florence 285

109. Nardo di Cione, *Last Judgment, Christ*, ca. 1357, Strozzi Chapel, Santa
Maria Novella, Florence 287

ACKNOWLEDGMENTS

My interest in the art of the fourteenth and early fifteenth centuries was born in Oberlin, Ohio, nurtured in Palo Alto, California, and cultivated in Florence, Italy, during the *longue durée* of the Reagan administration. In those days, and then through the 1990s, I came to think that the artistic traditions that drove Tuscan painting had much more to do with the mentality of the Middle Ages than it did with the early modern period. That belief led to and resulted in my examination of the artistic environment in the Camaldolese monastery of Santa Maria degli Angeli and the legacy of Lorenzo Monaco, its most famous member. When that work reached its logical conclusion, I felt compelled to turn away from the strictly controlled environment of the cloister and to think instead about the messier, more complicated, and only vaguely understood visual culture of the Florentine laity. Poor, undereducated, and largely disenfranchised, these usually overlooked viewers presented an enormous challenge for me: I had to teach myself a great deal about corners of society I'd only paid marginal attention to in my earlier work, and I frequently reached out to friends and colleagues for advice and guidance. The going was slow at times, but it was always richly rewarding.

Fortunately, the friends and colleagues to whom I turned were more than just enormously helpful. Without them, this project could have never reached its conclusion. Judith Steinhoff, David Peterson, Areli Marina, Barbara Deimling, Alick McLean, and Felicity Ratté engaged me critically at the early stages of my research and helped me identify the good, address the bad, and beautify the ugly throughout the process. Roger Crum and Perri Lee Roberts called upon their vast understanding of the early Quattrocento to lead me in worthy directions. Philip Earenfight, Megan Holmes, Kay Arthur, and William Levin were generous with their time and unreasonably patient with me when I asked them basic questions. Larry Kanter, Hayden Maginnis, Shelley Zuraw, John Najemy, and Marvin Trachtenberg provided encouragement during encounters that they surely won't remember as well as I do. Alessio Assonitis tenaciously advocated on my behalf on an utterly crucial matter and at an utterly crucial moment. Andrea Di Lorenzo was gracious with his time and his guidance. And Gail Solberg repeatedly aided me in this endeavor with her thoughtful

commentary, her tremendous intellect, multiple shots of espresso, and her affable unwillingness to accept anything less than sound argumentation.

Anastasia Graf, Beatrice Rehl, and the staff at Cambridge University Press showed great faith in this project and patiently helped guide it through to completion. The staffs at the Florentine State Archives, Biblioteca Nazionale Centrale, Kunsthistorisches Library, the Società Dantesca, and the Polo Musei were courteous, efficient, and enormously helpful at every turn. I was assisted greatly by the generosity of the staffs at the National Gallery of Art in Washington, D.C. and the Metropolitan Museum of Art in New York. Erica Garber at Art Resource tracked down photographs for me that I feared were hopelessly lost forever and advocated for me when others were difficult to obtain. Marcia Hall kindly lent the two diagrams of Santa Croce's *tramezzo* now accepted as the most accurate representations of that lost architectural form. The two anonymous readers solicited by Cambridge who pointed out embarrassing errors in the original manuscript made the final product infinitely better than it otherwise would have been. The Millard Meiss fund administered by College Art Association defrayed the cost of production in vital ways. And Lorri Olan and Cathryn Harbor read portions of the text and helped me rewrite them with an eye toward communicating my ideas clearly to actual human beings – a marvelous concept indeed.

A variety of colleagues, students, and friends at Washington and Lee University have directly and indirectly influenced the contents of this book. The late Pamela Simpson was a mentor and role model for me in more ways than probably even I realize: I miss her greatly. Kathleen Olson-Janjic took over for me as department chair at just the right moment, and that selfless act enabled me to focus on matters at hand and finish this project in a timely manner. Melissa Kerin, Elliott King, Andrea Lepage, and the late Joan O'Mara heard the arguments contained within the following pages and improved them through their observant and prescient suggestions. Hank Dobin, Suzanne Keen, Tom Williams, Harlan Beckley, June Aprile, Robert Strong, Marc Conner, and Daniel Wubah supported and funded this project from beginning to end. Martine Petite's generosity humbled me greatly, and without the support of Mary Hodapp and Betty Hickox, this study would not have been possible. And the hundreds (thousands?) of students – some of whom have been hooded with PhDs in the intervening years – who have listened, spoken, and even helped research some of the topics in this book contributed to my thinking in vital ways.

Long before I began this project, I was fortunate to have studied with masterful and deeply influential teacher-scholars. Robert Neil, Marcia Colish, Suzanne Lewis, Alessandro Nova, Judith Brown, Andrew Ladis, Marvin Eisenberg, and William Hood mentored me in my youth and nudged me forward at those crucial moments when I did not have the confidence to do so on my own: anything at all that is good in this book can be traced back to them.

With my adopted siblings in Italy – Carlo Zappia, Patrizia Lattarulo, Stefano Sacchetti, and Anna Lami – I have shared a quarter-century's worth of joyous memories and a deep, abiding love and affection: their insights have influenced me more than they can ever know. I send to Ruth Bent and to the late George R. Bent II, whom I miss dearly, heartfelt thanks for close to six decades of love and support. To William, Catalena, and Miles Bent I repeat what I have said to them from the day each was born: no father has ever been prouder of his children than I am of mine. And to Lorri Olan, who bridges my past and my future, I dedicate this book by way of thanks for joining me on this grand adventure of ours.

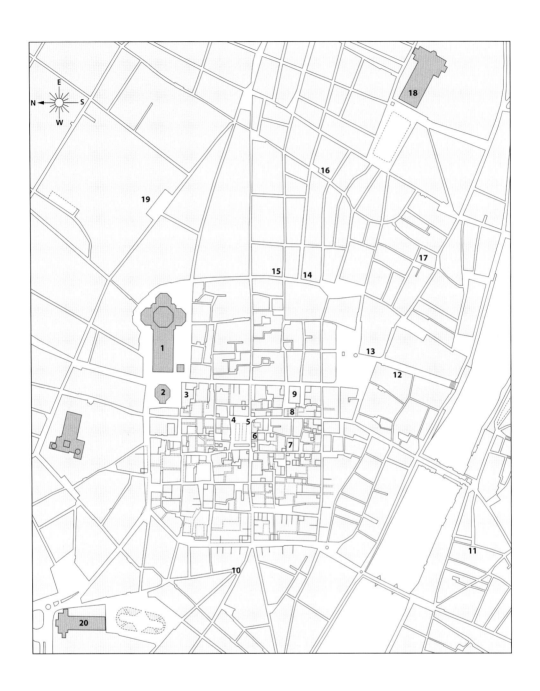

Map Key

1. Cathedral of Santa Maria del Fiore
2. Baptistery of San Giovanni
3. Bigallo/Confraternity of the Misericordia
4. Old Market/Mercato Vecchio
5. Oratory of Santa Maria della Tromba
6. City brothel
7. Headquarters of the Guild of Doctors and Apothecaries/Arte dei Medici e Speziali
8. Headquarters of the Guild of the Wool Merchants/Arte della Lana
9. Church of Orsanmichele
10. Via del Sole
11. Piazza Santo Spirito
12. Headquarters of the Mint/Zecca
13. Palazzo della Signoria
14. Bargello/Palazzo del Podestà
15. Headquarters of the Guild of Judges and Notaries/Arte dei Giudici e Notai
16. Prison/Stinche
17. Church of San Remigio
18. Church of Santa Croce
19. Hospital of Santa Maria Nuova
20. Church of Santa Maria Novella

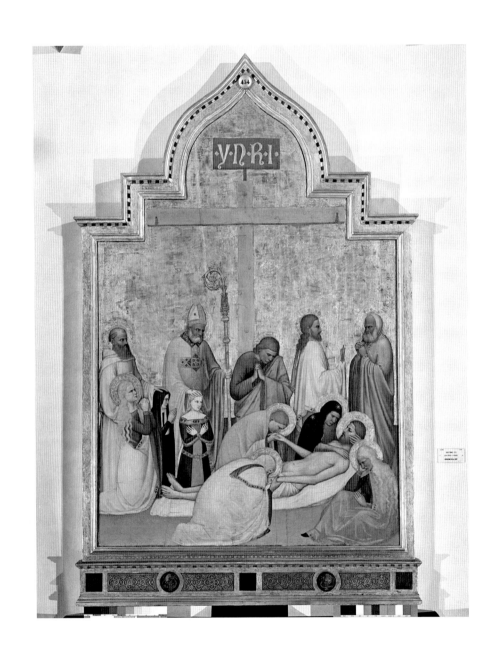

INTRODUCTION: PUBLIC PAINTING AND VISUAL CULTURE IN EARLY REPUBLICAN FLORENCE, 1282–1434

O N HIS WAY TO THE EXECUTIONER'S BLOCK, THE CONDEMNED CRIMINAL in Florence ran a gauntlet of acrimony. After a particularly sleepless night inside the Chapel of the Magdalene in the Palace of the Podestà, the prisoner was led from his chamber by hooded members of the Confraternity of Santa Maria alla Croce, down the steps of the government palace, and out into the streets.[1] With small paintings of the Crucifixion held before him by confraternity members, he was led through the center of the city to the place where the ancient crossroads of the *cardus* and *decumanus* met in the Mercato Vecchio.[2] There, at the very navel of Florence, the prisoner was made to kneel before a painting bearing the images of the Virgin, the Child, angels, the Baptist, and Saint Luke, known as the *Madonna della Tromba*. He was urged (and maybe required) to say a prayer – a Hail Mary, a Salve Regina, or anything else that came to mind. Activity in that bustling mercantile zone came to a momentary halt as vendors and clients alike took advantage of this opportunity to hurl garbage, rotten food, and insults at the condemned man before he was lifted up by his cloaked guardians and marched north and east through the Piazza San Giovanni and the city cathedral. The procession continued up the Via Servi, all the way to the ancient church of Santissima Annunziata, where the prisoner once again knelt before an image – this one the famous miracle-working picture of the Virgin Annunciate – to pray for his own soul on this, his final day on earth. Before long, he was uprooted from his position and processed

down a different route to the church of Sant'Ambrogio, on the east side of town, and then through the Porta alla Croce to the killing fields of Florence.[3] Again he heard the taunts of bystanders and felt the blows of fists and refuse as they struck him, but all he could see was the Tavoletta of the Crucifixion held only inches from his eyes by a member of the confraternity. The procession stopped at its final destination, the oratory of the Tempio, owned and operated by the confraternity and furnished to accommodate its members on occasions such as these.[4] The condemned was positioned before a crucifix and, by the middle of the fifteenth century, the painting by Fra Angelico of the *Deposition of Christ*, currently in the Museo San Marco, before which he murmured still more prayers (Figure 1). A lengthy series of questions, answers, songs, and final remarks were uttered by both the prisoner and his keepers before the retinue exited the chapel for the gallows or the chopping block, whichever fate the court had determined. At no point was the condemned left on his own during this process, and at no point was he deprived of an image. Indeed, the route was specifically chosen to position the condemned before public paintings, one in the heart of the commercial district, others situated in churches and respected for their healing powers, and still others at the end of his journey toward death. The city was littered with public pictures for common people, and these pictures took on a variety of different forms depending on their location, intended message, and expected audience.

THE EARLY REPUBLICAN CITY

Fourteenth-century Florence was a large and bustling city, as pristinely beautiful in its most prosperous neighborhoods as it was dirty and disease-ridden in its poorest. Different groups and classes rubbed elbows in most of them, with the city's wealthiest captains of industry living literally next door to the local cobbler, baker, or mason. Men and women lived separate lives, but often encountered each other at market, in church, and sometimes even in guildhalls. The landed aristocracy, banished from holding public office as "magnates" with a violent past, lived off rental incomes and avoided the humbling prospect of entering trades or professions, which they feared would reduce their social status. Merchants recognized a pecking order, too, with bankers and silk manufacturers vying for power with wool merchants, while grocers, armorers, and linen weavers brought up the rear in the annual civic processions of the guilds. Most boys and many girls attended school until they were twelve or thirteen, which helped create a fairly well educated population: there they learned to read and write, calculate figures, and even acquire a smattering of Latin to prepare them for the education awaiting them as apprentices in workshops (if boys) and newly wedded young women (if girls). Some of the quicker studies might advance to university with an eye toward garnering a career in the clergy

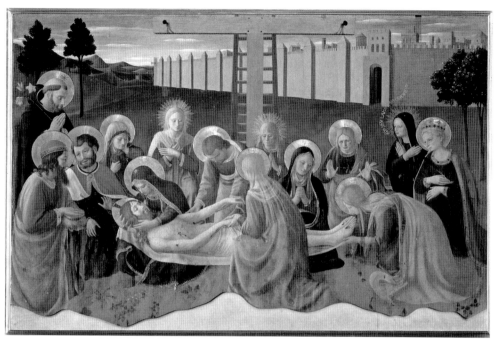

1. Fra Angelico, *Deposition of Christ*, 1435, Museo San Marco, Florence. Photograph courtesy Nimatallah/Art Resource, New York.

or courts of law, but if they did so they knew they would be sentenced to years of studying canon or civil law, medicine, or theology.

And then there were the poor, the unenfranchised, and tens of thousands of manual laborers who worked in the dangerously unsafe workshops of the wool industry as dyers, carders, and weavers. Many of these *sottoposti* – literally "underlings" unable to join the guilds reserved for wealthier merchants – were immigrants from small towns in Tuscany, second or third sons, either alone or with their wives and children, who needed work once their father's inheritance had been officially handed over to the eldest brother. Some came from Italian regions beyond the Apennines, speaking in accents that made them difficult to understand and lacking the social connections they needed to help them find the work they sought. The most vulnerable of the city's residents came from places where the entire Italian language, let alone the Florentine dialect, was completely and utterly foreign. These foreigners packed into tenements cheek to jowl, shared beds and clothes and food and bacteria, and – if they were lucky – held some of the very worst jobs imaginable. The most destitute of them turned to crime and vice, as Florence had its fair share of petty larceny, prostitution, and even occasional outbreaks of violence. The city crawled with these day laborers and hand-to-mouth wretches, and they were the most impressionable and most frequent viewers of public pictures in early Republican Florence.

When we speak of audiences, we need to remember that the vast disparities of income and education and family connectivity made for as eclectic a viewership as any artist would ever be forced to accommodate. In a city that promoted its communally based republic, only about three thousand men, or roughly 3 percent of the population, were actually eligible to hold office. These men constituted an elite class of merchants, and they enjoyed certain privileges unknown to their social, political, and economic inferiors. Among these were the right to purchase the rights to burial chapels already situated inside local churches and monasteries, the right to decorate those spaces as they saw fit, and the right to visit those spaces should the occasion arise. At the same time, we must also acknowledge the probability that many of these people had little interest in the images they had already paid for. Money does not necessarily buy culture, and the hobbies and interests of wealthy merchants and aristocrats of early Republican Florence were just as eclectic as those of their twenty-first-century descendants today. Some people just don't care very much for imagery, and it is no exaggeration to assert that the very best paintings produced in the city during the thirteenth and fourteenth centuries were intended for a very small percentage of the city's population, and were seen with any frequency by an even smaller one.

By contrast, a much larger number of people daily sought out pictures in the public realm, like the *Madonna of Orsanmichele* (Plate VII). They passed by frescoes in piazzas and panels in tabernacles at all hours of the day and night. They knew which pictures worked miracles and which ones didn't. They looked at paintings tucked into niches in the walls of staircases that wound up from the shop on the ground floor of the Wool Guild to the Sala d'Udienza upstairs, and then they stared at the fresco of Junius Brutus fending off threats from angry men in fancy clothes (Plate XXIV). They saw images on the sides of the exterior walls when they walked by the jail and the office of the podestà, inside communal offices operated by the state, and on the piers of churches when they flirted with *giovani* during the sermons they were supposed to be listening to (Plates XVI, XVII, XVIII, and XXXVI). Hundreds, maybe even thousands of people saw these public pictures every single day of every single week of every single year during the early Republican period. The artist who wished to burnish his reputation among the people of Florence was wise to accept a commission that would allow him to install his work on a street corner normally filled with immigrant prostitutes. The few common people who actually commented on images in their written chronicles or memoirs always and without exception named as the greatest examples of Florentine workmanship those objects on view in the public domain. Giotto's frescoes in the depths of Santa Croce were never hailed as the city's best art objects: that honor went to Andrea di Cione for his monumental tabernacle that contained the Madonna in the semipublic guild church of Orsanmichele (Figure 21).[5]

Despite the disadvantages that came with being of the "wrong" class, gender, or social status, common viewers in Florence got to see and contemplate an abundance of works of art in the city. True, they probably did not have the opportunity to see liturgical pictures like Andrea di Cione's *Strozzi Altarpiece* in the locked chapel of Santa Maria Novella or Giotto's *Coronation of the Virgin* behind its drawn curtain in Santa Croce, and their exposure to the more elaborate and imaginative fresco cycles that presented narrative illustrations of saintly lives in the burial chapels of their social betters was probably quite limited. Despite the fact that common people did not see these images, they did receive some visual instructions on proper devotional methods. Churches placed pictures of important heroic saints on the piers and columns on the congregation's side of the nave with some frequency (Plates XXV, XXVI, and XXVII). Devotional pictures based on the altarpiece design graced confraternity halls and governmental offices (Plates XVIII, XIX, and XX). Guilds promoted the celestial advocates who interceded on their behalf (Plate XXIV). If they wanted to, common people could see representations of all sorts of images, and of a variety that actually surpassed that aimed at their wealthier and better-positioned contemporaries in the transepts and choirs of strictly maintained ecclesiastical spaces.

One such example of liturgical art for the common man was Giottino's famous *Lamentation of Christ*, now in the Uffizi Galleries (Plate I). Giorgio Vasari first noticed the picture on the right side of the *tramezzo* in the modest-sized church of San Remigio, but his imprecise description of its placement there makes its original orientation unclear: we do not know whether the image faced the congregation occupying the front half of the church's nave or the clergy on the other side of the *ponte*.[6] At first the panel seems to feature a single event, the mourning of Christ's body after his deposition from the cross. But closer inspection reveals that Giottino painted two separate moments onto this otherwise unified field. The vertical crucifix forming the central axis effectively splits the scene into two discrete parts: to the right, mourners anoint Christ's body, discuss the injustice he has suffered, and (according to Vasari's description) express their profound grief with tears and subtle gestures of tenderness. This narrative representation of the Passion stands separately from the more contemporary fourteenth-century mystical apparition on the other side, to the left. Here, an ascetically dressed nun and a much more luxuriously depicted laywoman – perhaps sisters, with the more glamorous of the girls being the older of the two – kneel together, facing the group to our right. Depicted rather stoically, these young women strike subtly different reverential attitudes, with the nun pressing her hands together in prayer and the older woman crossing her hands over her chest. Joining them stand two contemporary male patrons, the first dressed as an ascetic reformer abbot – Benedict, Bernard, or perhaps even Romuald – and the second

appearing as a more worldly bishop saint, each one appropriately matched to the vocational status of the two girls. The monastic saint touches the head of the nun while the bishop does the same to the elegantly garbed lay woman, as both saints directly infuse into the minds of these two women the proper thoughts, attitudes, and emotional responses they ought to conjure as they contemplate the scene on the right. And finally, serving as an exemplary figure upon which to model their behavior, a kneeling female saint appears to the far left, her hands pressed together and her faced compressed into one of the more descriptive expressions of human grief produced in the whole of fourteenth-century European art. If the monk and the bishop instill in these women the intellectual thoughts they need to understand the meaning of Christ's sacrifice, the raw, almost guttural reaction of this woman provides viewers with the physical attitude they must strike as they think their thoughts. The painting, then, is not about the *Lamentation of Christ* per se, but is more accurately a picture about a *Vision of the Lamentation* that these two women experience – what they must think, how they must behave, and which emotions they should trigger to reach a similarly perfected, mystical state equal to that enjoyed by the nun and her sister in Giottino's painting. Lay viewers were shown how to worship, were instructed on the art of emotive veneration, and were privileged to see examples of what everyone in the church of San Remigio ought to do when considering Christ's ultimate sacrifice.

Despite (or, perhaps, because of) the limited access women had to liturgical pictures in formal ecclesiastical spaces, pictures placed in the public sphere often featured female characters as main protagonists. The actual presence of Mary or a particular saint represented in pictures was, as we now know, a foregone conclusion in the minds of most European Christians during the late Middle Ages.[7] Images were processed through the streets of Italian cities not only to allow people to see pictures normally tucked away inside chapels and rooms of medieval churches, but also to allow those figures depicted on the image to see (and bless) those who had come out to greet them.[8]

Bernardo Daddi's remarkable painting of the *Madonna del Bagnuolo* from 1335 illustrates dramatically the potential for animation with which all holy paintings were imbued, and does so in a way that features not only a female saint, but a contemporary supplicant as the recipient of heavenly benevolence from above (Figure 2).[9] Here, in what was almost certainly a copy of an earlier painting of this subject emanating from Daddi's workshop, two women and an acolyte kneel before an altar supporting a large painting of the Virgin.[10] Saints Catherine and Zenobius stand outside the frame that contains Mary, and as Christ blesses us as living viewers standing before this picture, the kneeling donors and their clerical attendant beseech a painting of the Blessed Virgin to come to their aid. Much to our surprise, we see immediately that the prayers offered by our genuflecting donor will be answered in the

2. Bernardo Daddi, *Madonna del Bagnuolo*, ca. 1335, Museo dell'Opera del Duomo, Florence. Photograph courtesy Gabinetto Fotografico del Polo Museale Regionale della Toscana.

affirmative: the Virgin's right hand dips down toward the supplicant, breaking the lower edge of the frame, crossing over the top of the table upon which the image has been perched, and extends into the realm of the living devotees below. The picture has unexpectedly come to life before their eyes – and ours. While Bernardo Daddi's illustration of this event confirms the miracle-working properties of the original image of the *Madonna del Bagnuolo*, it also suggests the pregnancy of potential that all devotional paintings possessed, which could allow them to respond directly and personally to those who invoked the advocacy of the holy figure represented there. Any and every picture, Daddi tells his audience in this frame-within-a-frame painting, has the potential to work

miracles, to come to life as animated figures, and to interact directly with human beings in this world.

It was an important lesson for common people to learn, and artists assumed the responsibility of teaching it to them. How painters came to understand the needs and expectations of such a wide range of viewers – wool workers and immigrants, prostitutes and illiterates, middle managers and doctors, mothers and lawyers, pickpockets and washerwomen – is a question we may never be able to answer.

But understand them they did.

STAGING A VISUAL CULTURE

At the end of her article concerning the patronage of a woman named Datuccia Sardi Da Campiglia, who commissioned Taddeo di Bartolo to decorate a chapel for her in the Pisan convent of San Francesco, Gail Solberg addressed one of the issues that she had raised in her own article.[11] Recognizing the problems inherent in a situation whereby a woman possessed rights to a chapel located in a sacristy where only priests were routinely permitted access, Solberg wondered,

> Did she (Datuccia) occupy her chapel only for her own funeral rights, the chapel that, through numerous visual devices, is so personal as to appear infused with her presence? Or was her insistence on being visually included her way of compensating for her physical absence?[12]

In a broader sense, Solberg asks essential questions: what were the rights of wealthy female patrons in fourteenth-century Italy? Could a woman access her own burial space, located deep within an ecclesiastical center, while she was still alive? Did she have to wait until she was dead before she could enter it? And, if the latter was so, did Datuccia try to overcome her exclusion from her own chapel by having references to her identity placed inside it by an artist so that she could be present symbolically, if not physically, during her lifetime?

Solberg's queries lead us to bigger, broader issues concerning the vagaries of viewership during this period. Exactly who got to see paintings during the waning of the Middle Ages? Where could they see them? What rituals, if any, were performed before them when they did? And how did artists and patrons find ways to address viewers of common birth or the undereducated or those condemned to die or women or children too young to understand what wealthy, smart, enfranchised males were privileged to see? What role must viewership and audience play in our interpretation of image, texts and even musical performance in this period? These are not only good questions: they are, in fact, fundamental ones that scholars of Florentine painting of the early Republican period have only recently begun to ask.

Florentines of common birth, or those unlucky enough to have been born female, did not have the same opportunities to see the city's most influential works of art as could men born into prominent families or admitted to the clergy. As had been the case throughout the thirteenth century when major Italian urban centers experienced a surge in the production of the visual arts, paintings produced during the fourteenth century tended to decorate spaces intended for only a few spectators. The most important and influential images were often created with funds donated to churches and religious institutions by wealthy laymen and, occasionally, their wives or widows. These patrons often wished to decorate ecclesiastical spaces with fresco cycles, altarpieces, sculpted effigies, and a vast array of votive and symbolic instruments to facilitate official religious services. Donors eagerly acquired burial chapels for themselves and their descendants not simply because they provided for their families suitable resting places that could service them until the Day of Judgment, but because they enhanced their social status within their neighborhoods and communities. Exactly how often they visited these burial chapels, or even whether they were allowed to visit them at all, has remained an elusive topic.

The explosion of building projects that marked the city's rise during the late Middle Ages surely laid the groundwork for the volume of fresco cycles and altarpieces painted in Florence during the period. But most of these pictures were installed deep within the architectural confines of religious communities. Paintings in the Franciscan church of Santa Croce by Giotto, Taddeo Gaddi, Maso di Banco, and Bernardo Daddi – most of them landmarks in the history of western painting – could have only been seen by those willing to venture through and behind the massive *tramezzo* (or *ponte*) that ran from one side wall to the other, a marble barrier that effectively divided the large church into two sections (Figure 3).[13] In big churches, like Santa Croce and Santa Maria Novella, this *ponte*, or literally "bridge," was an architectural unit unto itself, a building within a building, rising anywhere from four to nine meters up into the air and extending back toward the transept another eight meters. Chapels and tombs could be embedded in it, which in turn allowed churches to raise additional funds from donors who sought alternative spaces to inter their ancestors and descendants (Figure 4). An occidental relative of the Byzantine *iconostasis*, the *tramezzo* created a barrier that formed two distinctive spaces inside a church: one for the laity, who were expected to mill about in the nave, and one for the clergy, who controlled the choir, crossing, transept, and support rooms in the back. Wealthy benefactors appear to have had the ability to buy their way into this reserved space. No written records specifically state that women and common men were disinvited from visiting the spaces beyond the *tramezzo*, but that massive obstacle with solid walls and doors that stood between them and, say, the frescoes by Giotto in the Peruzzi Chapel acted as a deterrent.

3. Isometric project of Santa Croce with *tramezzo*, before Vasari's renovation. Reproduced from Marcia Hall, *Renovation and Counter Reformation: Vasari and Duke Cosimo in Sta Maria Novella and Sta Croce 1565–1577* (Oxford, 1979), 198, Figure 3.

Friars, laymen with ownership rights to the burial chapels in the transept, and influential civic and mercantile leaders with business in the heart of the church had access to these magnificent pictures. But the level of accessibility to poor men, women, and children is much harder to ascertain. Some evidence suggests that access to spaces behind the *tramezzo* was limited and gender specific, although no chronicles, textual descriptions, or contractual arrangements specifically say so. Circumstantial evidence suggests that women were discouraged from inspecting altars at close range. Giovanni Boccaccio, when framing the narrative for *The Decameron*, opens his story by placing his seven heroines inside the church of Santa Maria Novella, where they commemorate their dead not by seeing or attending Mass but rather by listening to it from a distance – presumably from the congregation's side of the *tramezzo*. The famous frescoes of the *Miracle at Greccia* and the *Burial of Saint Francis* in the upper basilica of San Francesco at Assisi, both of which clearly depict female devotees cordoned off from the sanctuary (but eagerly straining to see inside), suggest that women were unwelcome beyond the *ponte*. Gates attached to *tramezzo* entrances and, often, to the portals of burial chapels sometimes made access into these sacred

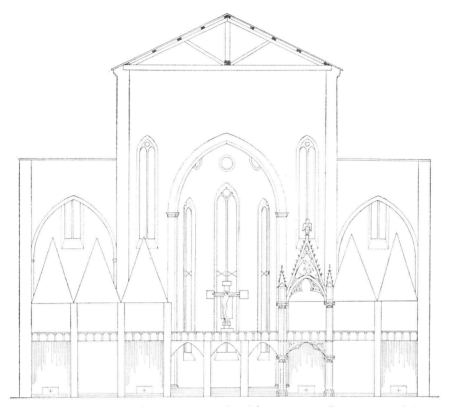

4. Sketch of Santa Croce with *tramezzo*. Reproduced from Marcia Hall, *Renovation and Counter Reformation: Vasari and Duke Cosimo in Sta Maria Novella and Sta Croce 1565–1577* (Oxford, 1979), 199, Figure 4.

zones utterly impossible. The placement of screens in the walls of the *tramezzo* permitted laymen and women to see the elevation of the Host, but this was necessarily from a great distance and reserved only for the fortunate few who fought their way to a post directly in front of the opening there.[14] Monasteries, friaries, and nunneries maintained strict rules that limited access to their facilities to people of the opposite sex. Some institutions observed severe claustration requirements (as did the Camaldolese in Santa Maria degli Angeli), and extended their visitation restrictions to everyone outside the community of monks who resided in the cloister.

This does not mean that the laity did not attempt to get a closer look at objects and images on or at consecrated altars. As Joanna Cannon has noted, the Dominican constitutions of 1249 allowed women to move beyond the *ponte* in their churches and proceed into the friars' zone, but only on its consecration day and then annually on Good Friday.[15] Some women were granted permission to sign wills in the choir of the Franciscan church of Santa Caterina in Pisa,

an unorthodox luxury underscored by its very articulation.[16] And in 1309 and 1310 the civic government of Siena passed a law that prohibited women from approaching altars during the celebration Mass, and imposed a stiff penalty on those who failed to obey it: the law's passage indicates that the leaders of Siena perceived a need to address a current problem, for legislative decrees are rarely proactive.[17] We may surmise that the enactment of the law to keep women away from altars was passed precisely because women were, in fact, approaching them during Mass.

Other bits of evidence support the idea that the laity was discouraged from venturing near the ornamented spaces beyond the *tramezzo*. The Bishop Durandus, writing his manual for the proper handling of services, recommended the segregation of the sexes when they congregated in the area of nave designated for the laity.[18] Churches were designed to make this section of the nave appealing for lay visitors, as the pulpits used by preachers were commonly attached to columns or perched atop free-standing boxes located more than halfway up the nave between the *tramezzo* and the entrance wall, precisely in the zone designated for commoners (Figure 97). Even if they could venture beyond the *ponte* into the transepts, the altarpieces they encountered were usually hidden from view by the curtains or shutters that normally cloaked them when not in use during the Mass. Although they were technically allowed to enter into the transept and wander through its spaces, common viewers routinely found a layer of obstacles in their path that made the most elegant paintings in Florence extremely difficult, if not entirely impossible, to see.

These barriers reduced substantially the volume of pictures easily available to common people. In the Franciscan church of Santa Croce, only two major pictures in the transept would have been seen by the vast majority of lay viewers during most of the fourteenth century – the *Assumption of the Virgin* and the *Stigmatization of Saint Francis* – both of which were placed high enough to be visible above the *tramezzo* from the congregation's side of the nave. Only frescoes of the *Last Judgment* by Andrea di Cione and images of Christ's Passion by an unknown fourteenth-century painter, which faced each other on either side of the nave near the entrance, could be inspected by the congregation (Plate XXXVI and Figure 98). Santa Maria Novella was still more exclusive. The *tramezzo* there was extremely tall and deep, and ornamented with pinnacles that blocked sight lines from the nave to the crossing. Even the large, now-lost frescoes painted by Andrea di Cione in the Cappella Maggiore in 1351 were largely illegible. The Strozzi Chapel, built into the west transept, was doubly removed from the public domain: not only was it tucked away behind the left corner of the crossing, where it was visible only to those standing directly in front of it (namely friars and aristocratic men), but the entire chapel was literally locked away behind massive wooden doors that were unlatched only a few times during the liturgical year.[19] Andrea di Cione's famous altarpiece and

the frescoes of the *Last Judgment* painted simultaneously by his younger brother, Nardo, would have been off-limits to the entire city. Andrea di Bonaiuto's magnificent cycle for the Spanish Chapel in Santa Maria Novella's Green Cloister and the elegant frescoes in the Cappella dei Morti below were even less accessible than that. Only the friars who lived there, plus the occasional powerful guest, were allowed to enter the community's inner sancta, meaning that these pictures were intended from the outset to be seen by an audience of fewer than two hundred men, most of whom were members of the cloister. Not a single one of them would have been considered a "common viewer."

The wording of contractual agreements between individual patrons and institutional hosts supports the notion that lay viewers were not expected to spend much time looking at art works in their own chapel spaces. With remarkable frequency, lay donors requested that monks and friars recite prayers and Masses for the dead on clearly specified days – sometimes daily, other times weekly, and occasionally only annually, depending on the wishes of lay patrons. In return for these spiritual exercises, the community was rewarded with a healthy bequest that became part of the institution's endowment. Some donors intentionally sought out severely cloistered communities precisely so they would not need to spend the time to visit their commemorative chapels or offer obsequies to their ancestors: they essentially paid monks to do their praying for them. Ironically, some patrons paid lots of money to decorate spaces inside monasteries that they had neither the interest nor the ability to see. It was understood that private chapels were to be used primarily by those friars or monks who inhabited the cloister, and only infrequently visited by the lay benefactor whose ancestors were interred therein.

In sum, most Florentines – tens of thousands of them, in fact – were highly discouraged from seeing the city's major artistic monuments installed behind the *tramezzi* of their churches, and then would not have seen very much if they managed to venture forth into those special spaces, legally or otherwise.

PUBLIC PAINTING

Yet Florence was filled with paintings that literally everyone could see daily. At the most basic level, men, women, and children of all classes and backgrounds encountered paintings and sculptural reliefs placed in niches carved into walls high above streets and alleyways, inside confraternity headquarters, on the walls of guildhalls, and inside and outside various public offices. Artists faced some constraints as they considered compositions and subject matter, for the spaces designated for use were often fairly tight. Relying as they did on trusted formats, painters like Bernardo Daddi and Giottino, Jacopo del Casentino and Jacopo di Cione, Lorenzo Monaco and Andrea di Cione frequently adapted public paintings from pictorial types with which they were familiar, and for them,

the altarpiece was the standard by which all other panel pictures were judged (e.g., Plates XXV, XXVI, and XXIX). When faced with the fresh opportunity to produce a painting for a secular space and a common audience, these artists naturally referred back to the forms with which they were most familiar, and they habitually combined into a single, abbreviated composition the multiple components normally seen in the main compartments, side panels and predella strips of liturgical polyptychs. This modification of one type of painting for use in another, and seen by an altogether different audience than the former, resulted in an array of pictures that offered to lay viewers a snippet of those themes that appeared in pictures located beyond the *tramezzo*. They thus provided to common people a sense of what they were missing inside the transept.

By 1330, paintings for consecrated altars had taken on a largely homogenous format, marked by a central panel bearing primary figures of veneration, usually the Madonna and Child, with lateral pictures added to feature standing or seated iconic representations of saints. These flanking figures were often spread out across an even number of panels, with each portion of the polyptych devoted to an individual occupant that appeared like a statue in a sculptural niche (Figure 71). Even seraphim and cherubim got their own panels, albeit in truncated forms and in smaller panels mounted above the saints painted in side compartments. The identities of these characters varied from place to place and setting to setting, as occupants of side panels and even the angels above might refer to specific patrons of a city, institution, benefactor, local bishop, or cult figure associated with issues of specific concern to the localized community. But the altarpiece's central figures rarely deviated from the two key deities of western medieval devotion, Jesus Christ and his virgin mother, Mary.[20] Sometimes they were shown enthroned and sometimes they were seated on the ground, but they always displayed attitudes of reverence, regality, or humility. These were the kinds of images that priests and canons and bishops and abbots and monks and nuns knew well. As painters began to borrow them from altarpieces and then inserted them into compositions for common people, they also became the kinds of images that lay viewers came to expect from public pictures.

Not all public paintings were defined by traditional altarpiece formats. Those images that sat outside the heart of the ecclesiastical center were, by definition, freed from any constraints or restraints that might be laid upon them by an artist trying to please a clerical viewership. When situated in a civic or mercantile setting, the subject matter of public pictures was much broader and more diverse than that seen on altarpieces, and probably contributed to the experimental nature of fresco design employed by artists during the latter half of the fourteenth century (a period of great narrative innovation and exploration). Dante and Junius Brutus and Hercules and Coluccio Salutati were honored in fresco paintings in guildhalls. Walter of Brienne, the loathed Duke

of Athens (whose tyranny shaped the visual vocabulary of early Republican painting with surprising vivacity), was vilified repeatedly in pictures for government offices and corporate headquarters alike. The allegorical figure of the Madonna of Mercy was invented for a confraternity. Genre pictures of orphans and beggars and wool workers and maybe even a prostitute or two appeared once in awhile. Even inside churches, painters enjoyed the freedom to produce unusual pictures, as long as they were intended for a lay viewership and not a clerical one: the remnants of the *Passion, Hell* and *Last Judgment* by Andrea di Cione for the congregation's side of Santa Croce's nave suggest that a vast expanse in that Franciscan church was originally decorated with a wildly entertaining scene of all sorts of vice that surely captivated its audience while simultaneously providing preachers the fodder they needed to fulminate against everything they illustrated (Figure 98). The general public had access to hundreds of paintings during the "long Trecento" and their placement in plain view, often in positions that gave common people no other choice but to see them, suggests they were inspected each and every day by a multitude of laborers, servants, shopkeepers, doctors, lawyers, beggars, mothers, fathers, and children.

In fact, the public art from this era reveals the wonderfully imaginative visual world that shaped the lives of everyday people. It also adds a certain degree of freshness otherwise missing from the litany of Madonnas (found in church after church, chapel after chapel, altarpiece after altarpiece) that we have become accustomed to examining. A rich and exciting world of paintings greeted common people in early Republican Florence.

CHAPTER ONE

PAINTINGS IN THE STREETS: TABERNACLES, PUBLIC DEVOTION, AND CONTROL

STANDING A FULL TWO AND HALF METERS TALL, A DETACHED FRESCO OF the *Madonna Enthroned* greets visitors at the top of the stairway leading into the *primo piano* of the Florence *Accademia*, the world's largest repository of late-fourteenth-century Florentine public painting (Plate II). Seated on a sumptuous throne draped with a cloth of honor, a young, blonde Virgin Mary holds the Christ child in her left arm. His right hand blesses his mother as well as those spectators who view his image. Eight angels flank the pair, moving from foreground to background in symmetrical groups, obscuring the figures behind them with their bodies and the gilt gold halos that gleam behind their heads. The pair at the back reach forward to pull a canopy toward them, stretching the fabric to extend the soft drapery across the throne and to accentuate the sense of tactility that this silk or wool cloth references. At the base of the composition appear John the Baptist and a white-clad, tonsured, monastic saint who defies secure identification: he could represent the fifth-century church father Saint Augustine, the eleventh-century reformer Saint Romuald, or the ever popular twelfth-century aesthetic Saint Bernard.[1] The Baptist, cloaked in his familiar camel hair shirt and draped in a red cloth, turns his head over his right shoulder to address viewers – the only figure in the image to do so. He points to the child and, more important, to the holy woman holding it in an attitude of reverence and admonition, while beseeching us to do the same. While his gesture refers to the picture's core, his gaze breaks the picture plane and moves into the viewer's zone, thus creating a conduit that moves from our realm to the fictive one

created inside the painting. As if to underscore this idea, the bearded monk at the lower right foreground imitates the viewer's position as he turns his back to us and focuses on the larger-than-life-size figures that sit before him. He has become a member of the audience and joins us in our contemplation of the sacred. Too busy venerating this woman to acknowledge our presence, this saint and the angels joining him push our eyes into the painting's core. Only John the Baptist, patron saint of Florence, notices our presence.

Traditionally dated to the year 1356 and attributed to the artist Tommaso di Stefano (better known as "Giottino" due to his study of the work of Giotto di Bondone), the fresco originally addressed viewers from a niche carved into a building on a street corner that faced out onto the Piazza Santo Spirito (Figure 5).[2] Surrounded by the homes of Florence's laboring classes in the Oltr'Arno district south of the river, and set only a few blocks away from the equally important centers of San Frediano and Santa Maria del Carmine, the niche that contained Giottino's street picture looked out onto a square filled with the city's "little people." This was one of Florence's poorer districts, known more as a center of the laboring classes than as a nexus of luxurious *palazzi* (found in other parts of the city). The niche containing Giottino's painting, known as the *Madonna della Sagra*, was recessed into the wall facing the Piazza Santo Spirito and the people who passed by there. The picture presided over them, in daylight and at nighttime, in sun and in rain, and in times of serenity and moments of genuine tumult. Unlike the paintings that common viewers could only glimpse from afar, tucked away as they were inside locked burial chapels or behind the *tramezzi* of churches restricted for use by the clergy, this painting of the *Madonna della Sagra* could be seen by men of all occupations, by women of all social strata, and by children of all ages. This picture spoke to people across all demographic demarcations and with no considerations what-soever of its audience's age, sex, educational background, or socioeconomic standing. Like the hundreds of other street paintings installed in Florentine neighborhoods during the fourteenth century, Giottino's painting occupied a niche, looked out over an unpredictable audience, and was referred to, rather generically, as a *tabernacolo*.

Throughout the early modern era, the Italian word *tabernacolo* carried rather vague connotations. While its appearance in archival sources usually demon-strated a notary's desire to describe a roofed architectonic space designated specifically to hold an image, the functions, appearances, and motivations for creating such spaces were almost limitless.[3] Sometimes *tabernacolo* denoted a small niche in the wall of an ecclesiastical institution where the Host was pre-served for the Mass. At other times it described framing devices in worship spaces into which paintings or sculptures were fitted. And in special cases, the term *tabernacolo* referred to a large, free-standing object that framed a miracle-working cult object – like Orcagna's sculpted monument that framed Bernardo Daddi's famous *Madonna* inside Orsanmichele or the elaborate marble casing

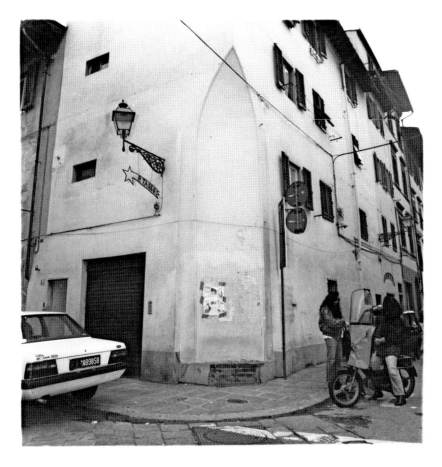

5. Niche, Piazza Santo Spirito, Florence. Photograph courtesy Gabinetto Fotografico del Polo Museale Regionale della Toscana.

for the fresco of the *Annunciation of the Virgin* inside Santissima Annunziata that cost its patron, Piero de'Medici, the tidy sum of four thousand florins (Figure 21).[4] By way of distinction, the word *tabernacolo* was not used when writers described altarpieces or panels hung on the walls of churches: instead, they used words like *pala* or *tabula*. In fact, the word *tabernacolo* was almost exclusively used for spaces and images that were decidedly not liturgical in nature, as though the word itself connoted an extraritualistic function.[5] There was no agreed-upon size, shape, or use for the *tabernacolo*, and the relief, statue, panel, or fresco inside it could be of any subject whatsoever. The word *tabernacolo* was essentially a catch-all term that acknowledged a special container in which an image was placed and seen. It was the setting of the *tabernacolo* that determined the use of the term rather than the other way round.

One of the most popular settings for the most public of pictures was the so-called street tabernacle. Pictures placed on Florentine streets generally fell

6. Taddeo Gaddi, *Madonna and Child*, ca. 1340, Via Antonino, Florence. Photograph © George R. Bent.

into one of two basic types, determined largely by their location or physical setting. If the picture was embedded on a wall or adorned a narrow street, like those attributed to Taddeo Gaddi on the Via Antonino (formerly the Via della Cella di Ciardo) or Andrea di Bonaiuto's fresco of the *Madonna of Humility* on the corner of Via delle Ruote and the Via San Gallo (formerly the Borgo San Lorenzo), it was framed by a ledge, a set of pilasters, or some kind of lunette or pediment (Figure 6 and Plate III).[6] Neither altars nor offertory boxes accompanied these street images, for the addition of such protrusions would have interfered with daily foot traffic and may even have resulted in acts of vandalism.

On the other hand, if an image overlooked a major intersection or a fairly large piazza, like the image of *Saint Sixtus* painted perhaps by Niccolò di Tommaso at the intersection of the Borgo San Pancrazio and the Via del Sole (the old Via di Trevigi) or the fresco of the *Madonna* by the "Maestro di San Martino

7. Niccolò di Tommaso, *Saint Sixtus*, ca. 1385, Via del Sole, Florence. Photograph © George R. Bent.

a Mensola" for the niche in the Piazza del Carmine by the Piazza Piattellina (245 × 149 centimeters), a deeply recessed niche was carved into the street corner to elevate the image's prestige and provide the picture with some protection from the elements (Figures 7 and 8).[7] These pictures were occasionally attached to platforms that could serve as devotional tables positioned beneath them, as was the case with the image of the *Madonna dei Malcontenti*, viewed by common people daily and, less frequently, by condemned criminals as they processed past the corner of Via delle Casine and the Via dei Malcontenti on their way to the executioner's grounds outside the Porta della Croce (Plate IV). Sometimes the niche receded in a rather straightforward manner, creating ninety degree angles perpendicular to the picture plane. But when placed in an open setting, like Giottino's *Madonna della Sagra* on the Piazza Santo Spirito, the sidewalls were recessed at wider angles, creating a pinched space in the back that allowed for greater accessibility from the oblique (Figure 5 and Plate II). The paintings inside these distinctive tabernacles, then, acted as separate images

housed in covered shells that focused a viewer's attention on the image within a specific, unified interior.

The street tabernacle was designed as an abbreviated reference to sacred chapel spaces commonly found in churches. It appeared as a self-contained unit, almost always conforming tightly to the confines of a single panel or, in the case of Giottino's painting, a unified frescoed lunette. It tended not to function as an altarpiece, of course, because it had neither a consecrated altar beneath it nor an attendant priest to perform Masses there; thus, the street tabernacle accommodated no official ceremonies. And because it usually had no discrete liturgical function, the paintings in street tabernacles did not look like actual altarpieces that ornamented consecrated religious spaces. Their audiences changed from day to day, hour to hour, even from minute to minute. The painting inside the street tabernacle was the most public of all public paintings, and its viewers were the most common of all common viewers.

And this diverse, unpredictable, and highly transitory audience naturally created unusual challenges for the painters who made these public pictures. Artists could not afford to present esoteric information in these paintings, for the cultural literacy of their viewers simply could not be trusted. The highly sophisticated philosophical, theological, and political messages often inserted into altarpieces for learned audiences could only have a limited impact on casual viewers walking past street tabernacles propped up in niches of busy street corners. To accommodate the distinctive composition of their common audience, painters tended to focus their compositions on single figures or reduced, tightly packed groupings. Eliminated altogether were the predella panels that were, by 1310, commonly placed at the foundation of altarpieces both to emphasize the devotional thrust of the image and to elevate the object over the liturgical table so it could be more easily viewed by those privileged enough to see it. Pictorial narratives were untrustworthy in the paintings placed in the public realm, for there was no way of telling who did or did not know the story lines behind certain tales and legends. Moreover, painters had to consider with some care the position of their pictures, usually placed over the heads of viewers, in a place of authority. The result was a series of street tabernacle pictures that communicated basic information through iconic renderings of holy figures intentionally designed to appear rigid, stately, and intimidating. Set in niches in markets, squares, and intersections of densely populated neighborhoods, these paintings competed with a hubbub of activity that preyed upon the attentions of the common people who lived and worked there. They needed to be easily read, quickly understood, and uncommonly authoritative to be effective.

Most tabernacle pictures produced for these urban settings featured a fairly standard approach to figurative content. The Virgin Mary almost always occupied the position of honor in the composition's center, and the Christ child was rarely far from her protective bosom. Although some exceptions creep into

8. Maestro di San Martino a Mensola, *Madonna and Child*, ca. 1395, Piazza Piattellina, Florence. Photograph courtesy Gabinetto Fotografico del Polo Museale Regionale della Toscana.

the equation, usually these two figures were placed on a throne which featured straight or spiral colonnettes supporting a pediment or pinnacle behind their heads. As in case of the *Madonna della Sagra*, angels added to the composition's edges formed a figural backdrop that served as a framing device for effigies of standing saints occupying positions in the lower corners of the image (Plate II). A variety of these celestial advocates were used in different street pictures, probably selected because of local interests or due to the specific connections of a neighborhood's users, and were almost always positioned either in profile or in a three-quarters pose that caused them to look up at the Virgin seated above. Only John the Baptist, patron saint of the city, appeared with any kind of frequency (although not nearly on the same level as Mary and Christ). When his likeness was inserted into the composition, as it was in the image of the *Madonna dei Malcontenti* where his rigid position contrasts with the turned body of Saint Peter, John almost always appeared in a way that allowed him to address viewers

directly with both eyes (Plate IV). Giottino surely knew of the importance of John's gaze, and in the *Madonna della Sagra* he intentionally twisted the saint's body in a dramatic effort to maintain that connection between viewers and subject through the communicatory device of the saint's eyes. Of all the pictorial components that went into the common picture installed into the urban street tabernacle, the most important may have been this emphasis on direct visual contact between featured figures in the composition and those viewers who looked up at them from below.

Precisely who was watching whom, however, was not always entirely clear.

PAINTINGS IN THE STREETS AND THEIR VIEWING PUBLIC

Every street tabernacle produced during the early Republican period was its own entity, with its own function or set of functions either prescribed for it at its creation or heaped upon it after its installation. Because a vast majority of them featured the image of the Virgin Mary, and all the rest were dedicated to other intercessors of significance, these pictures clearly contained more than a kernel of devotional strength. Knowing that paintings like these adorned altars stationed beyond the *tramezzo* of churches, common people understood that street tabernacles possessed the same kind of authority as pictures attached to consecrated Eucharistic tables, even though they lacked the altar that gave altarpieces such a powerful presence. Some had specific prayers associated with them that were recited by lay worshippers who congregated before them.[8] Others were surrounded by groups of men and women in Laudesi Companies, who sang religious hymns in front of them.[9] It has even been suggested that the recessed nature of some of them, like the *Madonnone* commissioned by the Dyers Guild in the late fourteenth century and featuring a long and deep platform at the base of the niche, were intended to hold the elements of the Eucharist so that impromptu Masses could be said by priests in public places (Figure 9).[10] But most importantly, images of Madonnas in the street provided lay sinners the opportunity to interact directly with the Virgin Mary in ways they simply were not allowed to repeat in the sanctified realm of the medieval church.

In one important setting, we get a glimpse of how common viewers addressed public devotional pictures and what they hoped to get from them. In the southeast corner of the Guild Church of Orsanmichele appear three beautifully crafted stained glass windows, all situated at approximately the spot where the cult image of the *Madonna of Orsanmichele* was originally positioned sometime around 1291. The trio of windows, designed and installed in the early years of the fifteenth century, clearly refer to miracles associated with the Virgin Mary and, more specifically, with legends attached to the power of the *Madonna* that was (and is) located beneath them in the southeast bay of the

9. Lorenzo di Bicci, *Madonnone*, ca. 1390, Via di San Salvi, Florence. Photograph courtesy Scala/Art Resource, New York.

church.[11] The window to the far left features a young man who kneels before a street tabernacle bearing the image of the Virgin Mary enthroned with the Christ child in her lap (Figure 10). In the background looms a bridge that supports a sculpted figure of Hercules, a reference to the ancient sculpture that adorned the Ponte Santa Trinita until its destruction in the flood of 1333. A similar narrative brackets this story in the window on the far right side of the bay. Here a supplicant prays before the same tabernacle containing the *Madonna of Orsanmichele*, but this time witnesses from the community crowd around him to watch (Figure 11). Squeezed between these two scenes of personal devotion, the central window relocates us at an executioner's station, where a condemned criminal dangles from the gallows as the Virgin Mary descends from heaven to come to his aid (Figure 12). The message in this trio of windows is clear enough: the Virgin prayed to in the street tabernacle shown in the right and left windows is the same Virgin who comes to the thief's rescue in the central one. Importantly, the sequence reminds the viewer that power of the

10. Giovanni del Biondo (?), *Renunciation of Worldly Goods*, ca. 1390, Orsanmichele, Florence. Photograph courtesy Gabinetto Fotografico del Polo Museale Regionale della Toscana.

Virgin supersedes even that of the civic authority and that even the most hardened criminal might enjoy an eleventh-hour respite with an authentic appeal to her.

The theme of these windows revolves more around the manner in which common Florentines used street tabernacles than any specific event. In fact, the exact narrative in each of these windows has never been determined, for nothing in contemporary literature or chronicles of the period conforms to anything here depicted. Indeed, one suspects that this was precisely the point: the more generic the story, the easier it could be for individual viewers to map onto the image their own experiences, real or imagined.[12] Instead the artist instructs viewers on proper devotional attitudes. In each of Orsanmichele's windows, supplicants approach the picture individually and independently of any interpretive agent: no priests or friars or bishops instruct or edify the viewer, and no one there seems interested in making sure the devotee utters the proper

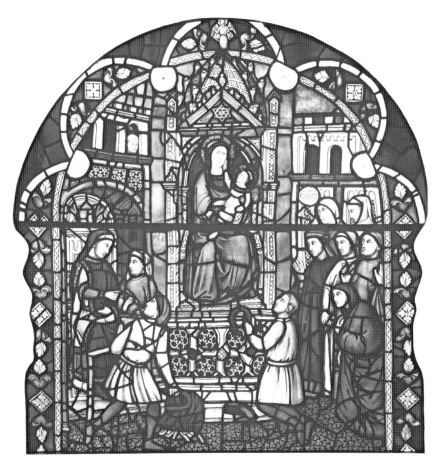

11. Giovanni del Biondo (?), *Miracle of the Ordeal by Fire at the Grain Market*, ca. 1390, Orsan-michele, Florence. Photograph courtesy Gabinetto Fotografico del Polo Museale Regionale della Toscana.

prayers or recites those prayers correctly. Instead, our male worshipper interacts personally and privately with the Madonna, even though this personal and private interaction has been staged outdoors and in the public eye. It is true that this supplicant cannot enjoy a completely intimate experience with the street tabernacle: but it is equally true that the lack of priests allows for a deviation from prescribed litanies and liturgies, which in turn creates an opening for personal reflection, interjection, and supplication.

If Orsanmichele's windows illustrate normative uses of street tabernacles, then we must recognize the liberating quality they must have had for those commoners who rarely, if ever, had the chance to approach a painted image of the Madonna in the sanctified setting of a consecrated altar. This was their chance to mimic what they thought happened at the altar, to tap into the powers that pictures of the Madonna could have, and to speak directly to the

one intercessor who had the complete and undivided attention of Jesus Christ in heaven. We may infer that street pictures provided common people with a direct connection to celestial advocates and allowed lay viewers a means by which to bypass clerical intermediaries as they practiced their personal devotions. Street tabernacles were popular for a reason.

This personalized and direct interaction between lay viewers and painted objects formed the core of the legend of the foundation of the Confraternity of the Neri (the Compagnia alla Croce al Tempio). According to the *Libri varie*, a book of the confraternity's various comments and records, the idea of forming this group of lay brothers came about in 1343, when a group of unnamed young boys – *fanciulli* – congregated around an image of the Virgin that may, in fact, have been the *Madonna dei Malcontenti* (Plate IV).[13] After saying their prayers, the boys determined – there on the spot – to form their confraternity. Although the *Libri varie* does not explicitly claim that the picture actually spoke to the *fanciulli*, the implicit message suggests that the interaction between them was in the form of a dialogue: Mary planted in their minds the idea of creating an organization dedicated to the conversion of convicted criminals, and her image in the painting sparked the use of other paintings in the confraternity's ritualized processions of the condemned as they marched toward the execution grounds outside the Porta alla Croce. It would take the young boys another thirteen years to realize their dream, but when the confraternity was founded, the *fanciulli* credited their experience before the public painting of the Madonna as the impetus for the creation of the Neri.

Italian urban communities evolved and prospered as the sacred and the profane merged. So inextricably woven were they that the two often coexisted in spaces originally and officially designed to suit one or the other. Commercial transactions occurred in religious structures and deals were negotiated and confirmed before images of holy figures, while markets and workshops were situated around street tabernacles, pilgrimage sites, and objects of devotion. Edward Muir has noted that Italian merchants often felt the need to possess pictures that might help "facilitate business," and shrines were erected on Venice's Rialto for precisely this reason.[14] Affirming profit margins with holy sanction, he notes, seemed perfectly natural, as "traders and artisans sought to sanctify their commercial dealings by notarizing, signing, and witnessing their contracts in a church where the parties might be invested with a fear of divine punishment for breaking their word."[15] While the ecclesiastical setting was important for instilling in all parties a sense of *gravitas*, it was the image before which such contracts were finalized that mattered the most. And, of course, churches were the most obvious place in which to find sober pictures to remind clients and merchants of their obligations to each other. But when ecclesiastical structures were unavailable, or the images in their exclusive settings were inaccessible, the common street tabernacle came into play.

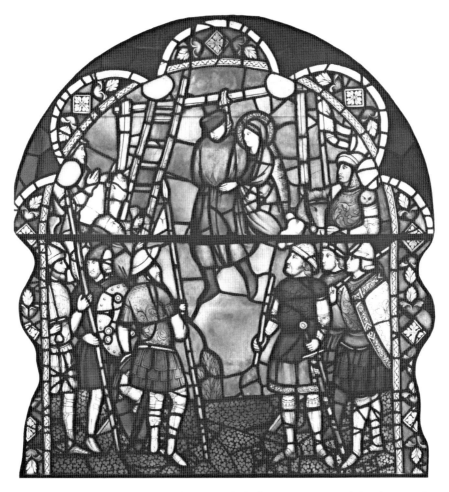

12. Giovanni del Biondo (?), *Miracle of the Hanged Thief*, ca. 1390, Orsanmichele, Florence. Photograph courtesy Gabinetto Fotografico del Polo Museale Regionale della Toscana.

Street images provided the laity with substitutes and surrogates for Bibles, altars, and images inside churches, the latter of which could be hard to reach due either to their physical distance from a merchant's stall or to the obstructing *tramezzo* intended to limit access to a church's inner sanctum. Paintings in street tabernacles served the purpose of creating impromptu meeting places in public areas where people could meet under the eyes of holy figures, strike bargains with partners or clients, and remain safe in the knowledge that holy witnesses had participated in the agreement. Public pictures of the Virgin Mary, in particular, lent to secular spaces an air of sanctity, irrespective of the realities of life in that particular quarter. Even the most squalid of neighborhoods retained at least some sense of security through the presence of a public Marian image.

Indeed, the highly utilitarian culture of late medieval Italy mandated that street-corner Madonnas and roadside shrines of specific patron saints

contributed to the public weal explicitly. Edward Muir and Richard Trexler have long argued that popular paintings of religious figures were imbued with a number of potential powers. For Muir, these pictures were made to perform miracles, cure the afflicted, ward off plague, prevent crime, and (most importantly) remind "the living of obligations to pray for the dead."[16] When installed in public settings in highly cultured cities like Venice or Florence, these pictures invoked a sense of community and civic pride that could help people overcome parochial allegiances and clannish factionalism that constantly threatened to undermine the authority of the city-state.[17] In Venice, images of Saint Mark reminded local viewers of the power of the *serenissima*. Florentines considered the figures of Saints Reparata, Zenobius, or John the Baptist their celestial advocates and heavenly protectors as citizens of the commune rather than merely as members of guilds, confraternities, or parishes. Viewers had before them an array of painted exemplars, strategically positioned at spots in the city where models of good behavior were most needed. Long before the commune could afford to organize and support an official police force, paintings of saintly figures were used to keep the peace, shame wrongdoers into submission, or – better yet – discourage miscreants from engaging in antisocial activities *before* they had a chance to begin. Public pictures controlled public behaviors.[18]

On a very basic level, public pictures provided the nocturnal traveler with a brief respite from the dark.[19] Because their keepers wished to promote them to the public, torches were placed near them at night so passersby could see them, thus illuminating the otherwise pitch-black streets.[20] Not surprisingly, most street tabernacles installed inside the city walls were strategically located at intersections of at least two (and sometimes three) thoroughfares, often in tough neighborhoods where pickpockets, ruffians, and organized gangs would otherwise cluster. This addition to the nocturnal landscape was most welcome: when Guido Cavalcanti, writing at the end of the thirteenth century, praised public tabernacles for their restorative and salvific powers, he also noted their pragmatic significance in this age before electric lightbulbs. Wrote the poet, "Sana in pubblico loco gran languor//con venerenze la gente l'inchina//dua luminiara l'adornan di fuori."[21] The painting, he said, was revered by the people who could see it, illuminated as it was by the two lamps lit beneath it. Of course, these lamps also illuminated the streets below during the night, thus providing at least a semblance of comfort for those who risked walking the city alleyways after sunset. Presenting people with an image upon which to focus their devotions was all well and good, but providing light on an otherwise enshrouded and profoundly perilous street corner was truly invaluable.

But even this important utilitarian function was of secondary importance to the broader general public, who viewed these paintings as essential components of their daily spiritual, social, and commercial lives. Public pictures provided the

laity a sense of comfort and security, as general audiences could feel safe under the watchful eye of holy protectors whose images watched over them from the sides of buildings. When describing in his thirteenth-century *Rime* the powers of the *Madonna of Orsanmichele*, Cavalcanti wrote, "li 'nfermi sana e' demon' caccia via//e gli occhi orbati fa vedere scorto," reminding his readers that this street tabernacle could heal the sick, chase away demons, and quite literally see everything before it. As Megan Holmes has demonstrated, paintings of the Virgin Mary not uncommonly featured large eyes that were prominently displayed on the Madonna's face for precisely this purpose.[22] For honest people, this was a welcome attribute.

This concept of "watching" and "seeing" formed one of the core components of late medieval visual literacy. Richard Trexler's fundamental studies of Florentine life have demonstrated conclusively that a wide cross-section of people fervently believed that images of holy figures had the potential to contain inside them the physical presence of the person depicted. Mary was actually inside the *Madonna of Impruneta*, to cite the subject of Trexler's most famous case study, and could see through the eyes of the Virgin depicted on its surface.[23] This miracle-working panel was not the only picture infused with supernatural powers. As Trexler notes, Savonarola warned his listeners about the dangers of sinning within the sight of the Virgin Annunciate in Santissima Annunziata, Bernardino of Siena advised women in his audience not to act in a lascivious way before pictures of saints even in the privacy of their own homes, and those who dared defile images of the Madonna were not only punished by the legal authorities but were occasionally left to suffer at the hands of angry, homicidal mobs.[24] A legend surrounding a now-lost street painting of the Virgin Mary that was once installed outside the church of San Michele Bertoldi (in the notoriously bawdy Mercato Vecchio) described how the painting's central figure, disgusted by the antics of those who cavorted before it, actually closed her eyes to signify her moral repulsion: it is not clear exactly what it was that she found so horrifying, nor whether the Virgin averted her eyes in an act of silent protest or out of a sense of embarrassment – or both.[25] David Freedberg's examination of the powers of images in early modern Europe reminds us that paintings, sculptures, prints, and drawings had the ability to make human beings do things they otherwise might not be inclined to do. The *tavolette* and small pictures of the crucifixion shown by members of the Neri to condemned prisoners as they made their way to the gallows were intended to inspire both their contrition and their genuine penitence as they prepared for an eternal fate that could be worse than the one they were facing at that moment.[26] While images certainly inspired their users to celebrate them, they also had the power to act upon viewers – to condemn or even destroy them, if their behavior warranted it.

In addition to providing lay residents with images before which they could pray for miracles, consummate solemn agreements, or show the Virgin

their piety, street tabernacles also served as elements of control in chronically tumultuous times. Public pictures of Mary flanked by angels and protector saints constantly gazed out at all those in view as a pictorial security team that enforced the law and fostered domestic tranquility at all times, day and night. The lamps lit at dusk by the Commune beneath these street tabernacles not only shed light on the otherwise darkened alleyways of the city or illuminated images even at the darkest times of the day: they also provided light for the fig-ures depicted in the image so that they, through the eyes the artist had painted on them, could see the faces and actions of those below them. Paintings of holy figures were imbued with the ability to see, were provided the light they needed to use this power, and kept the peace by discouraging villains from doing their worst before the seeing eyes of a powerful and punishing image.

THE *MADONNA DELLA TROMBA* IN THE MERCATO VECCHIO

Among the many surviving examples of street tabernacles from the early Republican period, perhaps the most famous is the *Madonna della Tromba* that once looked down on the Mercato Vecchio in the very heart of the city, but which now adorns the northeast corner of the Palazzo Arte della Lana (Plate V). Probably produced sometime during the 1330s, Jacopo del Casentino's large painting – at 194.5 × 123 centimeters, it stands almost two meters tall – was framed by an ornate box with a pinnacled top.[27] If the miracle-working image at Orsanmichele (celebrated in the stained glass windows there) was Florence's most famous street tabernacle during the decades bracketing the turn of the fourteenth century, then the *Madonna della Tromba* was probably the city's most visible. Standing at the mouth of Florence's chaotic mercantile center, the paint-ing in the tabernacle looked out upon activities transpiring in the busiest piazza in Florence, the hive around which all the region's worker bees buzzed. Its placement inside the oratory of Santa Maria della Tromba – a shallow room that had been carved into the building that once stood at the corner of the piazza where it could be seen by venders, customers, and window-shoppers alike – allowed everyone entering and exiting the market to see the image and for it to see them, thus giving it a certain guardianship over Florence's most vital and, at times, most villainous neighborhood.[28] It also made the painting acces-sible even to those who did not wish to enter into the oratory, but rather view the painting from the vantage point of the street outside it. This was surely the perspective taken by prisoners of the commune who were forced to stop there during the procession that led them from their cells in the Palazzo del Podestà to the executioner's grounds outside the city walls at the Porta alla Croce. The public setting of this street tabernacle made it a crucial image in the city's center.

The Mercato Vecchio, located squarely in the middle of the city in what is now the Piazza della Repubblica, contained a labyrinth of alleyways, corridors, and tiny courtyards. This was where guilds built their residences, merchants

13. Mercato Vecchio before its demolition, Florence. Photograph courtesy Archivi Alinari, Florence.

operated shops to advertise and sell their wares, and venders offered fruit, vegetables, and meat of various quality. Taverns and inns serviced customers by day and night – and sometimes by the hour – with a few offering more than just a good night's sleep for lonely travelers. One can only imagine the stench rising up daily from this poorly ventilated cauldron of commerce. While we can today sympathize with the historian Guido Carocci's despondence at the thought of the Mercato Vecchio's demolition in the late 1880s, we can also understand why the Italian leaders of the newly created nation wished to do away with this rather dangerous den of hawkers, hotheads, and whores when they did.

But Carocci's protest is understandable, for when the Italian government chose to destroy the Mercato Vecchio, they ostensibly eradicated an area steeped in ancient and medieval history. This area had once been known as the *Foro Romano* during Florence's earliest days, and even then it was considered the city's absolute center. The piazza stood at the crossroads of Florence's two main arteries, where the *cardo* and the *decumanus* intersected, thus marking it as the true umbilical cord of the old city (Figure 13). Its fortunes waned in the early Middle Ages, but after centuries of neglect the area was revived and reformed as a market in the tenth century. A large column, brought from the worksite of the new cathedral in the early fourteenth century, was affixed at the main

corner formed by the Via Calimala and the Via Corso. The Mercato Vecchio represented the very soul of the rising Tuscan city – its values, its wealth, its very way of life. By this time the Mercato Vecchio had also gained a reputation as one of the most dangerous sections of the city, and the list of crimes committed there was as varied as it was extensive. Thieves and pickpockets preyed upon unsuspecting rubes, preferably foreigners. Unscrupulous shopkeepers, counterfeits, and forgers happily sold shoddy products to naïve buyers. Quarrels between penny-pinching customers and profit-hungry merchants occasionally devolved into violence, endangering bystanders and spectators. Entrepreneurial prostitutes added a pinch of salaciousness to this environment of vice and infamy. And the image that oversaw it all was Jacopo del Casentino's impressive *Madonna della Tromba* that was tucked inside a small oratory that opened out into the mouth of the Mercato Vecchio in a way that invited the general public to seek solace and shelter within.

Like the large column erected at the city's navel during the first quarter of the fourteenth century, the oratory of Santa Maria della Tromba stood at the intersection of Via Corso and Via Calimala, at a small alleyway known as the Chiasso della Tromba (still a busy center of commerce in the nineteenth century when Giuseppe Moricci painted his genre picture there; see Figure 14). Built with funds secured from the Guild of Doctors and Apothecaries – which included in its membership the city's painters – the small oratory featured a convex opening that provided sight lines from obtuse angles for those moving to and from the heart of the old market. Rather than spend additional funds on its decorations, the guild moved some of the furnishings from its own headquarters over to the oratory.[29] The setting of this small religious niche, there in the midst of the chaos that seems to have beset the old market regularly, seemed a fitting one, for the text of the agreement explicitly describes this spot as one contaminated by villains who performed the worst kind of vices on a regular basis ("in quo multa turpia et inhonesta fieri solebant"). It was a rough and tumble area, indeed, and the need for a spiritual oasis in this sea of sin was obviously pressing. Judging by the scene depicted in Johannes Stradanus's sixteenth-century painting of the Mercato Vecchio, the chaos described in the document did not change much over time (Figure 15).

Among the items transferred to the market from the guildhall was a dossal panel that promoted the Doctors and Apothecaries. The earliest recorded reference to the picture appears in the official provision of July 1361, in which the Florentine government ceded to the Doctors' and Apothecaries' Guild (the Arte dei Medici e Speziali) responsibility for the oratory that they had just renovated and refurbished on the corner of the Mercato Vecchio. The document notes that the Doctors and Apothecaries had already attempted to address the squalid conditions there, and had installed this panel in the prominent setting by the entrance to the market ("posita fuerit quedam tabula ipsius ymaginis devota

14. Giuseppe Moricci, *Santa Maria della Tromba*, ca. 1860, Galleria d'Arte Moderna, Florence. Photograph courtesy Scala/Art Resource, New York.

et pulcra et ibidem factum fuerit oratorium cui tabule ob ipsius virginis glo-riose reverentiam per homines et personas transeuntes apponuntur candele").[30] In a manner that clearly indicates the picture's new function as a street image, the Doctors and Apothecaries were ordered to illuminate it with lamps and candles that were to burn every night until one of their members extinguished the flames in the morning. The image was to be honored reverentially, and was intended to address the needs and the sins of all those who saw it from the market. The painting came to be known as the *Madonna della Tromba*, a reference to the street upon which it was found, the oratory in which it was installed, and the behaviors of those who traversed it right up until the day it was removed from its setting in 1785.[31]

Jacopo del Casentino, an efficient and popular (if uninventive) painter of the first half of the fourteenth century, has been associated with this painting for a long time. Active for at least thirty years, from roughly 1320 until his death in either 1349 or 1358, Jacopo received a steady flow of commissions that led to the production of a variety of small, private devotional images, the occasional altarpiece for a local church, and a number of dossal panels that featured the

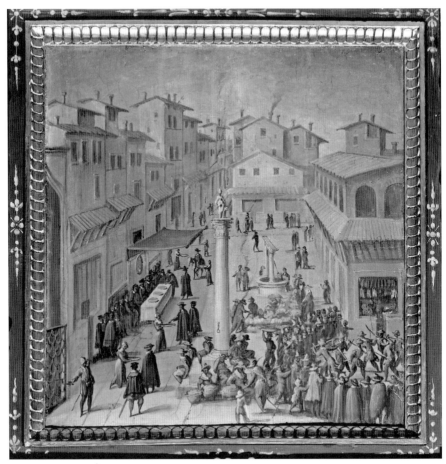

15. Johannes Stradanus, *Mercato Vecchio*, Palazzo Vecchio, Florence. Photograph courtesy Scala/Art Resource, New York.

effigy of a single saint surrounded either by angels or by narrative scenes.[32] Deciphering Jacopo del Casentino's career poses threats to specialists in the field, for his artistic output, like that of so many of his peers in the poorly documented early fourteenth century, must be reconstructed based largely on connoisseurial judgments that have changed over time. Still, most agree on the following proposals: in the 1330s Jacopo produced for the granary at Orsanmichele a panel for the Delicatessen Owners' Guild (the Arte dei Pizzicagnoli) that displayed an enthroned *Saint Bartholomew* gripping a knife while surrounded by a group of attendant angels (Figure 74).[33] During this period he also painted the picture of Saint Miniato for the church of that name on the hill overlooking Florence. Sometime before 1349, Jacopo produced the painting for the street tabernacle on the corner of the Via Giraldi and the Borgo degli Albizzi that included references to Saint Benedict and Saint Peter, probably to honor the Benedictine nunnery of San Pier Maggiore in that neighborhood

16. Jacopo del Casentino, *Madonna and Child with Saints Benedict and Peter*, ca. 1345, Borgo degli Albizzi (Via dei Giraldi), Florence. Photograph courtesy Scala/Art Resource, New York.

(Figure 16).[34] Jacopo appears to have been a capable and devout administrator, for, in 1339, he helped form the Compagnia di San Luca, the confraternal order comprising city painters, and, along with Bernardo Daddi, served as one of its first advisors.[35] Conflicting archival information places Jacopo's death either in the year 1349, as noted in the book of the Compagnia di San Luca, or in 1358, according to a notice dated in that year.[36] In either case, the artist was deceased by the time his painting was installed in the oratory of Santa Maria della Tromba, and the image installed there by 1361 appears to have been painted some two decades earlier, sometime in 1330s, for an undisclosed setting inside the meeting hall of his own Guild of Doctors and Apothecaries.[37]

As it did when it was first installed inside the recessed walls of the oratory in the old market in 1361, the *Madonna della Tromba* today presents viewers with

a fleshy image of the Virgin Mary seated on a throne with the Christ child in her lap (Plate V).[38] Flanked on her left by John the Baptist and on her right by an unidentified evangelical saint (seen by some as Saint John the Evangelist, by others as Saint Luke), the enthroned Madonna sits between six angels who stand behind and beside her, their heads peeking around the bodies of their partners or through the pinnacles which form the framework of the throne. Both the arms of the throne and the marble step upon which it rests recede in angles more or less comparable to the pinched design of the oratory's walls, as may be seen in the fifteenth-century drawing of Santa Maria della Tromba appearing in the famous *Codice Rustici* of 1442 (Plate VI).[39] The effect of viewing the painted architectural forms as extensions of the actual oratory must have been impressive indeed. Only Mary and the Baptist look toward the viewer, as Christ, the standing evangelists, and the angels glance toward other figures inside the composition. Their identities, their presence in the oratory on the Chiasso della Tromba, and the gazes of the two most important intercessory figures in the painting, Mary and John, confirm that this picture was more than just a decorative image to be enjoyed or commented on for its aesthetic qualities: it was selected for its setting in the oratory to address the needs of people living and working in this mercantile sector of Florence.

At a basic level, the *Madonna della Tromba* most probably satisfied an age-old need of a corporate patron, in this case the Arte dei Medici e Speziali, to advertise its services. As the guild to which painters belonged, this body would have had a special interest in displaying a large picture inside its head-quarters, located squarely in the midst of venders and clients crammed into the alleyways that composed the bustling commercial center of Florence. In fact, their residence hall was only a few meters away from the oratory, making this an obvious motive. The guild seems to have intentionally selected this as the painting, almost certainly painted between 1335 and 1340, to fit into the oratory that seems to have been constructed at least twenty years later, possible in 1361.[40] This, in turn, suggests that the design of the oratory, which moved in obliques toward the back of the room and the picture standing there, may have been influenced by Jacopo del Casentino's angled throne and floor, rather than the other way round.

As the only public image in the Mercato Vecchio accessible to the general audience in the market, the oratory and image of the *Madonna della Tromba* designated that corner as a possession of the Guild of Doctors and Apothe-caries and asserted its presence there. If we identify the white-haired saint standing to the lower right as Luke the Evangelist, patron saint of both the Compagnia di San Luca and the Arte dei Medici e Speziali, then we may understand the importance of placing this symbol of corporate commercialism in such a prominent, public place. While the image inside the tabernacle surely admonished its viewers to behave themselves, and in fact was installed there

explicitly for that purpose, it also promoted the political and economic inter-
ests of one of the leading guilds in the city. As we shall soon see, the nearby
Wool Guild, the Arte della Lana, similarly promoted their specialization
through the use of pictures appearing in a public space located not far from
the corner of the Mercato Vecchio.

Some two decades after the installation of the main panel inside the oratory,
a second, lunette-shaped panel depicting the popular image of the *Coronation of
the Virgin* was affixed above the *Madonna della Tromba*.[41] This painting, produced
by an artist working in the orbit of Niccolò di Pietro Gerini (if not the artist
himself), repeated some of the same pictorial features of Jacopo's painting. As
in Jacopo's picture, the throne with decorative finials supports an elaborate
cloth of honor promoting the textile industry that made Florence famous in
the fourteenth century. The square and diamond pattern in the floor echo that
placed at the feet of John the Baptist and the standing Evangelist in the panel
below. And the acute recession of the architecture, combined with the sharply
inclined tiles upon which these angels kneel, reproduces the same spatial feel
emphasized in Jacopo's primary work underneath.

Iconographic links to the large dossal also form important connections
between the two. Mary's duties as mother, clearly articulated in her role as
protector of the infant Christ in Jacopo's main panel, evolve into more regal
ones as she lifts her head after receiving the crown from her son's hands. The
centrality of the crown in this picture designates Mary as a woman transformed
from her earlier, more humble state, while the depiction of Christ as an adult
underscores this distinction in even grander terms. And, on a more mundane
level, the horns held aloft and blown by the angels kneeling at either end of
the composition most probably allude to the word *tromba*, a not-so-clever ver-
bal/visual connection that designated this image as one marking the alleyway
that bore this word in its name.[42] But there appears to have been an added layer
of meaning that a specific subset of contemporary viewers would have under-
stood as they considered the street tabernacle in the oratory at the mouth of
the Mercato Vecchio. To glean this ulterior meaning, we need to dig deeper
into the underbelly of Florentine society and, specifically, the kinds of vice and
dishonesty the picture was intended to combat when it was installed there in
1361.

The things these street pictures could see extended across the entire spec-
trum of human activity, and the more commercial the setting the more expan-
sive this range of activity became. As is the case in open markets today,
consumers went there not only to buy their daily necessities, but also to shop
in a more capricious sense. Things that struck one's fancy might be bought
impulsively, a chance that vendors always counted on as they displayed their
wares from the open loggias of their shops or, more simply, on the benches
in front of them. And just as the market might be filled with honest salesmen

offering quality products for an honest price, an equally prominent number of forgers, thieves, and confidence men prowled these spaces, eager to separate their victims from their money. Images like the *Madonna della Tromba* may well have been positioned in full view of the open market not only to discourage rioting or rebellion, but also to protect the innocent from villainy and to chastise – and, hopefully, dissuade – the villainous for preying on the innocent.[43] Indeed, it is imperative to recall that the acts of vice and moral turpitude that had earned the Mercato Vecchio its reputation for dishonesty were the only motives recorded by the government when they granted their consented to the Arte dei Medici e Speziali to erect and decorate the oratory of Santa Maria della Tromba in 1361: the site was, as the official decree stated, "super angulo fori veteris in quo multa turpia et inhonesta."[44] The commune seems to have felt the need to impose some kind of order on the place, and it approved of the decision to install Jacopo del Casentino's painting of the Virgin Mary at the market's main entrance as a way to enforce proper conduct and to impose on its occupants and its audience a sense of honor, decorum, and honesty.

There can be no question that the temptations facing visitors to (and regulars of) the Mercato Vecchio were perceived to threaten the safety, health, and moral fiber of nearly everyone in the city. Although not mentioned specifically in the government's acceptance of the guild's petition to create the oratory there, surely one circumstance influencing this discussion must have been the presence in the Mercato Vecchio of a series of taverns, inns, and backrooms favored by scores of prostitutes working in the neighborhood's labyrinthine series of streets and alleys. The Latin word used in the document of 1361 that describes the location of the oratory, *inhonesta*, had very specific connotations in the mid-fourteenth century. It did not mean "dishonesty" in a general sense, but rather "moral turpitude" or, crassly put, "whoring."[45] The city acknowledged this problem inside the crags and crevices of the Mercato Vecchio, and it was this problem that motivated the commune to create the public oratory at the corner of this troubled spot in the first place.

For most of the medieval period, the commune had attempted to stamp out illicit sex altogether, and explicitly outlawed acts of prostitution in the city – as they were elsewhere in most European communities. But by the middle of the fourteenth century, the Florentine government recognized that this was an unwinnable war: too many women depended on this source of income, too many men participated in the exchange to stamp it out entirely, and the time and energy required to chase down the women and men practicing prostitution simply was not worth the effort. In 1325, after passing a series of restrictive laws for the better part of a quarter-century, the city acquiesced to the inevitable and initiated a set of sober regulations. Prostitutes were required to keep themselves at least two hundred *braccie* (about seventy meters) from churches and holy sites, and fifty *braccie* from the major avenues and arteries that led to any one of

Florence's eight major city gates. However, prostitutes were not outlawed and not prevented from seeking clients.[46] Moreover, the government sanctioned the construction and maintenance of a brothel to house sex workers north of the city, outside its walls, near the stream called the Mugnone. A second one was built in 1342 under orders from the Duke of Athens who, as a military man, probably knew a few things about the profession.[47] A statute of 1355 allowed prostitutes into the city to earn their living on Mondays and Saturdays, while sumptuary laws were passed in 1384 that forced streetwalkers to wear gloves, bells, and unusually high-heeled shoes that distinguished them from "honest" women.[48] Indeed, the term used in these statutes to describe acts of prostitution, and to distinguish between women of vice and women of virtue, was *inhonesta*, the same word used to describe the oratory of Santa Maria della Tromba in the document that ceded control to the Guild of Doctors and Apothecaries in 1361.

But the city's permissive attitude toward prostitution did not end there. In 1403 the city created the office of the *Onestà*, which devoted its energies to the review and maintenance of the city's moral codes.[49] Now charged with the added (and more difficult) task of stamping out homosexuality, this body also enforced the rather liberally permissive laws the commune had created for its female sex workers. During the first decade of the fifteenth century, laws were written to ensure that heterosexual prostitution would not be stricken from the community, but rather contained, regulated, and taxed.[50] Along these lines, in 1415 the *Onestà* persuaded the commune to build inside the city walls a single, officially sanctioned brothel for female prostitutes, a decision that directly affected the Mercato Vecchio and the oratory of Santa Maria della Tromba. The bordello in question was located right in the middle of the market, only a few feet from the public oratory and the image of the *Madonna della Tromba* that decorated it.[51] Inside it worked women from all across Italy and as far away as England (but rarely from Florence itself), officially registered as legal prostitutes, who agreed to pay a portion of their earnings to the state as a tax, and who were expected to provide their services to clients only inside the brothel at the mouth of the Mercato Vecchio. The creation of this new center was intended to contain and confine this commercial exchange to a single, monitored location. Although the documents do not say as much, it would seem natural that the building selected to house this activity was, in fact, already operational in an unofficial capacity before it received official sanction.

The brothel soon became one of the city's most infamous locales. Connected to a tavern that opened out onto the piazza, this house of Ill Repute was known to people from all walks of life, including the city's most literate humanists. Its popularity was confirmed in the early-fifteenth-century writings of Antonio Beccadelli, who mentioned it in his book of erotic poetry, *L'ermafrodito*, and

specified its location for those readers whose curiosity might seek satisfaction. "Arriving there, take a right," he instructed his readers. "Proceeding a little, stop and ask, oh [my] tired book, for the Mercato Vecchio. Near it is the obelisk, the genial bordello is right there; the place betrays itself by its odor."[52] Beccadelli then identified those whom we are led to believe were his favorite workers there, both by name (or pseudonym) and by their physical attributes.[53] This was the kind of *inhonesta* that infected the Mercato Vecchio in the fourteenth and early fifteenth centuries, and this was the kind of *inhonesta* that the picture was intended to fight when the Madonna was installed inside the oratory in 1361. Given the proximity of the *Madonna della Tromba* to the column in the Old Market, Beccadelli's rather precise description of the Florence bordello's location at the entrance to the piazza indicates that the oratory was oriented in a way that created a clear visual path that allowed the picture inside it to look down at those men and women who moved in and out of that house of infamy.

And this in turn may well explain the unusual title of both the oratory and the picture that was placed inside it in 1361. The word *tromba* has many meanings. In one sense, it refers rather innocently to the "trumpet" and those who play it. Given the proximity to the oratory of a workshop that made and repaired musical instruments, this title makes a great deal of sense. But, as any Italian teenager knows, the more vulgar meaning of the word *tromba* implies something altogether more tawdry, as the verb *trombare* implies an illicit sexual act between a man and a woman, with the implication of a monetary transaction thrown in for good measure.[54] By association, the word *tromba* has come to signify a person who engages in such activities, a definition that conforms completely to the description of the area (*inhonesta*) rendered in the agreement between the Commune and the Arte dei Medici e Speziali in 1361.[55] The title of the painting and the structure in which it was installed may well have referred to both of these meanings, alluding to the music shop at one end of the Mercato Vecchio and the notorious tavern located only a few steps away. Given the language of the 1361 document and its open concerns about *inhonesta*, the more salacious of the two terms in fact seems more likely.[56]

It was no coincidence that the image of the Virgin in the tabernacle was installed in Florence's red light district, and that the city's only brothel was set up but a stone's throw from the painting intended to protect the area from vice. The sexual sins committed required the attention of the heavenly matriarch, either as an image inspiring penance from the guilty or as one possessing the power to assist those who might otherwise succumb to temptations of the flesh.[57] As such, the small building and Jacopo del Casentino's picture inside it functioned as public control agents in the vicinity of this house of prostitution.

In fact, this relationship between religious imagery and human sexuality, both licit and illicit, was the subject of some interest to the day's most

celebrated moralists. Both Saint Bernardino and, later, Fra Savonarola fulmi-
nated against even honest women who walked in front of holy (and all-seeing)
public images dressed like harlots, or dared parade before images in their own
homes in various states of undress.[58] This may well explain the decision to dec-
orate the intersection of the Via del Sole and the Via Trevigi, known for cen-
turies as a haven of streetwalkers and their male clients, with the fresco of *Saint
Sixtus*, painted late in the fourteenth century, perhaps by Niccolò di Tommaso
(Figure 7). Strategically located at the intersection of streets that, then as now,
create a mini-piazza between Santa Maria Novella and the Via Tournabuoni,
the standing Pope gazes down on the tangled mass of pedestrians from his
canopied niche above. In what is both an intimidating and a watchful pose, the
saint simultaneously admonishes mischief-makers in an attempt to limit their
sinful activities and provides protection for those virtuous viewers who seek it.
If pictures were used to promote religious veneration and maintain order on
Italian streets, and if they could be offended by lewd acts of married couples
inside Italian bedrooms, they also had the ability to curb sexual appetites and
expiate the sins of those whose appetites could not be curbed.

Yet as we consider the reception of the *Madonna della Tromba* in the context
of contemporary social morays, we must recognize that the public and official
stance on prostitution evolved significantly during the decades surrounding
1400. As the commune begrudgingly acknowledged prostitution as an insur-
mountable evil at the turn of the fifteenth century, the controlling agency of the
public image in the oratory appears to have gained, at the very least, an alterna-
tive function in the eyes of those who witnessed, but did not participate in, the
sexual transactions occurring in the brothel of the Mercato Vecchio. When
it was first installed there in 1361, the *Madonna della Tromba* was intended to
look reproachfully at those engaging in villainous acts in the market: the doc-
uments describing the oratory and its location make that clear. But by 1415,
with the regulated legalization of state-controlled prostitution centered in a
city-sponsored brothel located within a few meters of the oratory, the function
of the *Madonna della Tromba* may have gained an alternative meaning. Now the
image reached out to those in the neighborhood who had to contend with the
brothel, its employees, their clients, and the rowdiness that ensued as a byprod-
uct of the activities therein. The *Madonna della Tromba* actually became a beacon
of rectitude for those "honest" women and men who went about their daily
business alongside those whose interests were skewed toward *inhonesta*.

Religious performances enacted inside the oratory of Santa Maria della
Tromba confirm that the public devotional site, and the picture that stood
guard inside it, carried redemptive qualities for those threatened (at least spiri-
tually) by their morally challenged neighbors. In 1402 the commune permitted
Masses to be performed inside the oratory, thus adding a more official liturgical
component to the prayers uttered silently by visitors there. These Masses were

soon supplemented with more public displays of veneration, for a document from 1408 indicates that now the oratory in the old market – still considered a locus of vice and *inhonesta* – was the site of *laudesi* performances sung by devotees who congregated in front of Jacopo's picture.[59] And the famous *Codice Rustici*, a manuscript penned between 1442 and 1447 as a review of important Florentine civic centers and religious institutions, contains in its section on the Mercato Vecchio the prayer repeated daily inside the oratory and before the painting of the *Madonna della Tromba*. After acknowledging all of the worthy things the Virgin Mary was known to do for Florentine devotees, the text of this unusual prayer ended with the words:

> Most sweet Mother, thank you for your mercy, for using this grace as the great advocate before Christ your son, who watches with pity and with sorrow; and also for praying to the savior who accepts your love and peace and consolation. And protect us from every persecution and temptation and bad intention and all the mortal sins [that threaten us], and in the end give us a good life to contemplate the Holy Trinity. Amen.[60]

The last sentence of this verse bears comment, for it quite clearly speaks to listeners about the physical dangers that might await them outside the oratory's doors. These types of prayers were, of course, also recited in other more sanitized settings: but uttered in the open-ended oratory of Santa Maria della Tromba, with the sights and sounds of the throbbing neighborhood accompanying, the plea for strength in such a den of iniquity must have been unusually heartfelt. The prayer that people said there had special meaning for them, for the sinfulness they feared and from which they sought protection was literally just across the threshold from their location inside the narrow oratory.

But in this prayer, and with the circumstances surrounding the commune's approach to vice in the Mercato Vecchio, a subtle shift in emphasis appears before us. Rather than shame or convert those who profited from sins of the flesh, now the niche and its image spoke also to those not involved in the trade, but who were adversely affected – and, perhaps, potentially tempted – by the newly legalized vice. The fish mongers and goldsmiths and cloth merchants who shared the Mercato Vecchio with the harlots occupying the only officially sanctioned brothel in Florence were given the opportunity to use the Oratory of Santa Maria della Tromba and the image inside it to protect themselves from lascivious temptations that might confront them during the course of their workday. For in the eyes of the church, and in the eyes of God, irrespective of the commune's legal sanction, prostitution was still a sin.

The oratory's intended audience was now expanded to include not only those thieves and whores and miscreants whose dishonesty had induced the commune to combat them in the Mercato Vecchio in 1361, but also the virtuous among them who needed protection from those sinners who had received

permission from the state in 1402 to continue their sinning ways. The installation of Jacopo del Casentino's *Madonna della Tromba* inside the oratory, which now appears to have been intended to address the problem of prostitution in the Mercato Vecchio, coincided with a rather lengthy, but pronounced, loosening of restrictions on the sale of sexual commerce in Florence. If at first the image was intended to shame whores and ruffians for their acts of *inhonesta*, within fifty years the picture's function changed dramatically. By 1415, the *Madonna della Tromba* seems to have acted not only as a moral agent to reprimand participants, but as an image imbued with the power of protection to those who sought it from them. Those who worked in the Mercato Vecchio – virtuously and otherwise – had the ability to hear and to participate in this ceremony every single day, both morning and night.[61] The image inside the oratory had not changed at all: but its setting, audience, and social context were altered to give an old picture a variety of meanings, each of which was aimed at different kinds of viewers.

Understanding its placement in the midst of this lair of thieves and whores helps us understand why the *Madonna della Tromba* was one of the stops during the procession taken by condemned criminals from the Palazzo del Podestà to the gallows outside the city gates. Kneeling before the street tabernacle there in broad daylight, before the eyes of the painted virgin and those of his peers in this hotbed of *inhonesta*, the picture gave the prisoner a chance for redemption in the midst of "temptation and bad intention and all the mortal sins" that surrounded him. It also made him an example for those others in the Mercato Vecchio who might need a periodic reminder of the swiftness and finality of communal justice in early Republican Florence. The painting in the oratory served those pursing salvation, as well as those clearly in need of it.

CULT IMAGES IN THE URBAN WILDERNESS: THE *MADONNA OF ORSANMICHELE*

Florence, home to thousands of laborers and merchants and clerics and intellectuals, was also home to thousands of images. Panels and frescoes decorated the interior of homes, the walls of chapels, the ceilings of workshops, and all the other places where regular people congregated both publicly and privately. Great powers were attributed to many of these pictures, while an even greater number were valued in part for their potential to equal their peers in potency. Just as priests looked to altarpieces as vibrant players in liturgical performance, lay Florentines often approached paintings in both the sacred and the secular spheres as conduits for their devotional energies and as vessels that could convey to a higher power their prayers and requests for miraculous solutions to vexing problems. Around these images were formed specific cults, comprising lay Florentines who attached significance to miracle-working paintings, sites,

and the marvels associated with them. A mid-fourteenth-century fresco of the Virgin and Child – the so-called *Madonna dei Chierici* – was removed from its original placement on south nave wall of the newly designed cathedral some-time around 1400 and placed at a more prominent location on the church's entrance wall when a cult grew up around it.[62] The aforementioned fresco of the *Annunciation of the Virgin* on the entrance wall of Santissima Annunziata grew in popularity at precisely the same moment, and came to earn the devotional respect of local Florentines as the fifteenth century progressed. Special prayers and rituals were performed before these images, and others like them, both to honor past events and to encourage more to ensue – preferably with the devotee as the specific beneficiary. Cult centers were places of hopefulness, extreme piety, and serious veneration, and the images located inside them – many of which had inspired the cult to begin with – were assigned with truly extraordinary powers and responsibilities. But each differed according to its nature, its history, and its setting in the urban environment.

It was only the rare, unusual picture that did more than merely provide a focus for devotional practice. These special paintings actually performed miracles for the desperate: they cured the sick, provided rain in drought and sunshine in deluge, and warded off evil in times of instability and insecurity. Located in areas where common viewers could see them and be healed by them, they were usually found outside the closed sanctuaries of altars and beyond the confines of secured burial chapels for wealthy families. They could not perform miracles, after all, if no one could get to them, and as a result, cult images tended to be public pictures for common people.[63] For most fourteenth-century Florentines, the most important miracle-working painting in their environment was the *Madonna of Orsanmichele*, located in the former grain distribution center at the city center (Plate VII). This picture, so important and so effective in carrying out its mission, underwent an evolutionary process of remarkable complexity that transformed it from a common street tabernacle to a cult image to the official protector of the entire city – and its story not only warrants a thorough telling, but demands it.

The miracle-working street tabernacle of the *Madonna of Orsanmichele* was originally attached to a pier in an open loggia run by the city as a distribution center for grain allotments.[64] Originally constructed as a monastery, the religious structure of Orsanmichele was appropriated by the city in 1239 when it was severely damaged during the civil unrest caused by factional fighting between rival members of the Guelf and Ghibelline parties (Figure 17).[65] Despite pleas and directives from Rome to return the structure to its monastic owner, the city retained possession of the strategically important site, located in the heart of Florence near the major trading centers of the Mercato Vecchio and Mercato Nuovo, and converted the building into a granary. In 1284

FIGURE 17. Orsanmichele, Florence. Photograph courtesy Scala/Art Resource, New York.

the Commune renovated the old structure so that it could function more efficiently in its new capacity. For roughly five years workers erected a two-story building there with an open, wooden-roofed loggia that rested on brick piers on the ground floor. Here residents of Florence came to collect food rations, as the upper floor served as a storage room for the grain that was distributed to them in the arched – but not walled – *piano terreno* below.

Despite its importance to the city, not all of the facility was under communal control. The exception was a small corner of the building that captured the attention of a group of men and women who selected the site as a staging area for ritual performances. In August 1291 a Laudesi Company congregated there to sing hymns in honor of the Virgin in the middle of the open loggia. Precisely why this company elected to meet in the central granary remains a mystery, for the setting certainly created challenges for the pious confraternity when they met at dusk. The combination of noise, heat, dust, and physical activity that swirled around them at that hour must have made it doubly difficult to concentrate on the words and music they sang in Mary's honor. One can well imagine this group, some standing and others on bended knee, literally

surrounded by a throng of shoppers, housekeepers, merchants, and patricians who either passed by them or stopped to listen. They must have seemed like an island of serenity in an ocean of chaos.

From the time of the inception of the Laudesi Company of Orsanmichele in 1291, confraternity members had the pleasure of focusing their devotions on two pictures in the loggia, each of which was attached to a wooden pier. The first displayed the figure of Saint Michael, an obvious reference to the name of the site and the heavenly patron charged with its protection.[66] While a useful decoration for the space, its importance paled in comparison to the second picture, an image of the Virgin and Child – the Alpha version of the *Madonna of Orsanmichele* – that appeared on a column in the eastern portion of the loggia from which grain was meted out. According to the oft-cited report in Giovanni Villani's *Nuova Cronica*, at first the two pier pictures were considered merely devotional adornments, and for all we know they were not included in the company's initial laudesi performances. But it wasn't long before unusual things began happening. In July 1292, only eleven months after the formation of the Laudesi Company and much to the chagrin of the local community of Franciscans (who did not yet have the magnificent and beautifully ornamented church of Santa Croce of which to boast), the picture on the granary's southeastern pier unexpectedly began to work important miracles that captured the attention of the laity. It soon became an extremely important civic site. According to Villani:

> In the said year (1292), on the third day of the month of July, the figure of Mary – painted on a pilaster in the loggia of Orsanmichele (where grain is sold) – began to perform a large number of miracles in the city of Florence, including healing the sick and lame, and curing those possessed by the devil. But the … friars, out of jealousy or other reasons, didn't believe they really happened and thus fell out of favor among the Florentines. Orsanmichele … had once been in disrepair in the piazza; but for the use and devotion of the said figure, every evening the laity sang lauds; and it was believed that all of the fame and merits of the Madonna's miracles brought pilgrims from all across Tuscany to celebrate the feast days of Mary, and they brought wax images to encourage her to make miracles, and they filled the inside of the loggia and its surrounding area, and they believed in the status of that confraternity – comprising some of the best people of Florence – so much that they left gifts and donations for them to distribute to the poor.[67]

Almost immediately, the image acquired a serious following among the laity. Within weeks of its first miraculous performance, the street picture of Virgin Mary had become the most celebrated painting in Florence.

FIGURE 18. *Supplicants before the Madonna of Orsanmichele, Chigi L VIII 296*, fol. 152, ca. 1342–1348, Vatican Library, Vatican City. Photograph © 2015 Biblioteca Apostolica Vaticana. Reproduced by permission of the Biblioteca Apostolica Vaticana, with all rights reserved.

A miniature from an illustrated copy of Giovanni Villani's Chronicle in the Vatican Library, known as the *Chigi Villani*, refers to the public adulation the picture in the loggia received (Figure 18). In the picture on folio 152, men and women kneel together before the miraculous image of the Virgin and Child, elevated on a plinth. Before the painting flicker votive candles, an important feature of any shrine. The illumination of pictures, as we have seen, both allowed viewers to see images and allowed images to see viewers. And the viewers in this miniature, presumably members of the Laudesi company, address the painted figures on the cult image, who in turn seem to move inside their casing. Mary dips her head toward them, while Christ looks down and to the right rather than straight ahead, as one would expect from a frozen painted figure. Just as Bernardo Daddi animates his characters in the *Madonna del Bagnuolo*, so too have the Virgin and Child in this representation of the *Madonna of Orsanmichele* come alive before the eyes of supplicants. The picture was imbued with unusual powers and was venerated regularly and frequently.

In short order the company set out a formalized approach to its venerations. Pasternosters and Ave Marias were sung daily, as were laudatory hymns

at sunset.[68] Among these evening songs was one that beseeched the Virgin's benevolence and compassion:

> Donna per qual amore
> che m'ha avut'el tuo figlio
> dever' aver en core
> de dar'mel tuo consiglio
> Succurrime, aulente giglio
> Veni e non tardare.

> My Lady, for the love that your son
> must have for me in his heart,
> Give me your wisdom,
> succor me, gentle lily:
> come, and don't be late.[69]

Priests were imported to deliver outdoor sermons near it on Sundays, and on Mondays members sang Masses for the dead. Services for the Virgin were observed four times each year, which in turn coincided with the election of new rectors for the confraternity. The *Madonna of Orsanmichele* received special veneration during fourteen major feast days, including the eight principle holidays connected to the Virgin Mary (including Christmas, Easter, Ascension, Pentecost, the Annunciation, the Purification, and the Birth of the Virgin) and six dedicated to individual saints (including the civic patrons of John the Baptist, Reparata, and Zenobius).[70] Twice annually the company made processions to one of the city's major churches in an effort to demonstrate both its piety and its loyalty to the miracle-working street picture.

The presence and power of the Alpha *Madonna of Orsanmichele* were short-lived, however. In 1304 a calamitous fire wiped out a broad swath of the city center, including the grain loggia at the center of town.[71] Most accounts place the blame of the conflagration squarely on the shoulders of a disgruntled, deranged member of the Florentine Black Guelphs who lit the blaze with the intention of destroying the entire city. But not everyone agreed. In his chronicle that bitterly recounts the failures and betrayals of his fellow Florentines, Dino Compagni blamed the holocaust on a small blaze that was started in Orsanmichele when scalding hot wax, dripping from votive candles placed before the *Madonna*, caused the loggia to catch fire and spread to other buildings in the vicinity.[72] For Compagni, the cult image of the *Madonna of Orsanmichele* and the unbridled enthusiasm it generated within the general public was responsible, either directly or indirectly, for one of the greatest urban catastrophes of the day. What, exactly, those wax candles ignited is not described in this chronicle, but the implied suggestion here seems to be that something connected to the picture – shutters, curtains, or maybe even the painting itself – caused the great fire of 1304. The lack of confirming evidence or

accounts to support his claims makes Compagni's version of the story sus-
pect in the extreme, but it does contain one kernel of information useful for
our examination of the Alpha *Madonna of Orsanmichele*: if Compagni believed
that the blaze started when the picture and/or its coverings caught fire, then
we may surmise that this original painting was almost certainly painted on
a wooden, flammable panel, and not as a fresco painting on the surface of
the pier in the granary.[73] Indeed, we may surmise that the picture disap-
peared in the fire. Giovanni Villani leaves no doubt that the fire, spread by
extremely heavy winds, consumed the entire structure. In his chronicle he
writes, "E fu sì empito e furioso il maladetto fuoco col conforto del vento
a tramontana che traeva forte, che in quello giorno arse le case degli Abati
e de' Macci, e tutta la loggia d'Orto Sammichele."[74] The picture inside the
granary that had worked so many miracles, had inspired so many pilgrims, and
had prompted so many devotees to donate much-needed alms for the poor was
gone.[75]

Orsanmichele's destruction in 1304 caused a series of projects to occur
simultaneously, the most important of which was the rebuilding of the gra-
nary in brick rather than flammable wood.[76] Recognizing that the loss of the
miracle-working image not only weakened the performance of lauds by the
confraternity but also diminished the amount of money donated to it by an
admiring public, the Laudesi quickly commissioned a replacement picture for
their burned original – the Beta *Madonna*. As was the custom in this period,
this replica had to recreate faithfully the original it was intended to replace,
although, as Blake Wilson has noted, the efficacy of the picture was based
entirely on the connection between ritual performance and setting, rather than
on the forms that appeared on the painting's surface.[77] To continue working in
the same effective way, the new version of the old icon had to be situated in the
same place and inside the same structure, but most importantly it had to receive
the same kind of veneration as the first one.[78] Failure to do so risked destroying
the ability of the picture to perform its miracles. And thus a pier in the south-
east corner of Orsanmichele, the same place where the Alpha *Madonna* had
been located, was selected as the home for the new iteration of the *Madonna
of Orsanmichele*.

Specialists have long argued that the Beta *Madonna* was an exact replica of
the original miracle-working Alpha picture. While we may not have the image
available to us today, the setting for, and appearance of, the Beta *Madonna* can
be confirmed through its illustration in a miniature that decorates the *Biadaiolo
Manuscript*, painted sometime during the late 1330s and currently housed in
the Florence Biblioteca Laurenziana (Figure 19). In this miniature on folio 79,
which depicts the grain riots caused by the famine of 1329, a line of barrels
surrounds the tabernacle containing the famous picture.[79] The lunette-shaped
wooden panel appears inside an elongated and Gothicized tabernacle, complete

with spires, pinnacles, and a parapet in which a member of the confraternity guards an alms box at his left. This well-appointed volunteer, charged with the task of accepting monetary donations, also protects the miracle-working image of the Beta *Madonna* from the mobs of people surrounding it.

Students of the miniature have long noted three essential components of the picture and its setting that inform us of the Beta *Madonna's* appearance and function in the fourteenth century. First, its composition conformed entirely to the Laudesi prototype invented by Duccio in the late 1280s for the Company that met in Santa Maria Novella (Figure 22). The use of six angels flanking a rectilinear throne occupying the seated Virgin and Child corresponds closely to the thirteenth-century picture, and the kneeling pair in the foreground specifically calls to mind the figures in the same position that the Sienese artist painted in lower corners of the *Rucellai Madonna*.[80] Second, some specialists have noted that the framework in which the Beta *Madonna* stood during the first four decades of the fourteenth century demonstrates the elaborate nature of the shrine in its disposition long before Orcagna's even more elegant marble tabernacle was commissioned in 1352.[81] The extensive ornamentation surrounding the painted figures – complete with finial patterns, slender columns, and elongated pinnacle – indicates that the framing device that circled the painting was lavish, ornate, and unusually elaborate for a street tabernacle.[82] And third, the placement of a confraternity member before the painting but behind a parapet (upon which are situated a candle, cross, and strongbox) indicates that members of the *Compagnia* stood guard in front of their cult image, both to protect the image and to make sure that the alms donated to it were not disturbed by those who might be tempted by them. Indeed, the shrine appears to have been specifically designed to accommodate this sentinel, whose presence was mandated by the statues of the confraternity in 1294, in 1297, and again in 1333.[83] The disturbance surrounding the Beta *Madonna of Orsanmichele*, caused by the food shortages of 1328 and 1329, justified these security measures: without the tabernacle, parapet, and human guard, the miracle-working picture would have been in constant danger. And this raises the question of the extent to which the shrine was exposed in the streets running adjacent to the granary.

The few original sources that describe the image in Orsanmichele indicate neither the direction in which the picture faced nor its proximity to the street. The references to it in the Statutes of 1333 only refer to the picture's setting as "del pilastro della Donna nostra all' oratorio sotto la loggia d'Orto San Michele" without defining the exact side of the column on which the image hung.[84] Villani's description of the image echoes this vague comment, as he describes the picture and its placement as, "una figura dipinta di santa Maria in uno pilastro della loggia d'Orto Sammichele, ove si vende il grano."[85] While it is clear that the picture must have been underneath the ceiling inside in the

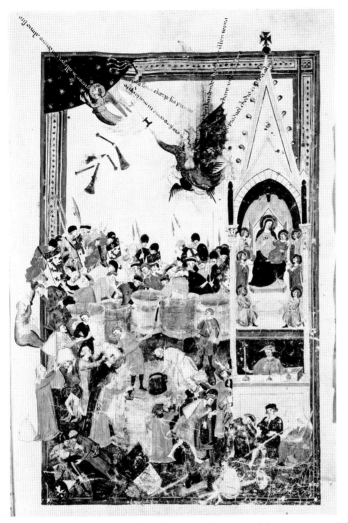

FIGURE 19. *Riot at Orsanmichele, Biadaiolo Manuscript*, fol. 79, ca. 1340, Biblioteca Laurenziana, Florence. Photograph courtesy Scala/Art Resource, New York.

loggia – how else could the confraternity sing lauds to it without interruption from outsiders? – it is equally clear that the open loggia made the shrine visible to the general public, and they to it.

But the relationship between image and audience was changing. In the statutes of 1294 and 1297, the image was to be left uncovered and illuminated with torches at all times to accommodate the growing multitudes who flocked to see it at all times of the day and night (unlike its painted partner, the image of Saint Michael, which was to be covered when not in use).[86] In 1333, the same year that Florence was submerged under two meters of water from the flooded Arno River, the Company of Orsanmichele updated its statutes. The tenth

chapter of the book specifies that the Beta *Madonna*, still attached to the southeast pilaster, was now to be covered by silk veils that were to be removed only on Sundays and feast days, as well as special occasions deemed appropriate by the Company's captains. It was also to be encased in a sub-structure that extended into the vault beneath it.[87] This chamber was built to hold two people who could collect donations and protect the image inside it from the pilgrims and, apparently, potential vandals who came inside the open loggia. The space was large enough to warrant its title as an "oratorio," a rather generic term that signifies only that it could function as a place where prayers could be said. Exactly how large this space was cannot be determined by the Company's book of statues, although the miniature in the Baidaiolo Manuscript provides a general description of its appearance. But it is clear that the painting inside it was not as readily available in 1333 as it had been in 1297. The incremental covering up of the *Madonna of Orsanmichele* would continue through the rest of the century.

And, in fact, there appears to have been some very real concern about the power of the Beta *Madonna of Orsanmichele*, for there was much to concern Florentines during the tumultuous years of the 1340s.[88] The epidemic of 1340, which carried off roughly ten thousand residents, was only a portent of things to come.[89] The banking crisis of 1342 was followed by the brief but tense reign of Walter of Brienne, the Duke of Athens, and his expulsion in early August 1343. Uprisings and threats of uprisings followed immediately thereafter. In 1345 and 1346 the Franciscan inquisitor in Florence, Fra Piero d'Aquila, was exposed and expelled as a fraudulent extortionist, but only after placing the entire city under interdiction. And, of course, in 1347 and 1348 a significant percentage (35 percent? 45? 50?) of the city's ninety thousand souls succumbed to the plague that ravaged all of Europe during the summer months of those years. Yet just before this final denouement, residents of Tuscany endured a fate almost as terrible as that suffered by victims of the Black Death. And this crisis, agricultural in nature, is what ultimately caused the Beta *Madonna* to fail, and thus be deemed expendable.

People went hungry in Florence in the middle of the 1340s. Severe rainfalls washed away one crop in autumn 1345 and were followed throughout 1346 by the worst year of drought in memory. Intense food shortages resulted in a dangerous famine that starved the neediest and, at the very least, threatened those of means. Medieval Europeans, it is true, were not unaccustomed to hunger, and two decades earlier the city had struggled to survive the famine of 1329, illustrated so well by the painter of the *Biadaiolo Manuscript*. But things were somehow different this time, as the grain and wheat harvests of the countryside surrounding Florence dropped to unprecedented lows. Literally every crop produced in Italian farms was ruined, and Giovanni Villani gravely noted that

food shortages of that magnitude had not been witnessed in more than one hundred years.[90] These shortages, of course, caused prices to soar, meaning that those most in need – the poor and the destitute – suffered most. As the months passed, the number of mouths clamoring for grain at Orsanmichele grew in inverse proportion to the amount of grain available for distribution. Starvation, always a very real threat in medieval Europe, now nipped at the core of the population with deadly aim, and Villani reports that more than four thousand Florentines, mostly women and children, perished by the end of the crisis in 1347.[91]

Orsanmichele was at the very center of this crisis, literally and figuratively. As the city's main source of grain, the building and its operators were under constant pressure to procure food for the tens of thousands of Florentines demanding supplies everyday. As the famine of 1346 turned into a year of death in 1347, the clamor was notable. Villani makes clear the general sentiment held by his fellow Florentines as they sought explanations for such a calamity: while some looked to the alignment of the stars as the reason for the great famine, most considered it a punishment wrought by a wrathful God seeking retribution for the sinful ways of the people. The famine, says Villani, was divinely inspired, and no amount of praying or posturing throughout 1346 and the first half of 1347 seemed to please the Heavenly Father.[92] With groups of starving residents congregating outside the granary's loggia, and with no deliverance in sight, more than one prayer to the miracle-working image on the southeast pier must have been raised. The *Madonna of Orsanmichele*, after all, was the cult image that assisted Florentines in time of famine, just like these. It was at precisely this moment, in the middle of 1346, when the Captains of Orsanmichele approached Bernardo Daddi to produce a new painting to be installed in the loggia of the besieged granary. The services of the Beta *Madonna* were no longer required.[93]

Indeed, something clearly was not right with the Beta *Madonna of Orsanmichele*. For reasons that do not appear in contemporary records, the image was replaced in 1347 by a third, Omega version produced by Bernardo Daddi. This change was not caused by a disastrous fire, as had been the case in 1304, and it could not have been replaced simply in the interests of updating the image, as some have suggested: both the retarditaire nature of Daddi's composition and the dangers involved in destroying one miracle-working image for a newer version argue against this suggestion.[94] Something else caused the Captains of Orsanmichele to abandon their miracle-working picture.

The Company's decision to dispense with the image that had received a place of prominence in the civic life of Florence could not have been an easy one, nor one taken lightly, with no concern for the consequences of failure. Indeed, it must have been made in a state of near panic. The pressure to do

something about a painting that was not containing the spread of famine – that is, to address the shortcomings of a miracle-working image that no longer appeared to have the capacity to work them – was obviously great enough to cause its removal. With no other plausible explanation forthcoming, we are left to surmise that Bernardo Daddi painted the third and final version of the street painting – the Omega *Madonna of Orsanmichele* – to replace a spent cult image that no longer worked.

Archival references reveal that Daddi received for his efforts the sum of sixteen florins in four payments from March 1 to June 16, 1347.[95] Although no reference confirms it, we may infer from the cessation of payments after this date that the painting was completed on June 16, and that Bernardo Daddi's picture was installed on the pier formerly occupied by the two previous versions of the *Madonna of Orsanmichele* on or about this same day. We can only imagine the sense of anticipation and genuine concern its new devotees and patrons must have felt as they watched the installation of a replacement (of a replacement) of a cult image repainted for people who demanded a response from it.

Miraculously, the new image did the trick almost immediately. Villani tells us that only eight days after Daddi received final payment for his work, on June 24, 1347 – notably the feast of John the Baptist – grain once again filled the storage rooms above the loggia of Orsanmichele.[96] Hungry Florentines received their wheat, bread was baked again, and prices – with some fluctuation – by August returned to a lower and more affordable level than they had been since 1346. The famine was over, and the city was saved. This version of the *Madonna of Orsanmichele* worked: and we know that contemporary Florentines believed it did because of the things they did to it and for it during the decades that followed its installation.

The role of the *Madonna of Orsanmichele* on the civic life of Florence had grown in importance for decades by the time Bernardo Daddi completed the Omega version of the picture. But during the crisis decade that ultimately resulted in the replacement of the Beta *Madonna*, the commune's devotion to the former street tabernacle became increasingly official. In January 1345 the Florentine Signoria approved a suggestion from the Captains of Orsanmichele to proclaim the Feast of Saint Anne a civic holiday.[97] In the wake of Walter of Brienne's expulsion from the city in August 1343, the priors agreed that the Mother of the Virgin had acted as the city's protector during a particularly dangerous political crisis, and that Anne should be venerated as a communal patron saint.[98] A provision mandated that the Signoria process to the granary and, before the image of Saint Anne, donate offerings to be distributed to the destitute by members of the Laudesi Company of Orsanmichele. An altar was installed under the vault in the building's northeast corner, adjacent to the quadrant of the loggia in which the Beta *Madonna* was venerated. Soon

thereafter, a polychrome wood sculpture of Saint Anne was carved, painted and installed inside the granary (Figure 20). But this would not be the end of the commune's interest in Orsanmichele as a civic center.

The scourge of the Black Death took a heavy toll on Florentine residents, particularly during the summer of 1348. Descriptions of those terrible months, particularly those by Boccaccio, surely only begin to define the horrors experienced in Florence's city streets, but some individuals and some institutions managed to profit from the carnage. Among the winners in this deadly struggle were charitable institutions that unexpectedly received massive windfalls of money bequeathed to them by a staggering number of pious people whose wills were suddenly and unexpected executed at exactly the same time.[99] Those bequests, of course, had been designed in the sincere hope that they would be converted into alms for the poor in the form of food, clothing, care for the sick, homes for orphans, and other offerings to promote the general well-being of those too destitute to meet their own needs. The confraternity at Orsanmichele was the leading recipient of such bequests, which were directed to their coffers by the wills and testaments of untold thousands of Florentines who perished during the summer of 1348. Estimated by Matteo Villani at topping the 350,000 florin mark, the *Compagnia* was said to have had more money at its disposal than the entire government of Florence.[100]

FIGURE 20. *Saint Anne*, ca. 1345, Orsanmichele, Florence. Photograph courtesy Finsiel/Alinari/Art Resource, New York.

Flush with cash, and with some prompting by the Signoria, the Captains of Orsanmichele moved to make their cult center even more elaborate. In 1351, the *Compagnia* voted to use their own resources to pay workers for the construction of vaults in the southeast corner of the granary, directly above the pilaster containing the Omega *Madonna*.[101] The three hundred florins given to one Pierozzo di Bancho di Ser Bartolo suggests that the work was impressive in scope and made the rest of the loggia, unvaulted at this moment, pale by comparison. Not even the neighboring vault containing the altar of Saint Anne, patron saint of Florence and object of great devotion after the expulsion of Walter of Brienne, received this kind of decorative attention. The company clearly wished to beautify the most important section of Orsanmichele, both

to emphasize their own devotion to, and veneration of, the miracle-working picture in that portion of the space. In so doing, they created a more presentable setting for the image that they hoped would continue to be adored by pilgrims and local devotees despite the previous transgressions of the confraternity. Almost as soon as this vault was completed, the "reformed" company of Orsanmichele expanded on this idea by commissioning the most unusual framework ever made for a cult image in the history of medieval Florence.

Sometime around 1352, the company hired Andrea di Cione to design the massive marble *tabernacolo* that would become the most famous work of art in the city (Figure 21). A fairly young artist who had only begun to produce frescoes and panel paintings a few years earlier, Andrea (soon to be known by his nickname of "Orcagna," or Archangel) had, as far as we can tell, practically no formal training as a sculptor. He seems to have apprenticed in the workshop of Bernardo Daddi in the late 1330s or early 1340s, which may have been a matter of importance for the company: perhaps his connection to the painter of the Omega *Madonna* was enough to earn Andrea di Cione the commission to sculpt the *baldicchino* to surround it. Andrea's new design for Bernardo Daddi's Omega *Madonna* was a fitting tribute to an image that, within only weeks of its installation, had responded to the crisis of 1347 and delivered the city from famine. The innovative structure took the form of a free-standing building, a loggia unto itself, with four enormous piers supporting a quadripartite vault, a staircase and chamber to contain and conceal the custodian who raised and dropped the curtain that veiled the Madonna, and a series of carved reliefs along the tabernacle's base.[102] Effigies of the cardinal and theological virtues, prophets and saints adorned the columns and pinnacles, with narrative scenes from the life of the Virgin placed in panels beneath the cult painting. The tabernacle also contained a variety of references to the city: the appearance of Saint Anne, the Marzocco, and the Florentine fleur-de-lis in the reliefs referred to civic interests as well as religious ones, and thus addressed the concerns of both the government and the confraternity it now directed.

The image inside it, covered with a curtain that could be drawn up from inside by an attendant hidden from view, was now a dazzling object whose mystery was heightened by its distancing from viewers.[103] It was a fitting design for an object to accompany a panel that, in fact, did not adorn an altar, but which demanded the veneration of an audience in a similar fashion. However, the appearance of the marble shrine now differed significantly from the normal frameworks that customarily surrounded street tabernacles. The cult image was now removed from the public eye, and its casing now made the picture different − more distant, maybe − than it had been before when it was in a

FIGURE 21. Andrea di Cione, *Tabernacle of Orsanmichele*, 1352–1359, Orsanmichele, Florence. Photograph Scala/Art Resource, New York.

more accessible setting. Gone were the simple pinnacles and shallow parapet that had framed the Beta *Madonna*. In its place came a marble house, complete with reliefs and an extended surface that propelled the panel forward in the structure, and a wide iron gate that was locked at all times. Now it was inserted into a protective chamber that was more difficult to see from the street, as the sides and columns of the enormous marble oratory obstructed most of the sight lines that common people would have had when approaching the grain

loggia. It was also shielded from public view by a second protective layer in the form of the vaults that Pierozzo di Bancho di Ser Bartolo had erected in the early 1350s. Whereas street tabernacles typically enclosed their images in recessed niches, this design did just the opposite: it was intended to make the cult image different from the average picture seen on street corners, and its design removed the picture from the realm of the average street-corner tabernacle. The painting, while elevated in stature by the tabernacle, was also being removed from the public domain. The commune was taking control of the image.[104]

Perhaps the city's most overt appropriation of the Compagnia's miracle-working picture occurred during the days just before the Feast of the Assumption in 1365. The Omega *Madonna* became the official protector of the entire commune. According to Ferdinando Del Migliore (writing in 1684) and Giuseppe Richa (writing in 1754), a public demonstration outside the granary on August 13 called upon the government to adopt the *Madonna of Orsanmichele* as the pictorial advocate of Florence.[105] Del Migliore, who cited a now-lost statute in the government's archives, wrote that it was an outcry from commoners ("tutto il popolo") that caused the government to proclaim the painting's unusual status as a civic icon.[106] Richa later confirmed this claim in the first volume of his history of Florentine churches, but added that the law decreeing public recognition of the *Madonna* as the city's advocate came into effect in 1366, and that the grand tumult occurred in the Piazza della Signoria, rather than the Piazza Orsanmichele.[107] In either case, the Signoria acquiesced, and the painting in the granary was proclaimed both the protectress of the people and the pictorial patron of the entire city-state. For decades thereafter, members of the Signoria processed to Orsanmichele on the Feast of the Assumption, adding the Omega *Madonna* into the public ritual of political theater as something of a stage prop. In so doing, the heightened function of the painting as a civic protectress simultaneously altered its earlier qualities as a street tabernacle that cared for the needs of common people to one that now also looked out for the commune's political needs.[108]

By now the process of converting the *Madonna of Orsanmichele* into an image of state ownership was nearing its final stages.[109] To finish the job, the image and its marble oratory were removed from the public domain. At precisely the time the government agreed to bestow upon the confraternity's image the honor of dubbing it the pictorial advocate of Florence, the priors also acquiesced to a suggestion the confraternity had made back in 1357. The function of the building was altered entirely. Its use as a granary was discontinued altogether and its status as a sacred place of worship was officially confirmed. In 1366 and 1367, during the months following passage of the law declaring the Omega *Madonna* as Florence's official protectress, the arches of the southeast corner

were walled up to protect the tabernacle and the painting it contained, and altars dedicated to saints of particular interest to the commune were added. The exclusivity of the city's pictorial advocate increased incrementally as the rest of open loggia on the ground floor was enclosed during the next fifteen years, with walls filling in the gaps of the last vaults of the building completed in the early 1380s.[110] The combination of curtains, marble structural framework, and mural barriers gradually made it utterly impossible for common people to have a chance or brief encounter with the *Madonna of Orsanmichele*. Appointments had to be made to see it, unless one was willing to jostle other visitors to the site to catch a glimpse of the Virgin on one of the feast days designated by the state for public viewing. By 1400, when the last arches forming the loggia (including the corner of the building containing the altar of Saint Anne) were completed, the former granary with a miracle-working image that had been open to the public and accessible to all had been turned into a enclosed church with a tightly controlled shrine visible only to those with the authority to see her.

As the finishing touches were added to the walls that grew up around the *Madonna of Orsanmichele*, artists completed the trio of stained glass windows and inserted them into the spaces provided for them above the lunette on the east wall that now served as a backdrop to the tabernacle that contained the cult image (Figures 10–12). The three colorful narratives recount in clear detail the redemptive powers imbued in the painting inside Andrea di Cione's structure. All three images provocatively position the picture and its stone tabernacle outside Orsanmichele's walls, repositioning it squarely in the midst of the laity and the city streets upon which their lives played out. In the *Renunciation of Worldly Goods* commoners pray to the image that has been situated along the banks of the Arno River and before a bridge that spans its flowing waters. The *Miracle of the Ordeal by Fire at the Grain Market* surely occurs in the Piazza Orsanmichele, as the building to the right of the tabernacle bears the insignia of OSM that marks the space as such. But the lack of a ceiling structure to the right of the painted tabernacle, as well as the appearance of a solitary heads that emerges from a window of a palazzo to the left, suggests an exterior setting (befitting the subject matter of the composition: an ordeal by fire positioned inside Orsanmichele, site of the disastrous conflagration of 1304, might have been an inappropriate approach to the narrative). And the *Miracle of the Hanged Thief* clearly transpires outdoors, specifically beyond the walls of the city and the Porta alla Croce where prisoners went to meet their maker. All of these windows featured the Virgin Mary as the main protagonist, and the two that led to the third indicated that the real Madonna in heaven was present in the image contained inside Orsanmichele's tabernacle – otherwise she would not know to come to the rescue when called upon to do so. Yet we must recognize that

these depictions of the tabernacle as a street painting, by 1400 an anachronism due to the fact that it was now walled up inside a building, was a poorly veiled attempt to return the cult image to its original setting in the public sphere and, perhaps, to remind visitors to the civic church that its sacred prominence was due largely to events and objects that had come to the fore a hundred years before the grain loggia was sealed and its function altered. The pictorial connection between street painting, cult image, and the actual presence of the divine permeated these stained glass windows, and helped underscore the civic role played by the *Madonna of Orsanmichele* and the picture's place in the urban landscape of Florence.

Bernardo Daddi's Omega *Madonna*, which had replaced early versions expressly intended for common viewers in a secular setting, was by 1366 deemed too important an image to be made available to the general pub-lic that it protected, and that had made it into such and important image in the first place. The street tabernacle had become too important for the streets.

IMAGES PLACED IN PUBLIC VIEW, LIKE THE *MADONNA DELLA TROMBA* AT the mouth of the Mercato Vecchio, addressed a multiplicity of needs in Early Republican Florence. The painted faces of Mary, Christ, saints, and angels saw things happening before them, and through their power of observation and response they helped police problem areas in the city by their mere presence. But because each neighborhood in the city had its own issues to worry about, each tabernacle took on the ability to combat different offenses. Some, like the one on the pilaster at Orsanmichele, actually performed miracles and worked to feed the hungry, and became so important that the commune appropriated it for purposes of political propaganda. Many, like the *Madonna della Sagra* by Giottino, inspired lay devotions in the form of laudesi hymns sung before them at regular intervals. Others, like those located near cloistered religious commu-nities, like Andrea di Bonaiuto's *Madonna* at the corner of Via San Gallo and the Via delle Ruote or Jacopo del Casentino's *Madonna with Saints Benedict and Peter* on the Borgo Albizzi, celebrated the virtuous women (and some-times men) who lived and worked nearby. And still others, like the one in the oratory of Santa Maria della Tromba, scolded the guilty, succored the needy, and calmed the passions of those desperately scrambling to make a living for themselves in Florence's old market. In much the same way that the word *tabernacolo* had so many different meanings and could be used to describe so many different kinds of images, so too did the pictures inside these niches address a multitude of needs for the local community. These public pictures had the ability to see, the power to control behavior, and the magic to perform miracles; as a result, they were installed in locations of strategic importance

all across the early modern city. Pictures had the ability to speak directly to common people; but because common people did not encounter altarpieces or private chapels in churches, the few pictures that earned reputations for speaking and healing and miracle-working were, by default, all in the public realm.

CHAPTER TWO

IMAGES OF CHARITY: CONFRATERNITIES, HOSPITALS, AND PICTURES FOR THE DESTITUTE

Public paintings, by their very nature, were accessible by day or by night to a wide array of lay viewers for long stretches of time. Some, like guild pictures or cult images in special settings, were available for consideration at specified moments. Others, like street tabernacles illuminated by lanterns and the frescoes of condemned enemies of the state, could be seen around the clock. But those institutions that filled in the cracks of Florentine society – the confraternities and lay organizations comprising members from all walks of life – often owned and displayed both kinds of images: they commissioned and presented pictures inside their headquarters for the consideration of a specific audience as well as those placed in areas traveled by literally everyone in the city.

The tradition of employing panel pictures as meditational tools for lay devotional societies originated at just the time the city was codifying its new republican government.[1] In 1285 the Laudesi Company in Santa Maria Novella, which had grown so quickly and had amassed so much money from dues and donations that it was ready to declare its presence in the new church and to the rest of the Florentine public, commissioned from Duccio di Buoninsegna the large dossal picture for the church's transept. Designed to accommodate the musical venerations of the confraternity, which sang hymns to the Virgin inside the Dominican church (only partially completed by 1290), the so-called *Rucellai Madonna* features figures and postures abundantly familiar to us (Figure 22). Like the *Madonna of Orsanmichele*, Duccio's self-contained

composition concentrates on the core figures of Mary and Christ, both of whom gaze directly at the viewer. The inward positions of the six atten-dant angels, all kneeling and holding the throne in a naturalistic attempt to emphasis the structure's actual weight, move the eye toward the holy pair, as though they participate with the lay devotee in the act of veneration. Small roundels that revolve around the contours of the image contain the effigies of the twelve apostles, twelve Old Testament prophets and patriarchs, and the five saints embraced by the Dominicans who ran the church in which the picture was installed – Dominic and Peter Martyr, Augustine, a female saint probably representing Catherine of Alexandria, and a bishop identified alter-nately as Zenobius, Gregory or Jerome.[2] Because this was not an altarpiece, and therefore could not be as wide or as multi-faceted as one, figures normally placed in pictorial positions of honor on single pinnacle or lateral panels were instead squeezed into the border of the *Rucellai Madonna*. Probably because the lauds sung before the image revolved entirely around the Virgin, and not other patron saints, their appearance in large format was not necessary.

The nature of the image and the status of the corporation that paid for it tell us more about the function of the *Rucellai Madonna* than we can glean from its possible placement inside the church. Indeed, Santa Maria Novella was only a fraction of its current size when the picture was commissioned in 1285. Its main entrance was probably in what is now the right transept, which served as the church's temporary facade during construction. The south end did not extend more than one bay deep, and inside this shallow space appeared the *tramezzo* that cut the nave into two parts. And the multiple cloisters and antechambers that now mark the conventual center had not yet been built. As Santa Maria Novella expanded over the years – particularly during the Vasarian campaign to cleanse the interior of its apparently disorganized and distracting decorations – paintings were moved from one place to another, often without proper records noting previous placements, functions, or settings. And thus, the precise original location of this enormous painting, towering some 450 centimeters high, has been the topic of some debate, as the traditional notion that the panel functioned as an altarpiece has been challenged, and with good reason.[3]

Various problems with the picture's appearance and function hamper our ability to identify its original location. The high altar of Santa Maria Novella, while a tempting possibility, is the least likely option of them all. A Laudesi panel, by definition, would have required use by the laity, and placing Duccio's panel at the church's crossing would have created traffic jams during Vespers that surely the priests and friars of the convent would have despised. The pic-ture could have been situated inside the *tramezzo*, or even on top of it, in a way akin to that illustrated in the famous frescoes of the Life of Saint Francis in the upper basilica of the mother church of San Francesco of Assisi. But such

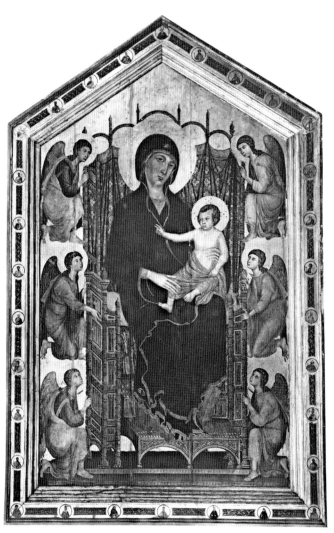

22. Duccio di Buoninsegna, *Rucellai Madonna*, ca. 1290, Uffizi Galleries, Florence. Photograph courtesy Gabinetto Fotografico del Polo Museale Regionale della Toscana.

a suggestion must be made tentatively until a more precise understanding of how that internal barrier would have been constructed in Santa Maria Novella and used in a nave space as truncated as the one in that thirteenth-century church.[4] Due to its size, its dimensions, and evidence indicating that the large dossal once had hooks on its back, Duccio's panel is now thought by many to have been installed on a wall surface, perhaps between the Rucellai Chapel and that dedicated to Saint Gregory in the right transept, at just the place where the laity entered the church during the last years of the thirteenth century, before Santa Maria Novella's enlargement. This suggestion seems logical, as we must remember that the picture had to be large enough to be seen by a group of lay men and women who gathered around it during their musical

devotions: placing it inside a modestly sized chapel would have made its devotion difficult for more than a handful of people (and the presence of women inside a burial chapel would have been highly unusual, if not altogether inappropriate, at the end of the thirteenth century). Positioned on the wall outside the chapel entrance, and immediately in the sight line of lay visitors to the church who entered from the portal in the transept, the *Rucellai Madonna* would have been large enough to be visible from most vantage points in Santa Maria Novella. And as the chapels in that transept are elevated by three steps that lead from the floor of the crossing into the sepulchral spaces, the picture would have been positioned well above the heads of the confraternity members singing before her, thus allowing them to see her – and for her to see them.

Duccio's painting for this early lay confraternity is one of the oldest and most influential public pictures to have survived into the twenty-first century, and its influence on other artists and corporate patrons cannot be overestimated. When the *Rucellai Madonna* was installed in Santa Maria Novella, probably sometime before 1290, the compositional features of the enthroned Madonna, benedictional Christ, and attendant angels almost immediately inspired Cimabue and his clients in the church of Santa Trinita to appropriate the identical theme for their church (Figure 23). Like Duccio's prototype, Cimabue's painting features a group of angels flanking the enthroned Virgin, who in turn supports and presents the Christ child to viewers below. Given the unified format of the *Santa Trinita Madonna* and its vertical orientation, it seems highly unlikely that this painting would have been suitable for a liturgical setting, as an altarpiece that tall would have dwarfed the ceremony and the celebrant it framed. Instead it seems more likely that Cimabue's imposing picture was commissioned and used by a lay confraternity in exactly the same way that Duccio's earlier picture was being used in Santa Maria Novella – hence the employment of the compositional forms used by the Sienese artist in the *Rucellai Madonna*. The most likely candidate as patron of Cimabue's work would have been the Compagnia di Santa Maria delle Laude, the resident confraternity that gathered in Santa Trinita sometime before 1300.[5] Those lay singers would have had just as much of a need for a large, visible picture to help inspire them as they sang their hymns as would the Laudesi viewing Duccio's similarly constructed dossal. Although not as large as Duccio's prototype, it still stood at an impressive 356 × 229 centimeters, thus making it perfectly legible from a distance. Thus, the two signature pictures produced by the thirteenth century's most distinguished painters – and the two pictures that influenced Giotto's innovative approach to the pictorial arts in the next decade – were most probably panels designed for use by confraternity members. Their general accessibility at once made them both popular among the laity and easy for artists (like Giotto) to study and emulate.

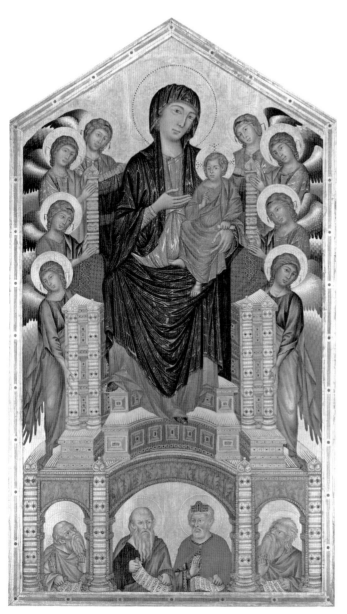

23. Cimabue, *Santa Trinita Madonna*, ca. 1295, Uffizi, Florence. Photograph courtesy Alinari/Art Resource, New York.

The Laudesi companies at Santa Maria Novella and the church of the Ognissanti were not the only collection of lay devotees in Florence. Equally selfless groups of laymen and women organized themselves into coherent ensembles that met regularly to worship, to donate funds dedicated to the support of particular subsets of people in need, or to offer their own time and energy on behalf of the sick, the poor, the hungry, and the condemned. In most of these confraternal settings, images were commissioned to illustrate for the curious

the activities of the membership, to promote their acts of charity toward others, and to celebrate within the company the status the members enjoyed among their neighbors. Paintings in hospitals, orphanages, oratories, and even a chapel situated near the executioner's grounds outside the city walls spoke to those who considered themselves members of various lay confraternities, encouraged those who might wish to join them, and comforted those who were served by them. The images that these institutions commissioned and displayed tell us a great deal about all of these intended audiences and stakeholders in Florence's web of necessary charitable organizations.

EARLY REPUBLICAN CONFRATERNITIES

In an age predating the modern socialized state, early Republican Florentines recognized that those who enjoyed the privileges of high birth, property, financial resources, and commercial and political opportunities had both a religious and a civic responsibility to tend to the less fortunate among them. As the early capitalist state expanded in size and economic might, the casualties of rapid growth increased in due proportion. By 1300, the population of Florence probably exceeded 120,000 mouths, many of them recent immigrants drawn by the promise of economic opportunity, and all of them crammed within an urban area roughly two miles wide. Many, if not most, of them had few connections, fewer resources at their disposal, and a mountain of threats and challenges to overcome. In an age that predated the creation of basic government-sponsored social services, the only way for the hungry to eat or for the naked to be clothed was through the good graces of charitable organizations operated by volunteers and funded by the donations of individual and corporate sponsors. Gradually at first, and then in a steadier stream by the late fourteenth century, men and women of nearly every imaginable profession and station sought admittance into one of the dozens of volunteer organizations set up in the city to cater to the well-being of their fellow citizens.[6] People genuinely felt an obligation to serve, understood that their participation made themselves and their commune a better place, and urgently believed that their acts of charity and humility could be seen and would be rewarded by a God infinitely more charitable than they were.

Not all confraternities were outwardly dedicated to the charitable support of Florence's most destitute. In fact, most of the companies that dotted the urban landscape were much more inwardly focused, and had more to do with the promotion of personal and collective spiritual cleansing than with more public acts of charity seen in organizations like the Compagnia della Misericorida. The most common were Laudesi companies, collections of men and women who gathered together at regular intervals (sometimes weekly, sometimes daily) to sing hymns of praise to the Virgin Mary. The first among these was probably

a group of lay worshippers who were convened in 1244 by a Dominican preacher named Peter of Verona, who had come to Florence in that year on a mission to fight a heretical movement led by sinners known as the Paterini (and to everyone else as the Cathars or Albigensians). In an effort to demonstrate both their own purity and their loyalty to Peter's Florentine crusade, members of the preacher's audience accepted his challenge to form groups of lay men and women dedicated to the devotion of the Virgin Mary and the defeat of the Paterini. This early group met inside Santa Maria Novella and gradually gained in popularity as the fervor against any and all opponents of Church authority grew in pitch during the thirteenth century.[7] The hymns they sang, written in vernacular Italian, served as surrogates for the Latin antiphons performed by priests during High Mass. The image to which they sang, Duccio's *Rucellai Madonna*, with its gold ground and iconic advocate grandly presented, bore some of the attributes of altarpieces found at the Eucharistic table. The laity could experience something approximating the service they were discouraged from seeing or performing for themselves at the altar.[8]

Most Laudesi companies organized their celebrations in distinctly formal ways. As devotional substitutes for the Eucharistic services from which they were shielded, confraternal members did their best to reproduce the official tenor and formality that marked the performance of the Mass at consecrated altars. Chaplains were hired to serve as spiritual leaders, hymnals were designed individually to order, and litanies of saints and feast days were observed according to the specifications of the group. Sometimes these chaplains were trained priests with parishes of their own to tend, but sometimes they came from other professions, albeit with sufficient training to do the job. When, in 1412, the Company of Orsanmichele sought a chaplain to tend to their religious observances, the man they chose was Lorenzo Monaco, a former monk from the Camaldolese monastery of Santa Maria degli Angeli who had just been involved in the project to design and glaze stained glass windows for the lunettes created in the walls of the guild church when the former granary had been transformed into a cult center.[9] A member of the confraternity of Saint Luke (formed by the city's painters), Lorenzo went on to produce miniatures for choir books used in the hospital of Santa Maria Nuova, the largest institution of its kind in Florence. His work with charitable organizations served him well professionally and personally.[10]

Alternatively, some Florentines in the fourteenth century (and in much greater numbers in the fifteenth) turned to a stricter, more expressive way of demonstrating personal piety within lay confraternities. These lay devotees, known collectively as Disciplinati or Flagellants, embraced a corrective process that replicated examples set by Christ and the Virgin. These corrections often came in the form of physical punishments, and were administered either weekly or monthly by officers of the confraternity charged with this

specific task. Sometimes they came in the form of mild taps on the shoulder; sometimes they were more violent, as painful beatings were carried out with knotted whips that ripped the flesh and drew blood. Andrea di Cione, still a young man in 1342, was one of those who felt the sting of flagellation. The painter later known as "Orcagna," or (ironically) Archangel, was punished for unnamed flaws by his superiors in the Confraternity of Gesù Pellegrino: he had "many defects that he was unwilling to correct."[11] But rather than think of Andrea as an anomaly, his state of defectiveness was instead quite normal. In an age when the concept of imitating the life and passion of Christ was recommended by preachers and moralists all across Europe, this form of personal piety and penance became enormously popular, even among those whose personal conduct might not warrant Christ-like comparisons. The plague of 1399 inspired widespread participation in them, as indicated by the processions of white-clad adherents called the Bianchi who crisscrossed northern Italy in an effort to appease an angry God that had brought the scourge of pestilence back on their soil once again.[12] These processions were filled with laymen who beat their own flesh raw, surely a remarkable sight for those laymen and women who watched them march slowly through their respective villages, towns, and cities. They obviously made an impression, too. By the time of Cosimo de' Medici's triumphant return from exile in 1434, over 40 percent of the confraternities operating in Florence were Flagellant, and hundreds of people in the city engaged in systematic ritual beatings administered in the name of absolution.[13]

It did not take long for lay companies to organize themselves in ways that made their devotional interests more civic and charitable in nature. By the end of the thirteenth century, members paid dues, volunteered their time, and secured donations from the government to fund service ventures that were often specific in nature. The Company of Orsanmichele focused on famine relief; the Company of the Bigallo, originally located in the church of San Bartolo in Corso just across the street from Orsanmichele, specialized in the care of orphans; and the confraternity of the Neri catered to the spiritual needs of criminals condemned to death. The members of the Misericordia cast their nets much wider, assisting the poor, the hungry, the sick, pilgrims, unmarried girls in need of dowries, and families who could not afford proper burial for their dead. In return for their charitable works, confraternity members in these organizations could count on enhanced social connections with fellow adherents, fairly elaborate funerals paid for by the company, and a certain security in the knowledge that they had shown mercy and charity toward those among them in genuine need of sustenance.

A few of the wealthier and more prestigious confraternities in Florence operated out of buildings specifically dedicated to them and their good works. In 1321 the Misericordia received property on the Piazza San Giovanni and

24. Mariotto di Nardo, *Coronation of the Virgin with Five Music-Making Angels*, 1408, Minneapolis Institute of Art, Minneapolis, Minnesota. Photograph courtesy Putnam Dana McMillan Fund 65.37, Minneapolis Institute of Art.

gradually transformed what appears to have been a rather large house into a set of offices and meeting halls that came to include the now-famous loggia at the mouth of the Via Calzaiuoli.[14] Not surprisingly, both the layout and the decorations of these rooms matched the templates then favored by the major and minor guilds for their respective headquarters, with entrance foyers leading

to larger, rectangular rooms with doors at each end that led to small offices, halls, and stairways for the upper floors. The plan of the Misericordia's seat reveals this progression of spaces, and is entirely consistent with the flow pattern of the buildings used by the Wool Guild and the Guild of Judges and Notaries. This was the type of architectural design most familiar to those who composed the confraternity, for the guildhall was the only corporate structure known to most of them in the fourteenth century, and this familiarity naturally bred repetition when a new public group was set to break ground for its headquarters.[15]

Still, the socially conscious institutions of the Misericordia, Bigallo, and Orsanmichele were exceptions to the general rule governing the activities and interests of Florentine confraternities. Most of them were created to satisfy the spiritual yearnings of the lay population, which naturally suggests that participants felt the need to sate an appetite left otherwise unaddressed by the clergy. Most companies congregated in chapels or oratories, where their devotional hymns could be performed in an appropriate environment (and, presumably, be witnessed in heaven by the patrons who resided there and in the pictures decorating confraternal spaces). As we have seen, in the 1290s the Laudesi company formed by Peter of Verona in 1244 met before the dossal of the *Rucellai Madonna* in the east transept of Santa Maria Novella, probably between the Chapel of Saint Gregory and the Rucellai Chapel. The flagellant company of the Gesù Pellegrino also met in that church, which was the setting for Andrea di Cione's punishment for unmentioned transgressions in 1343. The Neri built their chapel outside the Gate of Santa Croce, in what is now the Piazza Beccaria, to succor criminals condemned to execution by the state.[16] The Bigallo operated at least one chapel in the Carmelite church of Santa Maria del Carmine, complete with a now-lost altarpiece painted by Lorenzo Monaco between 1399 and 1400, thanks to funding provided by the Ardinghelli family.[17] And the two companies that shared a vast chapel space in the parochial church of Santo Stefano in Pane – the Compagnia di Santa Maria del Desco and the Compagnia di Santo Stefano – similarly shared a large and elegant polyptych by Mariotto di Nardo, the entirety of which must have extended some 250 centimeters (Figure 24).[18]

Other confraternities, less wealthy and smaller in size, congregated around piers in churches that bore images of special importance to them. The Company of Orsanmichele, as we have seen in great detail, did this no later than 1292 and continued to do so until at least the fire of 1304, and probably beyond that date. A number of Laudesi confraternities, including those dedicated to the cults of Saints Catherine and Reparata, met inside the Duomo during the fourteenth century, while the Company of Saint Zanobi gathered before a tabernacle that was attached to a pilaster (and draped with a processional banner) to conduct their devotions.[19] Other confraternities chose to meet outdoors in front of street tabernacles, like the one near Santo Spirito that sang hymns

to the Virgin at regular intervals.[20] All of them were careful to have images prominently placed on or in their meeting place, both to alert nonmembers to their interests and to bolster the pride and devotional practices of members who sang praises to the figures there depicted.

Literally every confraternity that operated in Florence placed enormous stock in devotional imagery. When listing their possessions in books of inventories, both the confraternity of San Zanobi, which met in the Duomo, and the Company of the Gesù Pellegrino, which met in Santa Maria Novella, begin their lists with the paintings on panel and canvas that marked their meeting areas in the churches that sponsored them. The former met before the tabernacle of San Bartolommeo in Santa Maria del Fiore that contained inside it a panel of the Virgin, but which could also be supplemented with a portable banner ("gonfalone") that bore a painted image of the Annunciation on one side and the Madonna and Child on the other.[21] They sang songs recorded in an illuminated Laudario ("un libro di Laude coperto dichoiame rosso bellettato dove sono scritte laude et sequerizie storiato …chessi cantano ogni sera"), owned pictures that they carried with them on processions ("Una tavola con due trespoli con sei piedi che si pone quando si fa processione"), and possessed two other pictures that bore the images of Saint Andrea and Saint Christopher.[22] They also owned two panels by a painter named Neri Ridolfi, one of which displayed the company's insignia (a red cross on a white field) and the other the figures of Mary, Saint Silvester, and Saint Francis.

Similarly, the Gesù Pellegrino owned pictures large and small, including a painting on the altar they used in Santa Maria Novella's Chapel of San Niccolò, a processional crucifix, and an image in a *tabernacolo* either for or of the Pellegrino.[23] Three large panels – *tre tavole grande* – revealed images of the apostles and company adherents.[24] One of them may well have been the large *Vir Dolorum* that today adorns the walls of the Accademia in Florence, and which Kay Arthur has connected to the flagellants in Santa Maria Novella (Figure 25).[25] Veils covered the larger picture and at least six large curtains or banners could be presented if the occasion called for them. White linens covered more modestly scaled pictures, including a *tavoletta* and a *crocifisso piccolo*, which could be used either for private meditations or processions in and out of the Dominican church.[26]

Yet another confraternity, the Compagnia di Santa Maria alla Croce al Tempio (also known as the Neri), was even more indebted to pictures, for the association reputedly owed its very existence to the power of images. Dedicated to the succoring of criminals condemned to death by communal decree, the confraternity was founded by a small group of young men who experienced a conversional moment in 1343 while venerating a painting near the city gate of Santa Croce.[27] In this legend, the image venerated by the Neri's founders was the street tabernacle on the Via dei Malcontenti, just by the

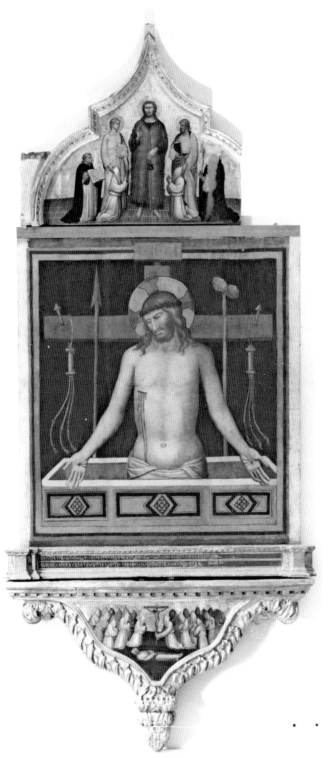

25. Niccolò di Pietro Gerini, *Vir Dolorum*, ca. 1400, Accademia, Florence. Photograph courtesy Gabinetto Fotografico del Polo Museale Regionale della Toscana.

church of San Giuseppe, and the effect of the picture was powerful enough to spark them to form a confraternity in commemoration of it (Plate IV).[28] Over time, the confraternity of the Neri was able to attract adherents and funding, construct an oratory, and stage processions through the streets of Florence with pictures of the Virgin Mary held aloft by its leaders. Adorning the high altar was a triptych that may have been produced by Taddeo Gaddi at the time of the confraternity's founding.[29]

But images also played an important role in the rituals performed by members of the Compagnia dei Neri. Responsible for tending to the souls of condemned criminals, confraternity members worshipped with those awaiting execution on the night before their punishment.[30] Depending on the inclination of the prisoner, the task at hand could merely entail a joint prayer session with the condemned, which focused on the absolution of his sins or a more challenging attempt to elicit from the recalcitrant subject a contrite plea for mercy. In either event, images were used both to help the pious channel their devotions and to encourage the reluctant to convert before it was too late. Small panels, or *tavolette*, were used for this purpose in the late sixteenth century; but it appears that fourteenth-century criminals may have gazed upon painted crucifixes as they processed through city streets, said their prayers in the church of Santa Maria alla Croce al Tempio, and stood before the executioner in the killing fields outside the Porta alla Croce. In 1991, Miklós Boskovits suggested that a modestly sized but beautifully painted crucifix, produced by an artist in the orbit of Bernardo Daddi and now in Milan, was intended for precisely this purpose (Plates VIII and IX).[31] The double-sided image features, on the recto, the familiar figures of Christ on the cross with Mary and the Evangelist occupying small compartments at either end. Above the cross appears the ascendant Christ, who emerges from a pink marble tomb holding in his hands a closed book and the banner of Resurrection. Below we see not a skeleton but a decomposing body, with flesh clinging to protruding bones that are still draped in the clothes he once wore in this life. The signal of impending death appears starkly before the viewer's eyes at the cross's base, but also partners with the more comforting scene of hope in the central lozenge above and the connecting figure of the Savior who hangs between them. This side of the cross encourages an upward reading that ends at the object's pinnacle, which finally allows the viewer to consider the ultimate rewards promised to the truly penitential. The skyward thrust of the painting's composition offers an optimistic message to those about to die.

Images on the obverse side clearly articulate the specific audience for whom the cross was originally painted (Plate IX). At the three edges of the crucifix kneel apostolic martyrs who have suffered identically horrific fates – and presumably the same one awaiting the viewer. Saint Paul, at the top, presses his hands together as his severed head faces down toward yet another depiction

of the Crucified Christ. To the right we see John the Baptist, still in an act of prayer, but with his head facing upward toward the heavens. And to the left appears a third decapitated saint, perhaps James the Major, whose face points down toward the rock of Golgotha.[32] These executed martyrs, with the bloody stumps of their necks displayed prominently to viewers, are finally joined at the composition's base by two Dominican friars – probably Peter Martyr of Verona and Thomas Aquinas – who gaze not up at the human carnage painted at the ends of the crucifix but rather at the mound into which it has been jammed. Either they conjure up in their minds a vision that we now have the ability to see, thanks to the intermediary act of the painter who has depicted it (and which, in turn, has been presented to the viewer as an invitation to recreate in their own minds) or they directly address the burial ground that contains the remains of all criminals similarly punished throughout history: a somber message that saints as well as sinners have met this fate.[33] This cross was intended for neither the sick nor the aged, but rather for those condemned to experience the same kind of death as that represented three times on this side of the painting.

The image also probably had a very specific function, for this was not the kind of picture one expected to use in a liturgical ceremony at church or see in the bedroom of a private home: at only fifty-eight centimeters it would have been too small to see from a distance, and its subject matter would not have fostered the kind of harmony families wished to see in domestic pictures. Rather, the crucifix was probably flipped back and forth directly in the face of the condemned by a member of the Neri as he worked with the criminal in his care during the all-important hours leading up to the moment of his death. Now the poor wretch saw images of broken bodies and of holy saints, one after the other, during this contemplative period that immediately preceded – or even transpired during – the procession to the killing fields. Indeed, as Boskovits has suggested, this double-sided crucifix may well be the one Giuseppe Richa described when he mentioned the presence of a "Crocifisso il quale dalla Compagnia de' Neri si porta all'incontro dei condanati" by one of the altars inside Santa Maria alla Croce al Tempio in 1735.[34] If so, then this cross would have been one of the very last images seen by condemned criminals before their deaths, and may even have been employed to elicit a penitential response at the very scene of their executions. Indeed, one wonders how many deaths Bernardo Daddi's painted crucifix has seen over its own lifetime.

By the dawn of the fifteenth century, most confraternities met inside churches or possessed their own spaces that included altars that serviced liturgical performances. Mariotto di Nardo, in his polyptych for the companies of Santo Stefano and Santa Maria del Desco, relied on a set of themes that were, by 1400, quite popular in monastic and mendicant churches in Florence

(Figure 24). The image of the *Coronation of the Virgin* in the Pieve Santo Stefano replicated altarpieces, stained glass windows, and frescoes in such major ecclesiastical centers like Santa Maria Novella, Santa Croce, San Pier Maggiore, and the Duomo. Lateral panels bearing standing patron saints, including the protomartyr for whom the church and the other confraternities were named, flanked the central compartment in adherence to common altarpiece forms. And the Annunciation in the pinnacles and scenes from Stephen's life in the predella conformed completely to the model of liturgical pictures that stood on altarpieces in literally every church in Florence by 1408.[35] From this painting we may deduce that those companies that met before altars in church chapels commissioned paintings for them that matched the typology of altarpieces for the day, which in turn suggests that confraternity members both knew what they were missing behind the *tramezzo* of a church and wished to imitate the experiences of clerics and special lay guests who celebrated Mass before the most sumptuous panel pictures in Florence. But precisely how they used these altarpieces, which presumably enabled chaplains to perform specialized rituals before them, cannot be divined from the appearance of the painting for the Pieve di Santo Stefano.

Even those companies that did not have chapel space or altarpieces at their disposal spent money on paintings they could use to promote their specific charges or collective interests. Processional panels and banners were the most common types of paintings owned and displayed by confraternities during the fourteenth century, for they were particularly useful during public parades at communal festivals, the celebration of their patron saint's feast day, or periodic movements through a neighborhood or church to mark the performance of hymns or other rituals about to transpire. Due to the desire for portability, these pictures were by definition smaller or lighter than the large and weighty dossals and polyptychs that marked an ecclesiastical space as a company seat. Portable *tavolette* (or *tavaglioule*) were durable, yet fairly expensive – which added to their prestige as symbols of corporate piety.

One of the most prominent and elaborate confraternal displays of piety and imagery occurred annually on February 5, when the confraternity of Saint Agatha assisted in a lengthy procession that touched the four corners of the medieval city. Beginning in the cathedral, perhaps as early as the late twelfth century, members and their clerical guides processed together to the convent of San Pier Maggiore, then crossed the river at the Ponte Vecchio, moved west to the Ponte alla Carraia, and then returned to the cathedral, stopping at each of these points to hear Gospel passages and to observe ritual placements of votive offerings.[36] Part of the ceremonial element of this grand public spectacle – one of the largest and longest processions undertaken in Florence – included the employment of a painted image of *Saint Agatha*, now preserved in the city's Museo dell'Opera del Duomo, attributed to Jacopo del Casentino, and probably

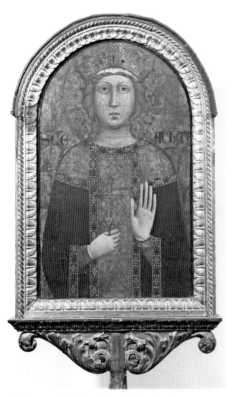

26. Jacopo del Casentino, *Saint Agatha*, ca. 1335, Museo dell'Opera del Duomo, Florence. Photograph courtesy Scala/Art Resource, New York.

painted during the 1330s (Figure 26). Contained within a lunette-shaped panel with a staff at its base, the half-length figure holds a crucifix in her right hand and raises her left in greeting. The panel appears to have been based on, if not copied directly from, an earlier painting that still survives, and the two surely worked together as an ensemble (Figure 27). This older figure's heavily striated nose and eyes, pinched chin, and schematized hands and fingers suggest a date of production sometime during the late thirteenth century.[37] Both panels bear the letters SCE AGHATA which, when considered alongside their unique shape, confirms the function of both panels as portable paintings intended for performative spectacle. It also suggests that they were commissioned and preserved by the members of the Societas Sant'Agate, whose date of origins and headquarters have never been determined, but who surely featured prominently in the February processions around the city.[38] With the completion of Jacopo del Casentino's updated version, the Societas Sant'Agate could carry two images of their patron saint during the festivities. Perhaps they were attached, back to back, to create a double-sided, albeit quite heavy, processional standard. Perhaps they were used in tandem, carried next to one another during the celebration on February 5. Perhaps they were carried separately, one at the front of the procession and the other at its back, as pictorial bookends of the parade through Florence. The pairing may have signaled to viewers the antiquity of the company, with the archaic version of Saint Agatha representing the earliest days of confraternity's formation and Jacopo del Casentino's more modern iteration suggesting the vitality of the current group.

This kind of processional image was commonly employed by companies even when the item in question was too large to be carried aloft by adherents. The *Vir Dolorum*, painted sometime around 1400 by Niccolò di Pietro Gerini, was unquestionably produced for a flagellant community (Figure 25). Above and below the central figure of the beaten body of Christ appear white-clad devotees who, alternately, kneel before Saint James (patron of pilgrims, or Pellegrini) and mourn the corpse of a fellow member during the ritual of burial. The open holes on their backs of their robes which

indicate their willingness to draw their own blood by beating their exposed flesh; while the presence of Saint Peter Martyr of Verona in the pinnacle above; and the featured place of Saint James both support the proposal that this picture was intended for the confraternity of the Gesù Pellegrino, which met in the Chapel of Saints Simon and Thaddeus in the Chiostro dei Morti of Santa Maria Novella, just below the west transept.[39] At a height of 358 centimeters and width of 158 centimeters, the cumbersome panel would have been too large and too heavy to carry in procession; yet the artist and his patrons nonetheless elected to design the picture in a way that would recall a smaller, more portable processional picture like that of Saint Agatha by Jacopo del Casentino.

With its appearance intentionally formulated to resemble a specific type used to promote a confraternity's legitimacy and prominence, this monumental picture was almost surely positioned in a way to serve as a meditational tool for the brethren of the Gesù Pellegrino.[40] The wounds in Christ's body, combined with the instruments of the Passion

27. Anonymous, *Saint Agatha*, ca. 1290, Museo dell'Opera del Duomo, Florence. Photograph courtesy Scala/Art Resource, New York.

propped up against the cross behind him, emphasized the physical torments endured by Jesus on behalf of Mankind, which in turn justified – and perhaps even glamorized – the ritual beatings that formed the core portion of the flagellants' rituals. Members of the company, which for a time included Andrea di Cione, appear to have been able to see this picture on a regular basis, for no protective covers or banners seem to have covered it deferentially.[41] Yet given the location of the confraternity's chapel, underneath the church, it is highly doubtful that the painting of the tormented Christ and the white-clad flagellants of the company was seen by unaffiliated outsiders. Like most paintings for confraternities, these public images bolstered the spirits and justified the sacrifices of those who were already predisposed to embrace the mission of the institution that displayed the picture.

More visible were pictures on canvas or linen, by rule much easier to carry than the wood panels like the *Saint Agatha* and the *Vir Dolorum*. In addition to serving as processional banners (or *gonfaloni*) in communal pageants, they could also be used as permanent decorations in company meeting areas, where they could be hung from the tops of tabernacles, church piers, or walls where

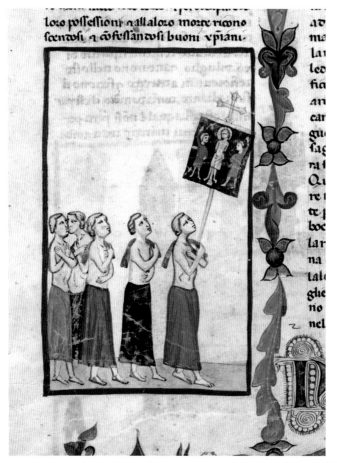

28. *Flagellants, Chigi L VIII 296*, fol. 197v, ca. 1342–1348, Vatican Library, Vatican City. Photograph © 2015 Biblioteca Apostolica Vaticana. Reproduced by permission of the Biblioteca Apostolica Vaticana, with all rights reserved.

members gathered. The Neri, as we have seen, itemized the *gonfaloni* in their possession, as did the confraternity of San Zanobi and the aforementioned Gesù Pellegrino. Some were used as portable billboards of their owners, proclaiming their piety through emblems that revealed the core purpose or central rituals performed by members. An illustration of a procession of flagellants from folio 19v of the *Chigi Villani* provides a helpful insight into the way some were used by groups of lay devotees, as supplicants stripped to the waist to walk barefoot before them while beating their own backs as they gazed at a lead image of Christ's Flagellation that dangles from a cruciform standard (Figure 28).

The flagellant company of San Giovanni Decollato had banners in their meeting place in the Duomo, and a number of paintings on linen have been identified by Caroline Villers as being likely candidates for use by other confraternities in Republican Florence. Among those that appear to have served a confraternal purpose were the four square narrative pictures on linen, formerly

in Leeds Castle (Plate X).[42] The four cloth paintings, square in format and narrative in content, depict the *Washing of the Disciples' Feet, Betrayal of Christ, Mocking of Christ*, and *Flagellation of Christ*. Attributed to Niccolò di Pietro Gerini, the images pronounce distinctions between those who follow the Way and those who reject it. Christ stands in the midst of each scene: first his apostles on the evening of the Last Supper, then a combination of Roman soldiers and Jewish bystanders, followed by two images that feature a collection of tormenters under the command of the provincial Governor, Herod. Christ stands in the center of the action in all four, with head inclined in three of them, and the emblems of humility, gentleness, and silent acceptance of physical punishment point toward an audience comprising members of a flagellant community. Exactly how they may have been seen or used cannot be determined in their present condition, although the high vantage points of all four pictures imply that viewers were situated well below the pictures, creating a modified *di sotto in su* experience.[43] The paintings encourage their audience to consider the viewing experience to be something akin to an eyewitness account of Christ's Passion – again, an approach consistent with the aims and rituals of Florentine flagellant confraternities at the end of the fourteenth century.

The value attached to materials helps us consider the intended audience for these cloth paintings. Whereas altarpieces and panel paintings promoted the company's mission to the brethren within the inner sanctum of their meeting area, processional banners served the purpose of celebrating the vibrancy and piety of that community to the general public, many of whom would have only been able to know about the motives and activities within that company through their processions through city streets and churches on special ceremonies and feast days. These banners served as advertisements for the confraternity, just as the *gonfaloni* carried by guildsmen on the Feast of San Giovanni identified them as proud members of their organization and reflected well on them in the eyes of the general public who watched them process. Pictures on wood or in fresco were for members only, whereas pictures on cloth were for outsiders. The fact that so few have survived for examination only underscores both their material fragility and the frequency of their exposure to the elements by those who employed their use when marching publicly in Florence.

The attribution of these cloth paintings to the workshop of Niccolò di Pietro Gerini is not unimportant here. Gerini, in fact, was quite a popular painter among confraternities and charitable organizations during his tenure as one of Florence's leading artists. From the early 1380s until the end of his career in the very early 1410s, Gerini painted pictures for the leading public organizations in the city that were among the most prominently displayed images of their day. Sometime before 1383 he painted a large dossal of the *Lamentation of Christ* for a confraternity connected to Orsanmichele.[44] In 1386 he collaborated with

Ambrogio di Baldese to produce a large fresco that addressed every person entering and leaving the Duomo, Baptistery, and Bishop's Palace – that is to say, literally the entire population of Florence at one time or another – from its perch above the doorway of the loggia operated by the Company of the Misericordia (Plate XII). In 1399 he painted a street tabernacle by the Piazza Orsanmichele that was funded and maintained jointly by the Bigallo (that had its headquarters in San Bartolo in Corso) and the Company of Orsanmichele.[45] And not much later, the Gesù Pellegrino paid him to produce the *Vir Dolorum* with references to the white-clad membership in the form of a processional painting. Gerini now followed in the footsteps of Tuscany's finest painters, including Duccio and Cimabue and Bernardo Daddi and even Giotto himself, in his acceptance of offers to produce public pictures for common people on a regular basis.

THE MISERICORDIA IN THE PIAZZA SAN GIOVANNI

The vast throng of visitors to the Piazza San Giovanni today, almost without fail, bypass one of the most important institutions of early Republican Florence. In their haste to walk around the Baptistery with its famous bronze reliefs and their urgent rush to see and then climb Brunelleschi's famous cupola, most fail to consider the small medieval loggia that once housed the confraternities of the Misericordia and the Bigallo (Figure 29). Those who do venture inside the Museum that once housed these mighty charitable institutions are rewarded with one of the very largest and most frequently viewed public pictures in the history of Florence: the *Allegory of Mercy* (Plate XI). This painting, like so many that adorned the confraternities and hospitals of the early Republican commune, reveals a great deal about the distinctly medieval mentality concerning social justice, the common good, the essence of Christian charity, and the different sets of audiences that came into contact with it.

And come into contact with it they most certainly did. The confraternity was stationed on the Via Adimari (today the Via Calzaiuoli) in a building that was purchased in 1321. A house adjacent to that original structure, located on the corner of the piazza, was then bought in 1351, with construction of an open loggia and an oratory begun immediately thereafter. The vaults of that oratory (not unlike the arched structures that designated workshops and merchants' shops as public places of business) were finished by 1359, and in 1361 the final touches were put on the building now referred to as the Bigallo.[46] Facing the south side of the Baptistery and the open space that separated San Giovanni from the facade of the Duomo, the confraternity's headquarters served as both a meeting place for membership and as the seat of its charitable works. It must have been large enough to hold separate spaces for company business, orphaned children, and the sick and destitute who sought shelter there. Exactly how it

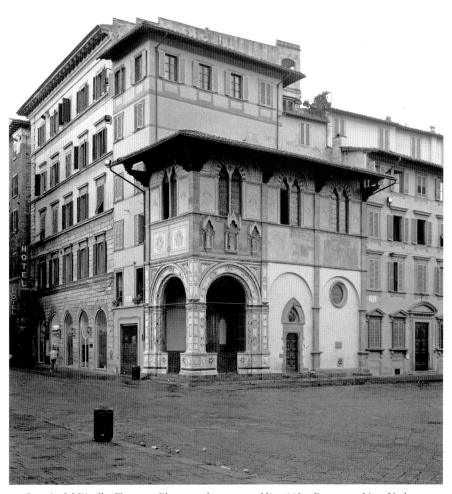

29. Loggia del Bigallo, Florence. Photograph courtesy Alinari/Art Resource, New York.

was organized is not completely apparent: its original layout was reconfigured in 1777, with larger rooms like the audience hall partitioned and smaller ones adjusted to fit new uses.[47]

Imagery was, of course, important for the company. During the early 1360s the sculptor Alberto Arnoldi produced and installed on the ground floor of the palazzo a sculptural ensemble that was then surrounded by frescoes painted in 1363 and 1364 by Nardo di Cione (Figures 30 and 31).[48] Clearly visible from street level, the sculpted figures of the Madonna and Child flanked by Angels faced pedestrians along the Via Adimari (today the Via Calzaiuoli), thus announcing to all the spiritual piety of the people who worked there and

30. Alberto Arnoldi, *Madonna and Child*, ca. 1365, Museo del Bigallo, Florence. Photograph ©
George R. Bent.

the clients that they served. Not surprisingly, this sculptural commission fell on
the heels of the one instigated by the Company of Orsanmichele, which netted
that space the magnificent and extremely popular marble tabernacle by Andrea
di Cione in 1359. A sense of competition between charitable institutions in this
case drove decisions within the membership.[49]

The impulse of the two confraternities was quite different, however, for
while the ensemble in Orsanmichele was turned away from the street and was
about to be enclosed behind the walls that were built between roughly 1368
and 1385, the Misericordia group was framed by its open loggia and was visible
to the public. Whether through coincidence or intentional action, just as the
granary of Orsanmichele was in the process of walling up its open loggia to
create a more exclusively inward looking space, the Company of the Miseri-
cordia was opening itself up to make it more accessible to the general public
than it had been before.

The key element in the Misericordia's open invitation to the general public
was the mixed media altarpiece and fresco combination completed by Alberto
Arnoldi and Nardo di Cione right around 1365.[50] Arnoldi's contributions were
the most dramatic, although not nearly as elaborate as the later framing device

31. Nardo di Cione, *Christ in Judgment with Angels*, ca. 1364, Museo del Bigallo, Florence. Photograph © George R. Bent.

from 1515 might suggest (Figure 30). The sculptural group features a standing Madonna who faces frontally, gazing out at viewers on the Via Adimari. She stretches her right hand toward the Christ child, whom she cradles with her left arm, and he in turn reaches with his left hand to grab Mary's right thumb. Flanking the couple appear two standing angels, each of whom bears a torch and incline its head toward the center of the group. Knowing the appearance and ultimate placement of these sculpted figures, Nardo di Cione painted frescoes in the vaults overhead and a *Christ in Judgment with Angels* on the lunette wall that framed Arnoldi's work (Figure 31).[51] The dual nature of the Son of Man, first as flesh and blood and then as immortal deity, alerted the common viewer to the liturgical function of the site. It simultaneously presented a figural

representation that was consistent with the mission of the Misericordia who owned and operated the loggia. On their way to or from the Duomo, or on their way to or from the Baptistery, the protective maternal instincts of Mary were seen as both a personal virtue and a theological symbol. As an artistic emblem of the confraternity charged with the care of orphans and unwanted children, the standing Madonna spoke clearly about the interests and merits of those who worked in the facility. But they also alluded to another image located inside the building that had, since its completion in 1342, overtly celebrated the mission of the Confraternity headquartered there.

The prominent placement of the *Allegory of Mercy*, its unusual subject matter, and the remarkable urban portrait of Florence in the early years of the 1340s have made this picture a distinctly important landmark in the history of Italian painting (Plate XI).[52] An inscription – now reconstructed after the fresco was relocated in 1777 to its current position in a chamber adjacent to the Piazza San Giovanni – bears the date of September 2, 1342, and indicates that the picture was commissioned by members of the Confraternity at just the moment the Florentine commune was negotiating to invite Walter of Brienne into the city as *podestà*.[53] Originally placed inside the confraternity's Audience Hall (the Sala d'Udienza), where it could be seen by confraternity members who congregated there for regular meetings as well as by passersby from the street through the open loggia, this promotional painting was abundantly available to literally every member of the Florentine population. Its placement in a charitable building in the spiritual heart of Florence, and the fact that the loggia and the Sala d'Udienza inside it were open to the public round the clock, made this a key monument in the spiritual heart of the city.[54] Standing like a great banner hanging from a standard or a church pier, this Allegory of Mercy was one of the most unusual and truly unique pictures produced during the entire fourteenth century.

Neither a Madonna nor a traditional Misericordia image, the painting in the confraternity's Audience Hall was more of an emblem of self-promotion than a call for mercy or benevolent protection that was then the norm. Nearly everything about this fresco connotes a freshness and originality that departs from traditional representations of Madonnas that had become common in guild-halls and confraternities by 1342. Occupying a fictive lunette, the enormous figure wears a red garment upon which have been painted eleven roundels, each containing small vignettes with inscriptions above. This large woman, an Allegory of Mercy, presses her hands together in a gesture of prayer, while the golden halo around her head frames a white hat emblazoned with a Tau cross in crimson. Above the point of this headdress appears a sacrificial lamb, based in part on the identical symbol used by the Wool Guild, and on either side of the fictive archway – no doubt designed to replicate the actual architectural structure of the company's loggia – emerge two angels who swing censors

32. Workshop of Bernardo Daddi, *Allegory of Mercy* (detail, roundels), 1342, Museo del Bigallo, Florence. Photograph courtesy Scala/Art Resource, New York.

from the oculi they occupy. A lengthy inscription extends across the top of the picture on either side of Mercy's head, while single words enumerating the charge of the confraternity, all taken from Matthew 25:35–36, punctuate the background as mneumonic cues to viewers (Figure 32).[55] Words like POTO (I give to drink), CIBO (I feed), and TEGO (I cover) represent longer verses from the Gospel text to form the justification for the acts performed by members inside this facility: "For I was hungry and you gave me something to eat, I was thirsty and you gave me something to drink, I was a stranger and you invited me in, I needed clothes and you clothed me, I was sick and you looked after me, I was in prison and you came to visit me." The single words provoked viewers to recite the rest of the text that joined them in the Gospel of Matthew, making the Misericordia a visual signpost of Biblical texts. Likewise, the duties of the Misericordia were traced directly back to the words of Christ himself, and were thus imbued with a sanctity that reflected well on those who gave their time and money and energy to succoring Florence's most destitute.

33. Workshop of Bernardo Daddi, *Allegory of Mercy* (detail, bread and wine), 1342, Museo del Bigallo, Florence. Photograph courtesy Scala/Art Resource, New York.

Running down Mercy's garments appear a series of roundels, each containing figures in various acts of charity. In one, a red-clad member pours a glass of wine for a poor man, who eats a morsel of bread that has been placed on the table before him (Figure 33). In another, a naked beggar receives a cloak from the hand of a Misericordia adherent. In a third, a funeral bier carries away the dead for last rites and proper Christian burial (Figure 34). In the fourth, a homeless man receives an invitation to seek shelter – presumably within the confines of the confraternity, represented by the crenellated building behind the pair of figures. The painting of the *Allegory of Mercy* championed the men and women who volunteered their time and money for the good of the Misericordia. Both were appropriate settings for genre pictures.

At the hem of Mercy's long garment appear kneeling members of the company, the heroes of these acts of Christ-like piety, who strike poses on either side of the monumental emblem of communal charity that invoke postures of devotion, supplication, and reverence.[56] It is absolutely vital to note that, unlike most other representations of Misericordia, none of these kneeling figures actually enjoys the protection of Mercy: her dress does not extend out and around them, but rather clings closely to the contours of her body. This seems not to be an image assuring the general public of the grace and love of the main character, but rather the level of devotion that adherents to the confraternity

34. Workshop of Bernardo Daddi, *Allegory of Mercy* (detail, funeral bier), 1342, Museo del Bigallo, Florence. Photograph courtesy Scala/Art Resource, New York.

have placed in her. And with its placement in the company's Audience Hall, the picture's nod toward the membership seems understandable. It is quite clear that, as public an image as this was, the *Allegory of Mercy* was aimed to please the membership of the Misericordia first and foremost, and then secondarily inform the rest of the general population of its activities.

Despite this rather overt, and even heavy-handed, homage to the collective patrons of the fresco, the fresco of the Allegory of Mercy contains an extremely important, and oft-remarked upon, reference to the entire commune of Florence and, therefore, to all viewers who came into contact with it irrespective of their affiliation with the Misericordia. At the picture's base appears a notably impressive architectural portrait of the city, complete with the marble facade of the Baptistery and the still unfinished exterior walls of the Duomo peeking up from behind the large defensive walls that occupy the foreground. Along with scores of churches, dwellings, and businesses, the towers and steeples of the Badia, Bargello, and Palazzo della Signoria circle around behind them with

little regard to their actual place in the urban landscape of Florence, all of them forming an inexact, distinctively impressionistic rendering of a city on the rise. The contemporary sensibility of civic pride referred to as *campanilismo* informs the image, and readings of the picture as an attempt to depict Florence as a New Jerusalem, or a heaven on Earth, seem well reasoned.[57] But mere references to the general virtues of the commune or to its prominence as an Italian power only begin to explain the picture's significance.

The setting of the fresco on the corner of the Piazza San Giovanni as well as the prominent misplacement of the city's most important and prestigious civic monuments suggest that a message of political significance has been injected into the composition. We cannot overlook the precise date of the picture's completion as noted in the inscription that originally accompanied it, and which was then copied and displayed beneath it after its detachment from the Sala d'Udienza in 1777. Indeed, if the fresco was finished on September 2, 1342, we may imagine an entire community in utter turmoil with no clear understanding of its immediate future. As shall soon become clear, Florence was not exactly a peaceful place to live in 1342, a year of extraordinary turmoil caused by financial collapse, political chaos, and social crisis. Nothing was assured – not even the completion of a cathedral that was draining city coffers with each passing month or the stability of an economy that depended heavily on the confidence of the Florin abroad and the solvency of banking houses that charged interest rates on loans to heavy spenders. The communal response was to seek a stabilizing force from the outside, and the ultimately regrettable decision to invite Walter of Brienne, the Duke of Athens, to serve as Podestà was directly connected to the cloak of desperation that befell the city that summer. So complete was their concern for the future that the city's priors acquiesced to Walter's demand that his appointment would last for the duration of his life – an extraordinary concession that reveals the dire situation the Florentines believed they faced. They were, in essence, willing to forsake their republican independence in return for Walter's leadership. Negotiations appear to have proceeded quickly, and Walter accepted their offer on September 7, 1342, only five days after the inscription on the *Allegory of Mercy* was written. If, in fact, the inscription bearing the date ANNO MCCCLII DIE II MENSIS SEPTEMBRIS accurately denotes the day of the fresco's completion, we must consider its production enshrouded by a prevailing atmosphere of chaos and fear.

And this atmosphere may help us understand the unusual appearance of the common people kneeling at the hem of Mercy – the same kinds of people the owners of the fresco wished to address from the halls of their confraternal residence. The well-dressed Florentines genuflecting in prayer kneel outside the matron's garments, which protect the city's buildings rather than its people.[58] The men and women who pray to her seem to beg for her advocacy on behalf

35. Copy, *Abandonment of Children and the Reunification of Families*, 1386, Museo del Bigallo, Florence. Photograph © George R. Bent.

of the commune rather than themselves – the entity of Florence takes precedence over the humble people who inhabit its homes. The picture certainly promoted the Confraternity of the Misericordia and honored the volunteers who gave themselves to its mission. But it also appealed for divine intervention on behalf of an entire city-state in turmoil, with this charitable institution offered as an example of the virtuousness of its citizenry to justify whatever benevolence may be shown to it. In this sense, the mercy sought by the kneeling supplicants on either side of Misericordia was not for human beings, but rather for the commune.

The theme of mercy, as well as the actual mission of the confraternity, was repeated on the exterior of the headquarters. Perhaps cognizant that the fresco inside the palazzo addressed only those who ventured inside the building, the confraternity boldly extended the propagation of their charitable contribution to the city when they commissioned Niccolò di Pietro Gerini and Ambrogio di Baldese to paint a large mural that could be seen by anyone standing below it – which, in 1386, would have been just about anyone living in or passing through the city of Florence. Originally occupying the open loggia of the Confraternity of the Misericordia, located in the central Piazza San Giovanni, the horizontally composed painting described the activities that transpired inside the building (Plate XII). Removed from its setting in 1777, the fresco was copied in watercolor by an anonymous artist working sometime during the reign of Archduke Leopold (Figure 35). At the picture's core loom the figures of bearded men wearing colorful robes and caps, each of whom extends his arms down and out toward viewers below. Some of these men clutch small children positioned below them, while others gesture toward groups of women who have congregated outside the building in which these men stand. To the right, a red-clad figure (marked by the insignia of the Confraternity of the Misericordia on his chest) nudges a happy child forward into the outstretched arms of the woman who reaches out to embrace her. A line of women, hair bound in braids

and covered by veils, forms behind the leader, dressed in yellow. Behind them, standing before an open door with an image of the Virgin and child, appears another group of adults who seem markedly happier than those to the far left. Here, mothers hold and cuddle children of their own to the far right of this now-damaged image that once towered over the piazza from its position just across from the Florentine Baptistery. This portion of the painting, commonly referred to as the *Consignment of Abandoned Children to Natural and Adoptive Mothers*, emphasizes the heartwarming effects of the restitution of families previously torn apart by parents forced to hand over children due to economic, social, or personal pressures.[59]

Yet the title commonly applied to this fresco does not completely reflect the true nature of the image. Indeed, the picture illustrates a number of themes simultaneously. The joyful union of children and mothers seen to the right of the composition has not been replicated to the left, which has a much darker focus. On this half of the fresco, the youth grasped by the man inside the loggia seems decidedly disturbed by the clutch of his adult overseer, who pulls the boy into the structure that occupies the picture's core while curling the fingers of his right hand in a gesture of beckoning. A circle of women to their left, one of whom turns her youthful back to us, engages in an active discourse complete with gesticulations, bowed heads, and folded hands. Farther to the left stands a woman leading two children toward the loggia. Her right hand caresses the head of one of them, while her left reaches out to take a pomegranate from the outstretched arm of the other. This half of the lengthy picture depicts not the restitution of orphaned children, but rather their rendition into the Misericordia by women (presumably their mothers) who can no longer care for them. The circle of women deep in conversation may suggest a debate or ethical discourse concerning the wisdom of such an act, and the braided, uncovered hair of the woman in the foreground may suggest that she – anonymous and unmarried – is one of those delivering a child into the Misericordia's care. This fresco shows not only the consignment of abandoned children to their natural parents, but the earlier dilemma and decision by those parents to abandon their offspring in the first place.[60] Perhaps a better title for this before-and-after sequence might be the *Abandonment of Children and the Reunification of Families*.

This moving painting, which plucks at the heartstrings of adolescent and adult viewers alike, was not only a public picture aimed at common people in late medieval Florence. This picture spoke to those who needed to know the function of the building located at the very heart of the urban spiritual center – e.g., the women and men in search of a philanthropic organization that could accept their unwanted children – and to those who needed reminding of the importance of this service in an economic and social environment that could make life for poverty-stricken families utterly unbearable. In an age when unmarried women were not infrequently coerced into sexual relationships

with socially or politically enfranchised men, when married couples could easily produce more children than they had the means to support, and when sudden and unexpected economic downturns or spectacularly contagious diseases could utterly ruin entire households, orphanages were both necessary for the maintenance of order and vital for the health and well-being of society. The city depended on safety-net organizations like the Misericordia to take care of its neediest residents, and it took great pride in the work of the volunteers and care-providers who labored inside them to provide enough support to keep the least fortunate among them off the streets, out of the stocks, and away from the gallows, a common fate for those whose desperate situations caused them to violate public standards of order. This image reminded passersby that the confraternity ran a safe and successful institution where parents could place their children temporarily should personal or financial straits force them to part ways with their offspring. Situated in a highly prominent location and easily legible from street level, the *Abandonment of Children and the Reunification of Families* addressed the city's most destitute demographic with a hint of optimism and provided hope for both those families that took advantage of the Misericordia and those that supported its efforts.

But this picture also addressed a broader swath of the population, as its special and carefully planned position struck at the very core of the urban center. Situated just opposite the Baptistery's south portal which, in 1386, was the only one of San Giovanni's doors decorated with gilded bronze panels, the *Abandonment of Children and the Reunification of Families* would have been the only painted image encountered by new parents and their entourages before and after the baptism of their own infant children.[61] This is no small matter. As a singularly pan-Florentine institution that bypassed parochial boundaries in an otherwise notoriously parochial city, the Baptistery of San Giovanni catered to the needs of every family in the commune, from one edge of the city walls to the other. This was the place all new parents brought their infants for that most important of sacraments, and the place where friends and relatives and Godparents congregated to show both their support for the new family and the alliances that were now forged between witnesses. In fact, the area between the Baptistery's south doors and the facade of the Misericordia bearing the fresco of the *Abandonment of Children and the Reunification of Families* was the most important zone of the piazza. As Amy Bloch has demonstrated, the ritual for baptism in fourteenth-century Florence called for fathers to process to the south doors with their newborns in tow. Joined there by the child's Godparents and other witnesses invited to attend, the entourage was met outside the Baptistery by a priest, who spoke to them there about their new responsibilities.[62] After this brief ceremony, the group was ushered to the baptismal font inside, located only a few feet from the opened south portal, where the sacrament was performed. From that spot, witnesses and participants could look out the door

through which they had just passed to see the only large-scale, colorful image visible in the entire piazza (Plate XIII). And that image, seen during and after the celebration of an infant's baptism, resonated with a particular power: for just as the priest's words outside San Giovanni's south door revolved around parental duties, the image overhead on the Misericordia's facade underscored the challenges facing the caregivers of children, both emotional and physical. And it also reminded them that the confraternity was there for them if ever a time arose when their services might be needed. In a paradoxical way, the fresco both warned new parents of the pressures they were sure to face and advertised the support they could offer should those pressures become too great to bear. The fathers, Godparents, and witnesses standing at the Baptistery's south portal could not have been the only viewers for whom this fresco was intended, but they certainly composed an important portion of its audience.

The Company of the Misericordia promoted itself to the world outside it by demonstrating to a vast audience the things that happened inside the building. They repeated this visual propagation within their headquarters as well, as the services they provided for the good of the commune were illustrated to its members and to visitors who ventured within its walls. And the ensemble composed of sculptures and paintings, standing inside the building but visible to those who passed by it on the outside, reinforced the virtues of its members and their mission. A program of images addressed all members of Florentine society, and did so logically and coherently at the spiritual core of the city.

THE *MADONNA LACTANS*

No single iconographic subject received the attention of every confraternity in Florence, just as no single iconographic subject was the exclusive propri-etary responsibility of the city's devotional and charitable companies. Images of the Madonna in a variety of forms were widely embraced, while patron saints of specific groups often appeared in different painterly contexts. The Virgin Enthroned was a favored image for Laudesi groups, and Crucifixions and Scenes of the Passion fueled the interests of flagellants. Charitable institu-tions were also keenly inspired by the relatively recent invention of the *Madonna Lactans*, a subset of the equally recent subject of the *Madonna of Humility* intro-duced during the late 1340s.[63] The Company of San Zanobi commissioned a sculpted relief of the subject for a tabernacle that was on display at their altar of San Sebastiano in the Florentine Duomo, as well as an altarpiece that featured that theme, produced for the Bigallo in their oratory of San Bartolo in Corso by Mariotto di Nardo in 1415–1417.[64] Images of Virgin Mary humbly nursing her infant son – sometimes enthroned, sometimes seated on the ground – can be traced back to confraternity and hospital settings with surprising frequency.

36. Pseudo Don Silvestro dei Gherarducci, *Madonna Lactans*, ca. 1380, Accademia, Florence. Photograph courtesy Gabinetto Fotografico del Polo Museale Regionale della Toscana.

One such image that can be connected by provenance to a medical institution is the *Madonna Lactans* that now appears in the Florentine Accademia (Figure 36). The picture was located in the hospital of Santa Maria Nuova until at least 1874, when it was seen and described in an unpublished manuscript, and then entered into the collection of the Florentine Galleries in 1900.[65] Located only two city blocks from the Florentine Duomo, Santa Maria Nuova's central

location made it the most accessible hospital of the early Republic, and by 1400 it was the city's largest and busiest facility of its kind. Run in close collaboration with the Camaldolese monks who resided in the adjacent monastery of Santa Maria degli Angeli, the hospital of Santa Maria Nuova retained close links with that center of culture and spirituality: its administrators acted as institutional procurators of goods and supplies for the monastery, the scriptorium operated by the monks designed and wrote the liturgical antiphonaries used in the hospital church during the first quarter of the fifteenth century, and when those manuscripts were ready to be painted the artist called upon to apply pigments to parchment was the monastery's most famous member, Don Lorenzo Monaco, who had left the cloister in the mid-1390s.[66]

Sometime during the last quarter of the fourteenth century, the modestly sized panel in a rounded lunette form was decorated with the image of the *Madonna Lactans* for an undisclosed setting inside the hospital of Santa Maria Nuova.[67] As was by now standard for this subject matter, the composition features a large image of the Virgin Mary seated on a pillow with a closed book beside her on the marbleized floor. Stretched across her lap appears the Christ child, draped in an ornate gold robe (which matches the gold gown worn by his mother), who reaches with both hands to squeeze the exposed right breast of the Virgin. Both protagonists face the viewer and while the infant's gaze meets ours, Mary's almond-shaped eyes look past us and over our left shoulder. Two sets of angels float above them on either side, while an apparition of God the Father emerges overhead to dispatch a dove of the Holy Spirit to Jesus. Virtues of humility, motherly love, and charity inform the image, as this Queen of Heaven deigns to nurse her own child (practically unheard of in fourteenth-century Florence, where wet-nursing was the norm at nearly all levels of society) without the luxury of the throne she so richly deserves.[68] Standing 162 × 90 centimeters and bearing no signs of alteration, the picture probably stood alone in its tabernacle setting, too narrow for an altar and too small to be seen from afar. But the intimacy of its size matches the intimacy of the scene, and we can well imagine that this *Madonna Lactans* was intended to greet viewers as they passed by it or as they entered into a small chamber, and acted as a reminder of the good works of charity that transpired inside the hospital of Santa Maria Nuova.[69]

The painting in Santa Maria Nuova was not the first *Madonna Lactans* to make its way into public realm during the second half of the fourteenth century. Its prototype seems to have been painted immediately beforehand, perhaps as late as the second half of the 1370s, and may be seen today in the Washington's National Gallery (Plate XIV). Attributed to Jacopo di Cione and his workshop, this picture of the *Madonna Lactans* is nearly identical to the one installed in Santa Maria Nuova, with the main difference between the two being the

superior level of quality inherent in the Washington picture.[70] Indeed, every-
thing about the picture matches perfectly with the latter hospital painting cur-
rently in the Accademia: the same white pillow supports the gold-clad Virgin,
whose right breast is similarly flattened by the identically over-stimulated infant
who stretches out in her lap. Two groups of angels again flank the central pair,
and the brown-haired figure of God the Father emerges in exactly the same
position to release exactly the same dove at exactly the same place near Mary's
head. Like the picture for Santa Maria Nuova, the expertly painted figures,
carefully stenciled fabrics, and intimate relationships suggest that this panel was
intended for close inspection, while its modest dimensions, white-lined lower
border and careful tool-work around the contours of the rounded arch at the
top indicate that the picture has not been reduced since its completion some-
time in the late 1370s. Its pristine condition, moreover, precludes a position of
honor in an outdoor setting, or at least one that might have exposed it to the
raw elements of the Florentine urban landscape. But in this picture, which is
some twenty-five centimeters smaller than the one in Santa Maria Nuova, the
faces of Mary and Jesus reveal a subtly of handling and an expertise of crafts-
manship that eluded the painter of that other *Madonna Lactans*. The Washing-
ton picture and its painter – perhaps Jacopo di Cione or someone very close to
him – inspired the painter and the patrons of the Florence picture rather than
the other way round.

The world of Florentine public art was essentially a copy-cat environment.
Popular pictures were seen freely and often by painters and patrons alike, and it
did not take a particularly astute student of current trends and tastes to know
what was considered a successful painting. It was no accident that the *Madonna
and Child* in the Wool Guild was a replica of the Alpha *Madonna of Orsan-
michele* in the building across the alley (Plate XXIII and Figure 19): it was no
mistake that street tabernacles came to play off the highly successful *Madonna
della Tromba* that literally everyone could see in the Mercato Vecchio: it was
perfectly understandable why the *Zecca Coronation* borrowed so heavily from
the same scene replicated in the mosaic over the entrance of the Duomo or
the ocular stained glass window in Santa Maria Novella's facade (Plates XVIII
and XXXIII). Things that worked were copied, and often they were copied
inside buildings that had similar functions or identities – especially when the
copier sought an elevated status and tried to achieve it through connections,
visual or otherwise, with the institution it emulated.

With this in mind, it makes sense to argue that the Accademia *Madonna Lac-
tans* was copied from the Washington version for the hospital of Santa Maria
Nuova not only because it was a beautiful and (quite probably) a popular pic-
ture, but because those who wished to have the copy executed had seen it in a
setting similar to the one in which they wished the copy to be seen. That is to

say, if the Florence *Madonna Lactans* was originally intended for a hospital, it is likely that the Washington *Madonna Lactans* was probably painted for a hospital, too.

The *Madonna Lactans* was not an uncommon picture in such settings: homeless pilgrims and terminally ill patients who made their way north from the center of town to seek the large hospital on Via San Gallo (founded by Bonifacio Lupi in 1377) first encountered a street tabernacle situated immediately in their path only one block before their destination – a fresco attributed to Andrea di Bonaiuto – that was dedicated to this very theme (Plate III). The picture of the child squeezing his mother's breast alerted the indigent and diseased, as well as mothers who might be in the process of delivering their unwanted children to the hospital, that they were approaching a place of healing and care, while reminding those in more comfortable positions of their obligations to those in need. In a different context the theme might have seemed unusual, as *Madonnas Lactans* were not commonly rendered in exterior spaces. Because of its proximity to the hospital on Via San Gallo it would have been considered an appropriate subject.

Because of its quality, state of preservation, and subject matter, it appears to this writer that the Washington *Madonna Lactans* may well have decorated the interior of a hospital or a charitable confraternity, just as its Florentine copy in the Accademia had. Indeed, its size, setting, and subject suggest that the intended audience of the *Madonna Lactans* included both the men and women who sought assistance inside. While male viewers surely would have recognized the values celebrated in this illustration of the Virgin deigning to nurse her own child, women would have identified with Mary's predicament personally and empathetically. The subject's focus on the charity and humility of the Virgin Mary spoke to both those who volunteered their time and money in homes for the sick and dying, both male and female, as well as to those actually in need of sustenance from a power greater than themselves.

Yet it may also have been painted and installed in a hospital setting for specific group of viewers. The overt emphasis on the Madonna nursing her child suggests it was originally intended to promote proper infant care, support the practice of wet-nursing that orphanages and hospitals supervised, and alert the general public to the availability of child care within their facilities. Women were likely the most important viewers of these pictures, for the moralistic and logistical messages provided by pictures of the *Madonna Lactans* addressed their concerns and needs directly and unflinchingly. The paintings of the nursing Virgin in the Accademia, the National Gallery, and tabernacle on Via San Gallo suggest that one segment of the public addressed by pictures commissioned by charitable confraternities were both the women who worked for the hospitals where they were installed and the women who depended on them to care for their children.

THE CURIOUS CASE OF THE *DOUBLE INTERCESSION*

In this vein, it is useful to look at the influence that some of these confraternity pictures had on contemporary painting in Florence during the latter years of the fourteenth century, and it is to the innovative pictures in the Company of the Misericordia that we can find an immediate connection. The combination of images inside the building facing the Duomo and Baptistery on the corner of the Piazza San Giovanni clearly impressed at least one family in need of a picture and at least one artist eager to expand upon the public pictures in the confraternity loggia. Sometime around the year 1400, members of the Pecori family commissioned and installed in a family chapel at the entrance wall of the cathedral a painting on canvas that defied traditional description (Plate XV). The chapel was unusually shallow in depth, while the function of the space – funereal, commemorative, or celebratory – is still inadequately understood. Moreover, the image produced for it was painted on a series of canvas strips of unusual dimensions (totaling 239 × 153 centimeters) that were sewn together rather crudely and in a format that suggests the picture was in part conceived as a good way to put to use valuable cloth sections that would otherwise be destined for the dust bin. Neither the painting nor its setting were "throw-aways," but neither were they traditional pictures or spaces – particularly at the public entrance and egress of the most important church in Florence. Given all of these unusual qualities, students of the picture have been challenged to attach to it a useful, descriptive title, and it now goes by the name, the *Double Intercession.*

The images on the canvas only enhance the mystery of the picture, its function, and its intended audience. The *Double Intercession*, now located in New York's Metropolitan Museum of Art, features a mélange of forms clearly descended from paintings on view just across the square in the Misericordia.[71] At the apex of the composition emerges an image of God the Father, not unlike the one painted by Nardo di Cione in fresco above Alberto Arnoldi's very public altarpiece inside the loggia and visible from the Via Adimari (Figure 31). God the Father gestures toward the lower left corner of the picture and releases from his hands the Dove of the Holy Spirit at the kneeling form of Christ, who in turn displays the wound in his side both to viewers of the painting and to the figures that appear in the picture across from him. There, in the lower right corner of the cloth painting, kneels the Madonna of Mercy, breast exposed and cloak extended to protect the lay supplicants who join her as she reveres her son. The picture, painted on canvas and bathed in blue (rather than the normative gold ground customarily used for liturgical pictures of the day), borrows formal elements from those processional banners used by flagellant and Laudesi companies at the turn of the fifteenth century. It also employs a narrative subject matter that reminds one of a large-scale fresco painting. The

line of movement from top right to bottom left to bottom right and back again creates a triangular viewing pattern that echoes the trio of deities in the composition.

But it is more than an image of the Trinity. Mary's exposed breast calls to mind the *Madonna Lactans* image that would have been so appropriate for the neighboring lay confraternity, charged with the care of orphans and unwanted infants. And the nurturing image of kneeling supplicants sheltered by the raised cloak of the Madonna clearly reflects the similar concept (although differing depiction) in the Sala d'Udienza of the building used by the Misericordia just across the piazza. Why was this entirely unique and utterly innovative image created for a shallow worship space that was, given its dimensions and location, accessible to the general public at the entrance wall of the Duomo?

An initial reaction to this large, unified composition creates an air of doubt for contemporary viewers. It bears neither the shape, format, nor technical properties of a standard Trecento gold-ground altarpiece on panel, and its subject is better suited for the wall of a hospital than a chapel in an urban cathedral. Contemporary descriptions of the Duomo do not elaborate on its exact placement in the Pecori chapel, but given the truncated dimensions of its side walls we may speculate that the *Double Intercession* was placed against the entrance of the Duomo looking out into the nave where the congregation could see it on their way out of the church.[72] As they passed it, these common viewers would have noted the overt references to sacrifice (Christ's open wound) and the virtue of charity (Mary's exposed breast) in the context of a devotional image (the kneeling lay worshippers) under the watchful eye of God the Father above. This allegory about the give and take of the religious relationship between deity and devotee was an excellent message to present to lay Florentines in the process of exiting the cathedral and returning to the streets of the city, where ideals of piety could easily slip into an oblivion promoted in an early modern capitalistic system. The picture was akin to a final exclamation point added by the clergy at the very end of the visitor's experience inside the cathedral to remind the congregation to adhere to the lessons they had just learned as they departed from the church and re-entered lay society.

And beyond the walls of the church, of course, lay the Piazza San Giovanni and, just to the side of it, the Company of the Misericordia – home of charity and virtue and civic piety in the extreme. The *Double Intercession* seems to have been derived formally from some of the pictures in the confraternity, which predated it, and the themes of collective responsibility for the well-being of all members of commune were echoed in the subjects of pictures in both the headquarters of the Misericordia and in the small chapel space by the front doors of the cathedral. The painting in the Pecori chapel could not be called a copy of any of them; but it was related to them thematically and stylistically in ways that made them natural cousins, if not siblings, in the family of pictures in

the very public spiritual heart of the city. It literally and figuratively connected to the picture and the people on the other side of the wall to which it was attached.

WE HAVE SEEN PICTURES FOR LAUDESI, PICTURES FOR FLAGELLANTS, and pictures for charitable confraternities. The members of each had similar impulses, and their desires to express their personal piety drove their financial, operational, and decorative decisions in familiar patterns. Yet the subjects preferred by these three different types of companies were not interchangeable, and in two cases were so distinctive as to create something of an identifiable *modus operandi*. Laudesi companies favored images of the Madonna enthroned, which provided them with pictorial representations of a worthy focus of their musical entreaties. With paintings of Mary in their oratories and on the piers reserved for them by local churches, the performance of the hymns of praise from which their name derived were dramatic in tenor and intimate in scope. Flagellant companies were more interested in images of Christ during the Passion, and for equally obvious reasons. Pictures of the betrayal, torture, and crucifixion provided useful tools for private meditation, justified the physical torments they endured, and featured scenes and characters they wanted to emulate during (and presumably after) their ritualistic meetings in confined quarters.

Charitable confraternities, finally, had more complicated tastes and their occasionally competing visual needs required careful consideration when artworks were commissioned. These groups had both a pious and civic function, and they requested images that addressed both their membership and the clients they serviced. These images were then installed in spaces that had both private and public uses. Their pictures illustrated uncommon subjects, recounted narratives that promoted specific deeds and concepts, and contained references to the city that they helped support through their charitable acts. All of these lay confraternities welcomed members and visitors from a wide demographic swath, and a good number of them included women within their ranks and catered to the needs of children on a daily basis. The viewing public of the images inside them was broad, continuous, and largely unpredictable, which in turn forced painters and their patrons to decide whether the next commission for the company would appease the tastes of those seeking the familiar or would, instead, foster excitement for a confraternity desirous of publicity. Pictures in lay confraternities, then, advertised and promoted the good works performed inside the facilities in which they were placed, and by extension celebrated the wealth of civil services they provided to the commune at large.

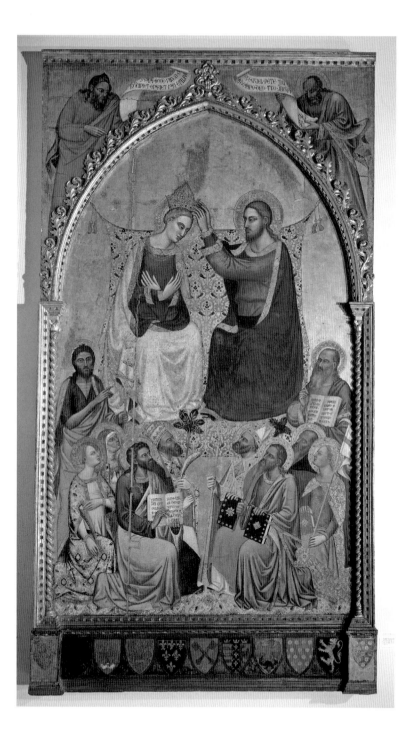

CHAPTER THREE

ART AND THE COMMUNE: POLITICS, PROPAGANDA, AND THE BUREAUCRATIC STATE

A LARGE, DAMAGED FRESCO PAINTED DURING THE SECOND QUARTER OF THE fourteenth century and attributed to the workshop of Giotto di Bondone puzzles today's visitors to the Bargello Museum (Plate XVI). Although framed by a familiar architectonic throne – complete with a gothic arch, fictive groin vaults, and colonnettes that end in spiked pinnacles at the top – the figures that occupy the elevated niche do not behave the way a Madonna and Child normally might. Neither figure addresses the viewer below it. Both extend their right arms diagonally, but in opposite directions, with the infant stooping to receive the gift offered by the headless form below him. Attending adults, their identities marred by surface damage to the picture, stand in vermilion robes, with a saintly advocate to the far left nudging the lily-bearing donor in red forward toward the Virgin. Children flood the composition's base, with those at the left clutching symbols of the city's six districts: the wheel of San Pier Scheraggio, the baptistery of San Giovanni, the keys of San Pier Maggiore, the goat of the Borgo, the lion's paw of San Pancrazio, and the bridge of the Ponte Vecchio. To the right, a white-clad child turns its back to us, while a woman in black kneels with left hand and fingers extended. All of these figures, clearly symbolic of the regions and citizens of the city, frame the central act of donation, whereby the standing adults hand to the holy couple the most precious gifts that the commune could offer: the lily, a reference to Florence's devotion to the Virgin Mary, and the red heart of charity, a reminder of Christ's selflessness and the city's support of the institutions that succored the needy,

fed the hungry, and cared for foundlings. While the imposing fresco, which stands some 395 centimeters tall, suggests a prominent placement that accommodated a fairly distant viewership, no pictorial references within the image help us understand its original setting.[1] In fact, the location of its first home still evades us, although the overtly political quality of its iconography suggests that the *Enthroned Madonna with Symbols of Florence* once decorated a prominently featured site in the city center. The painting clearly united the concerns of the commune with the spiritual interests of its citizens, but we have no way of knowing who saw it, where they encountered it, or how the context of its setting informed their understanding of the imagery. All of these things matter when considering public paintings in political places.

Paintings carried great weight in fourteenth-century Florence. They gazed down at pedestrians from street corners, performed miracles in tabernacles, and promoted the virtues of the city's charitable institutions. But the importance of these pictures was not lost on the communal government either, for coinciding with the birth of the republic at the end of the thirteenth century came the employment of artists on behalf of the state, followed by the crafting of official policies that informed contemporary artistic responses to matters of public security, both mundane and extreme.

Just as confraternity halls contained pictures that promoted services to residents and street Madonnas protected the safety and security of individuals from hundreds of settings, political pictures delivered their messages from specific sites in the city: at the city gates; in and on the Palazzo del Podestà (known today as the Bargello); inside the Palazzo della Signoria; and occasionally in buildings that served as branches of the communal government, like the debtor's prison (Stinche), the mint (Zecca) and offices of civic security – the Executor of the Ordinances of Justice, the Office of the Night, and the Onestà. These buildings were located in the neighborhood that ringed the Piazza della Signoria and, thus, were conjoined in a fairly tight nexus of the city. Ultimately, these buildings and the images inside (and on) them came to symbolize both the good things the republic had to offer its citizens and the bad things that might threaten them without their due vigilance.

Perhaps the most public of those pictures that contained a purely civic or politically charged message were applied to the exterior walls of the Palazzo del Podestà, the very symbol of Florentine security. Designed and constructed on the Via Ghibellina in the middle of the thirteenth century, the facility functioned in a variety of ways. As an administrative center, the building served as the main office of the Capitano del Popolo, who was entrusted with keeping the peace in Florence both by apprehending criminals and sniffing out treasonous plots before they took hold. Constables stationed there investigated crimes and brought suspects back to the palace for interment. Trials were conducted, judgments rendered, and punishments meted out. Those convicted of

crimes against property (including bankruptcy) or of acts of simple assault were jailed for a period of time commensurate with the crime: fines, prison terms, and forms of public humiliation were the norm. But those found guilty of murder, high treason, or blasphemy, as we have seen, could be sentenced to death by magistrates who heard cases and rendered decisions from within the walls of the Palazzo del Podestà. The condemned rarely spent much time awaiting their fate there, and most were executed within only a few days of sentencing – and some within only a few hours. Images were used to prepare them for the next life that awaited them.

Criminals could be convicted of capital crimes *in absentia*, an avenue taken with some frequency. When the guilty fled their homes before justice could be served, Italian communes saw to it that villains paid their debts to society in a variety of ways, including public reprimand, the confiscation of property or, worst of all, exile. In extreme cases, the guilty were also punished by having their likenesses painted on public spaces in so-called *pitture infamante*, or pictures of infamy, which were affixed to the walls of any number of official buildings in such a way as to be seen by anyone (and everyone) who chanced to walk past them during their daily travels. For many of those depicted *in absentia*, this was a crippling form of punishment that could damage the reputations of extended family members, cast a showdown of humiliation over one's legacy, and hinder (if not destroy altogether) the guilty's ability to pursue commercial and political interests. The *pittura infamante*, in fact, was a frequent and effective penalty that added to the genre of public painting a distinctly ominous flavor.

The *pittura infamante* came in many different forms, but usually revolved around likenesses of the guilty with various symbolic attributes attached to them that specified the nature of their crimes. Serpents, miters (the medieval equivalent of a dunce cap), demons, monsters, or the scales of justice often accompanied the defamed.[2] In 1308 Carlo Ternibili d'Amelia, a former Podestà, was depicted on the city gates and the walls of the Palazzo del Podestà wearing a miter and holding the seal of Florence that he had tried to steal.[3] In 1377 Ridolfo Varano, a mercenary captain who had switched sides during the controversial War of the Eight Saints, was depicted on the Bargello's facade hanging upside down by his left foot while giving the finger to the Church and the commune: he, too, wore a miter and clutched a snake in his hands.[4] Bonaccorso di Lapo Giovanni, another traitor to the Florentine cause (this time transferring allegiances to Visconti-led Milan in 1388), was painted on the exterior of the Palace of the Executor of the Ordinances of Justice donning a miter, holding a basilisk, and wearing an iron collar that was attached to a leash pulled by a demon. He was accompanied by a She-Wolf and a pig, and was identified by an inscription that proclaimed: "Arrogant, avaricious, traitor, liar, lustful, thankless, full of deceits: I am Bonaccorso di Lapo Giovanni."[5] The subjects of these characters, and others like them that appeared on the walls of government-operated

buildings in cities all across Italy, considered such depictions the ultimate humil-iation. In some ways they were more harmful to them than the fines, confis-cations, and jail sentences to which they were also subjected.

With only one exception (a fresco dedicated to Walter of Brienne's tyranny), every picture of infamy produced in Florence during the thirteenth and four-teenth centuries was white washed within a few years of completion. The debts accumulated by the bankrupt were forgiven or forgotten. The treachery of traitors was overshadowed by more recent acts of betrayal. And sometimes the guilty were absolved of their crimes entirely and freed not only from phys-ical or financial penalty but from the shame of the *pittura infamante*, as well. For most, the humiliation lasted but a few years and then faded into oblivion.

The *pittura infamante* was, in fact, a relatively new form of punishment in the European criminal justice system of the thirteenth century, and it was imme-diately considered an extremely effective one. References to pictures of the condemned appear in Parma, where a statute recommending their implemen-tation was considered in 1255 and approved in 1261, Bologna (by far the most frequent user of the *pittura infamante*) during the 1280s, and Florence in the 1290s.[6] By 1303 this kind of defamation of character had become common in many Italian cities, with some surprising consequences. Painters, it seems, were not at all interested in producing these pictures of the infamous, due probably to fears of being associated somehow to those they were charged to repre-sent. In 1292 an artist named Fino di Tedaldi was forced to produce images of Ghibellines defeated at the Battle of Campaldino, a service for which he received the paltry sum of twelve lire: they were affixed to the entrance wall of the Palazzo del Podestà, clearly the locus of this form of public humili-ation, and were also featured prominently over the bench used by judges as they considered cases brought before them.[7] Vasari tells us that in 1344 Stefano di Giottino initially refused the commune's offer to depict the hated Walter of Brienne (known as the Duke of Athens) and his henchmen on the afore-mentioned tower of the Palazzo del Podestà, and was persuaded to change his mind only by the entreaties of no less a figure than Angelo Acciaiuoli, the Bishop of Florence.[8] Their concerns appear to have been justified: in Bologna, it was not uncommon for the painters of *pitture infamanti* to be included among the criminal element, and David Freedberg has noted the astounding statistic that, "of the 112 paintings of criminals between 1274 and 1303, 59 were done by painters accused of attempted homicide."[9] The task of producing repre-sentations of enemies of the state was considered just as humiliating as being depicted as one. It is no wonder that Fino di Tedaldi was "forced" to paint effigies of Ghibellines on the walls of the Bargello in 1292, and no surprise that Vasari imagined the painter of the Duke of Athens to have shown reluctance when asked to perform the task for the commune in 1344. No one sought to be associated with the worst elements of society, no matter the context.

The Palazzo del Podestà was a place for criminals and their keepers, and the images inside and outside the facility spoke of the rough and tumble nature of the place. More than just a jail for enemies of the state, the Bargello served as the commune's palace of execution, for those condemned to die for their transgressions usually ended an urban Walk of Shame by entering into the former Palace of the Podestà, spending a sleepless night considering their fates, and then processing through the streets of Florence on the way to the Porta alla Croce where they could expect to meet their maker courtesy of the business end of a hang man's noose or executioner's blade. In addition to pictures of the condemned, this penal facility contained two extensive and intimidating decorative programs clearly intended to reprimand enemies of the state and to warn citizens to be on their guard for those who might join their ranks. Both were attributed by Ghiberti and Vasari to the hand of Giotto. The first was a fresco inside the main hall on the second floor of the building where law enforcement personnel conducted their business. Ghiberti, as was his custom, tersely noted that Giotto was responsible for a painting there of "the city as it is robbed" ("el comune come era rubato") without any further comment or description.[10] Vasari expanded on Ghiberti's rather dry observation, despite the fact that the fresco had already faded well beyond recognition by the time of the publication of the first edition of *Le Vite* in 1550.[11]

Although we cannot describe with any certainty this fresco's exact format or even its specific subject matter, we can infer from Vasari's brief passage that the painting revolved around an allegorical representation of a seated figure and four attendants besieged by assailants. Given their distinctive uses of identical characters and concepts, we may further speculate that Giotto's painting on the walls of the Palazzo del Podestà served as the template for both the *Judgment of Brutus* that, as we shall soon see, decorated the Sala d'Udienza in the Florentine the Wool Guild and Ambrogio Lorenzetti's *Allegory of Good Government* in Siena, where the appetites of the scurrilous and the vigilance required of the righteous were so well articulated (Plate XXIV and Figure 60).

The opposite side of the palazzo's *piano nobile* contained a more extensive program of images, also attributed to Giotto workshop and probably painted sometime between 1321 and 1337, that addressed basic themes of importance inside the communal police station.[12] Inside the Magdalene Chapel, used primarily by condemned prisoners on the eve of their executions, appeared frescoes that contained one of the least subtle appeals to sinners of the period. The east and west walls bore, respectively, scenes of *Paradise* and *Hell*, with the latter image placed directly above the door through which viewers processed as they left the space (Figures 37 and 38). The north and south walls alternately bore narrative moments from the lives of Mary Magdalene – the bad girl turned good – and John the Baptist, patron saint of Florence. These paintings have suffered mightily over time, and only snippets survive for our

37. Workshop of Giotto, Chapel of the Magdalene with *Last Judgment*, ca. 1321, Museo Nazionale del Bargello, Florence. Photograph courtesy Gabinetto Fotografico del Polo Museale Regionale della Toscana.

inspection. Both cycles focused on well-known scenes from their hagiographies: the *Noli me Tangere* and *Penitent Magdalene in the Wilderness* appeared on the south wall, along with additional paintings of the naked hermit before her confessors. Opposite these paintings, on the north wall, stood images from the life of Florence's patron saint, including the scene of the *Dance of Salome*, complete with John's severed head presented to Herod on a silver platter. With decapitation a likely punishment awaiting the condemned, this grim scene surely resonated as he considered his fate. However, the scenes of the penitent Magdalene across the way promised him forgiveness for his sins in return for sincere contrition: the sins of penitents were always absolved by God.[13] Repentance was here demanded of them, and was demanded of them for their own good.

Connecting these icons of communal patriotism and antisocial evil were images on the east and west walls, which detailed a vision of the *Last Judgment* that, by 1320, had become fairly standard in monumental art all across Europe. On the east wall, where the altar was located, prisoners contemplated a serene

38. Workshop of Giotto, Chapel of the Magdalene with *Hell*, ca. 1321, Museo Nazionale del Bargello, Florence. Photograph courtesy Gabinetto Fotografico del Polo Museale Regionale della Toscana.

collection of saved souls congregating beneath an enthroned Redeemer. With the exceptions of two kneeling men who cast their eyes skyward, the multitude of penitential adherents stand in rows that stack one upon the other to the very top of the lunette wall. The west wall, through which prisoners passed into the main rooms of the prison complex, bears remnants of an image of hell, based in large part on the similar scene on the entrance wall of the Scrovegni Chapel painted by Giotto in Padua some twenty years earlier. Barely visible today, we can still see the outlines of Satan, his attendant beasts, and a collection of tormented souls destined to spend eternity in an endless cycle of pain and suffering. With a full two-thirds of the composition largely obliterated, a thorough analysis eludes us. Still, the mere directional focus of the frescoes in this room alerts us to its function and, most probably, to its reception by common viewers unfortunate enough to form the cycle's audience. With the Redeemer presiding over the saved at the altar and the damned condemned to the ravages of hell at the exit, prisoners contemplating the next phase of existence saw their alternatives laid out plainly before them – and then passed

beneath the most horrifying of the two options as they exited the chapel to begin the slow march through the city streets, past the *Madonna della Tromba*, and on to the gallows.

Paintings in the Palazzo del Podestà focused on crimes and the criminals who committed them, and they were probably seen only by a limited number of viewers who did not live long enough to describe them to acquaintances. But this center of law and order was not the only official structure that contained images of symbolic importance for the local populace. In fact, few buildings in Florence held as much power in the imaginations of fourteenth-century residents as the Palazzo dei Priori, also known as the Palazzo della Signoria and, later, the Palazzo Vecchio. Initiated in 1298 and completed during the first years of the fourteenth century, the trapezoidal government hall was situated near the Arno River on the site of former Ghibelline palaces that had been razed to the ground in the late thirteenth century. This was the seat of the republican government, the place where the names of six (and, later, eight) guildsmen were selected from a larger group of candidates nominated by their peers. This was where councils of advisors great and small gathered to impart their wisdom to those priors, many of whom had only limited political experience. And this was where the early modern Republic struggled to maintain control of the city through a limited oligarchy, that expanded in the 1340s to include "new men" who did not enjoy the status of lineage or family name, and that later developed in the 1380s and 1390s into a bureaucratic commune administered by professional clerks who collected money and enforced policies. Many of these governmental figures worked in the Palazzo della Signoria, but many others performed their civic duty by handling daily tasks from offices located in official buildings scattered across the city. Despite the expansion of this bureaucratic presence from one end of Florence to the other, it was still the Palazzo dei Priori that retained its status as the symbol of the commune's republican liberty and unity.

This large, labyrinthine structure was partitioned into spaces large and small. The priors worshipped in intimate chapels during their two-month terms of sequestration. Ad hoc advisory councils (the *balìe*) gathered in rooms of larger proportions to debate the issues or problems that had caused them to be named to these bodies. Larger collections of residents congregated in its great halls to make their feelings known and have their petitions heard. Pictures were installed over doorways leading from one space to another, and devotional images adorned sacred spaces that appear to have been used more for meditational purposes than liturgical ones. Frescoes arranged as components of large pictorial programs appeared on walls of conference rooms. Nearly all of them are lost.

The oldest painting reputed to have been installed in the Palazzo dei Priori was produced by Giotto di Bondone sometime during the second half of the

1320s.[14] Representing the features of the city's *podestà*, Duke Charles of Cal-abria, the portrait enjoyed only a brief moment of artistic shelf-life. After his two-year appointment, the city endured a brief moment of hardship and the office (and officeholder) of the *podestà* was discredited. In 1329 a new policy severely restricted the types of decorations allowed inside the palace, with a prohibition placed on the representation of all living political figures (except for coats of arms of the pope, the King of France, or the family of Charles of Anjou).[15] Giotto's portrait seems to have disappeared then, with nary a hint of praise from his legion of admirers nor emulation from his legion of followers.

A second picture, produced for the palace's Chapel of Saint Bernard, endured for a much longer period. The panel adorned an altar there, and probably fea-tured an image of the twelfth-century Cistercian visionary; but its exact format has never been determined. Bernard was clearly an important character inside the halls of the palace, as official meetings were opened with the reading of his sermons and his legacy as an advocate for diplomacy was lauded in chambers. The most dramatic event from the saint's legend was his vision of the Vir-gin Mary, an episode illustrated in the beautiful painting now in the Florence Accademia, and there is a distinct possibility that the picture in the govern-mental palace represented or referred to this same scene. The picture stayed in the Chapel of Saint Bernard until 1432 when it was removed for cleaning, but it was never returned to the building and its ultimate destination was left uncharted.[16]

Other paintings of saints, heroes, and role models were produced for the Palazzo dei Priori during the fourteenth century. A picture of Saint Christo-pher, patron saint of accident victims, adorned the ground floor landing of the main staircase. It could not have protected the priors from liability, but at least those who tumbled down the stairs could be comforted by the presence of a sympathetic saint. In 1385 a painter was paid for a picture he produced for the Audience Chamber on the *piano nobile*, which featured the image of the *Incredulity of Saint Thomas* – probably not unlike the one painted for the Mercanzia forty years later by Giovanni Toscani (Figure 39). Franco Sacchetti's inscription next to the image urged the priors-elect to be open-minded in their deliberations and to "touch the truth" when considering evidence and arguments.[17] And the themes tied to both these images, those of wisdom and accidental incident, were conflated in a representation of the *Wheel of Fortune* in the Room of the Priors, where the Signoria were reminded that luck could run hot and cold, and that the same hands of fate that delivered them into the Palazzo dei Priori could just as easily remove them.[18]

Perhaps the most thoroughly decorated space in the entire structure was the Saletta, located on the second floor and accessible to the priors, advisors, and bureaucrats who effectively ran the communal government. According to contemporary descriptions, the room was extensively decorated with a series of frescoes that depicted single effigies of *uomini famosi*, based largely on the main

protagonists of Petrarch's *De viris illustribus*.[19] The cast of characters celebrated there now seems familiar to us: Junius Brutus was painted here, as were Scipio Africanus, Hannibal, Julius Caesar, and Octavian Augustus. Cicero, Cato, and Constantine were also honored in the Saletta, as were the five great Tuscan poets of fame – Dante, Petrach, Boccaccio, Claudian, and Zenobi da Strada – similarly celebrated in frescoes produced at roughly the same time in the guild residence of the Judges and Notaries. Painted sometime during the middle years of the 1390s, each figure was identified by a Latin inscription, written in verse by no less a figure than Coluccio Salutati, the Chancellor of Florence and early practitioner of civic humanism.[20] Salutati, who had only recently written a letter to the pope seeking official recognition for the miraculous powers of the *Madonna of Orsanmichele*, was obviously very much concerned with the place of images in late-fourteenth-century society, and expended ample time and thought designing strategies to elevate the status and appearance of pictures produced for civic purposes in republican Florence. In this he was surely not alone, for the main protagonists of the cycle of Famous Men in the Saletta, along with that of Saint Thomas in the Audience Hall, caught the attention of other corporate patrons and audiences.

Allusions and references to images located in other places (but used by the same people who frequented a variety of public spaces) became a vital consideration when designing public art in the city. The now-lost picture of the *Incredulity of Saint Thomas* may well have influenced the panel of the identical subject that appeared inside the Hall of the Mercanzia, or the Merchants' Court, sometime around 1420 (Figure 39). Located on the same piazza as the town hall, the Mercanzia claimed affiliation with the commune pictorially, as this intentional repetition of forms called to mind the picture that some of its elite clients knew and recognized from the neighboring governmental center. The commune, meanwhile, emphasized its links to a guild structure that sent into its official chambers the representatives charged with the responsibility of setting policies and asserting their authority for the good of Florence. A web of connections reminded viewers of the overlaps in their social matrix, of the common interests that bound the commune together with the social, economic, and religious interests of its constituents, and of the sense of unity and harmony that those in power wished to communicate both internally and externally at the end of the fourteenth century.

THE *EXPULSION OF THE DUKE OF ATHENS*

An example of this kind of associative approach to political imagery could be found inside the famous debtor's prison, called the Stinche, located just to the east of the Palazzo del Podestà on the Via Ghibellina. Inside this jail, perhaps installed within a tabernacle that decorated a small courtyard just inside the

39. Giovanni Toscani, *Incredulity of Saint Thomas*, ca. 1420, Accademia, Florence. Photograph courtesy Scala/Art Resource, New York.

main entrance, appeared the so-called *Expulsion of the Duke of Athens*, probably produced during the middle years of the 1340s by an artist whose identity is still debated (Plate XVII). The painting stands as both an exceptionally original composition detailing important events of a moment of contemporary history and an image deeply indebted to an earlier painting similarly dedicated to the theme of the betrayal of the public trust.

The saga of Walter of Brienne's tumultuous ten-month tenure as Podestà for Life is well known to students of late medieval Florentine history. Marred by a series of policy decisions and personality clashes that caused both elites and laborers to rise up against him, the Duke of Athens managed to lose the support of nearly every corporate group in the city in a remarkably short time.[21] The establishment of new taxes to swell empty civic coffers, the

heavy-handed imposition of punishments on debtors, and a clumsy attempt to promote the independence and power of the disenfranchised at the expense of the entrenched establishment (whose support he needed for political survival) combined to make Walter's term a blueprint for failure. Most damning of all was the Duke's ill-advised attempt to alter the composition of the Wool Guild by permitting a splinter organization to break away from its parent corporation and form its own guild, a disastrous move that had far-reaching ramifications, as we shall soon see.

After this series of political missteps, influential members of the Florentine elite conspired to eject Walter of Brienne from his post as podestà. Mobs formed in the Piazza della Signoria on July 26, and for two weeks rebels surrounded him and his guards inside the palace. On August 8, the tyrant was expelled and his lieutenants executed, thus ending the Duke's autocratic rule. With his departure came a return to the republican system of elections, selections, and governance that had been abandoned when the Duke of Athens had arrived in Florence in September 1342, albeit with some alterations to promote greater representation across the city's population.[22]

The fresco of the *Expulsion of the Duke of Athens* clearly refers directly and allegorically to Walter's demise. Sharing the core of the image sits the majestic figure of Saint Anne, on whose feast day the dramatic siege began, alongside an admirably accurate representation of the site of the people's revolt, the Palazzo della Signoria. These two characters (for, indeed, the building is a player in this drama) face outwardly in opposite directions: whereas the governmental palace faces to the right, Anne looks to the composition's left, reaching toward a banner bearing the red cross of Saint George, held by one of a number of armed soldiers who kneel before her in veneration. Perhaps a reference to an actual event, the standards may represent one of Walter's most egregious transgressions, that of allowing members of a newly formed guild, the dyers (who had splintered off from a now-irate Wool Guild only a few months earlier), to carry official processional banners during the festivities of June 24, the feast day of Saint John the Baptist. One wonders whether the artist here actually shows Anne returning this banner to its rightful owner, for within weeks of Walter's ouster the fledgling Dyers' Guild was suppressed and merged back into the Arte della Lana.

Paired with Anne is the famous Palazzo della Signoria, the seat of Florentine government in 1343, turned away from the Virgin's mother so as to suggest that it is from this structure that the Duke of Athens flees. Walter moves from the front door of the palace and across the empty throne he has just vacated, chased by the apparition of a winged figure (perhaps the virtue of Constancy, perhaps that of Fortitude) who swoops into the scene from the center, holding in its hand a column as a representation of stability.[23] The tyrant caresses in his hands a reptilian beast with a scorpion's tail and a man's head, interpreted by Roger Crum and David Wilkins as a reference to Gerione, symbol of fraud

and betrayal popularized by Dante in *Inferno* 17:1–13.[24] Littering the ground at Walter's feet appear symbols of his tyrannical rule: a snapped sword, a codex (presumably of laws and statutes), and the scales of justice rent apart at the core. His malevolent reign has now ended, and all of Florence is the better for it.

This painting of Walter of Brienne was not the only reference to the banished tyrant. At roughly the same time that the *Expulsion* was added to the Stinche's interior, a more openly hostile picture of the Duke's rapacious political appetites appeared in or on the main tower of the nearby Palazzo del Podestà, adjacent to the Stinche prison. The painting in the tower, so Vasari tells us, showed the Duke of Athens receiving as a gift from one of his six henchmen no less an item than the Palazzo della Signoria itself, the seat of political power and the symbol of Florentine civic pride.[25] Each of Walter's six henchmen appeared in a frontal pose, standing above his coat of arms and wearing on his head the miter of condemnation and humiliation.[26] Within this group stood Ser Ranieri da San Gimignano who, in 1342, had helped Walter of Brienne occupy the Palazzo dei Priori during the latter's bid to wrestle power from the commune. The painting on the Bargello's walls referred to this act of deceit overtly, as Ranieri held in his hands a miniature Palace of the Priors and offered it to the Duke as a gift. Below them were inscribed verses of condemnation, including one that was recorded in a contemporary *ricordanza*:

> Avaricious, treacherous, and then cruel
> Lustful, unjust, and false
> Never did he hold his state secure.[27]

Giovanni Villani commented on the figures depicted in it, as well as the acts that landed them spots in the composition, and the picture was considered so damning that it was briefly covered in 1394 during the visit of the Duke of Bari, a kinsman of Walter's, to avoid offending him.[28] For more than two hundred years, this reminder of usurpation confronted visitors to the Palazzo del Podestà. Walter of Brienne's status as the most reviled villain of Republican Florence did not wane for centuries, until well into the time of the Medicean principate.

Traditional evaluations of the lost fresco in the Palazzo del Podestà and the one that has survived from the Stinche agree that the motive for this picture was to produce a *pittura infamanta* to inspire public disapproval.[29] Giovanni Villani, writing about the image before his death in 1348, recognized its merit as an instructional picture, but also acknowledged the sting of its content: "The picture was met with disapproval by intellectuals, for it illustrated the defects and shame of our commune, brought upon us by our lord (the Duke of Athens)."[30] Villani was both humbled by the experience of suffering under the contemptuous reign of Walter of Brienne and proud of the courage his countrymen displayed by expelling the tyrant from their midst. Indeed, by recalling so vividly the failed reign of a political criminal, the *Expulsion of the*

Duke of Athens reminded Florentines of the suffering they had endured at his hands and celebrated their good fortune that Walter of Brienne was no longer in their midst.

Yet perhaps another layer of meaning was added to this picture (and the one in the Bargello) by the artist who painted it years after the events of July 1343.

The Florentine penitentiary system had been associated with enemies of the commune since the first prison had been constructed in 1293 on the grounds once owned by the infamous Uberti family, well-known supporters of the Ghibelline cause.[31] Originally constructed to hold magnates and violent offenders, the prison was soon outgrown by the number of inmates, which grew dramatically during the bitter years of internal disputes that marked the first decade of the fourteenth century. By 1308 the old prison was abandoned and new one built in its place, just down the road from the Palazzo del Podestà.[32] This new trapezoidal structure soon came to be known as the "Stinche" for political reasons: the term referred to the cliffs in the Val di Greve upon which was located the rural castle owned and operated by the Cavalcanti family, know supporters of the Ghibelline cause.[33] The name of the prison recalled quite vividly the territory occupied by the commune's most hated rivals, and a sentence in the Stinche came to be understood simultaneously as a symbolic banishment from Guelph society and a forced allegiance with the most dangerous agents of discontent imaginable in Florence. Just as the Palazzo della Signoria was interpreted as a symbol of victory over Ghibelline oppression, the Stinche bore the imprint of a symbol of the treachery that still festered within the city walls. Those debtors, ruffians, murderers, and traitors condemned to its cells were clearly connected to this foul condition at the very least through guilt by association.[34]

No contemporary sources from (or descriptions of) the Stinche prison refer to the fresco of the *Expulsion of the Duke of Athens*. We therefore cannot say with certainly where the image was installed or how and who saw the picture when it was produced. But in 1834, P. I. Fraticelli described an image inside the prison that, although misinterpreted, provides a reasonable starting point for a consideration of audience. At the opening of the fifth chapter of his book, Fraticelli noted that inside the small courtyard just beyond the only entrance to the prison was placed a tabernacle that contained a painting inside it. The image, he wrote, depicted Saint Reparata brandishing the banner of the Florentine militia, which was in turn used to chase away certain foreigners.[35] This vague and poorly articulated description hampers our ability to say with certainty that it was the *Expulsion* he had in mind when he wrote his lines: there was a reason for this, as Fraticelli (to his credit) confessed that he had not actually seen the painting under discussion, for the fresco was covered for its own protection as the Stinche was nearing demolition in 1834.[36] The misattribution of the central figure notwithstanding, Fraticelli's description of the image and its placement in the courtyard on the ground floor of the prison actually

approximates the subject matter of the fresco, and the condition and size of the image – at 290 × 260 centimeters it was almost three meters high – suggests that it was made to be seen in an exterior setting. If the *Expulsion of the Duke Athens* was, in fact, the painting inside that tabernacle, then we may say with some certainty that the intended audiences of this picture were the inmates who resided within the dank and dangerous prison, as well as those friends and family members who came to visit them.

Crucial to our understanding of this image is our consideration of the audience for whom the fresco was originally intended. While law-abiding citizens – like Giovanni Villani – obviously had an opportunity to see this illustration of Anne's intervention on their behalf, it is equally true that the majority of viewers confronting the pictures in the Bargello and the Stinche were debtors, death-row prisoners, foreigners captured on the battlefield, or Florentine traitors incarcerated for acts of treason (an estimated two thousand Pisans were housed in this single, dark building in 1364 after surrendering at the battle of Cascina).[37] They were also both men and women, as female criminals occupied cells in a women's ward within the facility.[38] Why would the commune spend money on paintings that offered not redemption for these enemies of the state, but an expression of national pride and power that, particularly in the case of prisoners of war, would probably be met with outright contempt?

The fresco in the Stinche was not crafted entirely from whole cloth. Ironically, the painter of this highly charged moment from Florentine history unquestionably used as his model one of the pictures decorating the Audience Hall inside the political seat of the city of Siena, the traditional arch-rival of Florence. This famous picture, the *Allegory of Good and Bad Government*, was completed in 1339 by Ambrogio Lorenzetti and stands today as the most famous example of secular painting from the fourteenth century (Figure 40). Even casual admirers of Italian art know the remarkably innovative images appearing in the Palazzo Pubblico: amateurs and specialists alike can describe from memory the unprecedented depiction of a fourteenth-century city at work, the imaginative representation of the virtues of a just republican government expressed allegorically, and the similarly inventive depiction of tyranny that stands as an ominous warning of the perils of Bad Government. Lorenzetti's innovations, in fact, appear to have been recognized almost as soon as the cycle was completed, for the last of his three allegories influenced the painter of the *Expulsion of the Duke of Athens* both thematically and compositionally.

If the picture in the Stinche may be read as an allegory instead of (or, at least, in addition to) an illustration of an historical event, then the picture for the prisoners viewing this image may be understood to convey specific messages that detoured from the traditional *Pittura infamata* interpretation. For here we have the Florentine version of Siena's condemnation of Bad Government, produced not only from an intellectual or philosophical perspective, but from one of actual experience. Whereas Ambrogio Lorenzetti places

the figure of Bad Government on a throne, with virtues bound and gagged by armed guards (who go on to burn and loot the adjoining countryside), the painter of the picture in the Stinche shows an actual Florentine encounter with this form of Tyranny. But unlike the Sienese version, this Florentine one proudly demonstrates the reactions of its citizens when Bad Government has been imposed upon them: rather than simply depict a fanged and horned character wielding power unjustly, the Stinche picture illustrates the responses of the city to oppressors who dare offend it. The evil villain gets his just desserts in the Florentine picture, as the wrath of God expels Tyranny from his ill-gotten throne, while the muscle-power of the state prepares to secure the city for the good once the banishment has been completed. The *Expulsion of the Duke of Athens* stood as a metaphor for the commune's response to all crimes committed against it, and thus both justified its incarceration of the criminal element confined within the Stinche and warned them (and their visitors) that the same fate awaited all others who might foolishly wish to replicate their crimes against Florence. The scene of Saint Anne and Walter of Brienne became the vehicle through which the city's most dangerous elements were warned of the commune's extended and eternal power. Whereas the Madonna in the street modified behavior by providing viewers with an exemplum, the fresco in the Stinche modified it through the shaming and intimidation of its audience.

The same concepts were also imbedded in the now-lost Bargello fresco, as Walter's despotism was symbolized by the gifting to him of the Palazzo della Signoria, while treasonous families were implicated in this betrayal by the appearance of their family crests below. These were not necessarily illustrations of specific events (as far as we know, Walter did not make the palace an armed camp until he was forced to on July 26, 1343), but were rather allegorical references to the Duke's character, aims, crimes, and punishment. Whereas Ambrogio Lorenzetti's *Allegory of Bad Government* merely described the face of despotism and warned Sienese viewers to beware of it should they encounter it, the pictures in the Bargello and the Stinche proudly announced that the Florentines had already seen this face and had done what was necessary to destroy it. The fact that the audience for the fresco comprised those who wished to promote such Tyranny made this allegorical reading all the more satisfying for Florentines who wished to make very clear to these special viewers that their efforts would forever be in vain. As an allegory and as a history painting, the *Expulsion of the Duke of Athens* was an appropriate decoration for the Stinche long after the memory of Walter of Brienne's crimes against the city had been forgotten.

While the historical element of political pictures was surely present, painters and civic patrons were smart enough to know that the collective memories of the viewing public were quite short: generic, thematic allegories were a much more effective way to teach lessons in civics than were accounts of battles

40. Ambrogio Lorenzetti, *Allegory of Bad Government*, 1339, Palazzo Pubblico, Siena. Photograph courtesy Scala/Art Resource, New York.

fought and won long ago. The *Expulsion of the Duke of Athens* surely alludes to the specific events of the summer of 1343, but was also painted as a teaching tool in ways to address a specific audience more generally. And this adds another layer of sophistication to the uses and interpretations of public pictures in fourteenth-century Florence: not only did they control behaviors on city streets, work miracles for the desperate, and advance the interests of economic entities; they also punished villains and promoted heroes from the walls of administrative centers where the commune's most important decisions were crafted and where its most controversial actions were taken.

A PICTURE FOR THE FLORENTINE MINT

As the city's greatest economic and political institutions consolidated their power, corporate bodies gradually expended their resources on the artistic decoration of headquarters, meeting halls, and judicial palaces. Paintings produced for these institutions regularly invoked the protection and patronage of religious figures, thus blurring the lines between sacred images in ecclesiastical centers and civic objects installed in buildings used by guilds, confraternities, and governments. Few of them remain, of course, as the interests and issues

driving Florentine affairs evolved as the city shifted from an independent, communal republic to an autocratic, territorial duchy, and then from a duchy to a province within a united Italian nation-state. But one picture does survive from our period that gives an indication of the type of painting that a fourteenth-century viewer may have seen upon entering into a bureaucratic office maintained by the early republican government.

The *Coronation of the Virgin*, originally produced for the administrative office of the Florentine Mint (the Zecca) and now located on the ground floor of the Florentine Accademia (Plate XVIII), incorporated specific visual references pertaining to the responsibilities and actions of the members of the Mint, trumpeted the importance of the institution in Florentine affairs, and intentionally employed images and themes found in some of the city's most important buildings. The so-called *Zecca Coronation* located the Mint at the very nexus of the secular state by using an array of themes commonly found in religious paintings of the day, thus using sacred imagery to demonstrate its secular importance.

Located diagonally across from the Palazzo della Signoria, the front door of the Mint stood barely fifty meters from that of the governmental palace, which in turn was on the same piazza as the guilds of the Bankers and the Cloth Merchants, as well as the newly constructed judicial palace of the Mercanzia (operated by the city's major guilds).[39] As in any treasury department, the people working in the Mint analyzed economic data, debated fiscal policy, set exchange rates, and monitored the production and use of money in and out of the city. In typical Florentine fashion, this extremely powerful body was headed by officials who served finite terms of office. Every September, eight new representatives from the major guilds of Florence took their posts on the governing Board. This body was, in turn, led by two co-superintendents, one chosen from the Bankers' Guild and the other from the Guild of the International Cloth Merchants – two of the city's most prestigious guilds, which had vital interests in the power of the Florentine florin and its status abroad. The Board held meetings to decide, among other things, the silver and gold content of all Florentine coins and the relative values of those coins in relationship to each other, and the Mint's directors met periodically to discuss economic indicators that might affect the status of both the coins and the currency they represented. From the records of these meetings comes the first indication of the Board's interest in obtaining a painting bearing the image of the *Coronation of the Virgin* within their offices. In the autumn of 1372, when the painting was commissioned for the Mint, the two superintendents were Tommaso Lippi Soldani (of the Arte della Calimala) and Bartolo di Giovanni de Siminetti (of the Arte del Cambio). The next autumn, when the picture was installed, two new superintendents headed the board – Bartolomeo di Caroccio Alberti and Davanzato di Giovanni Davanzati. Although these latter two men were the ones ultimately recognized on the surface of the picture, the decision to

initiate the project must have been forged and approved by the former. In the end, however, none of them may be identified as the sole patron of this governmental picture: that honor must go to the entire Board of Directors, who worked together as a corporate body to move forward with this commission.

Although archival evidence has not revealed their earliest location, the offices comprising the Zecca were clearly established on the Piazza della Signoria by the middle of the fourteenth century.[40] Once in 1350 and again in 1354 the government purchased homes from private citizens along the southern flank of that central square to be razed to create or expand space for the administrative leaders of the Mint.[41] Its offices and public areas stretched south from the piazza toward the Arno River in buildings that now compose the west wing of the Uffizi Galleries. A tower was constructed at its north end to mark the area operated by the Zecca, but that monument had a short life: it was demolished in 1356 to make room for the proposed Loggia dei Lanzi, which was projected to consume a portion of the Mint's facilities. While this demolition could have signaled the impending move of the Zecca to other quarters, the Mint retained its central location even after the Loggia's construction was initiated in January 1374 and remained in place thereafter. The Republic seems to have recognized the importance of having its chief financial center in close proximity to the Palazzo della Signoria.

Just as the project to construct the loggia was about to begin, the panel of the *Coronation of the Virgin* was installed in the Mint's offices. Thanks to the appearance of documents in the Zecca's record books, specialists have long known the names of the patrons and artists involved in this project. On October 30, 1372, the governing board of the Florentine Mint paid two painters, identified only by their given names of Simone di Lapo and Niccholaus, the sum of 134 silver lire for their work on a panel dedicated to the theme of the Virgin Mary and an unspecified collection of saints.[42] One year later, on October 31, 1373, a third artist named Jacopo Cini received a similar payment – this one totaling forty gold florins, paid out in 138 silver lire – for his efforts to complete the project begun by Simone and Niccholaus.[43] While documents specify neither the date of the initial commission nor the division of labor between these artists, the early employment of Simone di Lapo and Niccholaus (probably the painter Niccolò di Tommaso) indicates that these men were responsible for a substantial amount of work on the *Zecca Coronation* and probably should be credited with the picture's design. The painter called "Jacopo Cini" probably refers to the artist Jacopo di Cione (1320/30–1398), who was called to the project to render the figures and decorative elements. The collaboration between these painters resulted in one of the more elegant, important, and understudied panel pictures of the Florentine Trecento.

Archival records indicate that the unusually large, rectilinear *Zecca Coronation*, extending vertically some 350 centimeters and 190 centimeters horizontally,

41. *Stemmi*, Uffizi, Florence. Photograph © George R. Bent.

decorated an unidentified office inside the Mint's headquarters. As Simone di Lapo, Niccolò di Tommaso, and then Jacopo di Cione produced the painting, a stone mason named Giovanni di Ambrogio carved three now-lost marble brackets to support it. These brackets were engraved with the coats of arms of the commune (featuring the Florentine lily, the *giglio fiorentino*), the International Cloth Merchants Guild (the eagle clutching a bale of cloth), and the Bankers Guild (a shield covered with coins).[44] These stemmi repeated some of those already carved into the frame of the entrance to the Mint that may still be seen today on the Uffizi Gallery's western facade (Figure 41). The supports were installed on a wall in the Zecca on October 30, 1373, exactly one year after they had been commissioned and the day before Jacopo di Cione received payment for the completed picture. The very next day, Giovanni d'Ambrogio received another payment for the stone cornice he carved as a support for the picture, while another artisan, Federigho Benghi de Rubeis, was paid eighty-two lire to paint in gold the coats of arms of the Commune of Florence, the Guild of the International Cloth Merchants, and the Bankers' Guild on the three brackets that Giovanni d'Ambrogio had just installed.[45]

The painting features a disjointed composition borrowed from a number of Trecento altarpieces and mosaics dedicated to the subject. Four distinct picture planes jostle for our attention, as the diminutive saints that occupy the lower half of the panel extend toward the viewer from the stark gold ground behind them, while two prophets float in the corners of the frame and look down into the main compartment to gaze upon the dominant figures of Christ and the Virgin Mary (Figure 42). Christ, to the right, turns to his mother with hands outstretched, while the Queen of Heaven bows toward him as both his faithful devotee and as a co-equal in the celestial realm. Their enthronement is only alluded to, however, as the actual chair upon which they must be seated has

42. Jacopo di Cione, *Coronation of the Virgin* (detail, Virgin), 1373, Accademia, Florence. Photograph courtesy Scala/Art Resource, New York.

been covered entirely by a richly brocaded fabric, decorated in red, black, and gold and stamped with images of birds and flowers.[46] In an unusual departure from iconographic convention, Christ's hands move away from Mary's head, indicating that he has already completed the act of coronation. With her crown firmly in place, Mary is truly the Queen of Heaven and helps preside over the celestial court as an active co-agent. Isaiah and Ezekiel appear in the upper corners of the frame, each bearing a scroll that contains brief passages from the Book of Isaiah.[47]

Below the enthroned couple appear ten witnesses in a conflated composition reminiscent of dossals in street tabernacles, like Giottino's *Madonna della Sagra* and Jacopo del Casentino's *Madonna della Tromba* (Plates II and V). To either side of the expansive and elaborately draped throne stand John the Baptist and John the Evangelist. The Baptist points toward the figures behind him and holds a cruciform staff that overlaps Mary's gown, visually connecting the figures in the lower zone with those in the center. To the right, the Evangelist grasps his open gospel with one covered hand and delicately balances a quill pen in the other. The opening phrases of John's gospel – [I]N PRINCIPIO ERAT VERBUM ET VERBUM ERAT [DEUM] – appear on the opened text. Rising up behind the kneeling figures

before them, yet placed below the larger protagonists seated in the throne above, these two Johns serve as bookends of the composition. Before and between them kneel, from left to right, Catherine of Alexandria, Anne, Matthew, and Victor, each of whom occupies the space immediately below the Virgin Mary. On the other side, placed beneath the seated Christ, appear Zenobius, Barnabas, Anthony Abbot, and Reparata. The selection of these figures to accompany the image of the enthroned couple, seated in the Holy Paradise, was surely determined by their status as protectors of the commune, for all of these saints were recognized as patrons of the city and were venerated as such in the new cathedral of Florence, the massive structure that (dome notwithstanding) was nearing completion by the time of the *Zecca Coronation's* installation.[48] The political significance of these painted figures was underscored by a series of coats of arms at the very base of the frame.

The selection of saints occupying privileged positions of intercession directly below the central image of the Coronation may well have alluded to recent events that had affected in equal measure both the Zecca and the commune that it served. The selection of some of these saints for a picture with both Florentine communal and ecclesiastical overtones should seem self-explanatory. It comes as no surprise to students of Florentine history that John the Baptist, the patron saint of the Cloth Merchants Guild and a protector of the city, holds a position of honor at the left of the composition. The presence of Saint Matthew similarly conforms to our expectations, as his status as patron saint of the Bankers Guild required his inclusion in this image for the Mint. So, too, do we expect to see the figures of Zenobius, the fourth-century bishop of Florence and one of the city's patron saints, and Reparata, the third-century martyr for whom the original cathedral was named. All four were immediately recognizable as civic patrons. But the other, less frequently depicted, saints suggest that Victor, Anne, Anthony, and Catherine were equally important in the world of late-fourteenth-century Florentine affairs.

If the Baptist, Zenobius, and Reparata represented the "old guard" of the city's patron saints, then the other figures in the group painted at the base of the *Zecca Coronation* composed a newer collection of civic advocates. Barnabas, one of the saints specifically mentioned in the Mint's Book of Statutes as a patron, had been recognized as an intercessory figure since 1289, when an Aretine army had fallen to the Florentines on June 11, his feast day.[49] John the Evangelist, bearing a book containing the opening of his gospel (INITIUM. SCI. EVANGEII. SECHM IOHANNEM. IN PRINCIPIO ERAT VERBUM ET VERBUM ERAT), appears to have been recognized as a civic saint at least by the 1330s, when Giotto's workshop included scenes from his life (along with those of the Baptist) in the fresco cycle decorating Santa Croce's Peruzzi Chapel.[50] Victor received recognition as a protector in 1364, when Florence defeated Pisa on the battlefield on the saint's feast day.[51]

This brings us to perhaps the most intriguing figure at the base of the *Zecca Coronation*, Saint Anne, the Virgin's mother, who was revered as a patron saint in an entirely civic context. No chapels or altars, paintings or relics dedicated to her memory appeared in the city's cathedral, nor did Florentines participate in, or witness, processions in the Duomo on her feast day. However, her presence was signified prominently in those two distinctly governmental locales we have already encountered: in the Stinche, where the effigy of Saint Anne protected the city in the now-famous image of the *Expulsion of the Duke of Athens*, and on the altar of Orsanmichele, which only a few years earlier, in 1365, had become the site of the city's official picture (the *Madonna of Orsanmichele*), and which, since 1344, had been the final destination of the official communal procession held on Anne's Feast Day of July 26.

In the *Zecca Coronation* Saint Anne carries in her arms a replica of Florence's major architectural monuments in what amounts to a rare urban portrait of a medieval city. Included in this miniature version of Florence are the Palazzo della Signoria's bell tower, the Baptistery, and the facade of a building that Richard Offner identified as the Church of Santa Reparata as it appeared before its renovation and reconstruction in the fourteenth century.[52] Roger Crum and David Wilkins have argued that the decision to depict the old church, rather than the new and improved one, was made to encourage viewers of the *Zecca Coronation* to reminisce about an earlier age, the one before the calamities of the 1340s – beginning with the bank failures of 1342 and the arrival of Walter of Brienne – when Florence was a city of might, of dominance, and of influence.[53] Anne's presence in the group of saints kneeling to the left of center in the Zecca picture may well allude to the commune's days of glory, as well as to her importance as one of those responsible for preserving the stability and *libertas* of the commune. But there were other matters of the utmost importance inside the Florentine Mint to which the painting of the *Coronation* referred.

Any fourteenth-century state that hoped to retain a stake in international trade needed to boast a stable currency, and the governments of European powers worked hard to promote their coins at home and abroad. Understanding intimately the importance of consumer confidence, the Zecca took great care to manipulate the amount of raw material available for minting, as well as the amount of alloy actually put into each coin, to control the buying power of its two currencies.

And these two currencies – gold and silver – benefited different constituencies in Trecento Florence. The former, consisting solely of the single gold florin, was considered the benchmark currency of global trade. Without exception, international transactions of the later Middle Ages were conducted using gold coinage as the key unit of exchange. Bankers and cloth merchants, in particular, depended on a stable gold currency, for transactions with foreign governments and with international merchants were conducted in Florentine

florins, or "fiorini" (literally "little flowers"), one of the strongest currencies on the continent. It is no wonder that the two co-superintendents of the Zecca were annually selected from the guilds of the Bankers and the International Cloth Merchants, for these two trade associations had the most to gain from a strong florin, and the most to lose from a weak one.

Silver, on the other hand, was the currency of daily use in most cities. Because of its availability, silver could be broken down and meted out in differing amounts, thus allowing mints to create monetary units of varying degrees of value. Whereas the gold florin had only one denomination – the single gold florin – silver carried a wide variety of values depending on the bullion content of each coin: as a result, it was much easier to make small change with silver currency than it was with gold.[54] Wages were paid to workers in these silver coins, rather than the more valuable florins, and wage earners purchased their food, articles of clothing, furniture, and other domestic items with the *grossi*, *quattrini*, and *denari* that were made from silver.[55] Yet the value of silver could, and did, fluctuate against gold coins. During the course of the fourteenth century, depending on a variety of economic factors, florins could be worth as many as seventy-seven silver soldi or as few as sixty-two, which in turn meant that wages paid out in silver were somewhat elastic in value.

The Zecca, led by international merchants and financiers, worked to retain the strength of the florin by keeping its value relatively high with respect to silver, and occasionally manipulated their currencies by reducing the actual bullion content of silver coins.[56] This manipulation of the coins used by Florentine laborers rarely aroused any forms of discontent. But in the early 1370s, at precisely the time that Simone di Lapo and Niccolò di Tommaso were commissioned to design the panel in question, the Zecca faced a genuine crisis that threatened to undercut the value of its silver currency altogether, and in turn erode confidence in the entire fiscal stability of the Florentine monetary system. The problem was rooted in a seemingly innocuous policy decision made only a few years earlier.

In 1368 the Signoria approved a treaty with Pisa intended to improve trade relations between the two states. This agreement, coming only four years after the military victory of the Florentines over the Pisans at the Battle of Cascina on July 28, 1364 (the Feast Day of Saint Victor), allowed for an easing of restrictions on the use of each other's currencies inside the walls of both cities. This at first seemed like a sensible move for the Florentines, who were eager to put their coins into circulation in Pisa. In early 1368 the Mint created a new *grosso* coin, pressed rather secretively with a reduced silver content in an effort to maximize usage in Pisa and elsewhere.[57] But word of this devalued silver coin leaked out, and by 1370 consumers in both communes deemed Pisan silver more valuable than the Florentine kind, despite the fact that their coins had identical face values.[58] Because of their higher silver content, Pisan coins became extremely popular in Florence and surged in circulation there, creating concerns in the

Zecca when its members realized that local residents were circulating foreign currency rather than coins pressed in their own mint.

The threat to Florentine *soldi* was very real. Bullion ceased coming into the Zecca entirely, as silver coins minted in the facility on the banks of the Arno were now thought to be less valuable than the raw material brought in for conversion. The superintendents feared that their weak silver coin was in danger of being taken out of circulation altogether, which in turn would have disastrous implications for the currency. But more important, confidence in the gold florin, the king of all coins, might also fall into jeopardy internationally. Officials in the city government complained of the infusion of foreign coins, and the Signoria began to take note of the increasing economic threat to the commune.[59] By early 1371 the Mint, now receiving no silver bullion from metal mongers whatsoever and aghast at the superiority of Pisan *soldi*, stopped making silver coins altogether. Its superintendents were in now crisis mode.

Out of necessity, the Zecca took dramatic actions to counterbalance the strength of Pisan silver and address the weakness of Florentine coins. In October 1371, the Mint's supervisors reluctantly approved a plan to alter the face value of the *quattrino*, both to make it reflect more accurately its actual silver content and to put it on absolute equal footing with its Pisan rival.[60] The announcement that Florence was revaluing its silver currency was made to the general public soon thereafter, and in February 1372, the Zecca began minting new coins at a lower face value, reflecting the lowered amount of silver content in each coin. The move worked. The Mint infused into the city's economy a torrent of freshly pressed silver coins called *quattrini*, made possible by a surplus of bullion brought to it by individual residents eager to get the new *soldi*. Old coins were brought out of circulation and melted down for reuse, allowing the Zecca to press even more new coins and support both its silver currency and the gold florin that depended on it. Although records are incomplete, between February 1372 and April 1374 at least 23 million new *quattrini* (a stunning amount) were minted, and the Florentine silver currency was saved.[61]

Although we do not know the date of the painting's commission, it seems clear that Niccolò di Tommaso and Simone di Lapo were hired to produce this honorific panel in the midst of what was turning out to be a very serious financial crisis. Yet by the time they were paid for their work (in silver coins!) in October 1372, the Mint's supervisors had instituted their new policy of currency production and the Zecca was pressing new *quattrini* at an extraordinary rate of roughly 1 million coins per month. The early phase of production on the *Zecca Coronation*, then, coincided with the Mint's creation and implementation of one of the most important, and ultimately successful, shifts in monetary policy of the Florentine Trecento. The events and policies of 1371–1372 may have influenced the commission and content of the *Zecca Coronation* and surely affected the way viewers interpreted the image when it was finally installed in October 1373. There is no question that the forms

43. Jacopo di Cione, *Coronation of the Virgin* (detail, Victor and Zenobius), 1373, Accademia, Florence. Photograph courtesy Scala/Art Resource, New York.

painted on its surface referred directly to the work done in the Mint and to the concerns and customs of its Board members.

This intertwining of politics, religion, and economics was featured in the middle of the panel. Emblazoned on the morses worn by Victor and Zenobius, kneeling opposite one another in the picture's center, appear images that bear a striking similarity to the designs featured on either side of silver and gold coins produced in the Florentine Mint during the fourteenth century (Figure 43).[62] The fleur-de-lis painted on Bishop Zenobius's cope matches exactly the image struck on one side of the gold florin pressed in Florence throughout the fourteenth century (Figure 44).[63] The morse worn by Victor features a half-length blessing figure of Christ, surrounded by a blackened background, that resembles the likeness of John the Baptist regularly stamped on the city's silver coins. There, in the middle of the painting installed in the offices of the Mint, the men who dictated monetary policy through the valuation of gold and silver saw before them symbols of their power and prestige, and reminders to them of the importance of their duties to the commune. The coins that they pressed for the common good were prominently featured over the hearts of two communal saints recognized for their benevolence toward the city.

Yet these rather overt monetary references were not the only ones in the *Zecca Coronation*. At the base of the picture, where most liturgical paintings from this period contained a series of predella scenes, the designers of the *Zecca Coronation* added coats of arms, each of which represented the most important political entities in the city (Figure 43).[64] In the very center of this collection of *stemmi* appears the shield of the Bishopric See of Florence, complete with the two silver keys of Saint Peter. The bishop's shield, placed directly between the enthroned Virgin and Christ above, serves as a symmetrical core. The line of shields moves out toward the edges of the frame in balanced pairs that depend on the central Episcopal coat of arms as an axis. On either side of Peter's Keys appear the international forces allied with Florence, with the gold fleur-de-lis shield of the Anjou Family to the left and, to the right, the one representing the Anjou-Durazzo alliance from Hungary and Albania (marked by gold lilies, crowns, and a silver eagle). The next pair of shields moving out from the center made clear the link between the city and its most important political party: on the left appears the stemma of the commune of Florence, marked by the large red fleur-de-lis on the silver ground, while its partner on the right, featuring a red

44. Gold florins. Photograph courtesy Gabinetto Fotografico del Polo Museale Regionale della Toscana.

eagle clutching in its talons a green dragon on a silver background, signifies the Parte Guelfa, the only officially sanctioned political entity in the city. Beyond these local symbols of civic authority lie two shields of specific importance to the Zecca: the gold eagle on the red field to the left represents the Guild of the International Cloth Merchants, while the shield bearing gold coins on the red background forms the coat of arms of the Bankers Guild. Finally, the specific directorate of the Zecca at the time of the painting's completion receives a place of honor in this row of shields. Flanking the arms of the guilds of the Bankers and International Cloth Merchants appear, to the left, the *stemma* of the Alberti family, decorated with silver chains, and to the far right that of the Davanzati clan, bearing the gold lion. These shields surely salute both Bartolomeo di Caroccio Alberti and Davanzato di Giovanni Davanzati, the two men who served as co-superintendents of the Zecca in October 1373 when Jacopo di Cione was putting the final touches on the panel and the *Zecca Coronation* was installed.[65] Each *stemma* signified alliances that boosted the status of the Mint within the orbit of major power centers in and out of the city.[66]

Jacopo di Cione accentuated this *faux* predella by wrapping around them a thin strip of silver leaf, a decorative addition that signaled a specific kind of reading from its audience in the Mint.[67] This strip of silver, today blackened to the point of invisibility, would have been recognized as an unusual addition to

a panel painting of these dimensions. While burnished gold leaf was featured prominently in nearly every panel painting produced in Trecento Florence (including the *Zecca Coronation*), silver was rarely used in any abundance when applying pigments to the surface of important paintings. Its instability surely caused artists (and patrons) to refrain from using it, and examples of its employment are fairly rare. Even Cennino Cennini, when writing his treatise on the craft of painting at the dawn of the fifteenth century, barely mentioned the use of silver, and then only as a material to be employed for the representation of draperies.[68] And yet here, in the Mint, the addition of this metal was apparently deemed both appropriate and desirable. Contained within this unusually large amount of silver were the nine *stemmi* of the Zecca's protectors: and five of these employed silver somewhere on the shield, while the other four emphasized gold. The lower section of the *Zecca Coronation* stands out in a highly dramatic fashion. Rather than use the picture's base as a field upon which to paint predella scenes, Jacopo di Cione chose instead to emphasize the material content of the two metallic substances for which the Mint was responsible for pressing into hard currency.[69]

The use of these precious metals made the *Zecca Coronation* more than just an acknowledgment of pious devotion to the Virgin Mary and her Son/Groom, Jesus Christ. Gold, it is true, was used by painters to represent the heavenly realm in panel pictures installed in liturgical settings; but for those whose livelihoods revolved around the production, distribution, and exchange of currencies, it had a much more earthly meaning. The florins that drove the local economy were crafted from this mineral, and its presence in a painting located in offices used by those responsible for pressing coins overtly or covertly reminded them of the work they did there. Yet should this subtle reference to coinage and the duties of the Mint's Directors have escaped viewers of the picture inside the Zecca, then the orbs dotting the coat of arms of the Arte del Cambio – all of them gold – surely helped them see the florin's elevated status. The placement of the Bankers' *stemma* alongside those representing the commune – the Parte Guelfa, the Bishopric See of Florence, and the Anjou family – acknowledged the elevated position of both the guild and the currency most revered by the city's economically empowered.[70] The *fiorini*, and those responsible for its production and safekeeping, were placed on par with the most powerful political institutions in Florence.

But this was not the only allusion to the labors inside the Mint. The vast expanse of gold leaf surrounding the main protagonists of this picture was also offset and perhaps accentuated by the unusual additions of silver in and around the coats of arms at the bottom of the panel. This second precious metal must have caught the eye of beholders, for here the two materials of greatest value to them competed for their attention, although on distinctly unequal terms. The delicate silver leaf, tarnished today but brilliant to the eye then, could have only

made the larger portions of the gold that overshadowed it on the panel stand out in magnificent ways. Framing the silver *stemmi* and the border surrounding them, the lush expanse of gold spoke not only to the celestial realm occupied by the Virgin and Christ, but also to the very material the members of the Zecca were charged to protect. Thus bankers and cloth merchants saw in this picture references to their profession and the importance of their work for the survival of Florence. Gold and silver were every bit as much protagonists as were the saints who populated the main compartment of the *Zecca Coronation*.

Materials, of course, were only one way to address an audience of laborers in or visitors to the Florentine Mint. As we have seen, the scene selected for representation, the Coronation of the Virgin, was based squarely on the acknowledged devotion the members of the Zecca claimed to have for Mary as Queen, and the coats of arms at the picture's base denoted those international, civic, and social bodies with which it was allied during the third quarter of the fourteenth century. But the selection of saints positioned between these two zones in the composition also referred directly to the government that the Mint was charged to support economically and the religious figures that government embraced as protectors of the state. Here the sacred and the civic met and shared representation in a grouping of saintly advocates prepared to intervene on behalf of Florence.

PAINTINGS DECORATED GOVERNMENTAL OFFICES AND ORNAMENTED the facades of important civic buildings in the heart of the Republican civic center. Sometimes they spoke of evil; sometimes they addressed threats to Florentine sovereignty; and often they alluded to the struggle for both virtue and political autonomy. But when situated in specific settings, pictures for bureaucrats celebrated administrative successes, promoted the contributions of policymakers to the commune, and added a layer of affirmation onto the shoulders of those who fought the battles of Florence from desks and offices inside their damp buildings near the city center. They also condemned the guilty, reminded the public of the fragility of the commune, and implored the condemned to repent before it was too late. Oftentimes (as with the case of the *Zecca Coronation*) their compositions were fine-tuned versions of scenes that proliferated in sacred spaces, bringing into the civic realm the themes and concepts that had for years been popular in religious settings. But other times (as with the *Expulsion of the Duke of Athens*) the specific requirements of an image and its setting demanding a completely ex-novo response. The city used pictures in numerous ways, and the inventive approaches artists took resulted in a expanding repertoire of unconventional images that helped set the stage for a Renaissance penchant for narrative originality in the fifteenth and sixteenth centuries.

CHAPTER FOUR

PICTURES FOR MERCHANTS: THE GUILDS, THEIR PAINTINGS, AND THE STRUGGLE FOR POWER

W HEN THE SILK GUILD MADE PREPARATIONS TO PURCHASE PROPERTY IN the heart of Florence for their new residence hall in 1335, members of the corporation took pains to amend their Statutes Book to articulate a decorative vision for their headquarters. Under the title of "De ymagine Virginis gloriose fienda cum tabernaculo in tabula," members of the Arte della Seta mandated the installation of a painted image (on a wooden panel) of the Virgin Mary holding the Christ child in her arms, flanked by two saints. The painting was to be placed in their Audience Hall, the largest and most important meeting room in the building, where hearings, legal proceedings, and general assemblies were held.[1] The guild's interest in procuring this kind of image was shared by other mercantile institutions in the city. The Guild of Doctors and Apothecaries, for example, possessed two images of its patron saint, the Virgin Mary. One of them ornamented their Sala d'Udienza in a manner that was probably akin to that in the audience hall of the Arte della Seta (Figure 45).[2] A sixteenth-century inventory of possessions in the Guild of Butchers and Bakers similarly contains a list of painted figures in their audience hall, including effigies of the corporation's patron saints, a depiction of Christ, and an image of the Virgin.[3] Although these pictures have not survived (many were destroyed when the Mercato Vecchio was demolished to make way for the current Piazza della Repubblica), their careful descriptions indicate the importance that these guilds placed on possessing images of the Virgin, Christ, and their saintly advocates. Mercantile associations required images for their spaces.

45. Bernardo Daddi, *Madonna and Child*, ca. 1340, Accademia, Florence. Photograph courtesy Gabinetto Fotografico del Polo Museale Regionale della Toscana.

Among the best known guild pictures of the early Republican period is the complex ensemble of panels painted by Fra Angelico for the residence of the linen workers, located just a few paces from the Oratory of Santa Maria della Tromba (Plate XIX). The project was initiated by guild members in 1432, when overtures were made to Lorenzo Ghiberti for a marble cornice and frame for the picture intended for its core.[4] In July 1433, Fra Angelico accepted the guild's offer to produce panels to fit inside Ghiberti's tabernacle.[5] The sculptor and painter worked on this project for a number of months, with the latter

finishing the picture in 1435 and the former adding his elements to the ensemble the next year, when it was installed inside the guildhall. It took the linen workers another seven years to build into their Sala d'Udienza a niche to hold the image, with the project reaching completion in 1443.[6]

The magnificent object, one of the most elegant and artistically successful images ever produced for a mercantile corporation at any time in the city's history, features at its core the figure of the Virgin Mary. Seated on a brocaded altar cloth, the Virgin presents the standing Christ child, who wears a simple dressing gown presumably made of linen. Painted curtains of gold unveil the holy couple, echoing the real pair of shutters that revealed the central panel when opened. When closed, these shutters present to viewers images of Saints Mark the Evangelist and Peter, who stand on a rocky surface set off against a black background (Figure 46). The predella below, which was never hidden from view, depicts the *Preaching of Peter, Adoration of the Magi*, and *Martyrdom of Mark*. These saints were promoted at all times, even during off-hours when the main compartment was hidden by the closed shutters: when the shutters were closed, the tabernacle illustrated the guild's allegiance to the ecclesiastical authority in Rome, through the figure of Peter on the shutter's exterior. But when opened, the shutters revealed to guild members the iconic representations of John the Baptist, patron of Florence, and Mark the Evangelist, patron of the Linen Guild, engulfed by the gold leaf customarily applied to liturgical panels on altarpieces. Now the painting promoted the guild's dedication to the city through the figure of the Baptist represented on the picture's main compartment. Both allegiances were sanctioned by Ghiberti's relief of a benedictional God the Father holding aloft a book emblazoned with the Alpha and Omega perched above the main compartment.

Few today would argue that matters of the spirit dominated the thoughts and actions of a vast majority of common people. The churches, nunneries, monasteries, and confraternities of the city enjoyed the patronage of both the wealthy and those of modest means, and their spaces were filled (or, in some cases, literally covered) with devotional objects and images. But the city's populace was equally engaged in those economic entities that drove commerce, employed tens of thousands of laborers, brought enormous profits to a fortunate few, and formed a tax-base that supported and defended one of Europe's largest urban populations. These guilds were organized into collections of merchants, workers, and service providers with like-minded interests, although at times there could be a strange mixture of professions within an individual guild. Painters, by way of example, were included in the Guild of Doctors and Apothecaries not because of any artistic inclinations by physicians, but rather because they used the same kinds of minerals that were ground and mixed together for medicinal purposes in local pharmacies. Goldsmiths joined the

Silk Guild, as luxury garments produced there were frequently adorned with gold brocades sewn into robes and dresses with fine thread. Bookbinders and glove makers were folded into the Guild of Saddlers due to the employment of leather in their respective trades.[7] Guilds were often composed of workers from diverse backgrounds who plied distinctive areas of expertise.

Despite each one's specific focus, all Florentine guilds had some things in common. Rules and regulations appeared in Statute Books that extolled the roles, virtues, and civic status of the group. Items of importance were here recorded, including the elections of officers and their terms of appointment, the creation and revision of bylaws, and a variety of proscriptions against specific practices. The International Cloth Merchants, for example, were not permitted to use specific shades of scarlet in the robes they produced. Flax-workers had to buy raw materials from one of six appointed sales representatives selected by the Linen Guild's consuls: bypassing them to purchase directly from farmers was forbidden.[8] The foundries operated by members of the Blacksmith's Guild were inspected periodically to ensure that the materials and quality of work met their standards.[9] All guilds set up tribunal courts to enforce the codes each one set up for itself, and each was careful to monitor the behavior of its members in the areas of price-setting, wage payments, and advertising.[10]

To house these courts, but also to promote themselves in the eyes of the public (both domestic and international), all guilds erected headquarters in *palazzi* strategically located in sections of the city where their goods or services could receive the attention and deference they deserved. The Bankers' Guild, for example, built its palace on the Piazza della Signoria, just across from the governmental center of Florence. The Guild of Judges and Notaries occupied the corner of the Via Proconsolo and the Via Pandolfini, strategically located only one block from the Palace of the Podestà and the Stinche, the infamous Florentine Debtor's Prison. The Wool Guild was located between the city's two major trading centers, the Mercato Nuovo and the Mercato Vecchio, along the avenue that ran from the Porto San Gallo all the way through the city to the Porta Romana, and that connected the Ponte Vecchio to the Bishop's Palace on the Piazza del Duomo: it was clearly a place of primacy, and Giovanni Villani claimed the guildhall stood in the very core of Florence.[11] The palace of the Doctors and Apothecaries was not far from it, but their headquarters sat tucked away inside the labyrinth of alleys and streets adjacent to the Mercato Vecchio, in the heart of some of the city's worst – and often disease-ridden – neighborhoods. That's where physicians and pharmacists were most needed, after all. The urban location of guild headquarters signaled to the general population the professional interests of its members and the social needs and expectations of its clientele.

Guild residences differed from each other in their design and appearance only slightly. Most featured a loggia on the ground floor, where the goods

46. Fra Angelico, *Madonna and Child (Saints Mark and Peter)*, detail, 1435, Museo di San Marco, Florence. Photograph courtesy Nicolo Orsi Battaglini/Art Resource, New York.

made by that guild could be sold to customers on the street.[12] Small offices, chapels, and storage spaces were placed in rooms adjacent to these stores on the *piano terreno*. The guildhall's most important administrative area almost always rose up on the next floor, the *primo piano*, above the loggia below. Here an audience hall, often vaulted and formed by double or triple bays, served as the tribunal chamber, meeting room, and auditorium, again with smaller rooms supporting the main space as anti-chambers (Plate XXII). Depending on the size and importance of the guild, a third floor might be added above, again featuring small rooms for intimate conversations, private meetings, and, of course, prayer.

Mercantile associations spent large sums of money to decorate their residence halls, and took great pride in their appearance. While some guilds paid artists to paint frescoes in their most important rooms, the most common type of commission revolved around panel paintings of the Virgin Mary and the guild's patron saints, who were often depicted in compositions condensed onto a single frame in ways that echoed the unified compositions of public street pictures placed inside roadside tabernacles all across the city. Bernardo Daddi, for example, painted the picture of the *Enthroned Madonna* for his own Guild of Doctors and Apothecaries sometime in the mid-1330s, employing a set of figures based on those we have already seen appearing in the alleys and corners of Florence (Figure 45). Jacopo del Casentino's dossal panel of *Saint Bartholomew Enthroned* (Figure 74), complete with his iconographic attribute of the knife used to flay him alive, similarly conflates into a single compartment eight music-playing angels who surround the patron saint of the Delicatessen Owners' Guild in a celebratory pattern that echoes the ones used by Duccio in the *Rucellai Madonna* and by the painter of the Beta *Madonna of Orsanmichele* (Figures 19 and 22). And the *Madonna della Tromba*, we recall, had originally functioned as a guild image before its removal in 1361 from the headquarters of the Doctors and Apothecaries. The format and appearance of these panel paintings suggest that they were installed in small chapels or chambers designated for the purpose of veneration, with performative rituals led by chaplains employed by the guild to lead periodic spiritual exercises.[13] They looked like street tabernacles because they functioned like street tabernacles: the identical formats they shared bred familiarity, and their audiences knew how to interpret them because they were accustomed to seeing them everywhere in the city.

Not all pictures inside guildhalls were tied directly to devotional practice. Taddeo Gaddi's *Madonna* bears the eight-pointed star of the Arte dei Giudici e Notai, suggesting that it was once installed inside the residence hall used by the Judges and Notaries (Figure 47). It was too small to be a useful object of devotional focus in any formal sense. Its rounded top and half-length depiction of the Virgin, however, indicate a more decorative setting for the picture:

47. Taddeo Gaddi, *Madonna and Child*, ca. 1350–1355, Accademia, Florence. Photograph courtesy Gabinetto Fotografico del Polo Museale Regionale della Toscana.

perhaps it was installed above a doorway, or fitted into a small lunette forming the sidewall of a stairway or a small anti-chamber.[14] Likewise, Mariotto di Nardo's late Trecento picture of Mary and Christ for the powerful Wool Guild, which includes the patron saints of both the Arte della Lana (Saint Stephen) and the city of Florence (Saint Reparata), seems to have had more of a civic function than a spiritual one (Plate XX). Its lobed format, combined with the appearance of celestial advocates expected to protect guild members, suggests a somewhat informal function of the picture – perhaps a reminder to viewers and passersby of the power of those two patron saints before the Virgin and Christ. Sadly, these pictures cannot be placed inside their original settings with any confidence, as all but two of Florence's commercial residences were either stripped entirely of their contents and completely remodeled or demolished altogether during the cleansing of the ghetto during the Risorgimento.

A rare example of a devotional guildhall image still *in situ* is the fresco painted within a niche built into the residence hall of the Wool Guild, located behind the ground floor *bottega* where bolts of finished wool were sold. In a small room, perhaps used as a chapel, appeared the image of the *Madonna with Saints Stephen and Philip* (Figure 48). Designed and produced in a format familiar to contemporary common viewers, the fresco has been attributed to Jacopo del Casentino, the painter who specialized in these kinds of images during the 1330s and 1340s. Like a private devotional picture standing in the home of a devout worshipper, the "wings" of this frescoed triptych stand at 90° angles to the central panel, each one containing the full-length effigy of a patron saint: to the left, in the place of honor, stands Saint Stephen, protector of the Wool Guild, while Saint Philip occupies the section to the right. The composition's core features the Virgin seated on a bench with the Christ child balanced on the crook of Mary's bent arm. Their cheeks touch as the boy looks adoringly at his mother, while the Virgin gazes out at those viewers below who were expected to return her stare with appropriate reverence. In a fashion that would come to typify pictures of the Madonna in buildings and offices specializing in the manufacture of textiles, an elaborate wool tapestry spreads across the visual field, held aloft by two floating angels who effectively transform the architectonic throne-back into an emblem of regality via the beauty of materials made in Florence.[15] No self-respecting member of the Wool Guild, nor any foreign trader visiting its headquarters, could have missed the reference to the quality of the fabrics made and promoted by the Arte della Lana.

Not much of anything produced for Florence's twenty-one guilds (briefly expanded to twenty-three in 1378) remains from the fourteenth century. The gradual reduction of the guilds' political power – beginning with the restoration of the Albizzi-led oligarchy in 1382, extended during the Medicean regimes of the fifteenth and sixteenth centuries, and ending with the suppression of the system altogether in 1775 – caused the buildings used by these trade corporations to be reorganized, gutted, sold off, and in most cases ultimately razed to the ground. The decision to name Florence as capitol of the new Republic of Italy in the late nineteenth century altered the appearance of the city in dramatic ways. The venerable (but squalid) Mercato Vecchio was eliminated to make room for the more presentable Piazza della Repubblica. The neighborhoods, alleyways, and side streets that composed the mercantile and residential zones of that area were completely destroyed, and with the demolition of tenements in the Ghetto and the food markets in the main piazza came the destruction of most of the old residences of the guildhalls that once stood inside this compact collection of medieval buildings. This systematic sanitization was soon expanded to include the guildhalls built along the Piazza della Signoria, and even the old Bankers' palace and Cloth Merchants' headquarters were gutted and their furnishings sold off. Only the palace of the Wool Guild was left

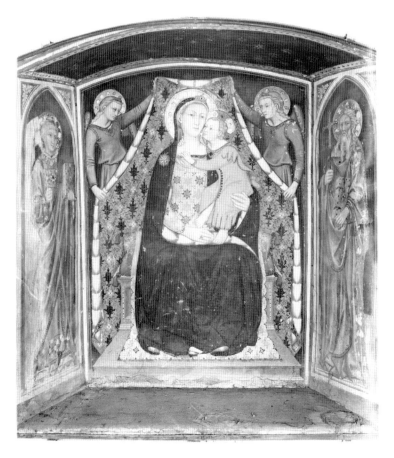

48. Jacopo del Casentino, *Madonna and Child with Saints Stephen and Philip*, ca. 1340, Palazzo Arte della Lana, Florence. Photograph courtesy Gabinetto Fotografico del Polo Museale Regionale della Toscana.

standing in its original form, while a second palace, belonging to the Guild of Judges and Notaries, was left intact, but in total disrepair. Of those that had not already been removed to centralized locations in the eighteenth century, some of the paintings, sculptures, and artistic objects that originally decorated the guildhalls of Florence were distributed to other locations. Others perished. By 1900, only a handful of the palaces that had operated during the early Republican period were still extant, and none of those that remained looked much like the original residences of the businesses that made fourteenth-century Florence the economic powerhouse of Tuscany.[16] In the end, practically nothing of the old merchant edifices or their decorations survived the late-nineteenth-century reorganization and reconstruction of the city center.

Today only two of these *palazzi* – one used by the Wool Guild and the other by the Guild of Judges and Notaries – contain remnants of images that

once decorated them, and only the former presents enough visual information to allow for truly substantive interpretation. The decorative programs in these two halls, however, reveal both a genuine interest in artistic production and a desire to create programs of an impressively sophisticated nature. If the other guilds that organized and maintained the economic well-being of the city's various industries looked anything like them (and they probably did) then the audience halls and office chambers of these great corporate bodies must have been repositories of unusual splendor and magnificence. The merchants of Florence wanted to demonstrate through visual schemes their allegiances to the city, to their patron saints, and to themselves, and throughout the fourteenth century they spent impressive sums of money to do so.

PAINTINGS IN THE GUILD OF THE JUDGES AND NOTARIES

Every guild in Florence claimed a place of primacy within the economic constellation of associations that formed the core of the local economy. Bakers and butchers boasted of their responsibility to feed the population, stone masons proudly proclaimed that they had built the city, and carpenters noted that they were the ones who filled homes with furnishings that made them repositories of luxury items in one of Europe's most glamorous cultural centers. The cloth merchants, wool producers, and silk weavers of Florence justifiably promoted their status as both primary employers of the local populace and as profitable industries responsible for the commune's fiscal health. Doctors and Apothecaries cared for the physically ill, maintained the wellness of the healthy, and worked with nearly everyone who was nearing death. But among all these corporate bodies, only the Judges and Notaries claimed to be "the first among the guilds."

Those who worked in the legal profession had access to literally everyone inside the walls of Florence. Their presence was required for finalizing contracts, settling legal disputes and court cases, writing wills and bequests, and making simple agreements between every configuration of parties imaginable. While they recognized that they neither produced goods for sale nor brought wealth into the city from foreign investors, the Judges and Notaries wrote the codes, regulations, and contractual agreements that bound Florentine merchants, local residents, and governmental officials to a rule of law that shaped their world in an organized manner. As such they thought of themselves as the glue that held together the fabric of the city.[17] As men of letters, they wished their fellow citizens to recognize their level of educational training and the intellectual gifts they possessed both individually and collectively. The Judges and Notaries thought highly of themselves, and the images they commissioned for their headquarters underscored their assumption that, when asked to

49. Palazzo Arte dei Giudici e Notai, Via del Proconsolo, Florence. Photograph courtesy Gabinetto Fotografico del Polo Museale Regionale della Toscana.

participate in negotiations and legal proceedings, they were the smartest men in the room.

The residence hall in which the leaders of the guild met was located on the corner of Via Pandolfini and Via del Proconsolo. The building stood only one block from the imposing Palazzo del Podestà, home and office of the temporary head of state, and two blocks from the dreaded prison called the Isola delle Stinche (Figure 49). Although it was some distance from both the Piazza della Signoria and the neighborhood surrounding the Mercato Vecchio, where the city's other twenty mercantile guildhalls were located, it stood as a central fixture in the criminal justice district. The residency of the Guild of Judges and Notaries was somewhat smaller in size than those industrial and professional associations. As they had no goods to produce or to sell, they had no need for a ground floor *bottega*, and their audience hall was therefore located on the street level rather than the *primo piano*, as was the custom. The chambers of their headquarters were thus immediately accessible through the front doors leading from the Via del Proconsolo.[18]

The building was standing by 1349 when Neri Fieravanti was hired to improve its vaults, and in 1358 a cheaply painted image of the Madonna

50. Palazzo Arte dei Giudici e Notai, Sala d'Udienza, Via del Proconsolo, Florence. Photograph courtesy Gabinetto Fotografico del Polo Museale Regionale della Toscana.

(probably in fresco) was commissioned for the palace.[19] In June 1366 Jacopo di Cione – still an assistant in his brother's workshop – and a colleague named "Niccholao" were paid for the production of now-lost frescoes in the guild's cellar.[20] Three months later, in September 1366, more pictures were painted on the ceiling of the *primo piano*.[21] By 1368, the year before his matriculation

into the Guild of Doctors and Apothecaries, Jacopo di Cione had received the
healthy sum of one hundred florins for his work in the residence hall of the Arte
dei Giudici e Notai, which we may infer indicates his participation in the pro-
duction of an extensive program of imagery inside the residency. However,
the only decorations in the palace that have survived were those produced by
Ambrogio di Baldese who, in November 1406, was paid to complete pictorial
compositions that had been initiated earlier.[22]

A lengthy restoration project initiated by the twenty-first-century owners
of the old residence hall has borne fruit. Portions of Ambrogio di Baldese's
paintings that appeared in the vaults and lunette walls at the beginning of the
fifteenth century can now be seen by the general public. What survives sug-
gests an elaborate and thoughtful program of decorations intended both to
celebrate the sovereignty of the city and commemorate famous figures from
Florentine history. Two large chambers compose the main floor of the guild's
residence hall, with each room partitioned by vaults forming bays in each sec-
tion (Figure 50). Today, only the double-bayed chamber on the east end con-
tains images for evaluation, and even these betray centuries of neglect; still, the
individual parts of these remaining pictures indicate that the headquarters of
the Arte dei Giudici e Notai was once richly decorated with images, and the
few pictures visible indicate an overtly patriotic theme.

The lunettes that supported the
painted roof overhead have suffered
the most over time. The first one to
the right, or southwest, side of the
chamber only bears the impression of
two heads engaged in conversation
(Figure 51). As one of these men bears
the tonsure worn by monks and friars
of the period, his identity as a cleric
seems hard to refute. His partner, how-
ever, defies even this rather generic
identification, for most of his form
has disappeared, leaving us no clues
for identification. The lunette across
from it is in equally ruinous condi-
tion, as only the border of what was
surely a scene filled with figures may
be discerned there. However, the ceil-
ing overhead still bears images from
the period, as the individual sections of
the quadripartite vault contain winged
angels flanking male allegorical figures.

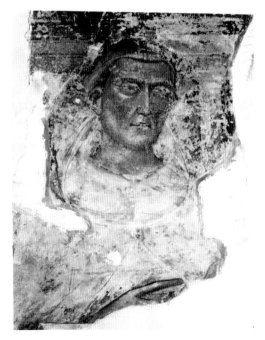

51. Ambrogio di Baldese, *Cleric*, ca. 1406, Palazzo Arte dei
Giudici e Notai, Florence. Photograph courtesy Gabi-
netto Fotografico del Polo Museale Regionale della
Toscana.

52. Ambrogio di Baldese, *Allegorical Women*, ca. 1406, Palazzo Arte dei Giudici e Notai, Florence. Photograph courtesy Gabinetto Fotografico del Polo Museale Regionale della Toscana.

Unlike the poorly maintained west bay, the eastern half of this chamber is in fairly decent condition, and contains a pair of pictures of tremendous importance. On the room's north side, two female figures (originally joined by a third) sit enthroned in richly ornamented chairs, each one holding a scroll or a book (Figure 52). The presence of these scrolls, held by the women above, surely suggests the power of writing, an appropriate theme for a guild whose members were dedicated to this very process. And, of course, the type of writing promoted here centers on that produced by men in red robes, those legal minds whose prose focuses on the rigorous and precise language of the law. Seated on the ground below them appear male figures, dressed as fourteenth-century laymen and probably included as a reference to the judges and notaries who populated the guild.

By far the most celebrated section of the guild's residence hall appears in the southeast bay of the chamber, where the representation of six famous men (known as the *Uomini famosi*) was assembled by an artist probably working sometime during the 1380s, at least fifteen years after Jacopo di Cione and his partner, Niccholao, produced the now-lost figures on the opposite lunette. Here we find features traditionally understood to represent the very finest literary minds of early modern Florence. Boccaccio and Petrarch,

53. Ambrogio di Baldese, *Uomini Famosi*, ca. 1406, Palazzo Arte dei Giudici e Notai, Florence. Photograph courtesy Gabinetto Fotografico del Polo Museale Regionale della Toscana.

Zanobi da Strada and Coluccio Salutati, Claudian and – famously – Dante Alighieri make appearances here (Figure 53). This was surely the lunette Ambrogio di Baldese was called upon to alter in November 1406, when he was paid to add figures to pictures already decorating this audience hall, for the recently departed Salutati had died only a few months earlier and the stylistic approach to the facial features of Claudian differs from that employed by the artist who painted the effigies of Boccaccio, Petrarch, Dante, and Zanobi da Strada.

In a guild where a premium was placed on one's ability to write accurately and persuasively, these heroes of the quill stood as monuments to the importance of the written word. No one who has read the contracts and agreements penned by Florentine notaries of the day could possibly confuse the legalese of these perfunctory and formulaic conventions for the regal poetic verse employed by the day's greatest literary minds. Yet in their residence hall the legal leaders of the commune rather presumptuously merged their greatest luminary figure – Coluccio Salutati – with the brightest lights of contemporary literature. Grouped together with Dante, Petrarch, Boccaccio, and Zanobi da Strada, Salutati and the prose he had used to represent the entire commune both locally and internationally was placed on equal footing with the verses

and stories that had fixed their city in the minds of so many as a center of great learning. In so doing, the lawyers in the guild were made to look every bit as thoughtful, florid, and intellectually gifted as those poets, theologians, and philosophers who used their pens for decidedly different pursuits. These judges and notaries thought highly of themselves, indeed.

The vaulting between these opposing lunettes, one with poets and the other with enthroned figures, connects the two walls only indirectly. Each section contains within it a single-winged figure who wears a robe or toga and holds an object that now, after hundreds of years, has dissolved to the point of obscurity (Figure 54). No two of these figures are exactly alike. One wears a crown, another a helmet, and still another covers his head with a cowl. One of these winged men holds in his hands a scroll and brandishes a sword. Another seems to hold a censer, a third brandishes a baton, and a fourth wields a staff. Such imposing figures invite interpretations associating them with angelic forms, civic virtues, or icons of power consistent with the role of the guilds-men who used this room. Were it not for the fact that fourteenth-century conventions normally dictated the appearance of allegorical figures of Wis-dom, Justice, Temperance, and Prudence in the guise of women, these winged creatures might well be understood to represent those virtuous traits celebrated in the Guild of Judges and Notaries. However, the presence of whiskers on their somber faces indicates that these were all designed to represent male charac-ters, which makes their identity as either virtues or angels improbable. These strange creatures were invented entirely from whole cloth, and defy positive identification.

Yet perhaps the most unusual image included in the decoration of this guild residence appears at the very core of the audience hall, where the sections of both vaults meet at the room's core. In what may well be an image unique in Florence, the Arte dei Giudici e Notai commissioned an artist to paint a symbolic portrait of the city that the guild was charged to protect and main-tain (Figures 50). Here appears a crenellated wall which serves as a circu-lar framing device, complete with sixteen towers and eight gates, exactly the number originally contained in Florence's third set of walls that surrounded the city by the beginning of the fourteenth century. Inside this architectural allegory appear the escutcheons of each of the twenty-one guilds, pyramidal symbols of the sixteen gonfaloni comprising the city's different districts, and the coats of arms of the four quarters of Florence. No human beings or rec-ognizable structures appear here, nor is any story or event recorded for our consideration. It cannot be considered a true architectural portrait, for a like-ness of the place has not been attempted. Instead, the city has been depicted as a unified whole, comprising all its separate parts and distinctive neighbor-hoods, with all rivalries and internal disputes washed away by the collectively protective walls and the equally important trade associations that employed so

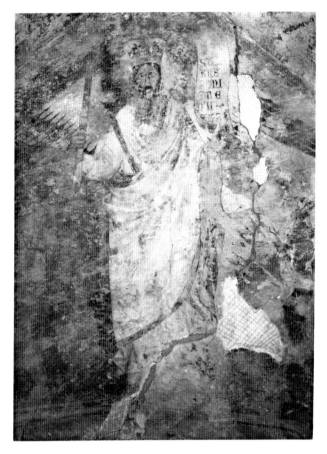

54. Ambrogio di Baldese, *Allegorical Winged Figure*, ca. 1406, Palazzo Arte dei Giudici e Notai, Florence. Photograph courtesy Gabinetto Fotografico del Polo Museale Regionale della Toscana.

many people in Florence. At the very center of this residence hall, members of the Guild of Judges and Notaries saw what it was they were working to protect, and were able to understand that the work they did in the private chambers of individuals and as representatives of a variety of clients held the entire community together.

Guild members liked to look at images inside their residencies that promoted their services to the community, advanced their elevated position in the social hierarchy, affirmed their collective piety, and celebrated their historic achievements in governmental and cultural affairs. As mainstays of a political and economic structure, the guilds felt a sense of entitlement, and the self-promotional aspect of the images they commissioned to advertise their virtues was designed sincerely and ardently. In an age marked by a spirit of corporatism that extended into the farthest reaches of late medieval society, Trecento Florentine merchants and service providers worked hard to show their worth, their

merit, and their potential for future successes. The best way to communicate these ideas to the widest swath of viewers possible was through the installation of pictures that articulated them clearly and concisely.

THE WOOL GUILD

For all of the posturing done by the Judges and Notaries, Florence was, in the end, a textile town.

Although not necessarily a "new technology," the production of finished and unfinished cloth was perfected in this city in ways that allowed the Florentine economy to expand exponentially during the early Republican period. Indeed it may have been intimately connected with its ability to achieve and maintain political autonomy as a republic. Slowly in the thirteenth century, but with a notable increase in volume in the fourteenth, local wool merchants supplemented the rather low quality of fleece produced in the fields of Tuscany with much higher quality imports from Flanders, England, and other centers in Northern Europe.[23]

A number of geographic and demographic features combined to make Florence an ideal setting for this industry. The natural energy created by the currents of the Arno helped turn looms that spun this fleece into cloth. Dyers used its waters to mix their colors. The width and depth of the river made for a perfect sewage system, as the human and animal urine used to bleach the dark and dirty wool could be dumped into it and sent downstream without polluting the urban drinking supply. And with a large population of workers eager to earn a livable wage, the city could call upon thousands of skilled and unskilled laborers to do the physically demanding (and often dangerous) work of carding, combing, dying, weaving, and spinning the cloth once it arrived. After the product had been prepared for sale to finishers, it was either shipped out of the city altogether, where it was fashioned into clothing or coverings by regional workers, or was made available to bottegas in Florence's own Cloth Merchants' Guild, which specialized in turning wool (and silk and linen) into Europe's finest and most elegant garments. With clients all across the Occident and Orient, Florentine wool merchants profited mightily from its international reputation.

Gaining entrance into this trade, however, depended on proper training, good fortune, and connections. The family business was often passed down from father to son, which helped keep fortunes intact while ensuring a seamless transition from one patriarch to the next as leadership changed hands. But even those who inherited a professional livelihood in the wool trade had to serve apprenticeships, just like those with no hereditary connections to the industry. In a competitive market where roughly 30 percent of the population

claimed some sort of affiliation with the Arte della Lana, entrepreneurship and charismatic salesmanship became essential traits for success. Once admitted to the guild, of course, all new members were required to abide by the rules that regulated trade and behavior within its system. These rules often revolved around the maintenance of fair business practices, the setting of prices and wages and tariffs, and generally ensured the longevity of the industry as a stalwart of the Florentine economy. Each guild had the ability to prosecute members violating these rules, and did so frequently and sometimes quite harshly, for these international merchants recognized that clients and customers abroad were monitoring their actions closely. In an effort to instill in these foreign investors the confidence they required to continue their associations with Florentine industries, guild leaders felt obligated to demonstrate their honesty by demanding from their own a high ethical standard. Those who managed to gain entrance into the guild were proud of their affiliation, and they worked hard not to jeopardize it. They abided by the policies and standards set by their leaders and accepted the judgments of their elected officers.

Less predictable were the *sottoposti*, those laborers who did the industrial dirty work but were not admitted into the prestigious corridors of the Arte della Lana. These were not the upper-middle-class businessmen and entrepreneurs negotiating with foreign clients or managing vast networks of local workshops. They were instead the men and women who toiled in the unsanitary and unsafe sweatshops to execute tasks necessary for the production of high-quality woolen cloth. Carders and combers received bales of unworked fleece and gleaned from this raw material the dirt, insects, and unwanted particles that settled there. Once this physically taxing work was completed, runners collected the cleaned wool and delivered it to beaters, spinners, and bleachers, who finished the cleansing process by running highly toxic liquids through the fleece. Weavers and stretchers then processed the material into a more refined product. Dyers were among the last to receive these bolts of cloth, and they helped transform them into various shades of vermilion, azure, and emerald that helped determine each bolt's final price. As with pigments used by painters of frescoes and altarpieces, each color had a specific monetary value and buyers of woolen cloth were well aware of the financial distinctions between wool tinted sky blue (*celestino*, worth eight florins per hundred pieces of cloth), monkish grey (*monachino*, twelve florins per hundred), and deep rose (*rosato*, twenty-five per hundred).[24]

But not everyone involved in the industry profited the same way that guildsmen did, and the relationship between *laniauoli* and *sottoposti* oscillated with some volatility. The people responsible for doing the manual work necessary to produce fine cloth were not granted access to the guild, despite the fact that their wages, the prices their products fetched, and the conditions in which

they worked were fixed by that body. Yet these same laborers were expected to adhere to the regulations imposed upon them by the Arte della Lana. Discontent simmered among laborers excluded from the guild that dictated their economic fortunes, and on occasion boiled over with unexpected consequences. With little to lose from flaunting guild regulations, these *sottoposti* could cause trouble for their more established supervisors by sidestepping trade agreements, undercutting the prices charged by guild members, or as we shall soon see, fomenting insurrection within the system.[25] When that happened – during the mid-1340s and again in the late 1370s, for example – these *sottoposti* were forced to attend legal proceedings inside the headquarters of the Arte della Lana, where elected officials presided over petitions and claims between Florentines engaged in the wool industry. The residence hall, as a result, could be a place of contention, discord, and high drama during particularly tense moments in the city's history.

As was the case with every other guild in Florence, the Arte della Lana retained in its residence a Statute Book that set down matters of policy that all its members were obligated to follow. These bylaws were revised periodically when new problems or circumstances dictated a fresh approach, and the Wool Guild made sure that their rules and regulations were up to date and available to *lanaiuoli* at all times. When fire engulfed their residence in 1331, the original manuscript bearing those bylaws disappeared, along with the furnishings and decorations of the building. A new book was completed in 1333 for the benefit of the membership, with old statutes rewritten and new ones added to supplement the original foundation of the guild. The Wool Guild's book contains a painted image on its incipit page, immediately following the table of contents that consume the first five folios (Plate XXI).[26] This professionally executed miniature, painted on expensive vellum usually reserved for liturgical texts and other luxury books, uses the tendrils of a lengthy plant to circle three sides of folio 6. At the very top, contained in a blue roundel, appears the image of the *Agnus Dei*, symbol of the Wool Guild and the subject of a carved relief that had been inserted into the guild's residence hall when they purchased their property on the Via Calimala in 1308 (Figure 55). This nimbed white lamb moves across our visual field from right to left, lifting its front-right paw to hold a cruciform banner marked by the red cross of the Resurrection. From the lamb's chest spurts a stream of blood, echoing apocalyptic images found at a variety of sites all across western Christendom. In this miniature, the image of the lamb worked as the symbol of the Wool Guild, a symbol of John the Baptist as the *Agnus Dei*, and as a symbol of the ultimate blood sacrifice by Christ on the Cross.

But the image in the Statutes Book includes two other figures of equal importance. Running down the left margin, the tendrils of this miniature's

55. Palazzo Arte della Lana, Via Calimala, Florence. Photograph courtesy Scala/Art Resource, New York.

fictive plant evolve into a rectangular initial I, beginning the text of the page with the words, "In nomine Deo amen." At the letter's base we see the half-length image of Stephen the Proto-martyr, patron saint of the Wool Guild, gazing toward his left in the direction of the text that appears next to him. With three small rocks imbedded in his head, the red-clad deacon seems at once dignified and humbled by his martyrdom. The watchful gaze of Stephen was surely intended to remind readers of his vigilance and approval of these rules and regulations, for the very presence of the Wool Guild's patron saint indicated his assistance both with their creation and with their enforcement, thanks in no small part to his service as a heavenly advocate for these businessmen in the Celestial Court. The inclusion of the guild's patron saint on this page reminded readers of his constant presence in the Palazzo Arte della Lana and provided a precedent for Stephen's appearance in pictures produced later in the century for sites important to the guild (Plate XX and Figure 48).

As if to underscore Stephen's power in heaven, the miniaturist paired him with the Supreme Authority for whom he serves as advocate. At the top of the initial I appears the half-length figure of Christ the Judge. Draped in a purple robe, the bearded man holds in his right hand a sword that leans against his shoulder, while in his left he clutches a scroll that descends out of the framing device that contains him. Written distinctly on this scroll appear the words, "Fa misericordia: Fa justitia" – "Have mercy. Be just." This unusual textual selection accompanies a similarly unusual visual choice, as images of Christ with a sword and scroll appear only infrequently in the art of fourteenth-century Florence. This militant Christ seems neither tender, nor humble, nor loving. Rather, he wields the sword as an emblem of bold objectivity and "tough love" in his role as final arbiter. This judging Christ seems to possess Solomon's decisiveness and Junius Brutus's somber judiciousness, while simultaneously emphasizing that Cardinal virtue of Christian Charity.

When connected with the image of the *Agnus Dei* above and the martyred Saint Stephen below, the heavenly placement of Christ and his role as active judge make clear the importance placed by members of the Wool Guild on the concept of swift, yet merciful, Justice. As readers in the guild considered their Manual of Policies and Procedures, images of the sacrificial lamb, their patron saint, and a merciful yet demanding judge reminded them of the context in which their rules and regulations needed to be read, understood, and followed.

THE SALA D'UDIENZA OF THE WOOL GUILD RESIDENCE

On July 16, 1331, the residence hall owned and operated by the Wool Guild was consumed by fire, killing at least one person who could not escape the flames. Although the stone exterior withstood the blaze, the building's interior was completely gutted, from the workshop on the ground floor to the top of the uppermost floors where leaders of the guild met to conduct their business. No records from the day tell us whether the objects, images, or documents stored in the building survived the conflagration, but the absence of books, records, and portable decorations predating 1331 suggests that nearly everything was lost that day. But the guild recovered quickly, and in an act befitting the city's largest and richest corporate body, the Arte della Lana soon rebuilt its headquarters with an eye toward quality. The new vaults in their three-story building so impressed Villani that he was moved to mention them in his otherwise terse description of the guildhall's destruction and renovation: "And then," Villani wrote, "on the 16th of July, inside the palace of the Wool Guild by Orsanmichele, a fire burned from the first vaults upward, killing one man who was caught watching it, thinking he could escape: then the Wool Guild refurbished it more nobly than before with vaults all the way to its top."[27] It was a magnificent structure in Villani's eyes.

56. Bottega, Palazzo Arte della Lana, Via Calimala, Florence. Photograph © George R. Bent.

The Wool Guild's residency was strategically located in the very heart of the city, literally next door to the granary of Orsanmichele. Situated on the ancient *decumanus* only one block from the Oratory of Santa Maria della Tromba on the Via Calimala, the palazzo sat on the main artery that connected the Mercato Vecchio to the Mercato Nuovo, the Arno River, and (after 1345) the Ponte Vecchio. Like most other large buildings in Florence's commercial district, the new palace featured at street level a double-vaulted, open loggia with a shop inside it, where clients could purchase the wool that guild members produced (Figure 56).[28] Thankfully the building was preserved in the late nineteenth century, perhaps due to its significance as the headquarters of Florence's most important industry.

As was the case with the Guild of Notaries and Judges (and, presumably, every other guild in the city), the most important collection of images that pertained to the industry appeared in the palazzo's Audience Hall on the *primo piano*. In the Wool Guild headquarters, two vaulted chambers were joined together to form a single rectilinear room for guild members and their elected officials. In this Sala d'Udienza were held the conversations that forged guild policies and the judgments that announced to its members the kind of justice meted out by the governing body of the Arte della Lana. Petitions brought by *lanaiuoli* were presented to the consuls of the guild, who listened to the arguments of all parties and then attempted to resolve them through acts of

57. Vault, Palazzo Arte della Lana, Florence. Photograph © George R. Bent.

restitution, restrictions, and the imposition of fines.[29] Like the vaults of the ground floor below, the primo piano was decorated along the lobed areas of lunette-shaped walls with scenes that addressed an unpredictable audience. While visitors to this inner sanctum were almost all participants in the wool industry, their socioeconomic standing, educational background, and even sex were not at all fixed. *Sottoposti*, who could be women as well as men, occasionally addressed the consuls in chambers, and Villani's description of the building's interior suggests that he – a banker and a member of the Cloth Merchants' Guild – had access to this official room, even though he was not a member of the Wool Guild.

This fairly large room, spanning two vaulted bays and oriented longitudinally on an east-west axis, was decorated periodically during the decades following the disastrous fire that engulfed the building on July 16, 1331.[30] Each section of the two quadripartite vaults bears a single figure within it, with the west bay's vaults containing the Four Evangelists seated before lecterns and joined by their respective iconographic attributes. The east bay's vaults present half-length winged virtues, embedded within a rosette frame ornamented to suggest a church window (Figure 57). The north lunette wall directly below is, today, unimaginatively covered with a smattering of familial coats of arms, while the east wall (with windows opening out to Orsanmichele) and the south wall bears

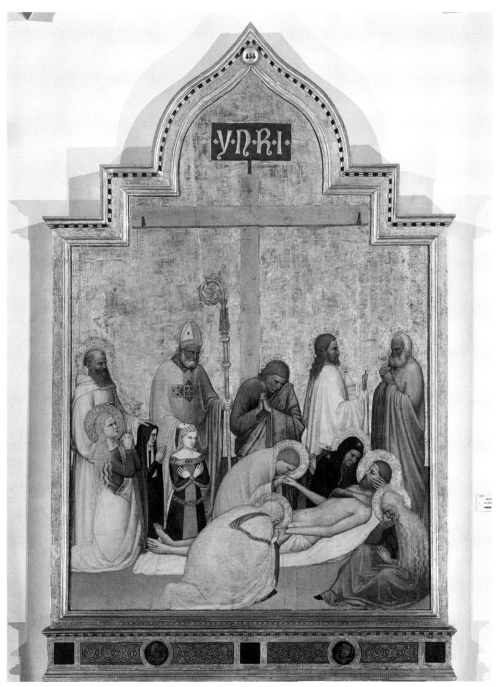

PLATE 1. Giottino, *Lamentation of Christ*, ca. 1360, Uffizi Galleries, Florence. Photograph courtesy Scala/Art Resource, New York.

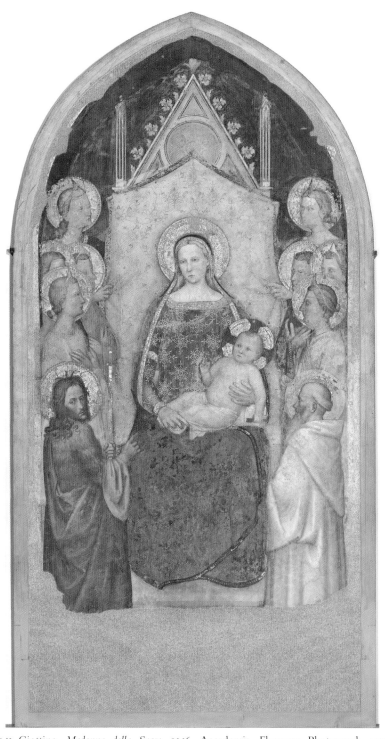

PLATE II. Giottino, *Madonna della Sagra*, 1356, Accademia, Florence. Photograph courtesy Scala/Ministero per i Beni e le Attività Culturali/Art Resource, New York.

PLATE III. Andrea del Bonaiuto, *Madonna of Humility*, ca. 1375, Via San Gallo, Florence. Photograph © George R. Bent.

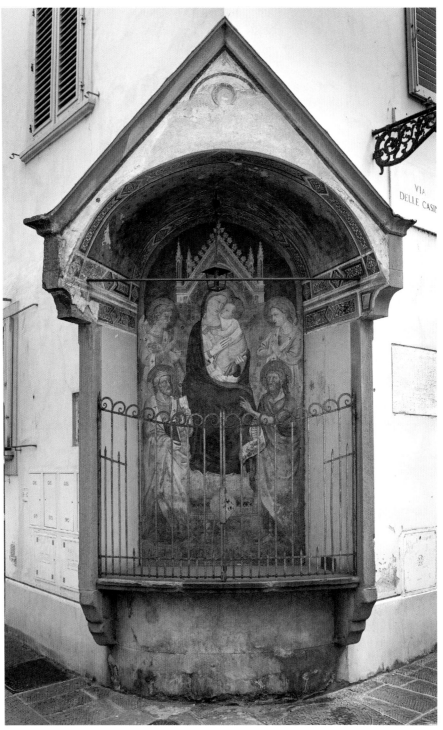

PLATE IV. *Madonna dei Malcontenti*, ca. 1385, Via dei Malcontenti, Florence. Photograph courtesy Scala/Art Resource, New York.

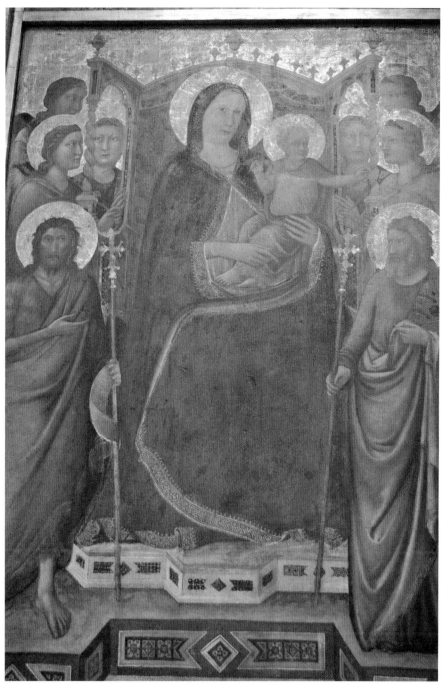

PLATE V. Jacopo del Casentino, *Madonna della Tromba*, ca. 1335–1340, Palazzo Arte della Lana, Florence. Photograph © George R. Bent.

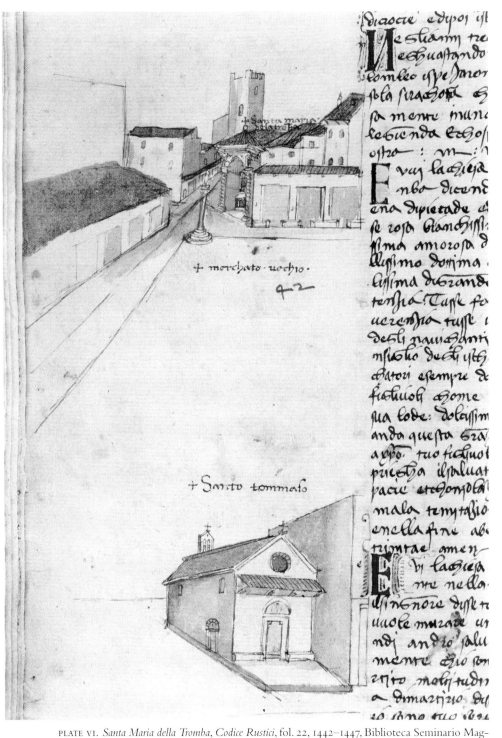

PLATE VI. *Santa Maria della Tromba, Codice Rustici*, fol. 22, 1442–1447, Biblioteca Seminario Maggiore, Florence. Photograph courtesy Scala/Art Resource, New York.

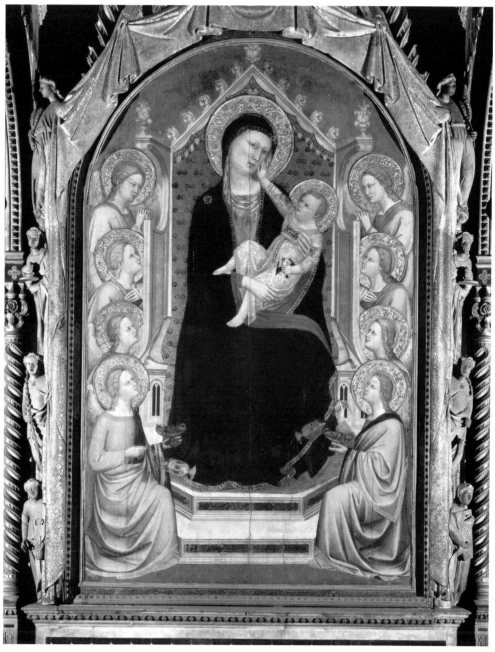

PLATE VII. Bernardo Daddi, *Madonna of Orsanmichele*, 1347, Orsanmichele, Florence. Photograph courtesy Scala/Art Resource, New York.

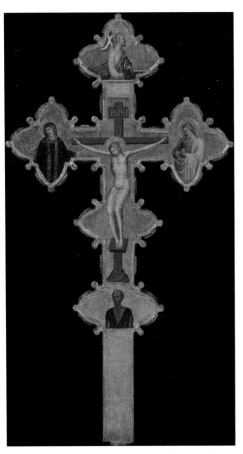

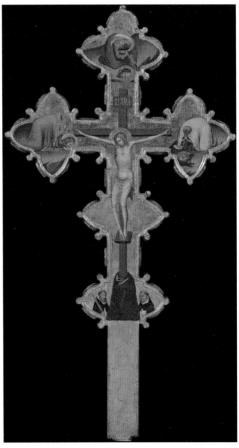

PLATE VIII. Bernardo Daddi, *Crucifix* (recto), ca. 1345, Museo Poldi Pezzoli, Milan. Photograph courtesy Museo Poldi Pezzoli, Milan.

PLATE IX. Bernardo Daddi, *Crucifix* (verso), ca. 1345, Museo Poldi Pezzoli, Milan. Photograph courtesy Museo Poldi Pezzoli, Milan.

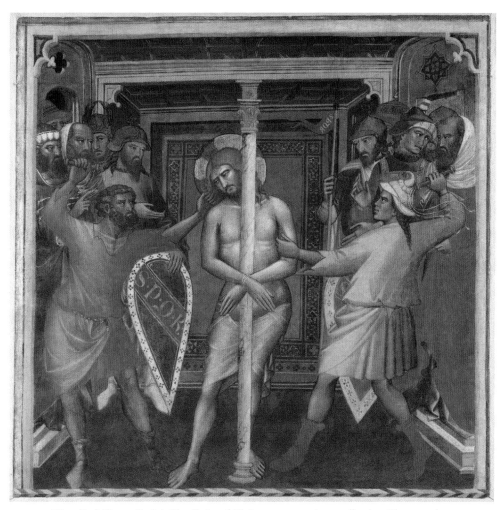

PLATE X. Niccolò di Pietro Gerini, *Flagellation of Christ*, ca. 1390, private collection. Photograph courtesy Sotheby's.

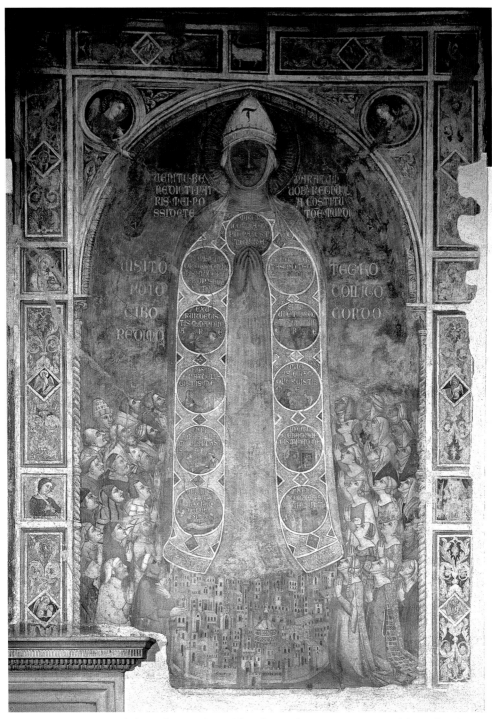

PLATE XI. Workshop of Bernardo Daddi, *Allegory of Mercy*, 1342, Museo del Bigallo, Florence. Photograph courtesy Alinari/Art Resource, New York.

PLATE XII. Niccolò di Pietro Gerini and Ambrogio di Baldese, *Abandonment of Children and the Reunification of Families*, 1386, Museo del Bigallo, Florence. Photograph © George R. Bent.

PLATE XIII. Reconstruction, *Abandonment of Children and the Reunification of Families*, 1386, Museo del Bigallo, Florence. Photograph © George R. Bent.

PLATE XIV. Jacopo di Cione, *Madonna Lactans*, ca. 1375, National Gallery of Art, Washington, D.C. Photograph courtesy National Gallery of Art, Washington, D.C.

PLATE XV. Workshop of Lorenzo Monaco, *Double Intercession*, ca. 1400, Metropolitan Museum of Art, New York. Photograph © The Metropolitan Museum of Art, New York.

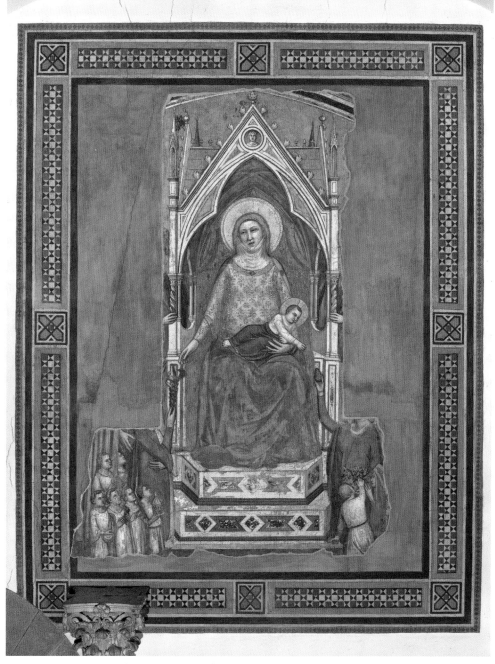

PLATE XVI. Giotto (?), *Enthroned Madonna with Symbols of the City*, 1334–1336, Museo Nazionale del Bargello, Florence. Photograph courtesy Scala/Ministero per i Beni e le Attività culturali/Art Resource, New York.

PLATE XVII. Andrea di Cione (?), *Expulsion of the Duke of Athens*, ca. 1345, Palazzo Vecchio, Florence. Photograph courtesy Scala/Art Resource, New York.

PLATE XVIII. Jacopo di Cione, *Coronation of the Virgin*, 1373, Accademia, Florence. Photograph courtesy Scala/Art Resource, New York.

PLATE XIX. Fra Angelico, *Madonna and Child*, 1435, Museo di San Marco, Florence. Photograph courtesy Scala/Art Resource, New York.

PLATE XX. Mariotto di Nardo, *Madonna and Child with Saints Stephen and Reparata*, ca. 1385, Accademia, Florence. Photograph courtesy Finsiel/Alinari/Art Resource, New York.

PLATE XXII. Sala d'Udienza, Palazzo Arte della Lana, Florence. Photograph © George R. Bent.

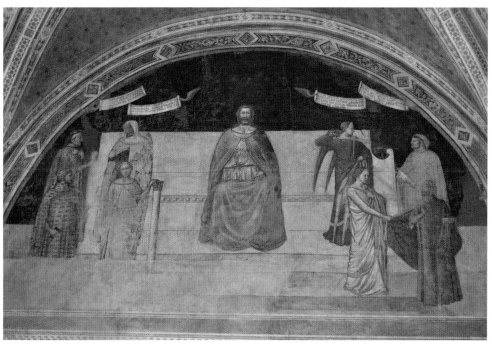

PLATE XXIV. Nardo di Cione (?), *Judgment of Brutus*, ca. 1345, Palazzo Arte della Lana, Florence. Photograph © George R. Bent.

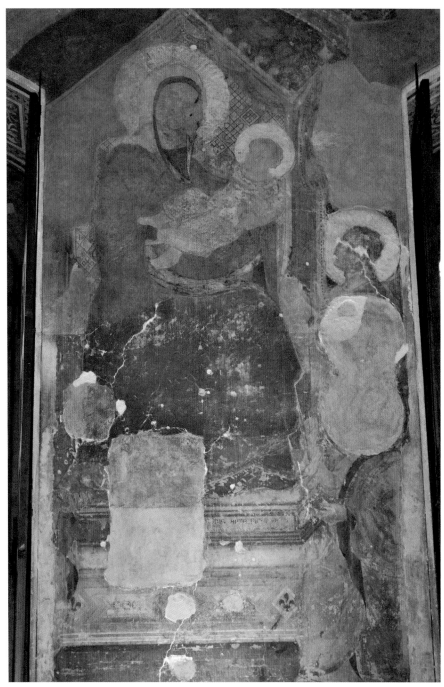

PLATE XXIII. *Madonna della Lana*, ca. 1315, Palazzo Arte della Lana, Florence. Photograph ©
George R. Bent.

PLATE XXV. Bernardo Daddi, *Saint Paul*, 1333, National Gallery of Art, Washington, D.C. Photograph courtesy National Gallery of Art, Washington, D.C.

PLATE XXVI. Giovanni del Biondo, *Martyrdom of Saint Sebastian*, ca. 1376, Museo dell'Opera del Duomo, Florence. Photograph courtesy Scala/Art Resource, New York.

PLATE XXVII. Jacopo di Cione and Giovanni del Biondo, *Saint Zenobius*, ca. 1390, Santa Maria del Fiore, Florence. Photograph courtesy Scala/Ministero per i Beni e le Attività culturali/Art Resource, New York.

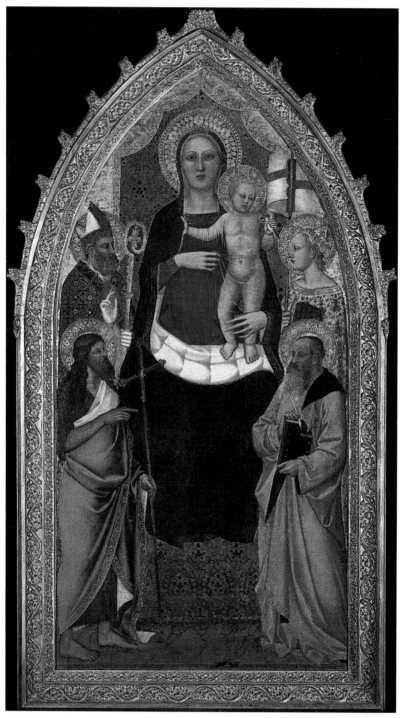

PLATE XXVIII. Nardo di Cione, *Madonna and Child with Saints Zenobius, John the Baptist, Reparata, and John the Evangelist*, ca. 1360, Brooklyn Museum of Art, Brooklyn, New York. Photograph courtesy Brooklyn Museum of Art, Healy Purchase Fund B gift.

PLATE XXIX. Giovanni del Biondo, *Saint John the Evangelist*, ca. 1380, Accademia, Florence. Photograph courtesy Finsiel/Alinari /Art Resource, New York.

PLATE XXX. Andrea di Cione and Jacopo di Cione, *Saint Matthew and Scenes from His Life*, 1369, Uffizi, Florence. Photograph courtesy Scala/Ministero per i Beni e le Attività culturali/Art Resource, New York.

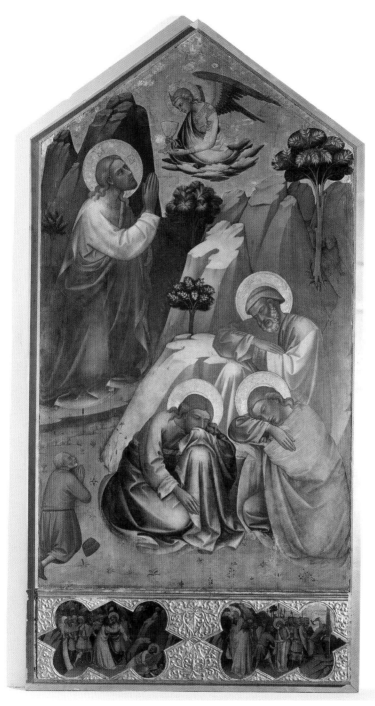

PLATE XXXI. Lorenzo Monaco, *Agony in the Garden*, ca. 1396, Accademia, Florence. Photograph courtesy Scala/Art Resource, New York.

PLATE XXXII. *Saints Mary Magdalene, Nicholas, Miniato, Andrew, and Christopher*, ca. 1380–1390, San Miniato al Monte, Florence. Photograph © DeA Picture Library/Art Resource, New York.

PLATE XXXIII. *Coronation of the Virgin*, ca. 1300, Santa Maria del Fiore, Florence. Photograph courtesy Mondadori Portfolio/Electa/Art Resource, New York.

PLATE XXXIV. *Last Judgment and Biblical Scenes*, detail, *Last Judgment* (southwest, west, and north-west vaults), ca. 1275–1300, San Giovanni, Florence. Photograph courtesy © DeA Picture Library/Art Resource, New York.

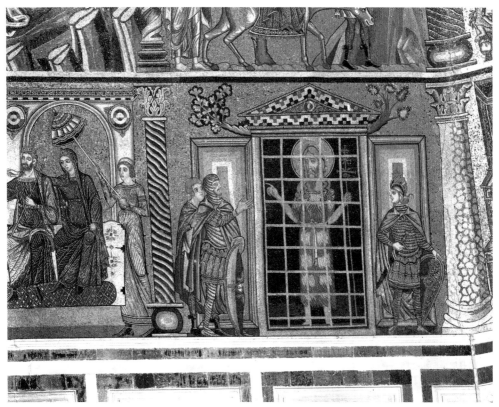

PLATE XXXV. *Last Judgment and Biblical Scenes*, detail, east vault, *John the Baptist Imprisoned*, ca. 1275–1300, San Giovanni, Florence. Photograph courtesy Erich Lessing/Art Resource, New York.

PLATE XXXVI. Andrea di Cione, *Hell*, ca. 1345, Santa Croce, Florence. Photograph courtesy Scala/Art Resource, New York.

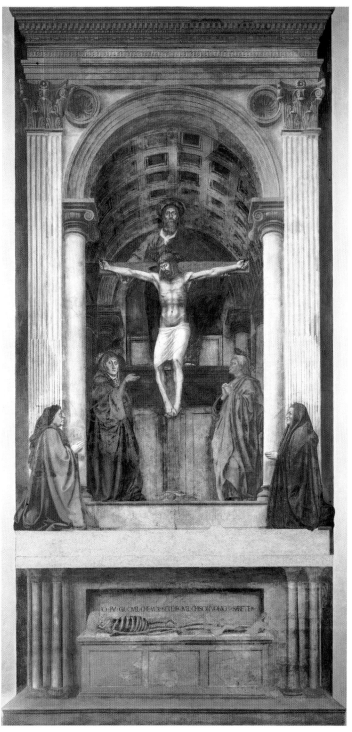

PLATE XXXVII. Masaccio, *Holy Trinity*, 1427, Santa Maria Novella, Florence. Photograph courtesy Alinari/Art Resource, New York.

PLATE XXXVIII. Pulpit, Santa Maria Novella, Florence. Photograph courtesy Scala/Art Resource, New York.

PLATE XXXIX. View of the *Holy Trinity* from the east portal, Santa Maria Novella, Florence. Photograph © George R. Bent.

58. *Annunciation of the Virgin*, ca. 1315, Palazzo Arte della Lana, Florence. Photograph © George R. Bent.

no images whatsoever. We have no archival evidence to indicate its original appearance in the fourteenth century. However, the west bay of the Audience Hall was an entirely different matter, and the inexplicably understudied imagery that still survives there today warrants our full attention.

The western end of the Sala d'Udienza contains three large and prominent pictures elevated over the viewer's eye level (Plate XXII). The west wall bears an image of the *Madonna della Lana*, with the Virgin and Christ flanked by angels (Plate XXIII). Three individual roundels surround this imposing group: here are painted a sword-bearing Christ the Judge, centered between representations of the Archangel Gabriel and the Virgin Annunciate (Figure 58). The frescoes in the west bay look inward toward the core and the eyes of these characters focus their attention – and ours – on proceedings and conversations transpiring between them. Quite clearly, this portion of the Audience Hall served as the focus of attention on the primo piano.

The earliest of these paintings, the *Madonna della Lana*, referred directly to the conflated compositions normally seen in street tabernacles and confraternity Madonnas (Plate XXIII). Framed by a pinnacled throne with fenestrated sides and located beneath the roundels of Christ and the Annunciation, the blue-clad Mary holds her reclining son with arms that act as a basket for the child. Six angels – three on each side – align beneath the holy couple in veneration. The angels at the bottom kneel and swing censors, while the couples above them lift their faces toward the Virgin reverentially. Mary twists in her regal throne just enough to provide a comfortable crook in her arm in which to support her child, who playfully raises his right hand to his mother's cheek for an intimate caress. The focus on the Holy Couple with Angels in a unified format recalls

the thirteenth-century template of the *Rucellai Madonna*, Cimabue's version in
Santa Trinita, and the cult image of the *Madonna of Orsanmichele* (Figures 22
and 23; see also Plate VII).

The painting functioned partly as a devotional image and partly as a refer-
ence to the proceedings that occurred in this setting. Below the fresco of the
Madonna della Lana was written an inscription (still visible) which states, "O
sweetest ever Virgin Mary, angels will take joy in you; just men find grace (in
you), sinners reach for eternal forgiveness. In the lap of the mother rests the
wisdom of the Father."[31] Written in a manner akin to that used in texts for
hymns sung in religious confraternities, these verses provided for visitors to the
Sala d'Udienza a reminder of the potency inherent in the image of the Virgin
Mary.[32] The similarities with the almost identically rendered cult image of the
Beta *Madonna of Orsanmichele*, literally across the street from the Wool Guild
residence and facing the *Madonna della Lana* from the loggia of the grain distri-
bution center, marked the fresco as a picture potentially imbued with spiritual
power.[33] Yet the actual message of the inscription, which emphasizes justice,
wisdom, humility, and redemption, focused the viewer's attention on matters
more closely at hand than that of the soul's final destination. The *Madonna
della Lana* illustrated the jurisdictional range of the guild's tribunal court, the
authority of the consuls who presided over it, and the respect owed to them
by everyone in the room before, during, and after official proceedings were
conducted. Mary was present as an advocate for the consuls, and any displays
of disrespect aimed at them would also be aimed at her.

While the surface of the *Madonna della Lana* prevents serious attributions
to artists active during the first half of the fourteenth century, the painting's
compositional appearance and the events of the 1330s help us narrow down its
date of completion. Surely the *Madonna della Lana* postdates Duccio's *Rucellai
Madonna* of circa 1290 and Giotto's *Ognissanti Madonna* of circa 1310, just as
it must have followed on the heels of the Beta *Madonna of Orsanmichele*. Its
compositional proximity to these seminal works has led many to consider the
Madonna della Lana as an immediate descendant of them, with a date of com-
pletion sometime before 1320.[34] Yet the all-consuming conflagration of 1331
suggests that such an early date cannot stand, for the fire destroyed the struc-
ture's interior entirely and caused the corporation to rebuild its Sala d'Udienza
into a "more noble" space.[35] Such a space must have demanded the attentions
of the artists who produced the paintings that adorn its walls today, including
the *Madonna della Lana*. This important *terminus post quem*, combined with its
compositional dependency on important paintings produced during the first
third of the fourteenth century, suggests that the *Madonna della Lana* was painted
in the Wool Guild's Sala d'Udienza sometime between 1332 and 1340.[36] But
it was also designed to refer to older, venerable forms that graced the public
realm and were known to common viewers standing inside the Audience Hall.

59. *Saints Martin, Pancras, Peter, and Frediano*, ca. 1370–1380, Palazzo Arte della Lana, Florence. Photograph © George R. Bent.

Finally, the images on the west wall have much in common with another important image produced for the Wool Guild in the middle of the 1330s. The roundel bearing the image of the sword-bearing Christ above the *Madonna della Lana* imitates with surprising fidelity the miniature of *Christ the Judge* we have already encountered from the frontispiece of the guild's Statutes Book of 1333 (Plate XXI). The same half-length representation, complete with the sword extending beyond the rounded border containing the head of Christ, presided over the consuls in the Audience Hall of the Wool Guild's residence on the primo piano, echoing the smaller painting in the rule book these same officials used as their guide. Indeed, the phrase "Fa misericordia; Fa justitia" that accompanied the miniature of the same sword-wielding Christ figure in the guild's Statute Book comes immediately to mind. While it is impossible to say which of these two images came first, it appears that the miniature and the fresco were both produced at approximately the same time, sometime soon after 1333.

Two lunette walls abut this section. On the south side appear figural representations of Florence's four urban quarters, while on the north wall we see the highly unusual image of the *Judgment of Brutus* (Plate XXIV). The frescoes of *Saints Martin, Pancras, Peter and Frediano* on the south wall of the Wool Guild's west vault represent the most traditional portion of the area (Figure 59).

Standing rigidly above their symbolic elements, the four saints – representatives of the city's four quarters – stand in fictive niches marked by slender twisted columns that partition the field into four separate units.[37] Each saint wears vestments distinguishing one from the other, with ecclesiastical copes, long woolen robes, and brilliant color combinations marking them. All of them stand on a ledge that runs from one side of the lunette wall to the other, and that elevates them to a position of dominance over the heads of viewers in the room.

Dating these standing saints to a particular decade, or even to a quarter-century, should be done only cautiously. No mention of them appears in the guild's archival records and their ruinous condition makes connoisseurial evaluation nearly impossible. Still, a few observations may help us deduce a general period of production. The tight scrolls of the columns, which seem more carefully rendered than the loose swirls marking the columns on the niches for the saints appearing in the nave of San Miniato al Monte, suggest a date of execution sometime after mid-century, as columns produced in paintings completed before 1350 tend to be straight and flat, while more ornate decorations appear more frequently after the passing of the Black Death (Plate XXXII and Figures 82–85). The robes of Martin on the far left do not suggest an undulation of decoration befitting a textile garment, and instead remind one of a curtain or carpet design, reminiscent of paintings produced after the deaths of Giotto, Maso di Banco, and Bernardo Daddi. The protruding feet of Saint Pancras, furthermore, seem dependent on free-standing pictures of saints painted by Giovanni del Biondo in the 1360s, Jacopo di Cione in the 1370s, and Agnolo Gaddi in the 1380s. We may therefore wish to consider these badly damaged frescoes as products of an unidentifiable painter working in Florence during the decade of the 1370s.

The appearance of the four saints of Florence's main urban districts clearly presented to viewers a communal reference that connected their profession to the city, and the city to the celestial court that included these patrons. But the manner in which they were depicted added a layer of meaning that spoke directly to the room in which they appeared. The separate frames that contain each saint, in both their design and their placement side by side, refer directly to the side panels of polyptychs that normally stood atop altars in nearly every ecclesiastical structure in the city. In the Wool Guild, this approach gave the room the feel of a liturgical painting, as these "side panels" were arranged in sequence, missing only the central panel that traditionally served as the focal point of the altarpiece. But now, in the Wool Guild, this missing central compartment of the Virgin or Christ could quickly be found on the adjacent wall, where the fresco of the *Madonna della Lana* appeared over the heads of guild members grouped together on the floor below it. In the Sala

d'Udienza of the Arte della Lana, a replication of a polyptych was here pulled apart and reassembled, with side panels gathered on one wall and a central panel situated near it at a 90 degree angle. And this dissected altarpiece, in turn, gave the Audience Hall the air of sanctity its consuls desired. For their judgments had to be respected and obeyed to the letter in order for the guild to survive.

CRISIS IN THE WOOL GUILD AND THE *JUDGMENT OF BRUTUS*

The most enigmatic fresco in the Wool Guild's headquarters is also the room's most innovative and, in the end, its most important picture. On the north wall of the Sala d'Udienza appears the image of the *Judgment of Brutus*, featuring the well-dressed First Consul of Rome surrounded by four virtues and four male figures (Plate XXIV). Wearing a purple cloak of regality that covers his blue gown, the enthroned man sits alone on a bench adorned with moldings and scrolled armrests at either end. In his right hand he holds a scepter, and in his left a small bowl now obscured due to the same surface damage that resulted in the destruction of an inscription that originally identified him as Junius Brutus, First Consul of Republican Rome. The eight figures that flank him wear gowns and cloaks of equal fullness and color that celebrate the beauty of cloth produced from Florentine wool. Laymen in blue, pink, and green wear stylish caps, while the virtues they approach wear fine dresses and cloaks as they interact with the men who confront them before the central seated figure.[38] These well-appointed men and allegorical women engage in spirited discussions, transcribed for viewers through inscriptions that originally accompanied them in the composition, to which we shall return shortly. Among them, the figure in the lower right corner of the composition appears to have primacy of place: Brutus, the officious man at the composition's core, glances down at him while his virtuous partner points with her left hand back toward the seated presider, thus forming a diagonal that causes our eye to move back and forth between them. This pair was clearly an area of primary concern for both the fresco's producers and its viewers, for the suggestion of interaction between the authority figure and his supplicants referred directly to a percolating crisis that threatened to tear the guild apart.

The fresco in the Wool Guild's palace was not the earliest illustration to feature a seated protagonist attended by allegorical virtues. Ambrogio Lorenzetti's more elaborate (and more famous) *Allegory of Good Government* in Siena's Palazzo Pubblico, painted between 1338 and 1339, represents the most important precedent for the Wool Guild's fresco (Figure 60). Many of the specific features found in Lorenzetti's painting reappear in the fresco in the Palazzo Arte della Lana. Notably, the painter of the Florentine picture

employed as a foundation for his image a lengthy bench, posed the Roman judge in a frontal position, surrounded him with the four Cardinal Virtues, and commented on matters of political importance through the use of inscriptions on the picture's surface. Although the Florentine fresco places greater emphasis on the aggressive confrontation between the four Virtues and their male counterparts, the concept of representing wisdom allegorically through the figure of Enthroned Justice – advised by personifications of intelligence, strength of character, mercy, and objectivity – depends on the Sienese prototype. While the Florentine fresco does not contain the same number of figures and avoids the narrative component of bound defendants facing stern Ben Comune, as in Lorenzetti's fresco, the interactions between male petitioners and female allegorical figures echo those dotting the larger and more involved Sienese narrative. The painter of the fresco in the Palazzo Arte della Lana clearly knew this precedent and used it as a guide when designing his *Judgment of Brutus*.

Yet the *Allegory of Good Government* was not the only picture that inspired the artist of the *Judgment of Brutus* and the corporate patrons who commissioned it.[39] Appearing in the Florentine Palazzo del Podestà was a now-lost fresco described briefly in both the writings of Lorenzo Ghiberti and Giorgio Vasari, who attributed it to the hand of Giotto di Bondone. Ghiberti mentioned this picture only in passing, stating that the artist painted it for the Commune (Giotto "dipinse nel palagio del Podestà di Firenze …il Comun come era rubato"), but Vasari elaborated on this terse pronouncement in a way that suggested it was a very close relative of the guild's picture, stating:

> In the Great Hall of the Palace of the Podestà he (Giotto) painted the Commune threatened by many people: there was seated the figure in the form of Justice with the scepter in hand, and above his head was positioned scales for the cause of administering justice; he was helped by four virtues.[40]

Based on this description, the missing picture in the Palazzo del Podestà may well have been a template used by the artist who painted the fresco for the Wool Guild. We can safely presume that the painter of the *Judgment of Brutus* knew the frescoes in the governmental palaces of both Florence and Siena, and referred to them directly in this picture for the Wool Guild's Sala d'Udienza. As such, this latter picture contained cultural connections to well-known, politically charged frescoes in the governmental palace of Tuscany's two greatest powers.

While a number of painters were active in Florence during the years immediately following Ambrogio Lorenzetti's completion of the *Allegory of Good*

60. Ambrogio Lorenzetti, *Allegory of Good Government*, 1338–1339, Palazzo Pubblico, Siena. Photograph courtesy Erich Lessing/Art Resource, New York.

Government, the stylistic features and compositional choices made by the artist responsible for the *Judgment of Brutus* align best with those working in the shop of Andrea and Nardo di Cione, who worked together in a single workshop during the 1340s. Although archival references mention Andrea's membership in a flagellant confraternity in Santa Maria Novella as early as 1343, no signed works by either Andrea or Nardo from their early years have survived to provide a definitive example of their early output.[41] Yet Andrea and Nardo quite obviously produced paintings that impressed contemporary viewers during the decade of the 1340s. In a letter penned at just around the time of the Black Death, the brothers were identified by a Pistoian critic as two of the six best painters then working in the city of Florence, a clear reference to the quality of the works they had produced by that time.[42] An *Annunciation* inscribed with the date 1346 bears Andrea's name, confirming his activity in the period, and a number of paintings assigned to the 1340s have been attributed to them, including frescoes of the *Last Judgment* in the nave of Santa Croce (Plate XV), the murals decorating the church of Santa Marta a Montughi, and the highly unusual and innovative fresco depicting the *Expulsion of the Duke of Athens* for

the Stinche (Plate XVII).[43] These pictures, and probably many more now lost to us, were obviously regarded highly by contemporary experts immediately upon their production, for the writer of the Pistoian letter must have used as evidence for his evaluation of the brothers the reputation they enjoyed in their home city, which in turn could only have been acquired through the merits of their accomplishments.

The complete lack of documentation of the pictures decorating the Sala d'Udienza in the Wool Guild's books of deliberations prevents definitive identification of the artists responsible for the paintings. Still, formal elements appearing in the *Judgment of Brutus* suggest connections to pictures produced by Andrea and Nardo di Cione both before and after the later years of the 1340s, the period when the fresco was most likely painted. In their early works, Andrea and Nardo employed combinations of static and gesticulating figures, not unlike those seen in the image for the Palazzo Arte della Lana. While the Virgin, Magdelene, and Evangelist strike poses of stoic remorse in the *Crucifixion* for Santa Marta a Montughi, the angels flanking Christ show a certain freedom of motion akin to the two figures interacting in the lower right corner of the *Judgment of Brutus*. This relationship reappears in the *Expulsion of the Duke of Athens* in the Stinche, most clearly through the gazes and gestures of the winged angels and the tyrant who skulks away from the empty throne to the composition's right. The tiny, disembodied head in the Stinche picture, cradled by its red-clad protector, echoes in form and concept an identically rendered face that peers out from the fictive dado beneath the main portion of the lunette in the Palazzo Arte della Lana (Figure 61).[44]

Perhaps the clearest connection between the fresco in the Palazzo Arte della Lana and works produced in the Cione workshop appears at the throat of the seated figure presiding over the confrontational interactions between Virtues and petitioners that flank the judge. The carefully and powerfully rendered neck of Brutus, complete with bulging muscles that form a "V" from jaw line to larynx, may be seen in Nardo's depiction of Christ in the fresco of *Paradise* in the Strozzi Chapel (Figure 62).[45] It also features prominently in the image of the enthroned and again in the Trinitarian depiction of Christ/God the Father in the altarpiece that Andrea di Cione painted there at approximately the same time (Figure 63). Indeed, the articulated muscles extending down the throats of frontally positioned authority figures is one of the signature stylistic features of pictures produced by Andrea and Nardo di Cione, as may be seen in the neck of Saint Matthew on the panel painted for the column in Orsanmichele (initiated by Andrea at the end of his career and completed by his younger brother Jacopo in 1369; see Plate XXX). Nonetheless, these paintings seem more expertly handled than those in the Wool Guild, suggesting that the image of Brutus and his court predated the more mature, fully formed figures decorating spaces in Santa Maria Novella, Santa Maria degli Angeli, and Orsanmichele. While

61. Nardo di Cione (?), *Judgment of Brutus*, detail (dado), ca. 1345, Palazzo Arte della Lana, Florence. Photograph © George R. Bent.

the painterly approaches of both brothers appear in the *Judgment of Brutus*, the fresco should probably be placed in the orbit of Nardo and his work-shop, produced sometime between 1344 and 1348. The messages transmitted by both words and images within the painting, and the issues demanding the

62. Nardo di Cione, *Paradise*, ca. 1357, Santa Maria Novella, Florence. Photograph courtesy Gabinetto Fotografico del Polo Museale Regionale della Toscana.

attention of members of the fresco's audience during these years, support this dating.

In fact, Florentines in general and *lanaiouli* in particular faced grave threats to their collective sovereignty at precisely this time. The most dangerous of them revolved around the brief but controversial reign of the infamous Walter of Brienne, the so-called Duke of Athens, who ruled the city from September 1342 to July 1343.

63. Andrea di Cione, *Strozzi Altarpiece*, 1357, Santa Maria Novella, Florence. Photograph courtesy Scala/Art Resource, New York.

Walter's failed regime, and the popular opposition to it that resulted in a return to republican rule, may well have influenced the commission and the subject matter of the unusual fresco in the audience hall of the Florentine Wool Guild's headquarters. The story of Junius Brutus was known to Dante, Petrarch, and their readers, and would have made him an ideal pictorial protagonist for the chamber that housed some of the city's most powerful and politically savvy leaders. With the events of 1343 still fresh in their minds, guild consuls may well have seen in Brutus – deposer of tyrants (like Walter of Brienne) and the founder of the governmental system upon which the Florentine commune was based – as a hero who both foretold the fortunes of their city through his own actions and offered contemporary Florentines a role model whose virtues and deeds they could understand and respect. The painting of Brutus in the Wool Guild told viewers that the siege of the Palazzo della Signoria and the expulsion of its tyrannical inhabitant were entirely justified, for a precedent dating back to the origins of Rome was here invoked to explain and justify their rebellion.

But this iconographic reading does not answer the question of why the *Judgment of Brutus* came to be painted inside the Sala d'Udienza of Florence's

most important mercantile corporation. The earlier representation of Brutus painted by Giotto inside the Palazzo del Podestà had nothing to do with Walter of Brienne or the deposition of autocrats in Florence, and there is nothing in the physical representation of the First Consul of Rome in the Wool Guild's fresco to connect the picture directly to the Duke of Athens's ouster. However, the inscriptions accompanying the figures flanking the enthroned judge in the Wool Guild's fresco seem to refer to contemporary events and debates consuming the attention of *lanaiuoli* inside the Arte della Lana at precisely this moment. As we shall see, the political crisis of the early 1340s was neither restricted to the policy decisions of Walter of Brienne nor limited to his poorly conceived notion of political diplomacy, and the picture in the Wool Guild addressed both the broad problems associated with his reign and with subsidiary issues that posed more direct threats inside their headquarters. To understand the appeal of the *Judgment of Brutus* to an audience of wool merchants, we must consider the tremors that shook the corporation following the seismic shifts caused by the deposition of the city's Podestà for Life in 1343.

Of all those Florentines who had plotted against Walter of Brienne in 1343, few were as disenchanted with the Duke's heavy-handed approaches to governance as the members of the Arte della Lana. The guild had been weakened by the Podestà, who had welcomed the opportunity to diminish its power and prestige by approving the formation of a splinter guild from within the ranks of the Arte della Lana. In the fall of 1342, disgruntled dyers had formally petitioned Walter to allow them to separate from the guild that governed them.[46] Citing a litany of transgressions, the dyers claimed that they had no voice in official proceedings, that the elites in the guild inflexibly set wages too low for any kind of economic advancement, and that the guild court hearing their complaints comprised the very men who had set these oppressive policies in the first place. The dyers persuaded the Duke of Athens on all these counts. Walter, to the incredulity and fury of the elites in the Wool Guild, granted the dyers permission to dissolve their association with their masters and to form their own guild in the autumn of 1342.

Tensions increased dramatically the following June, when Walter allowed the dyers to participate in the annual civic procession held on the all-important Feast of Saint John the Baptist, patron saint of Florence. This parade celebrated the sovereignty and power of Florence, and was usually reserved for representatives of the major guilds and the sixteen districts that composed the city. The unexpected appearance of the dyers, who carried banners that flaunted their newly sanctioned independence from the Arte della Lana, fueled the wrath of the members of the Wool Guild. Even Marchionne di Coppo Stefani, himself a member of the lower middle classes and a critic of the elites who controlled Florence's guilds, denounced the actions of both the Duke, whom

he thought presumptuous to alter the structure of the parade of Saint John, and the upstart dyers, who behaved arrogantly and inappropriately when given their independence.[47] Increased taxes and poor diplomatic skills were one thing; but interfering with Florence's most potent industrial corporation could not be forgiven. Within one month of the Feast of Saint John the Baptist, members of the Wool Guild helped organize the siege on the Palazzo della Signoria, and only six weeks after Walter's ouster it conspired with the newly established republican government to disband the fledgling Dyers' Guild that the tyrant had helped form. By the end of September 1343, the rebellious laborers who had joined the short-lived guild only twelve months earlier were forcibly placed back under the jurisdiction of the Arte della Lana, the body they had abandoned one year earlier. Not surprisingly, few of them were pleased by this arrangement.

In fact, separatist sentiments lingered within the laboring branches of the wool industry for much of the decade of the 1340s, as the taste of freedom that had been created by Walter of Brienne's actions whetted an appetite for independence. The records of both the Arte della Lana and the communal government confirm that the five years following the dyers' forced reunion with their guild masters in 1343 were exceptionally contentious. Laborers actively conspired to break free from the Arte della Lana, and the commune regularly uncovered plots hatched by workers to undermine the power of the reconstituted guild. In September 1343, only weeks after their forced reunion with the hated Wool Guild, two men – in two separate instances – were executed by the Capitano del Popolo for trying to organize a separatist movement to replicate the Dyers' Guild that had briefly arisen during the days of Walter of Brienne.[48] Groups of angry laborers roamed city streets, attacking the homes of upper guildsmen and chanting slogans of rebellion.[49] Giovanni Villani reports in his chronicle that the next summer, on August 8, 1344 (on the anniversary of Walter's exodus), fire swept through the wool district abutting the Piazza d'Orsanmichele, destroying eighteen homes and shops, along with a vast number of finished bolts of woolen cloth.[50] The threat of fracture unquestionably frightened the *lanaiuoli* who remained loyal to the Arte della Lana, for in 1344 the Wool Guild amended its statutes to make any and all proposed separations from their body nonnegotiable and, indeed, illegal.[51] The dyers, who had been forcibly reintegrated into the Wool Guild the previous year and had seen colleagues summarily executed for trying to form a similar separatist organization, were furious.

The ardor of some of the fiercest proponents of independence continued to build through 1345, and led to perhaps the most famous example of inner-guild strife in the years immediately following the restitution of the dyers. Under the cover of darkness on the night of May 24, 1345, a wool carder named Ciuto Brandini was pulled from his bed and arrested by officers working for the

Florentine Capitano del Popolo. Brandini was accused of conspiracy and sedition for his attempt to organize a new guild intended to splinter the Arte della Lana and form a new association composed of only carders and combers. Describing the venture as an "evil association" (*iniqua societate*), the Capitano del Popolo accused Ciuto of being possessed by the devil as he seduced the city's disenfranchised wool workers.[52] Ciuto's actions were deemed to constitute an act of overt treason, and his attempts to create this new guild were thought to threaten the entire commune with "tumult, sedition, and disorder."[53] Condemned as a traitor both within the ranks of the Wool Guild and in the Florentine city-state at large, Ciuto Brandini was tried, convicted, and executed for the crime of fomenting rebellion. One of those serving as prior on the night of Ciuto's arrest was a *lanaiuolo* named Bonsi d'Orlando, whose connections to the guild ran deep: he would serve as a consul for the Arte della Lana only one year later, in the autumn of 1346, at approximately the same time as the production of the *Judgment of Brutus*.[54]

Ciuto Brandini's transgression was echoed in the actions of other laborers in the guild, who plotted against the Wool Guild hierarchy throughout much of the 1340s. Only the appearance of bubonic plague in 1348 alleviated these internal disputes, and the economic upturn that followed it in 1350s combined with a collective reevaluation of socio-political realities in the stark aftermath of the unprecedented mortality to distract laborers for a full thirty years. Indeed, the impulse to revolt against a systematically oppressive economic corporation subsided with an increased demand for services, elevated wages that rewarded laborers for their work, and an improvement in conditions for *sottoposti*. When describing the years separating the advent of the Black Death and the Ciompi Revolt of 1378, Gene Brucker has noted the remarkable absence of anti-government activity and the general mood of acceptance among Florentine laborers across the city.[55] The anger of the 1340s, sprung from the failed attempt to organize in 1342, died out during the decade of the 1350s and lay dormant for all of the 1360s and most of the 1370s. The fresco of Brutus must be considered in this historical context.

The identification of the thematic content of the *Judgment of Brutus* was first confirmed by Salomone Morpurgo, who in 1933 published transcriptions of the verses that originally accompanied the fresco, and which confirmed the identity of the central figure seated on the bench.[56] Morpurgo demonstrated that the brief inscription at the base of the throne originally stated, "Every leader takes his cues from Brutus, First Consul of the Romans, who was prudent, just, and temperate," a phrase which echoed the one recorded in an anonymous commentary on Dante's *Commedia*, in which Brutus's devotion to his countrymen is credited to his endowment with the four virtues of Prudence, Fortitude, Justice, and Temperance.[57] While the compositional

similarities to contemporary images of secular authority might tempt us to consider the figure as an allegorical (and thus intentionally anonymous) reference to Justice or Wise Counsel, the reference that Morpurgo found makes clear this figure's specific identity as the early Roman consul.

Although an unusual choice of subject for an important mercantile setting, the selection of Brutus for this image was crucially important for the guild, and illustrates the pressures and tensions it experienced during the decade of the 1340s. Since antiquity, the First Consul's biography made him a role model of objectivity and respectability, all within the context of the concept of Republican Virtue, that resonated with the men who ran the Arte della Lana. Junius Brutus was recognized during the Middle Ages as the ideal personification of republican virtue and civic selflessness, based primarily on events and actions ascribed to him by Livy.[58] The first of these described Brutus's fearless (and risky) demolition of the first Roman monarchy and his role in the creation of the republic that replaced it in the sixth century BCE. The nephew of Lucius Tarquinius, King of the Romans, Brutus despised the heavy-handed approach to government that his uncle employed as ruler. Although eager to overthrow this tyrant, Brutus patiently bided his time and waited for the right opportunity to expose the king's cruelty. Brutus got his chance when he witnessed Lucretia's suicide, precipitated by her rape at the hands of the king's son, Sextus Tarquinius. As Lucretia's father and husband recoiled in horror, Brutus extracted the knife from her body, called for the ousting of the Tarquin dynasty, and then roused the city to expel those responsible for Lucretia's death. Livy's history contends that Brutus then went on to form the Republic of Rome and served as the city's First Consul, a distinction that must have resonated in those Tuscan city-states (like Florence) that were still developing a kindred form of government, and that actively celebrated this republican format as the basis of their communal *libertas*.

But Brutus, champion of Roman republicanism, was also lauded for a second act that further demonstrated his absolute and unbending commitment to the new society he had created and to the virtues of objective justice upon which it was based. When it became clear that his sons, Titus and Tiberias, had plotted to overthrow the Republic he had helped form, Brutus presided over their sentencing and then stoically supervised the torture and execution of his two children as just punishment for their crimes.[59] In the end, Brutus would die from wounds received from a reactionary Tarquin prince during a battle for control of the Roman dominion, ultimately won by the Republican army, thus making him a symbol of stoic patriotism, the father of Roman Republicanism, and a political proto-martyr, all at once. Brutus defended the virtues of the weak (Lucretia), condemned the decadence of unrestrained tyranny (Tarquinius), held his own family members accountable to the letter of the law

(Titus and Tiberias), and gave his life for the sake of the Republic. The figure appearing in the Palazzo Arte della Lana fresco, owing largely (if not exclusively) to Livy's laudatory lines, was an ideal embodiment of justice, republicanism, liberty, and selflessness.

Junius Brutus was an ideal role model for Florentine supporters of republicanism in the first half of the fourteenth century. Both Dante and Petrarch extolled his virtues as a model of jurisprudence and civic sacrifice; Dante, in particular, elevated the consul's status to unusual heights in *De Monarchia*, in which he wrote,

> Did not the first Brutus teach us that not just all other people but our own children must take second place to freedom of the fatherland? Livy says that when he [Brutus] was consul he condemned his own sons to death for conspiring with the enemy. His glory lives on in our poet's sixth book when he says of him: "In fair freedom's name the father condemned to death his own two sons plotting new wars."[60]

Petrarch pays more attention to Junius Brutus in *Africa*, his collection of poems about the ancient world, penned during the late 1330s and early 1340s. Consuming ninety lines of text, Petrarch's treatment of the First Consul of Rome reviews Livy's original account, but ends with the commendation that,

> Romans all, of every age and sex, lamented him, and sounds of mourning never heard before echoed throughout the land....So they mourned and for a year they sang his funeral dirge; nor shall the fame of Brutus ever die.[61]

Petrarch's consideration of Brutus in *De viris illustribus* is equally flattering, as the poet opens his review of the consul's life with a litany of his accomplishments led by the phrase, "Iunius Brutus, fundator liberates, vindex udicitie."[62] Defender of virtue and sworn enemy of tyranny, Brutus was fixed in the collective memories of literate Florentines as a Republican exemplum.[63]

The image of Brutus in the Palazzo Arte della Lana, then, conveyed a deeply communal and political message, due both to the appearance of the First Consul of Rome and to the picture's compositional connection to Giotto's earlier fresco of an enthroned authority figure surrounded by virtues in the Palazzo del Podestà. As the heroic foe of tyranny and a champion of Roman Republican virtues embraced by a city-state deeply invested in a government formed by its citizens, Brutus symbolized civic virtue and anti-imperial rectitude, particularly during times of political tension that might be thought to parallel the crisis that provoked the ouster of the Tarquins.

As we have seen, one iconographic reading of the Wool Guild fresco allows us to connect the figure of Brutus to the victory of republicanism over tyranny witnessed in Florence in 1343. But in a more specific way the location of

the *Judgment of Brutus* in the audience hall of the Wool Guild headquarters suggests that the choice of this subject, motivated by the function of that particular room, may have contained other iconographic references for the people who used that space during this period. The people in the Wool Guild who saw them there – consuls and guild magistrates, petitioners, complainants, defendants, witnesses, and members of the audience who had come either to watch or to participate in civil proceedings – has specific issues with which to contend.

The configuration of the Sala d'Udienza informs our consideration of the frescoes that were viewed by audiences during judicial proceedings. The trio of frescoes in this room, with Brutus and the Four Saints flanking the central image of the *Madonna della Lana* between them, suggests that the consuls sat in chairs or on benches just below the painting of the Virgin, with complainants and defendants facing them during court proceedings (Plate XXII). During these hearings, visitors and petitioners could not help but notice the *Madonna della Lana* overhead, modeled on the nearby miracle-working image of the *Madonna of Orsanmichele*, located across the street from the Wool Guild's headquarters. The inscription running along the picture's base, which includes allusions to "just men," "sinners reaching for eternal forgiveness," and "wisdom," was directed more at them than at those who congregated in those chambers to craft and enforce policy – for the consuls sat with their backs to the image and its inscription. The references to thoughtful adjudication promoted the co-dependent virtues of objectivity and wisdom that guild leaders were assumed to possess, and thus assured petitioners that their claims would be fairly adjudicated.

Affirming this concept was the image of Brutus, who looked down on petitioners from their right as the intellectual and moral ancestor of those living consuls of the Florentine guild who presided over hearings from their position directly below the image of the Virgin. Effigies of Martin, Pancras, Peter, and Frediano, representatives of the city and its four quarters, watched them from the left, inserting into this vortex of painted witnesses a specifically Florentine flavor. With the sword-wielding Christ, the Virgin Mary and angels considering them from behind the consuls seated beneath them, petitioners found themselves surrounded by images that constantly reminded them of the importance of this setting and the gravity of the proceedings in which they were involved.

This set of gazes could be considered an act of intimidation. The eyes of heroes and holy figures were upon everyone in the room, demanding their best behavior, threatening retribution for falsehoods, and destroying impulses to rebel even when testimonies or decisions went awry. The four standing saints, representing not only heavenly advocates but the honor and dignity

of the districts they symbolized, reminded everyone in the room that their words and their actions reflected on their friends, neighbors, and associates: dishonorable behavior here could have repercussions at home. Brutus, the man who had killed his own sons in the name of justice and to ensure the health of the state, also gazed down at them from the right, demanding from viewers and participants their full attention to detail and their solemn promise of truth and fidelity. And Mary, the figure modeled on the miracle-working *Madonna of Orsanmichele* and the behavior modifying street tabernacles upon which it was based, not only reminded petitioners of their obligation to represent themselves honestly but imposed on them the possibility of eternal punishments should lies slip from their lips. These paintings kept everyone in the room attentive, alert, and very focused.

Adding to the dramatic nature of these images, the allegorical and narrative components in the *Judgment of Brutus* referred directly both to daily proceedings in the Sala d'Udienza and to the uneasy relationships between enfranchised *lanaiuoli* and those disenfranchised *sottoposti* who wished to gain either equal footing with guildsmen or economic independence by virtue of the creation of an association of their own. Pointed references to actions in the audience hall and activities outside it appeared in the series of eight inscriptions (only four of which still survive) that originally joined the figures flanking the enthroned Brutus. The phrases in these inscriptions made clear both the expectations that guild officials held for those who came before them and the tenuous position in which the entire guild found itself during the dangerous years of the 1340s.

Three of the four pairs of figures flanking the enthroned Brutus interact with a malevolence conveyed both pictorially and textually. The two men to the left raise their hands to their female partners, while the threat to the Virtue on the right is so great as to cause her to brandish her sword in a defensive mode. The commentary contained in the inscriptions that appear above the heads of these figures echoes these physical manifestations of aggression. Written in the vernacular, an obvious attempt to address a merchant audience poorly versed in Latin, the brief phrases contained in all but one of these inscriptions employ an unusually sophisticated grammatical structure that echoes the poetic voice of Tuscany's most celebrated fourteenth-century writers and that places these elegant lines well beyond the scope of normal prose or common usage. With but one exception, the allegorical virtues and their male counterparts speak a highly cultured language, with the elegantly dressed petitioners feigning reverence to veil their ornate threats and the Virtues replying with equally decorous language no less aggressive in its defensive posture.

This sequence of elegant verbal thrusts and parries begins in the upper left corner (Figure 64). There, initiating this unusually prosaic discourse, a man in a red cap and cape attempts to ply the elderly figure of Prudence with

64. Nardo di Cione (?), *Judgment of Brutus*, detail (left figures), ca. 1345, Palazzo Arte della Lana, Florence. Photograph © George R. Bent.

flowery, ornamental phrases: "I praise you and say, 'never deign to use this place for virtuous things.' I pray you will understand these words that I say to you."[64] Although he honors Prudence at first, his corrupt desires become clear immediately. He is more interested in personal gain than the public good and warns Prudence to accommodate his wishes. Fortunately, wise Prudence understands that her partner wishes to deceive her. Addressing him directly, she asserts that she sees through his deceitful ploy: "Clever flattery," she announces, "enters quickly in foolish minds and works easily, but you who employ this do not love the truth."[65] Prudence accuses her petitioner of outright fraud, as she recognizes that his opening greeting clouds his devious intentions: a war of words has begun.

Perhaps in league with the first petitioner, a man wearing a hooded green gown and carrying a wreath continues the assault on virtue in the lunette's upper right corner (Figure 65). Speaking directly to the sword-bearing image of Justice, he says, "I can obtain all the honesty that I need, and so you can judge as you please the things that I say: my actions should not be enough to threaten you."[66] Not only does he imply that he has the power to influence decisions coming from the bench, but he also tries to lull Giustizia into believing that his ambitions are benign. Justice, however, recognizes that this man in fact does pose a threat and that his motives are much more dangerous than he proposes.

She raises her weapon against him, pointing the tip of her blade at his chest, and declares, "You deserve a shameful death! Now I judge; for glittering, false words will be returned back to those who speak them."[67] This liar has been exposed for what he is, thanks to the cold, objective abilities of Justice. Duplicity and aggression will not be tolerated in this place, for those who work here can easily recognize dissemblers and deceivers when they see them, and the threats they hurl at the innocent will only come back to haunt them. Like wise Prudence, militant Justice not only disapproves of wanton fraud and aggression, but punishes aggressors for them.

This confrontation was escalated in the now-missing inscriptions that once accompanied these figures at the composition's base (Figure 64). According to the lines published by Morpurgo, the man in the lower left corner wearing an exquisite blue robe – probably the most interesting garment worn by any figure in the image – addressed Fortitude, saying, "I understand well by your words that I have been mistreated; but be warned that if in case death doesn't come to me quickly, I will be able to prepare my revenge."[68] The threats hurled at Brutus's protective Virtues are now more brazen in content and tone: the vindictiveness of this intimidating attack indicates that the enemies of justice will not rest until they have punished those who rule against them, which in turn only dimly veils their violent nature and selfish ways. Yet Fortitude deflects these words of aggression. "If you are able to understand that your threats can come to nothing, then you will also be able to understand that your words only make you look foolish."[69] Fortitude, like Prudence and Justice, sees through this bombastic veneer, and she puts her adversary in his place with her curt reply and a sideways glance. Indeed, with her face pointed toward the audience rather than her painted opponent, Fortitude humbles not only the man who stands to her right in the image, but also viewers who might be tempted to employ tactics of intimidation from the floor of the Wool Guild's Sala d'Udienza. Prudence, Justice, and Fortitude respond to attacks made from petitioners approaching Brutus's bench, giving this fresco a sense of looming aggression that speaks poorly of the entire group assembled therein.

Fortunately, in the midst of these threats and retorts, one glimmer of hope appears in the lower right corner, where examples of proper decorum and virtuous humility are presented as exempla for viewers standing before the court of the Arte della Lana. In this pairing, the male petitioner – dressed in red like the man who initiates the dialogue in the upper left corner – shyly turns away from Temperance, his allegorical partner, and tries to hide from her a pair of scrolls that he holds in his hand (Figure 65). Using a more common vocabulary (as opposed to the more poetic, highly sophisticated speech of the other figures) this timid *lanaiuolo* announces, "I'm reluctant to state my case in front of you because I fear I have already offended some of you – and some of

65. Nardo di Cione (?), *Judgment of Brutus*, detail (right figures), ca. 1345, Palazzo Arte della Lana, Florence. Photograph © George R. Bent.

you are, indeed, angry."[70] His modesty, sincerity, and deference in the presence of the judge have caused him to bow before the authority. Moreover, his words suggest that he has already committed some kind of criminal offense that he fears will work against him in this high court. This man believes no one will listen to him, and that he will be punished for some earlier transgression.

Hope comes in the figure of Temperance. True to her nature, the thoughtful virtue reaches out to this honest and humble man, literally tugging on his garment to compel him physically to participate in the judicial process behind her. "Don't fear injustice here," Temperance implores him, "for although you have offended us once, that is not enough to tip the scales of justice against you."[71] This court, she reminds him, is a just one: first-time offenders, sincerely contrite and seeking the mercy of the court, shall be rewarded for their humility by those who judge them. After the earlier arguments between dishonest men and the virtues they attack, this broadly conceived Allegory of Improper Behavior concludes with an optimistic happy ending to a story that ultimately provides redemption and extends good will to the prodigal. Rewards await those who play by the rules and who admit their mistakes when they make them.

On one level, the *Judgment of Brutus* demonstrates, pictorially and textually, the manner in which petitioners were expected to approach the bench. As the painting was visible to parties as they entered the Sala d'Udienza, and as it no

doubt would have caught their attention during periodic lulls in proceedings, the figure of the Roman consul flanked by female Virtues and men in contemporary (wool) garments referred to the events transpiring there during legal hearings. Petitioners were provided with instructions about what to say, what to avoid saying, and even the mood and tone to strike when saying them to the presiding consuls. This painting was aimed at both complainants and defendants, and was intended to calm them (and, perhaps, lower their expectations) before and during the hearing in which they were engaged.

But the painting also refers quite specifically to themes of reconciliation and redemption. The angry, even vengeful phrases exchanged between petitioners and Virtues lead viewers to expect the worst as their eyes fall upon the last pair of speakers in the lower right corner. With Brutus's gaze settling on this couple, reinforcing their importance within the context of the entire composition, we are surprised to read in their words and their gestures expressions of humility, temerity, and redemption. Earlier faults are acknowledged, an apology is offered, and forgiveness is promised. But this unexpected turn toward reconciliation demands an explanation, for the contrition of the final petitioner and the desire of Temperance to bring him back into the fold point to other, specific problems that plagued the Wool Guild during the turbulent 1340s, at the very moment this fresco was conceived, designed, and painted in the Sala d'Udienza.

We have seen how the composition of the *Judgment of Brutus* called to mind other politically charged frescoes in Siena and Florence, and that the main figure of the Wool Guild fresco symbolized for Florentines ancient acts of defiance toward unjust tyrants. Now we recognize the more localized importance of the painting in the headquarters of the Arte della Lana. The flanking figures of male petitioners and female virtues, and the dialogue in which they engage via their accompanying inscription, may well have referred to the crisis in the Wool Guild during the months immediately following the expulsion of the Duke of Athens from the Palazzo del Podestà in the summer of 1343. Three of the male petitioners fume and fulminate, threatening the virtues that govern proceedings in the Sala d'Udienza. They represent the fury of those within the audience hall, and clearly speak to what was an almost constant parade of disgruntled *sottoposti* displeased with the judicial process inside these walls. Yet the fourth petitioner, located in the lower right corner of the lunette, deviates from this pattern and, in so doing, calls our attention to his unique situation. The straightforward, unadorned language of the figure, unlike the words spoken by the more worldly and highly educated men in the other three corners of the image, suggests that this person comes from a lower station than the others. In his nervous admission of criminal activity, his previous "singular offense," he presents himself as a prodigal supplicant rather than a well-educated, elite member of the exclusive Arte della Lana. His language marks him as a simple man

of lower standing, perhaps one of the *sottoposti* historically at odds with greater guildsmen who governed his mercantile corporation, particularly during and after the brief reign of the Duke of Athens. The "singular offense" noted in his inscription alludes to an earlier crime of importance that he fears will condemn him in the eyes of the guild for the rest of his life. I suggest that this brief exchange may well refer to the rebellion of the mid-1340s and to attempts to reconcile the antagonists responsible for discord within the Wool Guild.

In addition to celebrating Florentine republicanism, the ouster of Walter of Brienne, and appropriate behavior in the Sala d'Udienza, the *Judgment of Brutus* appears also to have referred to internal disputes that had threatened to fracture and weaken the Wool Guild during the aftermath of the tyranny of the Duke of Athens. The images decorating this hall, where policies were set and infractions condemned, addressed specific concerns dominating the thoughts and actions of the *lanaiuoli* at a critical moment in the guild's history. The date of the production of the *Judgment of Brutus* sometime during the mid-1340s coincides with the period immediately following the expulsion of the Duke of Athens, the failure of the fledgling Dyers' Guild, and the abortive efforts of *sottoposti* like Ciuto Brandini to organize a separate association of carders and combers. Leaders of the Arte della Lana, we know, had been profoundly threatened by these crises, and the image of Brutus surrounded by angry citizens and protective virtues speaks directly to the mentality that generated the drastic measures taken in 1343, 1344, 1345, and 1346 to regain control of their industry and consolidate their power. The inscriptions accompanying the petitioners in this fresco, including the one attached to the humble supplicant in the lower right, directly addressed the internal crisis inside the Wool Guild during those years.

But the image in the Wool Guild was obviously not the only one in Florence to articulate the consequences of the city's brief flirtation with autocratic rule, and in this regard the fresco of the enthroned Roman consul must ultimately be considered as the peer of the *Expulsion of the Duke of Athens* that was produced at roughly the same time (Plate XVII). A variety of factors connect the *Judgment of Brutus* to its cousin in the Stinche prison, in which the discord and uncertainty of the age was explicitly illustrated in the allegorical rendering of Saint Anne's intervention on behalf of the commune in 1343. Like the image that faced Florentine prisoners, the presiding figure in the Wool Guild's picture sits on a throne that has been positioned more or less in the composition's center. Both Brutus and Saint Anne receive the protection of flanking attendants, who interact directly with villains who threaten the sanctity of the common good. And both lunettes feature diagonally oriented engagements that heighten the dramatic effect of the narratives elucidated within them. The formal similarities that link these frescoes, including a similar approach to drapery patterns and modeling properties, help underscore the thematic concept that

makes the two paintings something of a pair. Both images posit, in similar formats, representations of the way in which a republican commune under duress addresses handles adversity, as well as the importance of forming a unified front in times of strife. Both paintings press to the margins the enemies of the state, emphasize the power that comes with deliberate and thoughtful engagement, and remind viewers of the presence and importance of literary and spiritual role models that guide the commune's leaders as they make difficult decisions. And both frescoes, we now see, point directly to the brief tyranny of Walter of Brienne as the prime example of how and to what extent an anti-republican bully can upend the status quo – and the responses that must be mustered to defeat such a bully. The two paintings, separated from one another by four city blocks and installed in buildings that functioned in completely opposing fashions, cannot be considered a pair in any literal sense whatsoever. But their similar themes and formal properties suggest that they were produced during the same period, with the same motives, and with an understanding that their audiences needed to see at regular intervals exactly what was at stake as the commune and the guilds that led it met to address various threats to its survival.

PAINTINGS FOR MERCHANTS IN GUILD RESIDENCE HALLS COME TO US only infrequently and usually piecemeal. When they do, a multitude of questions abound. Was Taddeo Gaddi's panel of the *Enthroned Madonna* hung on the wall near the lunettes of the *Uomini Famosi* inside the Arte dei Giudice e Notai? Where was Mariotto di Nardo's *Madonna with Saints Stephen and Reparata* placed inside the Arte della Lana? What did the Arte dei Medici e Speziali look like in the fourteenth century, and how did Bernardo Daddi's *Madonna* fit into that visual program? The images that guildsmen saw, the programs they invented, and themes they inserted into the pictorial decorations of their mercantile associations have mostly disappeared, leaving us with only a few coherent examples with which to make conclusions. If the paintings inside the Wool Guild next to Orsanmichele and in the Audience Hall of the Judges' and Notaries' Guild on Via del Proconsolo were anything like the other residence halls that once city, then a few general observations apply. Pictures for merchants included holy images of patron saints, Madonnas that looked like street paintings and acted as controlling agents inside audience halls where judicial proceedings could get testy. But in the depths of those guildhalls, where debates, petitions, and arguments could boil over into heated disputes, pictures had more specific motives. Sometimes the images decorating these halls, where policies were set and infractions condemned, addressed specific concerns that dominated the thoughts and actions of consuls at critical moments in the guild's

history. At other times they spoke directly to those within the guild structure who had either misbehaved already or who threatened to do so in the immediate future. And once in awhile, an image in a guildhall told all of its viewers, irrespective of class or status or claims, that the authority of the governing body therein could never, ever be challenged.

CHAPTER FIVE

PUBLIC PAINTING IN SACRED SPACES: PIERS AND PILASTERS IN FLORENTINE CHURCHES

A LARGE PAINTING DEDICATED TO THE FIGURE OF *SAINT PAUL* AND BEARING the date of 1333 greets visitors who venture into the Trecento room of Washington's National Gallery (Plate XXV). The bearded apostle holds a book in his left hand and brandishes a sword in his right, with his index finger curled around the handle in an accurate representation of contemporary modes of combat. Notwithstanding its truly impressive size (the tall and slender panel measures 234 × 89 centimeters), the painting's vertical orientation encourages modern viewers to identify it as a side panel of an even larger altarpiece that must have spanned a liturgical table at least five meters wide. Yet this standing saint seems not to have been part of a more extensive ensemble. There is no evidence of hinges along its sides or back, and the form is entirely centered in the picture's center with no reference whatsoever to other figures or images that might otherwise have joined it to the left or right.

The enormous figure of Paul stands not alone, but rather in the midst of two groups of much smaller adherents who kneel down, press their hands together, and tilt their heads up toward the massive saint above them. Formed by both men and women, this collection of supplicants indicates a viewership comprising members of both sexes, which in turn suggests that the owners of the *Saint Paul* were participants in a Laudesi company, one of the few religious organizations in the city that allowed for a mixed membership. These kneeling viewers invite inspection: their diminutive size places them in a different zone of reality than the grander iconic figure of Paul, and this suggests a

distinction of time and space that we have seen before in the highly innovative plane-breaking picture of the Virgin and her female supplicants in Bernardo Daddi's *Madonna del Bagnuolo* (Figure 2). Indeed, the same artist produced our *Saint Paul* in Washington only three years earlier than the representation of the miraculous Virgin now in the Florence Cathedral Museum. Yet the placement of Paul on a large pedestal might conversely refer to a more literal referencing of confraternity behaviors. Perhaps these devout witnesses are shown kneeling before a poly-chromed sculpture placed on a pedestal above their heads, or perhaps Daddi depicts them in the midst of a visionary experience in which the titanic militant advocate miraculously appears before them as a reward for their pious devotions. Whatever it is they see, they all share the vision in unison with heads and bodies inverted into the picture's core, and the closed compositional format they create serves to emphasize the image's independence as a stand-alone item. We cannot imagine the addition of flanking panels, for they would necessarily be excluded from the intimate representation that occurs within the contours of the Washington picture. The completed inscription at the panel's base, with no evidence of additional text that may originally have appeared on similarly shaped panels either to the left of it or to the right, confirms our suspicions that this panel was a holistic entity unto itself, which neither possessed nor needed to possess additional compartments to complete it. This picture stood alone.

The picture's provenance is decidedly unclear, and early pronouncements of an original home in the Florentine monastery of San Felice have been largely debunked by now. Moreover, there is no evidence of a confraternity operating in Florence during the fourteenth century that featured Saint Paul as its main protagonist. But the panel has not gone unnoticed. In an unpublished comment in the curatorial files of the National Gallery in Washington, D.C., Kay Giles Arthur has contended that the users of this painting may have been the male and female members of the Frati della Penitenza, also known as the Pinzocheri del Terz'Ordine di San Francesco, which operated the Hospital of San Paolo dei Convalescenti at the Piazza Santa Maria Novella and Via Palazzuolo.[1] This charitable institution, which seems to have been in existence sometime before 1308, was originally dedicated to the care of pilgrims and the poor. By 1345, however, it had roughly thirty-five beds in it that were dedicated to the infirmed, which in turn suggests that its charge had expanded to include the care of the sick. If Arthur's suggestion is correct – and the inscribed date of 1333 suggests that there might be substance to it – the painting in the National Gallery can reveal much to us. Too tall and narrow for either an altar or a tabernacle niche, the picture probably decorated a pier inside the hospital's chapel or in one of the institution's front rooms, where it would have greeted patients and staff members who entered and exited the space just between the second and third set of city walls.

Of all the paintings produced for common people in early Republican Florence, the most eclectic group was found inside the late medieval church. These pictures were placed in a variety of settings and were executed on differing surfaces. Some of them appeared on wood panels, others in frescoed murals, a few in mosaic form, and one or two were painted on canvas.[2] An array of pictures faced common viewers who did not enjoy the privilege of owning their own burial chapels beyond the imposing *tramezzo* that often stood between them and the transept where so many private spaces were located. These pictures for the public were attached to columns and piers – often maintained by confraternities – or were mural paintings produced on the walls of the nave that led from the church entrance, past the preacher's pulpit, and up to the *ponte* that stood as a barrier to the church's inner sanctum. They rarely adorned altars.

Modern renovations of nearly every church built during the early Republican period have resulted in the destruction or removal of most of their original pictorial decorations. Still, what remains of this admittedly fragmentary sample suggests that the pier panel was the most prevalent form of public picture in the ecclesiastical setting. Because a column's width was limited in scale, the panels placed on them were often narrow but quite tall – high enough to be seen over the heads of other onlookers standing around the column, but not so wide as to be bumped, damaged, or knocked over by those walking past it. Rarely did these pictures exceed a width of ninety centimeters, the better to fit within the confines of the pier to which it was attached.[3] Column pictures usually featured a single saintly figure, standing or enthroned, that faced out toward the audience. They were closed compositions, with frontal or inward-facing protagonists occasionally accompanied by subsidiary figures below, or by an independent predella panel that bore an illustration of an important scene from the saint's life. These independent paintings imitated the format of lateral panels that flanked the central compartments of polyptychs on altars, yet stood alone without the need for anything else to make them complete pictures. If the decorated columns that have survived in Orsanmichele, San Maria Maggiore, or the Duomo are any indication of the norm – and they surely are – we may surmise that these single panels covered piers in churches all across the city, creating an architectural forest of supports available for decoration by Florence's army of skilled painters.

Not all pier panels displayed purely iconic effigies of individual saints, and occasionally a set of longitudinally oriented dossals were fit together with hinges that created a triptych that receded backward, hugging the contours of the column. Giovanni del Biondo produced such a painting for the Florentine cathedral sometime after 1375, in which the miracles and martyrdom of Saint Sebastian were depicted in graphic detail (Plate XXVI; Figures 66 and 67). The central panel, a rather modest 147 × 67 centimeters, features the tormented figure of the Early Christian soldier pierced with a multitude of arrows

66. Giovanni del Biondo, *Scenes from the Life of Saint Sebastian*, ca. 1376, Museo dell'Opera del Duomo, Florence. Photograph courtesy Gabinetto Fotografico del Polo Museale Regionale della Toscana.

67. Giovanni del Biondo, *Scenes from the Life of Saint Sebastian*, ca. 1376, Museo dell'Opera del Duomo, Florence. Photograph courtesy Gabinetto Fotografico del Polo Museale Regionale della Toscana.

fired by executioners standing below him. In defiance of the accepted legend of Sebastian's plight, the bowmen who aim their arrows at him bear distinctively caricatured facial features (along with pointed hats) that carry the insinuation that Jews, rather than Roman soldiers, were responsible for the saint's death. The pictures in the left panel recount Sebastian's miraculous healing powers with references to contemporary events. At the panel's base appear a series of corpses stretched out in city streets and inside the portals of private homes, with a pair of men who lift one of them into an open casket. The scenes in the right panel continue the narrative of the left and central compartments, as Sebastian – nursed back to health by Saint Irene – is recaptured by his enemies, beaten to death, and dropped down a well. Irene is then instructed to retrieve his body, which she carries in her own arms. Human frailty and the inevitability of mortality permeate this pictorial ensemble, as the theme of sudden, horrible death covers all three portions of the triptych. This salient theme surely makes sense given the circumstances of its production, sometime during the late 1370s, after an outbreak of bubonic plague had terrorized Florence in 1375. Indeed, Sebastian was a patron saint of plague victims, due to the many sores that appeared on his body after his encounter with pagan bowmen, and the bodies piled in the streets in the left panel remind us of Boccaccio's ominous description of the Black Death of 1348:

> Most [common people] stayed in their homes or neighborhoods either because of their poverty or because of their hopes for remaining safe, and every day they fell sick by the thousands; and not having servants or attendants of any kind, they almost always died. Many ended their lives in the public streets, during the day or at night, while many others who died in their homes were discovered dead by their neighbors only by the smell of their decomposing bodies. The city was full of corpses. The dead were usually given the same treatment by their neighbors, who were moved more by the fear that the decomposing corpses would contaminate them than by any charity they might have felt toward the deceased: either by themselves or with the assistance of porters … they would drag the corpse out of the home and place it in front of the doorstep, where, usually in the morning, quantities of dead bodies would be seen by any passerby; then they were laid out on biers, or for lack of biers, on a plank.[4]

In some ways, Giovanni del Biondo's wrap-around pier panel illustrates verbatim the horror of plague that Boccaccio recalls, and might even have been based directly on that famous text. The only semblance of hope in the triptych appears in its upper registers. Presiding over this grisly recitation of brutally, pain, and suffering appear the kneeling Angel Gabriel and the enthroned Virgin Annunciate, with the Salvator Mundi blessing viewers from a quatrefoil above the wounded figure of Saint Sebastian. At least the carnage endured by

the living might be redeemed in heaven through individual acts of piety. This collection of panels that covered three sides of a pier in the Duomo addressed lay worshippers with a somber message that stemmed from popular literary sources rather than liturgical or theological texts.

With space at a premium, Florentine clerics used every portion of their church naves to present decorative images to their congregations. Columns and piers became important places to display representations of figures whose identities and hagiographies meshed with the interests of particular constituents. Confraternities happily congregated before images attached to "their" columns, as evidenced by the meeting place of Orsanmichele's Laudesi Company at the large pier of the grain loggia in the center of town. The Laudesi who congregated in Santa Maria Novella saw Duccio's *Rucellai Madonna* on the pier outside the Chapel of Saint Gregory (Figure 22). The confraternity of Saint Zenobius likewise met to worship before a column in the nave of the cathedral. And these columns, in turn, came to serve as semipublic areas that provided flexible spaces to accommodate groups of varying sizes depending on the type of ceremony performed there. The long, narrow pictures of singular saints or, occasionally, narrative scenes attached to these columns marked that structure as a locus of popular devotion that received the attention of lay worshippers on a frequent, and even regular, basis.

THE PANELS IN THE DUOMO

The erection of the new Florentine cathedral of Santa Maria del Fiore around the exterior of the old one of Santa Reparata created opportunities for donors to build and decorate spaces inside Europe's largest ecclesiastical edifice. Despite initial proscriptions against familial privileges inside it, the accretion of chapels and worship centers crept upward over the years: by 1665 no fewer than sixty-two devotional spaces were listed by Lionardo Masotti in his survey of the Duomo.[5] Unlike its current antiseptic state, the cathedral then was a cluttered church filled with paintings, sculptures and reliquaries commissioned by individuals and confraternities that wished to promote themselves and their piety to their neighbors. Only a fraction of these *objets d'arte* survives. Inside the city's Museo dell'Opera del Duomo stand a number of vertically oriented pictures that were removed from their settings during the nineteenth century, when the city was cleansed in anticipation of its new function as national capital. The oldest of these features the figure of Saint Catherine – long attributed to Bernardo Daddi and dated to his mature period, between 1330 and 1345 – standing tall next to her iconographic attribute of the wheel, which has here been doubled so as to flank her on either side (Figure 68).[6] A stenciled pattern accentuates her pink dress, lined with white fur, and her crown bears gems of red and blue. Her regal attire contrasts with the simpler dress of the supplicant

who kneels before her, head tilted upward with hands pressed together. This supplicant is no priest, but rather a member of the laity who prays to her for her advocacy. He may represent a confraternity member, a specific lay donor, or a more generic visitor to the cathedral, but his precise identity escapes us. The supplicant's presence, combined with the verticality of the picture and the self-contained composition (reinforced by the two wheels that hug Catherine's sides), suggests that the picture was somehow connected to one of the three worship spaces by the front doors on the congregation's side of the nave that were, in the fourteenth century, dedicated to the figure of Saint Catherine.[7] More specifically, its size and shape − 207 × 85 centimeters − suggests that it was originally fitted into a pier or column. Indeed, a description of the Duomo penned by Stefano Rosselli in 1657 identifies this panel (along with the coat of arms bearing the Medici balls) and notes its placement on a pilaster near the front entrance of the cathedral:

> S. Maria del Fiore … Passata la Porta, che' guarda verso la via de Martelli, cioè nel Pilastro, che è fra la d.a Porta, e l'Altare della Trinità: Quadro assai antico entrovi S. Caterina V.e Mart. Non vi si vede altro segno, che due scudetti con due Armi piccole di palla … che … appena si veggono.[8]

Given the rather late date of Rosselli's observation, there can be no guarantee that this image of *Saint Catherine* was originally intended to decorate a pier in the Duomo when Bernardo Daddi completed the picture in the 1330s or 1340s. Indeed, the presence of the Medici *stemmi* at the picture's base might, alternatively, connect Bernardo Daddi's dossal with the tomb marker for Vernis di Cambio de Medici (d. 1345) in the cathedral's nave that Giuseppe Richa transcribed in 1757:

> Magnificus, & potens Milex Dominus Verins olim Cambii de Medicis de Florentia reliquit seppelliri apud Ecclesiam S. Marie del Fiore in Sepulcro, seu in loco per dictum Testatorem iam electo ex concessione Operario-rum dicte Ecclesie, & Consulum Artis Lane, de qua apparet instrumen-tum manu Ser Antonii Ser Chelli Notarii dicte Artis, & reliquit supradicte Ecclesie, ubi seppelliri voluit, 50. libras in die sui Anniversarii. Actum in pop. S. Laurentii in domo Testatoris 12 Augusti 1345.[9]

Given the correspondence of Vernis di Cambio's death (1345) with the period of the painting's production (1330–1345), the donor kneeling at Catherine's feet may be this early member of the Medici family, and the picture may have been an image that marked the site of his interment inside the church of Santa Maria del Fiore. Irrespective of its exact placement, however, it is quite clear that this single panel was intended for public viewership.

So too was a second panel dedicated to the figure of *Saint Catherine*, painted by Giovanni del Biondo sometime after 1378, the year Noferi di Giovanni di

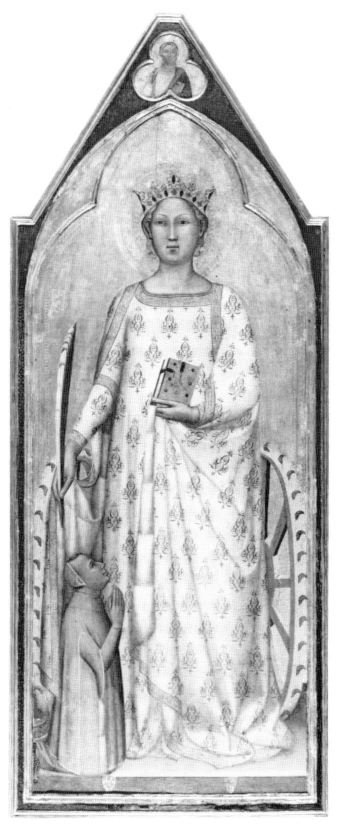

68. Bernardo Daddi, *Saint Catherine*, ca. 1335, Museo dell'Opera del Duomo, Florence. Photograph courtesy Gabinetto Fotografico del Polo Museale Regionale della Toscana.

Bartolomeo Bischeri – the largest of the three kneeling laymen – was named consul of the Wool Guild (Figure 69). The original picture, designed as a standard pier panel with dimensions of 163 × 66 centimeters, was expanded in the early fifteenth century with lateral compartments dedicated to scenes from Catherine's life and iconic depictions of Saints Bartholomew and John the Evangelist.[10] The latter two pictures were appended to the cusps over the central compartment when Giovanni del Ponte added the portraits of Noferi's sons, Bartolommeo and Giovanni, to the picture's base. Like Bernardo Daddi's long and slender panel of Saint Catherine, Giovanni del Biondo's original picture was perfectly suited for a column inside the Duomo. An archival entry from 1589 in which the production of a statue of Saint Anthony is discussed notes that a "pilastro … verso la Canonica" held many altars and "la figura di Santa Caterina."[11] Walter and Elizabeth Paatz argued that this pilaster was the first pier on the right side of the nave, but Klara Steinweg believed the pillar of Saint Catherine was instead located about halfway down the church.[12] Wherever this pier may have been set inside the cathedral, a chapel was dedicated there in 1407 by Bartolommeo and Giovanni Bischeri, and Giovanni del Ponte's additions to the original panel were probably done in conjunction with this act of filial patronage and piety.

The desire to commemorate one's self or one's ancestry is apparent in yet another pier panel used inside the cathedral by lay worshippers at the end of the Trecento. The standing figure of *Saint Zenobius*, attributed to Jacopo di Cione and probably painted sometime in the 1380s, features the ancient patron of the city in the garments of political and ecclesiastical power (Figure 70). Like other pictures attached to the Duomo's piers, the saint appears within the contours of a vertically oriented panel that reaches 164 centimeters high and extends some 76 centimeters wide. He wears his bishop's miter and holds a sacred book in covered hand, while the staff in his right hand contains at the top a faint image of a lion – perhaps a reference to the *Marzocco*, symbol of Florence.[13] Below him, emerging from the lower left corner, kneels yet another a genuflecting donor, but this one is identified as a woman dressed in the black robes of either a nun or, more likely, a widow. Indeed, one feature of the cathedral's dossals that distinguished them from other public paintings produced for the dozens of parish and conventual churches in the city was the addition of living donors kneeling at the feet of their patron saints, such as the nun in the panel of *Saint Zenobius*. These donor portraits became increasingly popular during the second half of the fourteenth century. Perhaps it was due to the evolution of the Republic, in which wealthy and powerful citizens came to have both the wherewithal to spend on luxury items (like paintings) and the desire to promote their own successes in a public forum in ways that would pay political dividends to them later. Perhaps it was also due to the artistic precedent set by Bernardo Daddi in his panel of *Saint Catherine* – or by some other artist whose pier panels

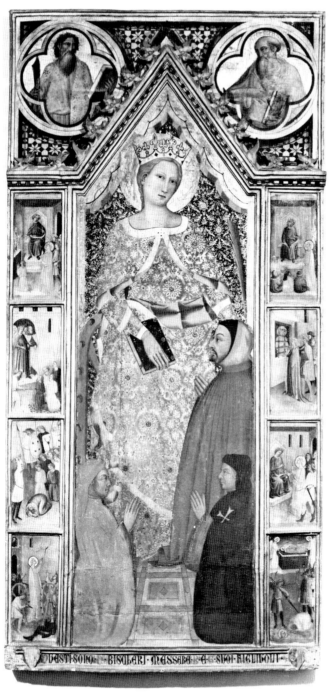

69. Giovanni del Biondo, *Saint Catherine with Noferi Bischeri*, ca. 1380, Museo dell'Opera del Duomo, Florence. Photograph courtesy Gabinetto Fotografico del Polo Museale Regionale della Toscana.

have not survived the ravages of time or taste – that encouraged other patrons to seek images that replicated its design inside the Duomo. Perhaps the appearance of the Black Death in 1348 and, importantly, its reappearance in 1363 caused lay devotees to think more intentionally about the possibility of sudden mortality and, thus, to emphasize overt acts of personal piety through the construction of burial chapels and the placement of portraits next to images of celestial advocates.[14] Or perhaps these additions reflected the gradually increasing focus on the importance of individuals at the expense of a corporate mentality – a Burckhardtian notion of an emerging Renaissance mentality at the middle of the early Republican period. Whatever the reason, the inclusion of donor portraits became a standard component of pier panel design in the Duomo during the late fourteenth century.

But the collective was also clearly influential in this period and in this panel, for the image of *Saint Zenobius* was not produced solely for the commemoration of the donor. Luisa Becherucci and Giulia Brunetti have argued persuasively that the picture was produced for the Company of San Zanobi due to payments made by that corporation to Jacopo di Cione in 1394.[15] Zenobius was obviously an extremely important figure, as his legacy was a direct connection to the early Christian origins of the city and the site of the Duomo when it was known as Santa Reparata. The cathedral possessed his relics, which were contained in an elaborate reliquary that took on the features of the bishop's head and face.[16] In 1408, some thirty years after the nave of the new cathedral had been completed, a new chapel dedicated to Saint Zenobius was constructed in its tribune so as to stand on a central axis with the high altar and main entrance.[17] But the panel of *Saint Zenobius*, due to its shape and narrow dimensions, was not attached to the altar in this chapel; it was still on its pilaster in 1416, when it was removed to make way for an altar inside yet another chapel that was to be dedicated to the Annunciation of the Virgin (a narrative event that was appended to the corners of the dossal panel of *Saint Zenobius* in the early fifteenth century).

The selection of saints for visual representation on isolated piers had much to do with the veneration of those figures by collective organizations inside the facility. In the Duomo the figures of Saints Catherine and Zenobius received much attention due largely to the relics contained inside the cathedral and, since 1281, the confraternities that met there to venerate them. Zenobius, in fact, was particularly popular there and a number of piers held effigies dedicated to the early Christian Florentine bishop. Among the most visible was the panel that is currently attached to the very first column on the north side of the nave at the entrance of Santa Maria del Fiore. Positioned above the heads of visitors appears the beautifully painted form of *Saint Zenobius*, who sits on a sparsely decorated throne (Plate XXVII). In his right hand he holds a crozier, and in his left appears a book that he rests on his left knee. His white

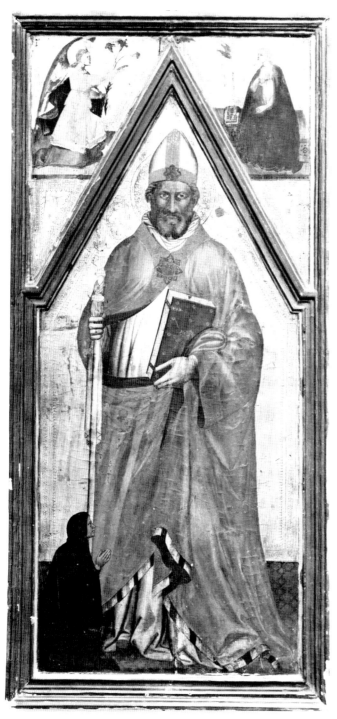

70. Jacopo di Cione, *Saint Zenobius*, 1394, Museo dell'Opera del Duomo, Florence. Photograph courtesy Gabinetto Fotografico del Polo Museale Regionale della Toscana.

garments, adorned with gold brocades bearing images of saints and a small crucifixion scene at his chest, contrast with the exquisite fabrics worn by the two kneeling saints at his feet and the cloth held aloft behind him by two angels that flank his head. Saints Eugenius and Crescentius, identified by inscriptions below them, restrain two bound figures in the foreground, partially obscured by the robes covering Zenobius's feet. Two predella panels illustrate miraculous moments from the saint's life. The tall pier panel in the Duomo (240 × 110 centimeters), produced sometime around 1380 as the cathedral's interior neared completion, imitates features normally seen in lateral compartments of altarpieces – like the Duomo's own high altarpiece (Figure 71) – but stands alone without the benefit of partner panels.[18] More important, the panel of Zenobius replicated the other images of the bishop that were sprinkled throughout the church, which then provided viewers with a series of landmarks inside the structure that constantly reminded them of the power and presence of their oldest patron saint. And the placement of this panel, and others like it, on the congregation's side of the church gave common viewers a sense of the kinds of images placed beyond the zone they were allowed to occupy, essentially giving them a taste of the things they could not actually access in the Duomo's inner sanctum.

Another picture that might be connected to this type of public painting in the Florentine Duomo is the sensitively composed image of the *Madonna and Child* in the Brooklyn Museum of Art, a large dossal panel attributed to Nardo di Cione that, at 197 × 100 centimeters, stands twice as tall as it is wide (Plate XXVIII).[19] The unified composition collects the figures of Mary, Christ, John the Baptist, John the Evangelist, Zenobius, and Reparata into a single setting. Jesus stands triumphantly on the Virgin's thigh, holding in his hand the goldfinch representative of his soul. The four flanking patron saints of Florence show a progression of currency, with Zenobius and Reparata standing in the background as the city's early medieval advocates and the two Johns standing in the foreground, pushing the older pair into the background, to demonstrate their more recent inclusion in the panoply of Florentine patrons. Such references to the commune clearly identify the image as one intended to speak to a lay audience eager to associate holy figures with the city. As such, Nardo's picture, probably painted sometime in the mid-1350s, could have been an appropriate image inside any office in Florence's ever-expanding bureaucratic network.[20] Yet its dimensions suggest that Nardo's painting was instead intended to fit onto a pier or column in much the same way that his younger brother's painting of Zenobius would later adorn the pier near the cathedral's entrance wall. As Richard Offner once suggested, the identities of the four saints in the Brooklyn picture that flank the Virgin and Child, communal patrons all, suggest that the panel may have been intended for the Florentine cathedral, which was at that very moment in the middle of its transformation from the church of Santa Reparata to the church of Santa Maria del Fiore.[21]

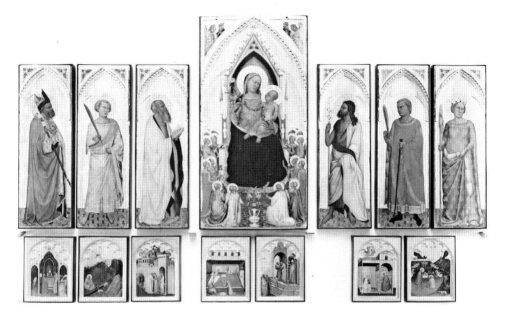

71. Bernardo Daddi, *Madonna and Child with Saints* ("San Pancrazio Altarpiece," ex–Santa Maria del Fiore), 1342, Uffizi, Florence. Photograph courtesy Gabinetto Fotografico del Polo Museale Regionale della Toscana.

The presence there of the Confraternity of Saints Zenobius and Reparata might explain the appearance of the two ancient Florentine patrons in Nardo's panel, which in turn may have been employed by the company during their recitation of lauds inside the Duomo. But the lack of flowers in the image, combined with the timing of the picture's execution – at just the moment when the production of elegant pictures would have been inappropriate for a space in the midst of total upheaval – causes one to pull back from a position of certitude.

The interest in the production of panels for the piers of the Duomo continued as the fifteenth century opened. At the turn of the century, the aforementioned *Double Intercession* (Plate XV) from Lorenzo Monaco's workshop was placed in the shallow chapel by the entrance wall, providing visitors a glimpse of it just before they passed through the Duomo's portals and spilled out into the Piazza San Giovanni, where their eyes would have fallen on the Loggia of the Confraternity of the Misericordia, in which was located the large fresco by Bernardo Daddi that we have already considered. The design of the picture of *Saint Reparata*, painted in the early 1400s by Lorenzo di Niccolò, matched those produced in the late decades of the 1300s by Giovanni del Biondo and Jacopo di Cione (Figure 72). Returning to a retardetaire approach to storytelling, Lorenzo di Niccolò appended an apron to the vertically oriented image of the standing patron saint, and included in it a series of narrative pictures that recount her torments and ultimate demise during the early Christian period.

72. Lorenzo di Niccolò, *Saint Reparata*, ca. 1408, Museo dell'Opera del Duomo, Florence. Photograph courtesy Gabinetto Fotografico del Polo Museale Regionale della Toscana.

The poorly maintained dossal of the *Enthroned Madonna Lactans*, with saints John the Baptist and Blaise peeking around the sides of the chair, was commissioned by a physician named Niccolò di Francesco Gialdi Falcucci (Figure 73). Falcucci, whose family name is inscribed on the painting's surface, left a bequest to the Duomo in 1408 that mandated that a picture containing the figure of Saint Blaise be placed in a tabernacle attached to a pilaster in the cathedral.[22] Twenty years later, in 1429, another patron from the medical profession named Antonio della Casa commissioned a picture of Saints Cosmas and Damian for a pilaster in the Duomo.[23] It has neither donors nor fifteenth-century additions attached to it, but the now-familiar theme of the Nursing Madonna suggests it was originally displayed in the cathedral by a company engaged in charitable works and medical support for the commune. The paintings in the cathedral formed an eclectic collection of pictures, many of which were attached to

73. Jacopo del Casentino, *Enthroned Madonna Lactans*, ca. 1335, Museo dell'Opera del Duomo, Florence. Photograph courtesy Gabinetto Fotografico del Polo Museale Regionale della Toscana.

columns that were surrounded at different times by confraternity members or individual worshippers who uttered prayers or sang songs before them.

THE PANELS IN ORSANMICHELE

The Florentine pier panel was not invented in Orsanmichele, the grain loggia that was transformed into a church by the communal government in the mid-1360s. But, for all intents and purposes, it was probably perfected there. As per the recommendation proposed by the Silk Guild, which shouldered the burden of Orsanmichele's maintenance in an act of the Signoria in 1336, Florence's twenty-one guilds took on the responsibility of decorating one of the interior piers designated to it by the government. Additionally, twelve exterior piers were to be filled with a sculpted effigy of a guild's patron saint. The piers were apportioned according to the areas each one offered by way of space. Nearly every guild shared a section of a pier: the Locksmiths, Bakers, and Cheesemongers, for example, had to share individual facings of the same column.[24] The same was true for the Vintners, Shearers and Tailors, and Harness Makers, who divided among them the western central pier in Orsanmichele.[25] The Wool Guild and the Guild of International Cloth Merchants shared the pier at the western entrance of the church, through which visitors would pass on their way toward the tabernacle that contained the city's official cult image. Only the Bankers managed to claim more than a single side of a pier, as they found a way to cover three full sides of the southwestern pier with images dedicated to their patron saint, Matthew. Seen as a privilege and intended as a mark of prestige, the commune hoped the guilds would take seriously the mandate they had received; but work progressed slowly.

Despite periodic pleas from the Arte della Seta, few of Florence's corporate bodies responded to the artistic responsibilities assigned to them at Orsanmichele. By 1352, only three guilds – the Wool, Delicatessen Owners, and, predictably, Silk guilds – had installed images of their respective patron saints on the pilasters of the granary. Of these paintings, the only one to survive was Jacopo del Casentino's *Saint Bartholomew Enthroned*, the unified panel for the pier maintained by the Guild of the Delicatessen Owners (Figure 74).[26] No other pier pictures were painted in Orsanmichele during the 1350s as Andrea di Cione worked on his tabernacle for the *Madonna of Orsanmichele*, but decorations inside the church picked up soon after the marble canopy was finally completed.

The first wave of pier panels occurred in the late 1360s and 1370s, but slowed after that. In the autumn 1390 the Wool Guild prepared to install on its pier a panel depicting their patron saint, Stephen, and eighteen months later paid a painter named Lapo di Francesco to varnish it and append the guild's coat of arms above it.[27] In February 1398 the company of Orsanmichele petitioned the

74. Jacopo del Casentino, *Saint Bartholomew Enthroned*, ca. 1335, Accademia, Florence. Photograph courtesy Gabinetto Fotografico del Polo Museale Regionale della Toscana.

Signoria to spend 720 lire per year on decorations inside their building, which included the production of stained glass, the installation of pier paintings, and the completion of frescoes in the vaults.[28] Periodic additions were made to the columns inside the church until a major third project was initiated in 1410 to replace all of the panel paintings with frescoes, thanks to an infusion of hundreds of florins that the confraternity's captains designated for the endeavor.[29]

All told, dozens of pictures were painted on the twelve piers inside the most central corporate structure in Florence. Some contained narrative moments: the panels of the *Trinity* and the *Good Thief* decorated the sides of the two central piers; the image of the *Annunciation of the Virgin* occupied the entire surface of the column attached to the north east pier by the Carpenters' Guild (Figure 75); and the triptych of Saint Matthew covered two-thirds of the pilaster of the Bankers' Guild (Plate XXX). Most of Orsanmichele's pier paintings, however, were in the form of single saints, standing frontally and carrying an attribute for easy identification, thus following the precedent set by Jacopo del Casentino in his image of *Saint Bartholomew Enthroned*. Smaller narrative pictures accompanied many of these pier panels, acting like a predella panel that had become a standard feature of early Republican altarpieces.

This reference to liturgical polyptychs was surely intentional, and for a variety of reasons. From one perspective, the depiction of static saintly effigies had been an essential feature of the painters' repertoire since the early thirteenth century, when rectilinear altar frontals gradually gave way to dossal panels that stood behind Eucharistic tables after the decrees mandated by Lateran IV in 1215.[30] No artist of any standing could survive in the city's competitive art market without understanding the importance of producing images of appropriately garbed and suitably intimidating celestial patrons for the hundreds of liturgical spaces that covered the Florentine center in the fourteenth century: by 1330, they were essential for any altarpiece's design, and selecting suitable examples of a "common" liturgical polyptych of the period is almost banal. Bernardo Daddi's massive polytych of the *Madonna and Child Enthroned*, produced for the high altar of the cathedral in the early 1340s, follows this typology closely and, from a structural standpoint at least, is absolutely typical for the period (Figure 71). Paintings that featured this core figural grouping in the central compartment, with rather static effigies of patron saints occupying individual panels on either side of it, could be found in literally each and every religious house in Florence.

The situation inside Orsanmichele was somewhat complicated. The most important painting in the building was surely the cult image of the *Madonna of Orsanmichele*, and the tabernacle that encased it made it the most recognizable (and remarked upon) art objects in the city (Plate VII). But because the painting had started out as a street tabernacle, its format deviated from that typically associated with altarpieces. Prior to the fire of 1304, the simple picture had followed the compositional layout commonly employed for devotional paintings placed in the public domain: it featured the Virgin Enthroned, the Christ child, and flanking figures all contained in a single panel. As Luciano Bellosi noted in 1977, this did not conform to the pattern employed by artists and favored by patrons for most Trecento Marian altarpieces, which typically included depictions of patron saints occupying their own panels that flanked

75. Circle of Andrea di Bonaiuto, *Annunciation of the Virgin*, ca. 1380, Accademia, Florence. Photograph courtesy Scala/Art Resource, New York.

the central compartment in a polyptych format.[31] Indeed, the cult image did not serve as the altarpiece of the church – that honor went instead to the polychrome wood sculpture of Saint Anne that was placed there during the mid-1340s (Figure 20). But when Andrea di Cione's tabernacle was completed in 1359, the ensemble came to overshadow its neighboring wooden liturgical image: the absence of lateral patron saints from the painting was both formally dissonant and culturally problematic, for the collection of celestial patrons normally joined together in a church sanctuary was not present here. Once the building's function was altered in 1365 so that it became a church rather than a granary – and an extremely important civic church, indeed – the single representations of Mary and Anne demanded amendment. It is no coincidence that it was at precisely this moment, in 1367, that the guilds responsible for decorating piers in Orsanmichele became much more interested in

completing those artistic projects that had been assigned to them thirty years earlier than they had been before the granary's transformation into an ecclesiastical space.

As a small and self-contained area, the church in the former granary did not have its own *tramezzo*. Lay worshippers, confraternity members, and foreign visitors eager to catch a glimpse of the *Madonna of Orsanmichele* could enter the church and approach its special site without interference. The laity were encouraged to approach the tabernacle that encased the miracle-working image to drop alms into the safe-boxes kept at the table before it. But the image encased by all of Andrea di Cione's marble must have appeared unusual to these viewers, for this ensemble did not look like an altarpiece: it had no saints accompanying it (Figure 21). Because the design of Orcagna's tabernacle prevented the addition of side panels containing these effigies, depictions of individual saints had to appear elsewhere. The piers that surrounded the massive marble baldacchino were the perfect place for them. And thus the twelve columns that supported the loggia and its storage rooms above were decorated with pictures of individual saints and with predella panels that contained scenes from their lives below, first with panel paintings (in the true tradition of the Trecento altarpiece to which it now alluded) and later with fresco pictures when, in 1409, the wooden pictures were removed.

As in the Sala d'Udienza of the Arte della Lana, Orsanmichele had within it something akin to a detached polyptych that celebrated the Virgin Mary, the Christ child, and all the saints whose patronage protected the entities responsible for the building's maintenance. The only difference between the polyptych in the former granary and the one on, say, the high altar of the Duomo was that the multi-paneled object in Orsanmichele was spread out across the entire church, revolving around Bernardo Daddi's *Madonna* in a way that both encompassed the entire interior and embraced all those who came inside it to worship the cult image there. The format of the side panel and narrative predella below, a visual duality that had come to form a fundamental component of late medieval painting, was appropriated from the altarpiece typology where it had been invented and incorporated into a new setting. Separated from other panels around it, the "side panel" found a new life as an independent image on the piers of Florence's most important ecclesiastical spaces.

The template used by painters from 1367 to 1409 appears to have been Jacopo del Casentino's panel painting of *Saint Bartholomew Enthroned*, which probably appeared on the pier of the Delicatessen Owners at roughly the same time that Bernardo Daddi's *Madonna of Orsanmichele* was completed for the granary (Figure 74).[32] The image of the disciple, in fact, was based largely on the Beta *Madonna* that had been attached to the southeast pilaster of the granary since

the early fourteenth century (Figures 18 and 19). Like that miracle-working Madonna, Jacopo's *Bartholomew* sits enthroned among a group of eight angels, four on each side, who venerate the regally depicted patron saint of the Delicatessen Owners' Guild. Now, however, a book replaces the Christ child, viols are substituted for censors, and the frontal position of the saint creates a more intimidating and authoritarian figure. The knife held by the martyred apostle surely refers both to Bartholomew's dramatic method of execution (he was flayed alive) and the dexterity with which the guildsmen responsible for the painting's production wielded their tools behind the meat and cheese counters of their shops. Despite its large size (266 × 112 centimeters), this pier panel was not intended to compete with Orsanmichele's famous image of the Madonna, but did refer to it just enough to encourage common viewers to make the visual link between the two. The Delicatessen Owners, it seems, wanted their saint to have the same pictorial presence as the miracle-working painting that had made the granary so important. This image of Bartholomew, then, was not considered as an extension of the *Madonna*: perhaps because Orsanmichele was not yet a church 1352, it was not conceived of as quasi lateral panel, but instead seen as an independent image that appropriated the format and, they probably hoped, the power of the potent cult image already there.

Some of the other panels produced for the pillars in Orsanmichele adopted the format of the enthroned saint as their submission to the interior decorations of the building. Two such entries, Giovanni del Biondo's imposing panel of *Saint John the Evangelist* (234 × 104 centimeters) for the Silk Guild (Plate XXIX) and Lorenzo di Bicci's more modest picture of *Saint Martin* for the Vintners' Guild (60 × 45 centimeters; Figure 76), suggest that this type of free-standing panel was still popular and employed in the former granary until well after 1380. Both images celebrate the authority of the patron saints depicted, with John and Martin enthroned, dressed in distinguishing garments, and brandishing tools to identify them as particularly powerful and important for the corporate patrons that had them made. The Evangelist, probably installed on the south central pier sometime after 1382, wears an ancient blue robe with a pink cloak draped over it. With quill and ink positioned next to him on his simple throne, and his attribute of the eagle perched at his side, John points toward the image of the Redeemer in the pinnacle above him, who holds an open book and lifts his right hand. However, unlike the panel by Jacopo del Casentino that seems to have informed this one, the only angels appearing in this composition surround the half-length figure of the resurrected Christ rather than his enthroned apostle, appropriately reserving heavenly reverence for the Son of Man rather than for one of his disciples. Moreover, Giovanni del Biondo adds to his composition three allegorical figures struggling under the heavy feet of the Evangelist. Pride, Avarice, and Vainglory succumb to

the virtues embodied in the figure of John and described in the pages of his Gospel, the opening verses of which appear on the pages that he holds aloft. These apparitions, unprecedented in the Trecento pictures installed in Orsanmichele but part of Giovanni del Biondo's personal stable of images, give the enthroned figure a moral authority unseen in the other pier panels that decorated the church's interior. The Evangelist appears as a supporter of Christ's mission, a witness of Christ's words as a first-person chronicler of his life, and as a redeemer in his own right empowered to protect and promote the worthy.

Not long after Giovanni del Biondo's image was completed, Lorenzo di Bicci produced his image of *Saint Martin* for the eastern central pier of Orsanmichele (Figure 76). Borrowing heavily from Biondo's model, the painter depicted *Saint Martin*, patron of the city's winemakers, in a similarly authoritarian manner. Adorned with the Bishop's miter and holding in his hand the crozier of his office, the enthroned Martin assumes the frontal position observed in Jacopo del Casentino's *Bartholomew*, but now without the accompanying figures of either angels or virtues suppressed. This Martin sits alone as representative of the Arte dei Vinatieri, needing neither a heavenly audience nor an example of things vanquished by his power. In a subtle way, this more modest representation of the Bishop succeeds more completely than Giovanni del Biondo's version of John the Evangelist, which perhaps tries too hard to impress the beholder with signs of potency and heavenly intimacy. *Saint Martin* commands attention without any need of additional allegorical or spiritual assistants.

One singular feature of these two pier panels reveals the changing nature of the genre inside Orsanmichele after the granary's transformation into a church in 1367. In both of these panels, Giovanni del Biondo and Lorenzo di Bicci added below the iconic representation of their corporate patrons' protector saint a single narrative panel dedicated to an event from the protagonist's life. In the case of the earlier picture, Giovanni del Biondo depicted the moment of the Evangelist's assumption into heaven, an appropriate addendum to the larger effigy that both points toward the skies above and emphasizes verses referring to the spirit. Lorenzo di Bicci, on the other hand, chose to show the famous moment from Martin's life when the noble saint divided his tunic to share one-half with a beggar in need. Recalling the original function of the Company of Orsanmichele, this image of charity surely spoke volumes to both Vintners and confraternity members who visited the church. It also reminds us that the audience for these pier panels, and others like them all across Florence, extended beyond the narrow constraints of their corporate patrons to include a wide array of common viewers who chanced to walk inside the structure.

Perhaps the most famous and most effective pier panel installed in Orsanmichele was that of *Saint Matthew*, commissioned by the Bankers' Guild and initiated by Andrea di Cione in September 1367, only a few weeks after the

76. Lorenzo di Bicci, *Saint Martin*, ca. 1395, Accademia, Florence. Photograph courtesy Finsiel/Alinari/Art Resource, New York.

granary had been officially declared a church (Plate XXX). Following the tra-
dition initiated by the Wool, Silk, and Delicatessen Owners' guilds of decorat-
ing piers with panel paintings, the Arte del Cambio hired Andrea to paint for
them a picture for three sides of the single pier for which they had secured the
rights. In a commission that would later influence Giovanni del Biondo in his
image of *Saint Sebastian* for the Duomo, the Bankers commissioned Andrea to
produce a three-paneled image that folded back on hinges around their des-
ignated column on the south side of the church. Their triptych featured the
effigy of their patron saint holding a pen and open book, and standing in a
compartment that towered almost three meters high (290 × 88 centimeters).
Flanking this main panel were two side panels of equal dimensions that bore
pairs of narrative scenes that both honored Matthew's dedication to Christ and
his occupational connection to the business of financial exchange. Whereas the
gold dots on the red field in the roundels above the lateral pinnacles alluded
to the guild's coat of arms (a feature that would reappear at the top of the
Zecca Coronation in 1373; see Plate XVIII), the elegant pink, red, and blue robes
worn by the saint gave Matthew and his corporate patrons the appearance of
nobility befitting international financiers. Wrapped around the central pilaster
along the southern wall of Orsanmichele, where it looked down upon visitors
standing or kneeling before the Omega *Madonna*, the pictures of the patron
saint of the Bankers' Guild enjoyed one of the most prominent settings inside
this most important civic church.

It is worth noting that by the time of this project, Andrea di Cione had
become the most important artistic personality in Florence – at least in the eyes
of the guildsmen and government officials who frequented the newly dubbed
"official church of the commune." Had he lived to see the *Saint Matthew* pan-
els through to completion, Andrea di Cione would have been celebrated both
as the painter of the exquisite pier panel for the Bankers of Florence and as
the sculptor of the all-important marble tabernacle that contained the miracle-
working Madonna only a few feet away. Perhaps this explains why the guild
approached the elderly painter with the commission in the first place: his status
had been confirmed by that earlier project, and lent an additional air of impres-
siveness to their pier pictures. But the leader of postplague Florentine art did
not have the time or the strength to finish the work before his death in 1368.
His younger brother, Jacopo, was called upon to complete the project. While
Andrea di Cione was responsible for the overall design of the unusual painting,
the two upper narrative scenes, and most of the standing figure of Matthew,
it was Jacopo who completed the bottom two narrative scenes and executed
the finishing touches on the entire ensemble.[33] Indeed, his participation was
extensive enough – and the project prestigious enough – to serve as Jacopo's
presentation piece when he applied for (and received) admission into the Guild
of Doctors and Apothecaries in 1369.[34]

Just as Jacopo del Casentino's painting of *Saint Bartholomew* followed the basic compositional and even iconographic pattern of the Beta *Madonna of Orsanmichele*, Andrea and Jacopo di Cione looked to a contemporary format just then coming into prominence in Florentine painting. Now the type of picture that influenced artistic decisions was the narrative triptych, a reduced version of the polyptych format that had been employed for large altarpieces through much of the fourteenth century. Popular in Florence after the Black Death and perfected by Nardo in the Cione workshop, the narrative triptych provided ample space for storytelling in the central panel and enough room for a standing or seated saint to occupy each of the two flanking compartments. A particular feast day that celebrated a specific event – Pentecost, the Assumption, or the Ascension, for example – could receive specific attention at the object's core, while effigies of additional patron saints appeared in a way that alluded to the particular interests of donors or audiences in its setting. Developed fully and effectively in Siena by that city's most important painters between 1333 and 1343, this type of painting was perfectly suited for smaller spaces commonly found in private burial chapels or side altars of modest dimensions where Masses were performed only on rare or distinctive occasions.[35] Andrea di Cione's *Pentecost* featured the narrative moment of the Descent of the Holy Spirit in the center, and then inventively added trios of genuflecting saints in side panels both as characters in the story and as iconic renderings of specific patrons. By 1365, Nardo di Cione and Giovanni del Biondo had produced medium-sized narrative triptych altarpieces for the Florentine monastery of Santa Maria degli Angeli, where chapels in the Camaldolese chapterhouse were decorated with at least three and possibly as many as five such objects.[36] The anonymously painted *Vision of Saint Bernard* continued the trend into the 1360s, and later painters like Niccolò di Pietro Gerini followed suit for decades thereafter (Figure 77). The narrative triptych would become a staple of Florentine painting well into the fifteenth century, and was replaced by the single, rectilinear panel popularized by the writings of Alberti and the paintings of Fra Angelico only during the late 1430s. When Andrea di Cione, who had shared his workshop with Nardo during the 1340s and 1350s, designed the Orsanmichele *Saint Matthew* sometime around 1367, it was to the narrative triptych that he looked.

Andrea di Cione's interpretation of the narrative triptych for the Bankers' Guild, however, deviated from the one his peers employed for liturgical spaces in churches. Obviously, the decision to feature an Evangelist rather than Christ or the Virgin made the image more consistent with earlier cult images from the thirteenth and early fourteenth centuries – of Mary Magdalene, Francis, Dominic, Clare, or even Margaret of Cortona – than it was with altarpieces intended to represent common Eucharistic themes (Figure 78). Panel pictures celebrating the lives and miracles of all of these figures had been produced in

77. *Vision of Saint Bernard*, ca. 1360, Accademia, Florence. Photograph courtesy Scala/Art Resource, New York.

and around Florence between 1275 and 1350, and all of them employed this same approach of centering the composition around a standing representation of a saint with no other competing protectors included in the image that might distract (or detract) from the power and importance of the central player. Narrative elements were appended to the apron that spread out on either side of the saint. Andrea di Cione's desire to connect the Orsanmichele *Saint Matthew* with these cult images was surely intentional. In addition to placing his standing saint in the center of the image, Andrea lined the effigy of Saint Matthew with the four narrative pictures that run along the sides of the main compartment. Clearly the artist chose to abandon the more common placement of these smaller images along the bottom of the image, where these scenes would have functioned like the predella of an altarpiece, in favor of an older approach. Now, the legend of Matthew was applied to the object in much the same way that small narrative scenes were painted on aprons that flanked standing cult figures in thirteenth-century pictures. The dimensions of the image, defined by the width of the pier it was to embrace, encouraged Andrea to reconfigure the narrative triptych format in a way that recalled older cult paintings, but also in a way that provided him with more room to paint narrative pictures broadly, dramatically, and legibly.[37]

78. *Saint Mary Magdalene*, ca. 1275, Accademia, Florence. Photograph courtesy Scala/Art Resource, New York.

And this intentional attempt to align the Orsanmichele *Saint Matthew* with cult images popular in the fourteenth century causes us to think more seriously about the function of this picture within the confines of the former granary. Although Andrea conflated into one picture the formats of both the narrative triptych and the standing cult image (with apron intact), the painting's placement on the building's south wall, nowhere near a consecrated altar, removed it from the context of Eucharistic practices that had influenced the structural and technical qualities of so many altarpieces from the late medieval period. Moreover, its dissociation with relics of the figure depicted and its physical separation from the locations of the saint's miraculous acts, witnessed not in Florence but in the Holy Land, stripped from it the immediacy of spiritual association that gave so many cult images the legitimacy they needed to demand the attention they got from the masses.[38] The painting may have looked like a cross between an altarpiece and cult image, but it truly functioned as neither: and how could it, what with the altar of Saint Anne under the northeast vault and, just next to it, the Omega *Madonna of Orsanmichele* – a genuine cult image that both performed miracles and was recognized by the city as its official civic protector image – so close at hand? Andrea's *Saint Matthew* could not compete with these two vitally important spaces.

The panels that lined the faces of Orsanmichele's twelve piers enjoyed only a brief period of recognition inside the church. With the move to emphasize the exterior niches through the installation of sculpted effigies came the project to remove from the columns those wooden pictures that had created the lively interior space around Andrea di Cione tabernacle of the *Madonna*. In their place came slender frescoed paintings of guild patrons, but now in purely iconic form.[39] These replacement pictures now followed a different kind of model than the one that influenced the painters of the wood panels that had been installed there forty years earlier. The narratives that those artists had featured in their works – the *Annunciation, Trinity*, and scenes from the life of Matthew, for example – were now replaced by single standing effigies of saints, accompanied by rectangular spaces dedicated to a scene from that patron's life or miracles. Jacopo del Casentino's influential *Saint Bartholomew* was replaced by a static rendering of the Delicatessen Owners' patron saint, standing stoically with knife in one hand and book in the other (Figure 79). In so doing, a uniformity of representation was imposed, whereby all of the pier images painted there now took on the identical look of the lateral panels normally seen on altarpieces, complete with the narrative in a predella panel below. The individuality of expression that each guild, and each guild's artist of choice, had been able to assert through the size and subject matter of the panels they installed there was eradicated in favor of a more democratized leveling of the playing field. Aside from the iconographic attributes that they held, the figures

79. Niccolò di Pietro Gerini, *Saint Bartholomew*, 1408, Orsanmichele, Florence. Photograph courtesy Gabinetto Fotografico del Polo Museale Regionale della Toscana.

painted in fresco on the piers after 1400 barely deviated from one another. The guilds appear to have been allocated exactly the same amount of space to commission painters to produce exactly the same kind of figure for exactly the same purpose and audience. Moreover, this allocation was surely done on the cheap, as the production of a single, modestly sized fresco was about the least expensive commission any pennywise patron could hope to find. The result was that the splendor of the space was diminished by the medium of fresco that the confraternity captains appear to have imposed on the guilds (and made more glaring, unfortunately, by poorly executed restoration projects in the 1770s and 1860s that significantly undermined the paintings' condition). One senses that this was precisely their intent, for the smaller, less vibrant paintings that were produced in fresco after 1400 allowed the cult image of the *Madonna of Orsanmichele*, made of wood and gilt with gold, to shine forth even more brilliantly than before, now that it was surrounded by lesser stars in this artistic constellation. As for all those wood panels that once glittered in the flickering fires that emanated from the wicks of all those votive candles sold by the confraternity

to devotees of the cult image, only a few survived. Poorly documented as they were, we may only speculate that most were sent off to new homes in various churches and institutions in the city, where they were kept and used as their adopted owners saw fit or ignored and discarded for one reason or another. They were not altarpieces, after all.

GUILDS, SAINTS, AND LORENZO MONACO'S *AGONY IN THE GARDEN*

One of the more enigmatic pictures of the late fourteenth century is the *Agony in the Garden*, generally considered one of the earliest panel pictures produced by Lorenzo Monaco at the beginning of his professional career as a lay painter (Plate XXXI).[40] The picture's undocumented history and problematic provenance, which can be traced back only to 1810 when it was removed from Santa Maria degli Angeli and transported to the Florence Accademia, have left specialists to speculate rather hazily as to its origins, setting, and function.[41]

Dated to the late 1390s, the painting's features reveal a self-contained narrative dedicated to a singular Biblical theme. Christ kneels in the left center, praying toward a silver chalice held loft by an angel that descends to him from heaven. As James, John, and Peter sleep in the foreground, a layman doffs his cap and kneels in veneration, mimicking the position of Christ in the composition's center. To the far right, a lone lion emerges on the pathway that bends around a boulder. Lorenzo Monaco has chosen the moment before Christ's arrest to emphasize the calm before the storm, yet he breaks this moment of serenity by draping his figures in vibrantly colored robes that make the four main protagonists leap from the panel's surface. Indeed, the peacefulness of the scene in the main compartment shatters in the predella panels below. Lorenzo follows a traditional narrative sequence and first illustrates Judas's betrayal in the *Arrest of Christ*. But he then deviates from standard depictions of the Passion by including as his second scene the rarely illustrated *Stripping of Christ* – a highly unusual choice. Indeed, in these small panels, Lorenzo uses the garments of Judas's entourage as points of emphasis: the rich robes of Christ, his apostles, and his persecutors are juxtaposed with the stark white linen loincloth torn from Jesus's body. The barrenness of the landscape in the main panel and the blackness of the background surrounding the characters in the predella scenes below cause the bright colors of these garments stand out in stark contrast to the somber atmosphere that enshrouds them.

The narrative content of the picture, along with the predella panels below, tempts one to consider this panel as an altarpiece. The chalice borne by the angel and the appearance of the lion on the side suggest that this picture took as its foundation some kind of liturgical or ritual performance appropriate for a church. The appearance of the lion may well refer to Saint Mark, as Marvin

Eisenberg suggested in 1984 and 1989, and the addition of the chalice-bearing angel could allude to specific verses chanted at the Hours of Matins and Complines during the Feast of Maundy Thursday that were lifted directly from Mark's gospels.[42] But we must also consider that lions had alternative readings in Florence, a city which kept four of them caged and on display in front of the Palazzo della Signoria during these years, and which were commemorated in Donatello's marble sculpture of the *Marzocco* in 1418–1420. Indeed, the lion came to symbolize the potency of the commune and the prowess of its military, and when cubs were born to the caged lion that prowled in its pen before the doors of the Palazzo della Signoria, Florentines considered it a very good omen indeed.[43] The specific elements in the painting do not necessarily designate it as an altarpiece and, as we have seen, the self-contained format of the *Agony in the Garden*, devoid of lateral panels, would have been patently inappropriate as a liturgical object in 1395.

Instead, Lorenzo Monaco's picture may well have been intended for the column of a church. The picture's dimensions support this theory: the *Agony in the Garden* measures 189 × 108 centimeters and is thus of a size comparable to that of the panel of *John the Evangelist* that Giovanni del Biondo had painted for Orsanmichele in 1382. The picture would have fit neatly into one of the larger piers that still support the building's corners and the center of its longitudinal walls, just as the Cione panel of *Saint Matthew* covered one of the flat areas of the south central pier there. And the emphasis on clothing, combined with the iconographic reference to Mark and the lions of Florence, would have made Lorenzo Monaco's picture a perfect fit for the pilaster maintained by the Linen Guild in the city church of Orsanmichele – located on the southwest corner of the church on one of the largest and widest piers of the church.[44] Jesus's white undergarment in the *Stripping of Christ*, the colorful patterns of the clothes worn by his sleeping apostles in the main panel, and the appearance of the symbol of the patron saint of guild – the lion of Saint Mark – suggest an connection to the merchants who sold clothing made of linen. Just as the scenes of Matthew in his bank referred to the Arte del Cambio and the knife held by Saint Bartholomew referred to the expertise of those in the Delicatessen Owners' Guild, so too would the figures and scenes and elements in the *Agony in the Garden* have spoken to the products produced in the Florentine Linen Guild and their historical significance in the Passion story. Given the abundance of other panels of similar size and subject matter in that guild church, along with specific references to one of the city's more important guilds, the panel's content, format, and dimensions suggest that its first home was in this central civic church.[45]

Orsanmichele and the Florentine cathedral represented the two most important civic churches in the early Republican city. They were filled with paintings

on panel and in fresco that communicated to common people the virtues of their commune, provided for them the space to congregate as corporate bodies, and reminded them of the favored status their patron saints provided through their advocacy in the celestial court. Large and important images – like the *Madonna of Orsanmichele* and the marble tabernacle that encased it – were publically applauded and collectively venerated by members of the community, but the slender, vertical effigies of saints and the hagiographic accounts of their sacrifices played an important role in the preservation of these spiritual centers as celebrations of the state. These institutions sought the day's best artists to decorate their piers and pilasters. Andrea di Cione, Nardo di Cione, and Jacopo di Cione worked there. Giovanni del Biondo and Bernardo Daddi received commissions from them. Lorenzo Monaco and Niccolò di Pietro Gerini painted panels and frescoes inside them. And, of course, Donatello, Ghiberti, and Nanni di Banco decorated their exteriors with the most innovative sculptures produced in Europe since the Late Antique period. It was an honor to be asked to produce images for Orsanmichele and Santa Maria del Fiore.

COMMON PEOPLE ENCOUNTERED PIER PANELS IN RELIGIOUS SPACES with great frequency in early Republican Florence. Although nearly all have been detached from their original settings – some as early as the first decade of the fifteenth century – the abundance of undocumented single panels that feature standing or seated saints suggests that nearly every church boasted at least one such image, and that most displayed many more. These pictures acted as decorations for confraternity meetings, as devotional foci for private prayer, or as commemorative markers to promote the memory of individual donors. They referenced side panels on altarpieces, but they also deviated from them importantly in the closed compositions they had to have. Because all representations of holy figures had the potential to work miracles, these public pictures commanded respect due their capacity to become cult images – should they suddenly become invested with the power to act. This possibility ensured the longevity of this pictorial tradition, and the general appearance of pier panels changed little during the fourteenth and early fifteenth centuries. The one exception was the inclusion of narrative scenes, which began to appear more frequently as the fourteenth century wore on, both in main compartments and in flanking panels on inversed triptychs that hugged their pier supports.

The circumstances surrounding their production did not stay static throughout the early Republican period, however. Most pier panels in the first half of the fourteenth century were commissioned by corporate bodies, as guilds and confraternities vied for the privilege to decorate pilasters in some of the city's most important churches. But with the rise in popularity of the donor portrait in the fifteenth century came new projects to adorn the columns of religious

spaces. Now came representations of individuals depicted in pious adoration of specific saints, who pictorially commemorated their dead, celebrated their successes, and promoted the prominence of their families. The number of these donor portraits increased dramatically as the period drew to a close, and a pronounced shift in the history of artistic patronage was under way.

CHAPTER SIX

MURALS FOR THE MASSES: PAINTINGS ON NAVE WALLS

T HE ROMANESQUE CHURCH OF SAN MINIATO AL MONTE STANDS WATCH over the city of Florence from its perch on a hill that overlooks the Arno River from the south. The eleventh-century monastery, with its brilliant green and white marble facing, then as now had a constant presence. The structure was visible from any one of the bridges that spanned the Arno, as well as from the roads that ran alongside it on its northern bank. Inside San Miniato appeared a number of paintings intended for lay audiences – perhaps added there as both an inducement to lure them up the steep hill and as a reward for them when they reached the destination. The isolated pictorial decorations at San Miniato were relegated to three main settings. A mosaic of *Christ with the Virgin and Saint Miniato* was produced on the facade sometime during the first half of the thirteenth century (Figure 80). By 1297 the theme had been repeated in a larger mosaic that covered the apse in the church's east end (Figure 81). Only a few years later, a monumental fresco of Saint Christopher carrying the Christ child on his shoulders appeared on the nave wall (Figure 82). For much of the fourteenth century, these three murals formed the primary images intended for public consumption in the church on the hill.

The first of these public images, and one that quite literally presided over the city below, was the rectangular mosaic of *Christ with the Virgin and Saint Miniato*, produced sometime before 1250 (Figure 80). Placed squarely over the facade's central portal, the symmetrical trio of figures features an enthroned

80. *Christ with the Virgin and Saint Miniato*, facade, ca. 1240, San Miniato al Monte, Florence. Photograph courtesy Alinari/Art Resource, New York.

Christ flanked by the Blessed Virgin and, to the right, Saint Miniato. Mary dips her head reverentially while extending both hands to her son. Christ, who gazes directly out at viewers below, blesses both his mother and his audience of lay Florentines with a single benedictional gesture. The youthful, clean-shaven Miniato approaches the enthroned Redeemer holding in his hands a crown that carries three references. The first recognizes the saint's royal lineage and his unusual renunciation of the riches he enjoyed because of it. The second acknowledges his demise in upbeat terms, as Miniato ultimately reaped the

81. *Christ Enthroned*, apse, 1297, San Miniato al Monte, Florence. Photograph courtesy Scala/Art Resource, New York.

rewards of his sacrifice with the crown of martyrdom. And the third alludes to the crown of regality owed to the Enthroned Christ, who sits before us bare-headed, in need of that final symbol of total authority in the Celestial Court over which he presides. Inscriptions do not identify these figures because none are needed: lay visitors who today gaze up at the facade of San Miniato al Monte can see quite clearly in the bright Tuscan sun the formal and iconographic elements that fix these characters in their visual lexicon. And the mosaic's composition helps us identify and understand the images we encounter immediately upon setting foot inside the church on the right (southern) wall of San Miniato's poorly illuminated nave.

Because of the architectural style employed in the nave design of the Olivetan church, the small openings in the clerestory provided then, as they do now, only a modest amount of light, and even a wide assortment of burning candles could have added only minimally to the sanctuary's luminosity. But once their eyes had adjusted, common viewers saw a wealth of large and clearly legible forms that appeared for their inspection. The church's split-level design precluded the need for a *tramezzo* inside the nave, and thus provided the laity access to the nave walls as far as the steps that lead to the choir and sacristy on the upper floor and the crypt down below.

82. *Saints on the South wall*, ca. 1380–1410, San Miniato al Monte, Florence. Photograph © Vanni Archive/Art Resource, New York.

The first and most impressive image visitors would have seen inside San Miniato al Monte did not adorn the nave walls, however. Once their eyes had adjusted to the sudden darkness, viewers entering the church would have stopped to marvel at the enormous mosaic in the apse, inscribed with the date

1297, that looms over the choir on the upper floor (Figure 81). There sits a stern Christ figure enthroned on a bench, supported by a long pillow and a subtly decorated cloth of honor that frames his hips, legs, and feet. Holding a book in his uncovered left hand, Christ gazes directly at viewers below while blessing them and the bowing Virgin to his right. For her part, the woman in red and blue extends both hands toward him from within a tight space, framed by a palm tree that has been elongated to replicate the local cypress trees indigenous to Tuscany and, to the right, the eagle and lion that represent the evangelists John and Mark. This cramped and overly busy collection of forms reappears to the far right, where Miniato stands with his now-familiar crown in hand, surrounded by the angel of Matthew, the ox of Luke, a narrow tree, and a collection of birds that form a border around the apse from his feet to the corner and up into the tree along the right flank. The large, luminous mosaic, made all the more impressive by the candles that flickered below it, framed the ceremonial performance of the Mass and any liturgical rites completed by the monastic community in the choir directly underneath it. It was the most important and most easily accessible image in the church.[1]

The arrangement of forms in the mosaic was not isolated within the setting of San Miniato al Monte. Instead they appear to have been intentionally modeled – even lifted entirely – from the rectangular mosaic that had ornamented the facade of the same church since the early years of the century. It takes only a moment to recognize that the image in the apse repeats the earlier image's compositional core. Not only do we see the same bench, pillow, facial features, iconographic elements, gestures, and stances; but we also see identical patterns in the garments of all three figures, similar facial features, and a repetition of postures. While the artist of the apse mosaic included the symbols of the four evangelists, the two trees, the aviary of various fowl, and inscriptions to clarify his crowded composition, the basic elements of the umbrella mosaic over the choir came directly from the image that greeted lay viewers to the church on its facade.

This repetition of form was not entirely unusual within specific ecclesiastical and charitable institutions. With great frequency, specific concepts and figures were replicated, often in disparate sections of the building, to underscore their particular importance for the community active there. We have already seen how the maternal theme of parental support covered the walls and niches of the Misericordia across from the Baptistery. The cathedral was filled with panels dedicated to Saints Zanobi and Reparata. The Servites at Santissima Annunziata owned several images of the *Annunciation of the Virgin* and the Camaldolese at Santa Maria degli Angeli were particularly invested in paintings of the *Coronation of the Virgin*. This repetitive chain of similarly themed pictures allowed viewers in different sections of the church to see the identical concept all at the same time, which in turn had the effect of insuring that a uniform message was

always presented to visitors, no matter who they were, where they worshipped, or when they entered.

In San Miniato, a dual replication was put in play. Clearly, the most obvious image repeated for the purpose of emphasis was the *Enthroned Christ with the Virgin and San Miniato*. Here, the viewer was reassured of the proximity of the local patron saint to Christ and the Virgin as a celestial advocate, for the pairing of Mary with Miniato in the enthroned figure's presence alluded to their importance in heaven. Moreover, the blessing Christ sanctioned the space at the entrance and over the choir as holy zones, both preparing visitors upon their arrival for the sanctified interior into which they were about to proceed and then celebrating the glory of what was being performed by the monks in the choir under the apse. The apprehension of the themes in San Miniato's mosaics depended on the viewer's willingness to walk – to process from the church's front doors, through the entrance, and then inside the nave as far as possible to the presbytery beneath the apse. The reward for viewers came at the end of the journey.

To facilitate this journey, the monks in San Miniato extended their pictorial program for common viewers through the nave of their church. The enormous fresco of Saint Christopher greeted visitors immediately upon their entrance, but for roughly eighty years it seems to have stood alone there. Only in the last quarter of the fourteenth century, and again at the end of the first decade of the fifteenth, were new artistic projects conceived to add to the earliest fresco. A series of saints, each one painted in its own pictorial niche and lined up after the other, served as a set of stops on an artistic itinerary that moved from the entrance toward the apse. The nave's south wall took on the appearance of a series of side panels on altarpieces (or pier panels in churches) found in religious spaces all across Italy, and guided visitors toward the front of the church.

The first of these programs was executed sometime between 1380 and 1390, and included two sets of saints standing within slender spaces formed by spiral colonnettes, gothic spires, and tall gabled pinnacles. Produced by painters associated with the Cionesque school of painting, including possibly Niccolò di Tommaso, the first set of figures presents iconic effigies of Saints Nicholas, Miniato with a genuflecting donor, and Andrew (Plate XXXII).[2] A second series of saints appeared on the walls of the presbytery surrounding the choir's southern flank, next to the entrance of the sacristy that contained Spinello Aretino's famous fresco cycle dedicated to the Life of Saint Benedict. Perhaps executed by Pietro Nelli, Saints Michael and Benedict serve as bookends to Florence's three great civic patrons, John the Baptist, Reparata, and Zenobius, and all of them stand inside niches that take on an identical architectural form to those in the nave (Figure 83).[3] All of these figures were painted at roughly the same time that Spinello Aretino and his assistants were painting their frescoes of Saint Benedict in the church sacristy at the end of the 1380s.

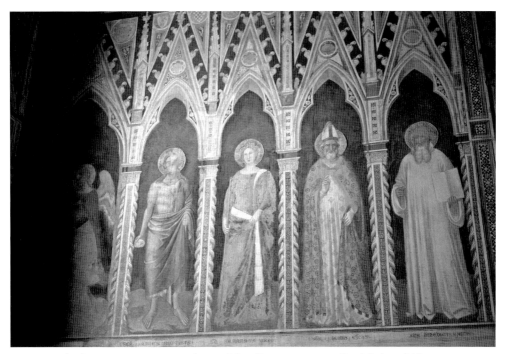

83. *Saints John the Baptist, Reparata, Zenobius, and Benedict,* ca. 1400–1410, San Miniato al Monte, Florence. Photograph courtesy Album/Art Resource, New York.

According to an inscription on the south wall, another project was executed in the summer and early autumn of 1409. This one extended the litany of individual saints on either side of the fourteenth-century figures. Saint James the Minor, with pilgrim's staff and scallop shell prominently displayed, joined the earlier group to the right. A detached pilaster was decorated with the image of the Mary Magdalene, and then beyond it were painted, from right to left, effigies of Saints Catherine with two female donors, Miniato, Julian, and the Vir Dolorum (Figure 84).[4] These forms have a heftier feel to them, with wider niches accommodating broader faces and torsos.[5]

This lineage of saintly advocates at first seems disorganized and almost arbitrary. Few have anything to do with the others, and there seems to be absolutely no narrative continuity tying them together. However, a thematic review of the order in which these figures have been arranged speaks to their arrangement as part of a broader message for viewers engaged in the procession from west end to the apse. A lay viewer standing in the church would have progressed down the south wall, seeing first the enormous late-thirteenth-century image of Saint Christopher bearing the Christ child on his shoulders, followed by (from right to left, down the nave toward the apse) Saints James, Anthony, Nicholas, Miniato with a kneeling lay donor, and Saint Andrew (Plate XXXII). These figures, while martyred for their adherence to the faith, all enjoyed a status that

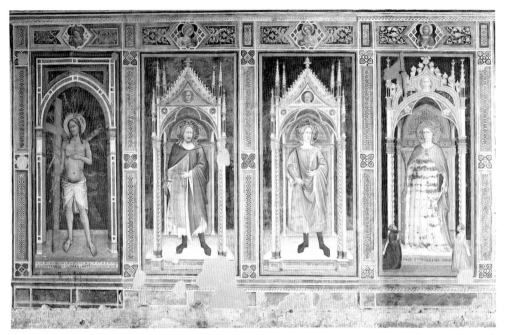

84. *Christ with the Instruments of the Passion and Saints Julian, Miniato, and Catherine with Female Donors*, ca. 1409–1410, San Miniato al Monte, Florence. Photograph © DeA Picture Library/Art Resource, New York.

extended beyond their flaws or grisly endings. An optimistic sense of help-fulness and hopefulness abounds, even in the face of imminent danger. But this understanding changes halfway down the wall. The single image of the penitent Magdalene, nude and kneeling in prayer within the mouth of a cave, alters this thematic approach. Now the darker side of these hagiographies takes hold, as the sinfulness engrained in these saints and the horrible torments they endured come to the fore. The last group of effigies, painted as an ensemble in 1409, moves from Saint Catherine to Miniato (again), on to Julian, and ends with a disturbing representation of Christ bearing a cross and surrounded by instruments of torture (Figure 85). The three beheaded martyrs join together as a group, and lead us to the final image of the martyred Christ and his bat-tered body. What had begun as an optimistic depiction of a youthful Christ at the beginning of his historic life's journey ended with overt references to the violent execution of a man cut down in the prime of life. In between them stood martyrs who had died in the name of the faith, with each figure more brutally attacked than the last. By the time viewers got to the apse at the end of San Miniato al Monte, they had run a gauntlet of martyrdom, which only rein-forced the power of the Enthroned Christ seated above them in the Celestial Paradise, beckoning them to come join him.

85. *Christ with the Instruments of the Passion*, ca. 1409–1410, San Miniato al Monte, Florence. Photograph courtesy Scala/Art Resource, New York.

MONUMENTAL ART IN FLORENTINE CHURCHES

Missing from this discussion of public pictures for common people are fresco programs produced in the great religious centers in Trecento Florence. We have encountered no lengthy cycles dedicated to the life or works of a great saint in a mendicant house, or vast mural sequences devoted to Passion stories, Infancy scenes, or the triumphs of Old Testament patriarchs. Those mural paintings we have seen that were intended for public consumption were relegated to singular

images located in secular settings, like the allegorical painting that advertised the responsibilities of the Confraternity of the Misericordia, the *Expulsion of the Duke of Athens* on the facade of the Stinche, or the *Judgment of Brutus* in the Audience Hall of the Wool Guild (Plates XII, XVII, and XXIV). In fact, a wide array of churches in the city possessed large-scale, monumental pictures aimed at lay viewers, but only a few of those mural paintings have survived into the modern era. Fragments of scenes, saints, or frescoed framing devices emerge occasionally and in damaged states, preventing a full comprehension of their original appearance. Churches like San Remigio, Santa Maria Maggiore, and Sant'Ambrogio still bear the remnants of these mural decorations, but only in abbreviated form. Our understanding of early Republican paintings in naves for common people is exceptionally limited.

Among the dozens of parish churches in the city grew a few Pan-Florentine institutions that catered to a broad swath of the population, irrespective of neighborhood, factional affiliation, or class. These institutions were either founded or dramatically updated during the first decades of the early Republican period. Santa Maria Novella, initiated in 1279, was only beginning to receive decorative attention by 1295. Santa Croce, its Franciscan rival on the opposite side of the city center, had only just begun construction by then. The project to decorate the exterior and interior wall of the cathedral's entrance began sometime between 1296 and 1300. The Baptistery of San Giovanni was a hubbub of activity at this very time, as mosaicists stood on scaffolding to craft its expansive Biblical cycle on the ceiling, and the interior of the Romanesque church at San Miniato al Monte experienced a decorative update in the late 1290s. Santissima Annunziata laid claim to the cult image of the *Annunciation*, a fresco on the Servite church's entrance wall that was ultimately surrounded by a marble shrine for which Piero de'Medici paid some four thousand florins (and which, in turn, made the fresco all the more difficult to see).[6]

Other churches in Florence featured monumental images on the congregational side of the *tramezzo* that bisected them during the early Republican period. San Miniato al Monte and Santa Croce can be said with certainty to have possessed mural paintings available to commoners, although the former was removed entirely from the matrix of streets, homes, and workshops that formed the core of the city. The Duomo, however, famously refused to ornament its walls with sculpted monuments to city heroes, and it was only after Cosimo's return to the city in 1434 that this provision was lifted (resulting in the adjacent references to military heroes – John Hawkwood and Niccolò da Tolentino – that were painted there during the Medicean period). As far as we know, a few scattered frescoes could be seen in Santa Maria Novella's nave, although they – like Masaccio's *Holy Trinity* (Plate XXXVII) – seem to have operated as independent entities inside chapels and shrines rather than as parts of a larger program. Similarly, Santa Maria Maggiore had no curtain

walls to hold a major fresco cycle, Santa Trinita's dark gothic interior could not support murals in its nave, and the various parish churches and monastic institutions around the city contained isolated images in their naves that have been either detached from their walls or whitewashed during the Risorgimento.

The vagaries of history cloud our understanding of decorative programs in churches intended primarily for common viewers. The churches of San Lorenzo and Santo Spirito were entirely rebuilt during the first half of the fifteenth century, and with these projects came the demolition of the walls that both supported their earlier structures and held the images inspected by the men and women who worshipped there. San Marco's interior was altered significantly in the late sixteenth and seventeenth centuries. We cannot reconstruct without difficulty the decorations for the Badia, Ognissanti, Santa Maria degli Angeli, Santa Maria del Carmine, San Pier Maggiore, or any of the parish churches inside the ghetto surrounding the Mercato Vecchio due to fire, the periodic purging of monastic properties, or the urban renewal efforts of the nineteenth century that cleansed areas of their ancient churches. And, of course, Giorgio Vasari's charge to revamp the major mendicant churches of Santa Maria Novella and Santa Croce during the Counter-Reformation altered the cluttered interiors of these major spaces in the name of clarity and tidiness. Still, the fragments that have survived from Santa Croce's renovation and the images that have remained intact in the Olivetan center of San Miniato suggest that common viewers had access to at least some monumental pictures when they attended services and sermons in urban churches.

Perhaps the physical spaces available to painters tempered the enthusiasm for expending time, energy, and money on decorations for the congregation's side of urban churches. Thanks to an architectural style that interrupted wide surfaces with tall, arched arcades, nave walls rarely possessed broad, clear, unadorned spaces conducive to the kinds of lengthy cycles we tend to associate with the fresco medium today. The clutter caused by monuments, tabernacles, and tombs reduced the size and scope of available pictorial fields on church walls. The nave was a poor place to install an exhaustive mural sequence, as most early Republican churches simply had no room for them. The few frescoes that appeared on the congregation's side of the nave featured either effigies of individual saints, didactic images, or Biblical narratives. These figures and scenes were intended to promote proper behavior, inspire the admiration of viewers, or startle them with the severity of the subject. They were nowhere near as complex, sophisticated, or entertaining as the elegant and elaborate fresco cycles that decorated the private burial chapels, chapterhouses, and choirs of Florence's great religious centers, or even pilgrimage centers like those in Padua, Assisi, or Rome. Common viewers in Florence rarely came into contact with fresco paintings in the early Republican period. Mosaics were used for this kind of audience.

Art for common church goers, then, appeared in selective (and limited) spaces specifically designated for them – on columns that formed the arcades of side aisles, in *tramezzo* niches that faced the congregation, in the apses of Romanesque churches, and occasionally on sections of nave walls between the entrance and the pulpit. And these images were normally stripped down to basic elements that formed the lowest visual common denominators needed to satisfy all those different types of viewers from all their different walks of life, educational backgrounds, and ethnic origins. Subject matter was limited, just as the spaces in which to illustrate them was limited. Representations of iconic saints, simplistic images of eternal suffering and damnation, and fundamentally basic stories known by even the least literate viewers carried the day. Yet these appeared in only a few venues, and then only in settings that could accommodate the very largest audiences in the city. Predictably, they were the ones frequented most often by common people in early Republican Florence.

THE *CORONATION OF THE VIRGIN* IN SANTA MARIA DEL FIORE

The church of Santa Reparata officially became the church of Santa Maria del Fiore in 1296, although it would take decades for the new name to gain traction in the minds of the laity who attended services there. The byproduct of a new republican spirit, which in turn was born of an economic boom that placed money and power in the hands of entrepreneurial merchants, the Duomo came to symbolize all that was impressive about the city of Florence. From its inception, the cathedral was a monstrously large facility, and by the time of its consecration in 1436 it was easily the largest religious edifice in all of Christendom. From entrance to end wall, the cathedral stretched 153 meters, and the nave expanded in width to 38 meters all the way to the crossing, which nearly trebled there at 90 meters. The arches that formed its arcade towered overhead by some 23 meters. The vaulted ceiling rested on enormous piers, most of which were decorated with panels that addressed the needs of confraternities and individual patrons who wished to congregate in the nave. A mosaic dedicated to the theme of the *Coronation of the Virgin*, only recently popularized in Rome, was installed on the entrance wall, just above the central doorway, sometime around 1300 (Plate XXXIII). A fresco of the *Vir Dolorum*, or the *Man of Sorrows*, was painted inside a semi-apse of Santa Reparata sometime in the 1340s, even though everyone knew it would be eradicated soon enough by the enormous cathedral that was growing up around the Byzantine church (Figure 86). Bernardo Daddi placed a large polyptych on the high altar, just beneath the open expanse that would later be capped by Brunelleschi's dome (Figure 71). But the nave walls appear to have been left undecorated, and many of the other spaces inside the cathedral of Santa Maria del Fiore were similarly

86. *Vir Dolorum*, ca. 1340–1350, Santa Maria del Fiore, Florence. Photograph courtesy Gabinetto Fotografico del Polo Museale Regionale della Toscana.

bare. The visuals capturing the attention of visitors were located in the smaller niches and meeting places within the cavernous structure.

The move to fill the new cathedral with depictions of heavenly patrons began soon after the building project was started in the late thirteenth century, and coincided with the early decorative programs then under way in the Baptistery, Santa Croce, Santa Maria Novella, and San Miniato al Monte. Sometime around the year 1300, just as Arnolfo di Cambio began carving figures of the *Enthroned Madonna and Child* for the church facade on the opposite wall, the mosaic of the *Coronation of the Virgin* was installed on the interior of the cathedral's west wall. Just as Arnolfo's sculptures of the Virgin could be seen by common viewers as they walked beneath them in the piazza, the mosaicist responsible for the *Coronation* knew that his image would be fixed in a place where all residents and visitors to the Duomo would see it as they exited the Duomo.

The modestly sized lunette was produced by an artist whose name has not come down to us, although it has traditionally been assigned to Gaddo Gaddi, Taddeo's father. Clearly aware of the mosaic projects either under way or recently completed in San Miniato and at San Giovanni, the artist presented in this *Coronation* an abbreviated version of Jacopo Torriti's prototypical composition that had been installed only a few years earlier in the apse of the Roman basilica of Santa Maria Maggiore. Perched in a pointed frame

atop the central door of the church, viewers had clear views of the mosaic from nearly any position inside the nave, particularly as they approached the portal on their way out of the church. When that portal was opened, audiences had an equally clear view of the Baptistery across the way. Although separated from them by the truncated space between the two facilities, the *Coronation* mosaic in Santa Maria del Fiore could be understood as an extension of the vast expanse of ceiling covered by the mosaics in San Giovanni. This connection would have been underscored and affirmed by any procession that extended from the cathedral to the Baptistery's interior, where viewers would begin their journey by gazing upon the scene of the *Coronation* in the Duomo and end it by considering the Biblical stories across the way.

The medium of mosaic was rarely employed in Florence at this time. Rather, it was commonly associated with and employed in the papal capital of Rome, still a vibrant spiritual and political center in 1300 and not at all reluctant to display its imperial grandeur at this time. Rome was full of mosaics, with apses, naves, and facades of scores of churches adorned with this luminous material, installed there throughout the thousand-year history of the Church. But few buildings in Florence boasted decorations in mosaic during this same period – only three by my count. When two of these three were linked visually and geographically, like those in the cathedral and the baptistery, people paid attention to them.

The mosaic's composition seems familiar now to modern-day viewers, for images of the Virgin's depiction as Celestial Queen have come to form a vital iconographic moment in Christian art. But Florentines in 1300 were not nearly as accustomed to it as we are today. When it was completed circa 1300, the *Coronation of the Virgin* in the Florentine Duomo would have been the first and only monumental representation of that scene found in the entire city.[7] Mary and Christ sit on benches, each one seemingly inlaid with reliefs or paintings of seated, book-toting scholars, and face each other while responding physically to this ceremony in appropriate ways. Christ fixes on his mother's head the crown of regality, while the two fingers of his right hand extend over her to perform a benedictional blessing. His eyes, cast upward, catch both the crown, his own right hand, and the seraph behind Mary all at once, while his exposed left foot projects toward the Virgin's two feet, pressed closely together – just as her knees seem locked into place beside each other. The Virgin's demure response denotes her submissiveness. She dips her head to receive the crown, crosses her left hand over her breast to grasp her right bicep, and raises her right hand in an act of invocation and acceptance that echoes, but does not imitate, the gesture of Christ's elevated fingers. Whereas his eyes gaze beyond Mary's head, hers gaze out toward the viewer below, as if preparing to extend the blessing she has received from Jesus on to the mortals below who take in the scene. Draperies swirl around limbs and joints, while the hems of her garment

undulate like leaves fallen from barren trees, while gold, blue, and red tesserae compete for the eye's attentions.

This holy couple does not sit alone. The four symbols of the Evangelists occupy lower zones of space by the edge of each royal bench. The eagle of John and the ox of Luke accompany the Virgin to the left, while the angel of Matthew and the wonderfully twisted lion of Mark gaze awkwardly up at Christ from the right. Appearing as bookends on either side of the lunette stand two horn-blowing angels, one in red and the other in blue. With instruments rising up along the edge of the perimeter, they form an insular pocket that creates a zone for additional angelic performers, four on one side and three on the other. Stacked one above the other, akin to the angels flanking the Enthroned Virgin Mary in Cimabue's *Santa Trinita Madonna* and, to a lesser extent, Duccio's *Rucellai Madonna*, their inclined bodies and neatly coiffed hair recall similarly crafted figures from large-scale panel paintings from the turn of the century (Figure 22). And above them float a seraph in red and a cherub in blue, covered in the multiple wings that signify their status. Now we see a total of nine angels, equaling the nine types thought to occupy the heavens, and recited as part of the liturgy sung by canons and monks all across western Christendom on a variety of feast days.[8]

The theme of the *Coronation of the Virgin*, new and fresh and exciting in the minds of makers and viewers of monumental art in 1300, appealed to contemporary artistic tastes and fit in well with the image's setting. The mosaic was produced just as the facade of the new cathedral was being erected in front of the remnants of the older basilica of Santa Reparata. With Arnolfo di Cambio busily carving figures of the Madonna and Child with Angels, the cathedral was being outfitted with a visual program that accentuated the Virgin's prominence in two central ways. The sculptures that faced the Baptistery (and the crowds milling about in the piazza between them) addressed Mary's role as mother and protector of the human Christ. His presence in her lap as a youthful savant naturally and unsurprisingly celebrated the first of Jesus's two natures – as God Made Flesh. The facade featured the Virgin in her earliest role as humble mother of a child, as described in the Gospels of Luke and John. The Infancy of Christ and the Agency of Mary greeted visitors to the Duomo.

Those exiting the cathedral, of course, saw the second part of this program, rendered in mosaic. Whereas the forms on the facade spoke of her humble accomplishments at the beginning of the Gospels, now the last phase of her story – in the form of her death, assumption, and coronation as supreme *sponsa* of Christ – received artistic emphasis. Surrounded by the heavenly choir and the creatures that simultaneously symbolize the Gospel writers and the Four Beasts of the Apocalypse, Mary's new role as Chief Advisor and Advocate of the People receives primary attention. Viewers attending services and meetings, or exiting the nave in either ceremonial processions or disorganized dismissals,

looked up to see a figure at once more authoritative and more accessible than the one depicted by Arnolfo in his sculpture on the front. While her presence by Christ's side in the court of heaven gave her a regal air of detachment, her direct connection with the audience below – created both by her gaze and by her genuflection toward lay visitors – made her the advocate of the people. This mosaic could be understood in multiple ways, although the message presented here probably did not possess the same kind of multi-valence we have encountered in other public images like the *Madonna della Tromba* at the mouth of the Mercato Vecchio, the *Abandonment of Children and the Reunification of Families* on the facade of the Misericordia, or the *Judgment of Brutus* in the Sala d'Udienza of the Wool Guild (Plates V, XII, and XXIV). The Virgin, lay audiences were here told, could be many, many things all at the same time; and some of them were diametrically opposed to each other in theme and concept. And this multiplicity of features may have alluded in part to the actual setting in which the mosaic sat, for the new cathedral was dedicated to Saint Mary of the Flower – the Virgin Annunciate (recipient of lilies), the Virgin Bodily Assumed (leaving flowers in her vacant tomb), and the Virgin Protectress of the City of Fiorenza.

The image of the *Coronation* also helps us understand the strange canvas painting produced about one hundred years later for the small chapel just below it (Plate XV). The complexity of the unusual image of the *Double Intercession*, discussed in Chapter 2, can only be understood in the context of the other two images of the Virgin and Christ that ornamented the west wall of Santa Maria del Fiore. Both the mosaic and the sculpture, in the high quality of their materials and in the subject matter they presented, emphasized the Virgin as a wise, regal figure who commanded the respect and adoration of viewers. Even the nodding of Mary's head in the *Coronation* and her guise as protective mother in Arnolfo's sculpted image were illustrated in the context of an enthroned and crowned Queen. Despite attempts to the contrary, the Virgin's role as protector of common people did not come across.

The installation in circa 1400 of the largely original scene of the *Double Intercession*, with the Virgin as Madonna Lactans/Madonna della Misericordia/Madonna of Mourning combined with the Trinitarian consideration of Father/Crucified Son/Dove of the Holy Spirit, completed what had been lacking at the entrance of the Duomo for a century (Plate XV). By addressing all of these themes, and by placing at the feet of Mary a collection of contemporary lay worshippers in ways that referred to the fresco of the *Madonna of the Misericordia* located across the piazza in the building that could be seen from the cathedral's front door, the virtues of Saint Mary of the Flowers as a champion of the people were layered onto those of mother, queen, and bride of Christ. The three images – one in stone, one in gold-covered glass, and one in pigment on simple canvas – combined to present ideas that were, in some respects,

arranged according to the material from which they were made: the steadfastness of Mary was depicted in marble; the regality of Mary was referred to by the gold that surrounded her; and the humility of a nursing mother, advocating for lay viewers of every stripe and color, was represented in canvas, a material so base that it was literally never used for formal liturgical ceremonies.[9]

Artists charged with the task of creating public art thought about more that just the composition of their audiences, the nature of their works, and the subject matter they were charged to illustrate. The way in which their works were to be seen and the sequence in which viewers took them in mattered a great deal. The movements of those viewers influenced the way they interpreted images, and thus the formal and informal processions and *passaggiate* they took affected their reception of early Republican painting. This was certainly true of perhaps the most important viewer of the *Coronation of the Virgin*, the Bishop of Florence, who passed by or under the mosaic at the entrance wall nearly everyday, and always in an official capacity.

The Bishop of Florence was kept quite busy. As Marica Tacconi has shown, the service books used by the canons of the cathedral before 1310 demonstrate clearly that the bishop moved about his city with great regularity during the early days of the republic. Accompanied by an entourage of canons, secretaries, and priests, the bishop processed formally to a different church (or churches) no fewer than twenty-seven times during the liturgical year.[10] He visited the Benedictine nunnery of San Pier Maggiore the day after Easter, on the feast of Saint Agnes on January 21, and during that of Saint Peter and Paul on June 29. He toured the parish church of San Lorenzo on April 25 and visited San Pancrazio on that saint's feast day of May 12. On the third Rogation day during Ascension week, he and his entourage made a circuit that took them from the front door of the cathedral (and the Baptistery before it) to the churches of Santo Stefano, Santa Felicita, and finally up the hill to San Miniato al Monte: when they reached this latter church, the bishop and his aides altered their liturgical litanies to demarcate that institution as distinctive among all others in the city. The typical point of departure for these processions was through the doors on the cathedral's facade, and the mosaic of the *Coronation of the Virgin* over the main entrance served as the last image the bishop would have seen as he left his ecclesiastical home to visit those in his diocese. How fitting it must have been for him and his entourage to end that particular procession in the church of San Miniato al Monte, ornamented just like the Baptistery in green and white marble, where he saw the mosaics on the facade and in the apse that formed a pair of golden images celebrating the power of Christ, the advocacy of the Virgin Mary, and the protection of Saint Miniato. His ending point looked a lot like his starting point.

The site visited most frequently by the bishop's retinue, however, was the Baptistery of San Giovanni, located only a few meters from the cathedral in

the center of the piazza del Duomo. The entourage performed ceremonial entrances into that facility almost a dozen times each year, including the feasts of the Octave of the Nativity on January 1 and the Purification of the Virgin on February 2, the celebration of the Litanies on April 25, the feast of Saints Philip and James on May 1, and the celebration of John the Baptist's feasts on June 24 and August 29. They also processed to the Baptistery on the movable celebrations of Holy Saturday, Easter Sunday, the first Sunday after Easter, the first Rogation day, and the feast of the Ascension.[11] Awnings were placed between the facade of the cathedral and the east doors of San Giovanni to create both a protective covering for the bishop and a ceremonial canopy to assert his authority. On May 1, when Saints Philip and James were honored, the relic of Philip's forearm was lifted from its protective case in the Duomo, covered in cloth, and then held aloft in a theatrical presentation for the laity before being carried personally by the bishop into San Giovanni.[12] As he and his followers made their way through the nave of Santa Maria del Fiore, lay witnesses behind him saw the bishop pass beneath that sparkling mosaic of trumpet-blaring angels celebrating the Coronation of the Virgin at the hands of Jesus Christ. It was a fitting way to pass from the bishop's seat into the piazza outside, and an equally fitting way to return to the cathedral after the journey to and from the Baptistery.

The *Coronation of the Virgin* was the last image the bishop saw as he crossed the threshold of the cathedral on his way through the piazza to the Baptistery (or any other destination included in one of his processional journeys). It was also the first image he saw as he set foot back inside the Duomo. The symbolic and stylistic themes he saw during this procession worked together to form a cohesive pictorial program, with just enough repetition to underscore salient themes without belaboring points. If the gold tesserae in San Miniato only vaguely reminded the bishop of his seat of authority in the Duomo, the medium of mosaic was surely the most fundamental visual linkage between the cathedral image and the wondrous expanse of ceiling decoration that awaited the bishop inside the Baptistery of San Giovanni. Santa Maria del Fiore was never, and would never be, as sumptuously decorated as the Baptistery – it was simply too big to be covered in gold – but the strategic placement of the *Coronation* mosaic on the entrance wall made for an appropriate reference to what awaited the episcopal encourage at the other end of the awning.

Some specific features in the cathedral's image signaled a visual connection for this specific viewership. The trumpets held aloft by the two largest angels at either end of the Duomo's composition likely referenced the pomp and circumstance of the bishop's procession, and these in turn were repeated in the Baptistery's western vaults that faced the cathedral and the bishop as he entered into San Giovanni through its east portal. The nine angels in the *Coronation* (five

on the left and four on the right) were echoed by the groups of angels in the upper tier of the Baptistery's mosaic program, which announced even more specifically the identities of the different types of angels one could expect to meet in heaven (Plate XXXIV). The depictions of the Cherub and Seraph in Santa Maria del Fiore's mosaic matched closely their partners in the Baptistery, again positioned exactly where the bishop could see them immediately upon his entrance into San Giovanni. And the overall reliance on a stylistic approach to mosaic decoration based on principles of late medieval Byzantine prototypes – even though probably produced by different teams of artists – connected the cathedral's lunette image of the *Coronation of the Virgin* to the more expansive program of mosaics inside the Florentine Baptistery. Monumental images in public sections of churches contained specific messages for specific viewers – and not just High Church officials.

SCENES FROM THE OLD AND NEW TESTAMENT IN THE BAPTISTERY OF SAN GIOVANNI

The mosaics inside the Baptistery were not intended solely for the Bishop's eyes, of course. As the communal baptistery for the entire Christian population of Florence, San Giovanni was a mandatory stop for anyone with children, anyone who had siblings with children, and anyone who had friends with children. The vast program of images inside the Baptistery was designed with the understanding that, at some point in their lives, literally every member of the community would stand beneath the mosaics on the ceiling for a considerable amount of time. They became the only true pictorial common denominator for all Christians in the city. The project, commissioned by the Guild of the International Cloth Merchants that championed all decorative works inside the Baptistery, stands as one of the very first examples of early Republican art and one of the very first attempts to produce an expansive narrative cycle in mural form in the city of Florence. The messages these images conveyed tell us as much about civic values as they do of the perceptions Florentines had of the power of personal and collective spirituality. In fact, the mosaics in San Giovanni may well represent the first large-scale monumental pictorial project of the early Republican period. What we see in them provides us with a glimpse of how a new political entity crafted its self-identity.

Produced during the years bracketing the turn of the fourteenth century, just as the facade of the Duomo next door was being erected and decorated, an artistic workshop executed an extensive series of scenes dedicated to stories from the Old and New Testament. Placed high overhead and designed to follow a circular path around supplicants below, the scenes spiral from a core group of angels and archangels down to the Creation Story, move to narratives

celebrating Old Testament heroes, continue with moments from the Infancy and Passion, switch to scenes of the life of John the Baptist, and finally depict a unique vision of hell that inspired generations of artists and scholars all across Italy, including both Giotto and Dante. Aside from inscriptions that identify specific individuals and the categories of angels that revolve around the core, no extensive texts accompany these marvelous mosaics. Illiterate viewers were placed at no disadvantage to their educated social superiors when considering these scenes. Imagery was the great equalizer, as it simply had to be. The scenes on the ceiling of the Baptistery were selected with an eye toward inclusion rather than exclusivity.

The importance of the cycle has not been lost on historians of Florentine art. As the literal and allegorical center of the city's cultural core, the five major themes on the Baptistery's ceiling have elicited a wealth of commentary by specialists eager to identify the artists responsible for their creation, the dates of production (probably between 1275 and 1315), and the connections to Giotto and Dante, the two greatest Florentine heroes of the day.[13] While most of the literature pertaining to the Baptistery's mosaics has been dedicated to issues of style, authorship, and dating, few have considered the subjects and messages of the program from the context of the audiences for which it was intended.[14]

In fact, San Giovanni was designed to accommodate different types of visitors. Lay viewers who ventured inside the baptistery tended to enter through the south portal, before which they had stopped to hear the first portion of the liturgy for baptism. The bishop and his entourage, as we have seen, entered the Baptistery through the east door and under the canopy that stretched across the piazza to the facade of the Duomo. The organization of the ceiling mosaics, then, addressed at least two different audiences, and were positioned and composed with the interests of these viewers in mind.

We have no surviving record of the liturgy of baptism performed inside or outside the Baptistery in the early Republican period, but some general features of the ceremony are known.[15] By the fourteenth century, baptisms appear to have been held with great frequency, maybe even as often as a few days each week (as opposed to the preceding era, when the sacrament was held only on the Saturday before Easter, the Feast of the Pentecost, and John the Baptist's Day).[16] Sermons were delivered and hymns were sung, although the content of these ritual utterances has not been passed down. Both men and women attended the ceremony, and new mothers could attend the ceremony if they felt strong enough to do so after the physical ordeal of birth. Importantly, female viewers were encouraged to participate, as is indicated by the balcony on the upper floor of the Baptistery that appears to have been designed as a *matroneo* to hold them. The audience inside San Giovanni was male and female, urban and rural, literate and illiterate.

The mosaic cycle must have been utterly stunning when finally completed. The entrance into San Giovanni resulted in a visual explosion of gold, vivid colors, and expressive storytelling that remained unique in public settings well into the early days of the sixteenth century. What viewers saw there was, by far, the most extensive and intricate compendium of Biblical imagery in the entire city, composed in a sophisticated manner that would influence artists for generations to come. Six interrelated, yet discrete, sequences compose the ceiling's design — five of which move in a circular orbit in horizontal bands that encourage active viewing. Appropriately, the very top section begins with the standing figure of Christ the Redeemer, who offers both a blessing and the open book of the Bible to the audience below (Plate XXXIV). With the A and O (the Alpha and Omega) beside his head, the figure stands as the supreme victor over sin, death, and temptation, the beginning and the end and all that is in between. Joining the Redeemer in this trapezoidal frame, marked by spiral columns and capitals articulated with painted acanthus leaves, appear two pairs of angels. The two at the bottom, in blue, represent cherubim and those above, in red, seraphim — for generations the highest order of angels in the hierarchy of the Roman liturgy. The seven other sections of this band contain pairs of winged figures, each identified with inscriptions, that identify them as representatives of the remaining orders: extending back from the image of the Redeemer with Seraphim and Cherubim appear Thrones, Dominions, Virtues, Powers, Archangels, Principalities, and Angels. These heavenly bodies face the west portal of the Baptistery, the door through which the most important visitor to the space processed during his numerous journeys to and from the neighboring cathedral. And all of these angelic forms reappear in the *Coronation of the Virgin* across the way on the entrance wall of the cathedral through which the Bishop passed. Angels in mosaic bid him farewell and greeted him in welcome whenever he passed from one building to the next.

Once inside the Baptistery, all viewers — but particularly the Bishop and his entourage — were immediately addressed by the enormous figure of Christ the Judge and the unusually expansive representation of the *Giudizio universale* on the ceiling's western side. Indeed, the *Giudizio universale* fills three of the eight vaults that cover the church's western portion. The massive figure of Christ as Judge dominates the composition's core, as the arched bands of blue and gold combine with his wounded hands and feet to define the iconographic subject matter in very clear ways. Two rows of angels flank his head, with a crucifix and crown borne by those on his right and the spear and sponge carried by those to his left. The tier below contains seated saints, seven on each side, with all but the innermost figures of Mary and John the Baptist presenting opened books to viewers below. Between them stand nimbed angels, most of whom tilt their heads toward the enthroned saint before them in ways that remind us of the conventions of space and figural relationships seen in the paintings of Cimabue.

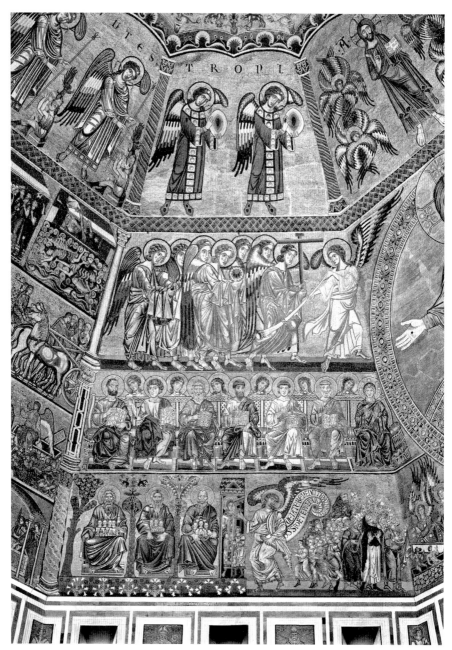

87. *Last Judgment and Biblical Scenes*, detail, *Heaven* (southwest vault), ca. 1275–1300, San Giovanni, Florence. Photograph courtesy Scala/Art Resource, New York.

The most innovative portion of this section extends below these martyred heroes, where an early and influential illustration of the Last Judgment plays out across the widest portion of the ceiling. To the left, winged angels invite the souls of the devout to pop up out of their tombs to follow Michael the Archangel through a portal and into the Holy Jerusalem, where the elect sit

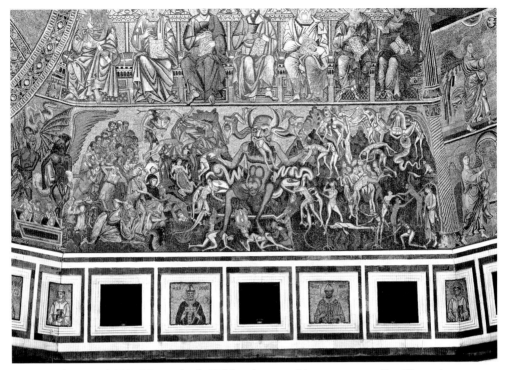

88. *Last Judgment and Biblical Scenes*, detail, *Hell* (northwest vault), ca. 1275–1300, San Giovanni, Florence. Photograph courtesy Scala/Art Resource, New York.

protected in the laps of patriarchs (Figure 87). Some of these fortunate few – notably those in official garments of friars, priests, bishops, and civic leaders – turn toward the massive judge with heads and hands raised in celebration. Others, commoners of indistinct features – men in the foreground, women behind them – scurry behind Michael toward the open gate. To the right of Christ the Judge, balancing perfectly the figure of Michael on the composition's left side, the horned figure of Lucifer presides over the tortuous punishment of the damned, the details of which formed the core of Italian representations of hell for centuries to come (Figure 88). Winged demons escort their company from open sarcophagi toward a twisted mass of humanity, at first clothed in the garments of contemporary viewers but soon stripped of their emblems of vanity and vulgarity. Female sinners now occupy the foreground with their male counterparts following behind, in a gender-based typecasting that makes clear the artists' skepticism of the virtues of contemporary women. Serpents devour nude sinners head-first. Devilish executioners roast the damned on spits. Elongated victims are tossed horizontally into a mass of kindred spirits. A clothed soul identified by an inscription as Judas (GIUDA) hangs from the gallows in the lower right corner). This visceral illustration of the fate awaiting the impious surely consumed the attention of an image-starved public when it was finally completed sometime around 1300. But, from its position on the three

western vaults overlooking the altar, this scene was also aimed directly at the east portal through which the bishop and his entourage of canons and clerics entered the Baptistery during processions from the cathedral. This upper register was created for an episcopal audience, and spoke to the activities and actions of that specific viewership that would have encountered the mosaics from the vantage point best suited for immediate apprehension. The rest of the ceiling addressed a much broader viewership.

Four narratives extend from this overtly intimidating scene, each one contained in a band that extends from left to right across the five vaults that compose the northern, eastern, and southern sides of the octagonal ceiling. Each of these vaults is divided vertically into three sections, with the amount of space available to recount a scene proportioned according to its proximity to the lantern: the highest scenes have the smallest amount of space, the lowest the most. The top band recounts specific early moments from *Genesi*, with particular attention paid to the stories of Adam and Eve, Cain and Abel, and Noah's Ark (and ignore Abraham, Isaac, and Jacob). In a manner famously employed by Michelangelo two centuries later, the narrative brackets the first book of the Bible, beginning with the Creation and ending with the second iteration of humanity, caused by God's destruction of nearly all living things in his effort to start afresh with Noah, his offspring, and their equivalents in the Animal Kingdom (Figure 89). In between, the sins of Adam and his progeny are explicitly illustrated, with the murders of both Abel and Cain featured to underscore the wretchedness of mankind.

The second band continues the stories of Genesis, but skips ahead to the legend of *Giuseppe*, son of Jacob, grandson of Isaac, and great-grandson of Abraham (Figure 90). This narrative begins with the touching account of Joseph's dream, marked by twinkling stars in a field of gold. But the following scenes tell the unhappy tale of a young man spurned by his own family, tossed down a well and left for dead, betrayed into slavery, wrongfully accused of rape, and imprisoned for his actions. Only at the very end do we see a happy ending, when he is reunited with Jacob, his father.

The third band features scenes dedicated to the life and death of *Gesù*, beginning with the *Annunciation* and ending with the *Three Marys at the Empty Tomb* (Figure 91). The emphasis here, predictably, lies on tales of Christ's infancy – a suitable subject for a Baptistery – with some surprising additions. The entire northeastern vault, a full three scenes, has been reserved for the story of the Magi, those kings from disparate corners of the world who came to honor the new king (Figure 92). While the *Adoration of the Magi* was (and remained) a popular subject in Florentine art of the period, the accompanying images of the *Dream of the Magi* and the *Flight of the Magi* were not (Figure 90). In fact, these scenes were rarely included in Infancy sequences produced during the early Republican period, and beyond for that matter.

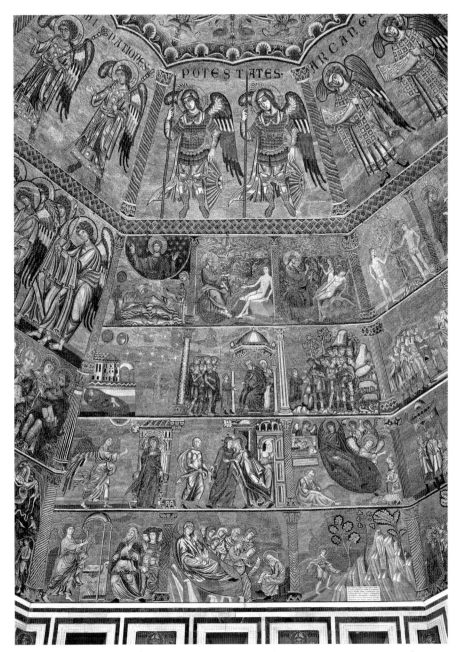

89. *Last Judgment and Biblical Scenes*, detail, north vault, ca. 1275–1300, San Giovanni, Florence. Photograph courtesy Scala/Art Resource, New York.

The fourth and final narrative that extended across the Baptistery's ceiling illustrated two textual accounts of the life and death of *Giovanni Battista* (Figure 93). Details from the Gospels were used to help the artist describe the moments of the visitation, his preaching in the desert, the baptism of his followers, and the basics of his imprisonment and ultimate demise. But the more recently

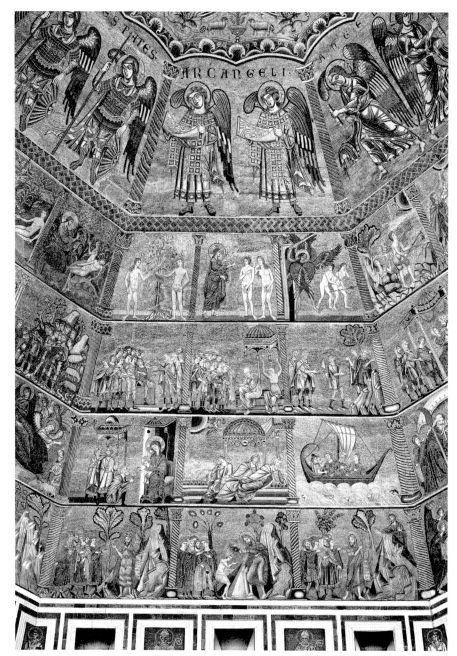

90. *Last Judgment and Biblical Scenes*, detail, northeast vault, ca. 1275–1300, San Giovanni, Florence. Photograph courtesy Scala/Art Resource, New York.

composed Italian hagiography, *La vita di Giambattista* from circa 1300 to 1310, helped flesh out the story of his conception, birth, youthful journey in the wilderness, and the deceit of Herod in his lust for Salome.[17] As may be seen in the other three bands, the cycle of John the Baptist begins with his earliest

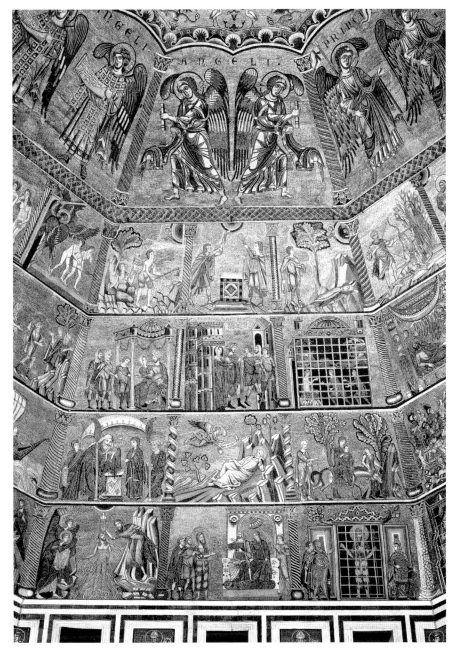

91. *Last Judgment and Biblical Scenes*, detail, east vault, ca. 1275–1300, San Giovanni, Florence. Photograph courtesy Scala/Art Resource, New York.

appearance and ends with an image of redemption – in John's case, the collection of his severed head by his followers and their solemn burial of his now reunified body.

Artists of this period took into consideration the perspective of their audience when composing images large and small, and the mosaicists who designed

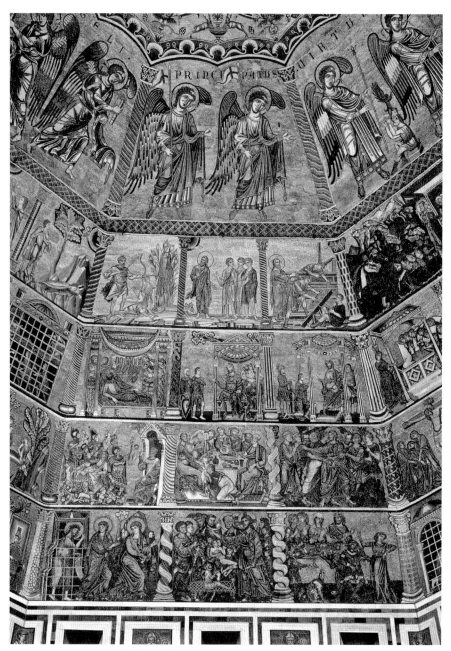

92. *Last Judgment and Biblical Scenes*, detail, southeast vault, ca. 1275–1300, San Giovanni, Florence. Photograph courtesy Scala/Art Resource, New York.

the ceiling decorations in San Giovanni were no exception. Early in the project, the decision was made to orient the four bands of Biblical narratives in a way that made them immediately legible to those entering the Baptistery from the south doors. Each of these stories begins on the northeast vault, directly

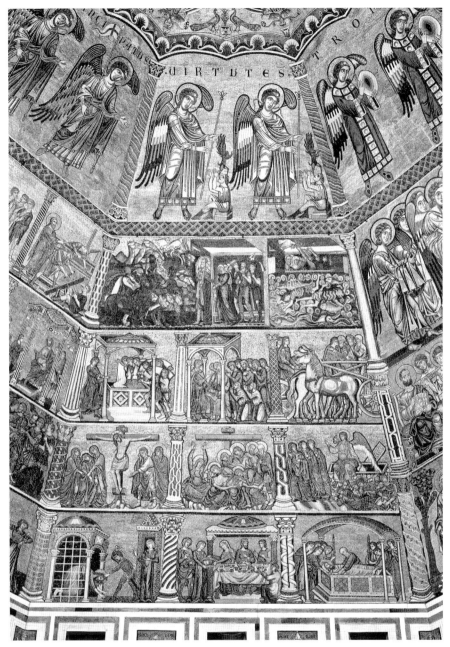

93. *Last Judgment and Biblical Scenes*, detail, south vault, ca. 1275–1300, San Giovanni, Florence. Photograph courtesy Scala/Art Resource, New York.

across from the door through which parents and godparents entered with their infants for baptism. They were permitted to begin their visual tour of the ceiling from that privileged vantage point, as opposed to the other two portals leading into the building, due to their special designation as the primary audience. Read from left to right, as westerners read a text, the placement of these

scenes caused them to turn 180 degrees as they interpreted each band, and then back again to the starting point, where their eyes dropped down to the next level to begin a new narrative. At the conclusion of the baptismal ceremony – and one must wonder whether witnesses paid much attention to the priest's liturgy while scanning the scenes overhead – the entourage proceeded to exit San Giovanni back through the same south portal they had used to enter. Overhead they would have seen, as their last vision before returning to the real world of the city streets, scenes of restoration and resurrection and reunification in the south vault (Plate XXXIV). Noah repopulated the world. Joseph survived his ordeal. Jesus was resurrected. John's body was solemnly interred. It was a fitting way to end their experience inside the Baptistery, particularly if they had spent time reviewing the grisly and largely pessimistic scene of the Last Judgment in the northwest vault at any part of the liturgical ceremony.

The forms contained in those last images seen by viewers as the celebration of baptism ended were repeated and emphasized as they processed out of San Giovanni through the south portal and into the piazza that surrounded it. By 1336, visitors walked past Andrea Pisano's bronze reliefs of the life of John the Baptist, attached to the surface of the south portal that opened inward, and there saw the same scenes that they had just considered in the lowest strip of mosaics on the ceiling (Figure 94). We might also remember that, after 1386, the first image these visitors the Baptistery would have seen as they exited the building and re-entered the secular sphere was the fresco of the *Abandonment of Children and the Reunification of Families* on the facade of the Misericordia (Plate XII). The poignancy of that subject resonated with new parents, their family members, and friends who were sworn to protect the newborn. Images worked together inside and outside the Baptistery of San Giovanni.

At some very basic levels, the design of the ceiling helped common people remember an otherwise complicated and perhaps difficult series of images. As simplistic as it may seem to us today, the selection of scenes for the Baptistery followed a linguistic alliteration that must have allowed for easy retrieval. All five of the major themes here – the *Giudizio universale, Genesi, Giuseppe, Gesù*, and *Giovanni Battista* – begin with the Italian soft "G" formed by the combination of "ge" and "gi." So, too, does the name of the main villain of the story, *Giuda*, the only character in hell identified with an inscribed name. Illiterate viewers could remember the main focus of each of these bands long after they had left the church after the baptismal ceremony had ended merely by recalling the phonetic soft "G" that initiated each of the bands, scenes, and major characters in the cycle. This quasi-mneumonic device gave the mosaic the power of longevity, and made it a powerful landmark in the collective imaginations and memories of an entire population.

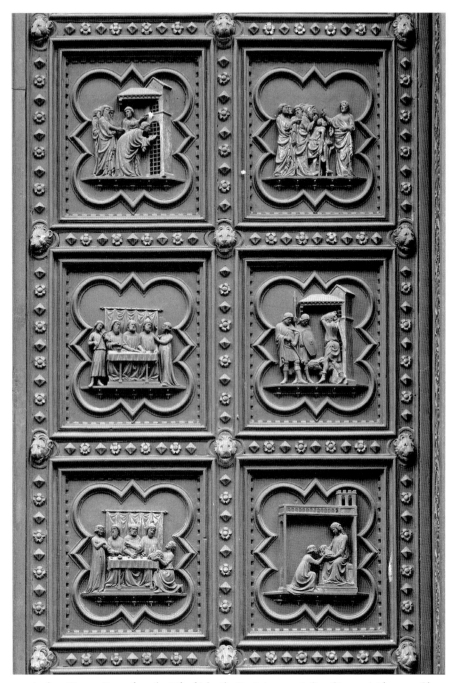

94. Andrea Pisano, *Scenes from the Life of John the Baptist*, ca. 1336, San Giovanni, Florence. Photograph courtesy Scala/Art Resource, New York.

At various moments in the cycle, mosaicists worked to align moments from the four stories in ways that tied them to each other either visually or conceptually. The vast expanse of the Baptistery's ceiling contains a number of these pairings. In the very first vault on the north side of the ceiling (Figure 89), the initial scenes of the *Creation, Dream of Joseph, Annunciation of the Virgin*, and *Annunciation to Zacharia* all repeated both the earliest textual reference to that story's protagonist and the divine interaction between heavenly figures (God, angels, and even dreams) and those on earth (Joseph, Mary, Zacharia, and the physical world created by the Father). The opening scenes of the next vault, to the northeast, were similarly connected to one another, as the two Old Testament compositions were aligned to suggest the appearance of evil – the *Temptation* and *Joseph Thrown Down the Well* – while the New Testament mosaics illustrated scenes of conversion in the *Adoration of the Magi* and *John Preaching at the River Jordan* (Figure 90).[18] The opening scenes in the southeast vault featured images of forgiveness and redemption. The images of *God Ordering Noah to Build the Ark, Joseph's Release from Prison, Last Supper*, and *Healing of the Paralytic* provided a kernel of hope for sinners eager to receive rewards after enduring hardships perpetrated upon them (Figure 92). And the four scenes that conclude the cycle in the south vault, inspected by common viewers as they exited the building, all invoked the promise of Salvation in the form of the *Apparition of the Dove, Joseph and the Chariot, Three Marys at the Tomb*, and *Burial of John the Baptist* (Figure 93). On a very basic level, common viewers could see and understand the pairings presented to them by those in charge of the Baptistery's decorative program.

Just as the south vault contained pictures aimed at lay audiences, an important set of linked images decorated the ceiling's east vault, above the portal through which the Bishop processed to and from San Giovanni. There, lined one atop the other, appear identifiable references to *Cain Killing Abel, Joseph Imprisoned*, the *Flight into Egypt*, and *John the Baptist Imprisoned* (Figure 93). The fratricide in Genesis, of course, condemns all of Cain's descendants as sinners, and the heinousness of this first murder is deliberately paired with the perpetrator's bald-faced lie in the presence of his interrogator. Cain innocently points toward his own chest as God asks of the whereabouts of Abel, and his deceitful claim that "I am not my brother's keeper" has been rendered a sin on par with the actual murder of his brother. The consequences of similar criminal behavior – even of unjust accusations – follow below. The physical space of Joseph's grated prison cell is repeated in the one below that contains the bearded figure of John, thus connecting these two victims of false witness. Both inmates manage to communicate with visitors who in turn observe the fortitude with which these prisoners endure their unjust confinements. Only in the *Flight into Egypt*, sandwiched between them, do we see our characters able to escape a crime of which they have been accused.

In fact, an important part of the mosaic program revolves around the issue of crime and punishment, and the scenes selected for inclusion speak to viewers about the constant struggle to shun vice in favor of the path of virtue. A whole litany of sins and potential traps for contemporary viewers covers the ceiling of San Giovanni. The nudity of Adam and Eve in the ceiling's first scenes carry the narrative away from a theme of innocence and toward that of Original Sin, which quite clearly revolves around sins of the flesh. The substantial changes to Adam and Eve in the succeeding scene involve not only the action of Adam – who holds in his hand a spade to indicate his punishment of laboring in the fields – but the fact that both sinners now wear garments to hide their nudity and ward off temptations of the flesh (Figure 90). Should there have been any question about the severity of their lustful sin, the viewer need look no further than the pit of hell on the northwest vault, where those souls rotting in a perpetual state of torment endure their pains as naked as Adam and Eve were on the occasion of their Original Sin and banishment from Eden. They are the only nude forms in the entire ceiling.

This sin of the flesh, however, pales in comparison to that of Cain, which follows in the north vault: the murder of Abel after the fateful sacrifice at the altar before God only heightens our understanding of the failures of human morality and underscores the need for Christ's appearance as a redeemer (Figure 89).

Again, a reference in the *Giudizio universale* shows us its degree of importance in the hierarchy of capital sins: at the very edge, or bottom, of the Baptistery's Hell swings Judas from the gallows (Figure 88). His presence there naturally conforms to traditional medieval iconographic references that place him there, but a second, more secular interpretation of this figure may also be found here as well. The victim's punishment, death by hanging, conforms precisely to that recommended in contemporary penal codes for those found guilty of committing Judas' crime. It is his betrayal of Christ in this particular scene that earns Judas his fate in hell, and as we have seen in the case of Ciuto Brandini, the crime of Treason carried with it the capital punishment in early Republican Florence. Other sins like deceit, adultery, calumny, and greed mark the stories of Joseph and John in ways that warn viewers of the threats that await them upon their return to the city streets beyond the confines of the church. The entire narrative sequence of all four stories focus primarily on sin, betrayal, injustice, and the pains they inflict upon those who suffer them. But in the end, Judas' sin of Treason is the worst of them all.

The emphasis placed on the criminal activities of Biblical heroes underscores the tensions their tales created in a Republican city dedicated to the maintenance of law and order, and they surely were placed here intentionally. Importantly, the commune included in its annual celebration of the Feast of John the Baptist, its patron saint, a public pardon of criminals currently imprisoned in Florentine jails – they were, as Irene Hueck has described it,

"consigned to the Baptist as spoils of war and then freed in his name."[19] The figure of Saint John, in fact, appears inside a prison cell no fewer than three times in the Baptistery's mosaic program (Plate XXXV), a pictorial emphasis that unquestionably alludes to the city's penal system – and, perhaps, helps explain the subject matter of the frescoes of the Baptist painted inside the Palazzo del Podestà's Chapel of the Magdalene, which were aimed at condemned criminals. With ceremonies and rituals performed at the Baptistery of San Giovanni in the saint's honor, the references to the imprisonment of John and the ultimate liberation of his soul (sadly by means of decapitation!) in the mosaic program doubled back to the commune's leniency as they released from bondage those whose crimes had been forgiven. On one hand, the *Last Judgment* on the ceiling of this pan-Florentine, communal church illustrated both the moral shortcomings that condemned sinners to an eternity of damnation and the civic ones that the commune would not tolerate. But on the other, they alluded quite clearly to the concepts of mercy, reconciliation, and redemption that the city tried to foster on the Feast of John the Baptist.

In addition to admonitions against sin and the crimes they caused, another important reference to a significant contemporary civic concern appeared in this massive mosaic program. We have already seen in this study the pride Florentines took in their Republican system, and the suspicions they reserved for tyrants who tried to take their *libertas* from them. This form of civic pride made its way onto the ceiling of the Baptistery in the way the program held in contempt the kinds of people deeply distrusted by members of the commune. While it is true that many of the perpetrators of sin and crime in the mosaic's narratives are people of common birth – Cain, the brothers of Joseph, and the unidentifiable souls of the damned in hell, to name a few – not all of the ceiling's villains claim such humble origins. In fact, a significant number of the cycle's sinners come from the ranks of royalty. Pharaoh, Potiphar and his scheming wife, and both Herods – each one of them of royal pedigree – directly contribute to the persecution of the just (Figure 91). Their tyrannical acts of whimsy endanger the main protagonists of the three lower cycles – Joseph, Jesus, and John – and result in the deaths of the latter two.

This level of suspicion for royalty extends to those who actually wind up doing the right thing. Even the three kings who come to adore the Christ child in the Magi scenes of the northeast vault endure some criticism from San Giovanni's artists (Figure 90). Two of the three scenes dedicated to their famous visit oddly place them in the compromising position of having to serve two masters. The first mosaic unsurprisingly celebrates their sense of conviction as they demonstrate their fidelity to the Christ, King of Kings. But the next two scenes deviate from this path in ways that remind viewers of the rather tenuous place in which Christian monarchs always found themselves. The first of these places the three Magi in a palatial setting, no doubt the home of Herod I, who

has offered his residence to them as a matter of professional courtesy, but also in the hopes of coaxing from them the location of this new king. While they sleep, the Magi have their dream in which a warning of their host's betrayal is made clear to them. In the third scene, faced with the conundrum of whether to remain faithful to their new Lord or reveal to Herod the identity of his infant rival, the Magi flee. On one hand, their decision to reject Herod's request for information leading to the apprehension of the child warrants our praise. But the way the artist has represented the Magi – in a boat with a helmsman, sail unfurled, hurtling over the ocean's waves as fast as they can go – makes them out to be more than just a bit cowardly. Kings cannot win in this mosaic cycle.

One cannot help but wonder whether this soured evaluation of royalty may have been employed for political reasons. The dating of the mosaic to the last third of the thirteenth century naturally contributes to my suspicions, for it was at precisely this moment when the Florentine state had repulsed the Ghibelline threat at Benevento, and had secured both its independence and its relationship with Guelph allies in Rome and France. In 1266 such an acclamation of political preference could only be read as an affirmation of a desire for papal allegiance and, simultaneously, a rejection of Imperial interference. Produced on the heels of what came to be understood as a final victory against royal intervention in Tuscan affairs – and the subsequent triumph of republican aspirations – the mosaics in the Florentine Baptistery may have alluded to political events and interests, as well as civic and spiritual ones. The kings of the mosaics, stripped of their moral authority by way of unjust persecutions and untenable diplomatic positions, may well be shown this way in order to reaffirm both their abhorrence of autocratic rule and the Florentine alliance with the papacy that, they believed, would secure their independence. Common viewers – the members and leaders of this new kind of government – got their cues inside the civic spiritual center in the city.

The marvelous scenes encrusted in gold tesserae obviously resonated with the leaders of the International Cloth Merchants Guild a few years later, when they went about the process of working with artists on other decorative projects for the Baptistery of San Giovanni. Andrea Pisano, when commissioned to produce his series of bronze reliefs for the south doors of the church, either chose or was directed to replicate in his narrative of John the Baptist the same scenes that appeared on the Baptistery's ceiling. On both the south portal leading into the centrally planned church and on its ceiling, audiences saw similarly rendered scenes of the *Birth of the Baptist, John in the Wilderness, Baptism of Followers, Baptism of Christ, John Before Herod,* and *Imprisonment of John* (Figure 94). When in 1407 Lorenzo Ghiberti undertook the project to cast bronze reliefs for the east portal, dedicated to scenes from the life of Christ, some of the moments chosen for representation also echoed those on the ceiling

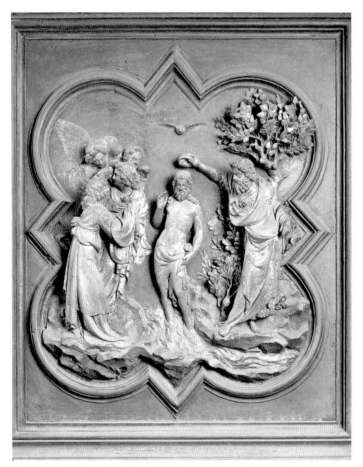

95. Lorenzo Ghiberti, *Baptism of Christ*, ca. 1407–1424, San Giovanni, Florence. Photograph courtesy Scala/Art Resource, New York.

of the interior – namely the *Annunciation, Nativity, Adoration of the Magi, Baptism of Christ, Last Supper, Arrest*, and *Crucifixion* (Figure 95). And then Ghiberti did it all again in the third and final set of reliefs that came to be known as the *Gates of Paradise*. Scenes from Genesis, Joseph, and Jacob are featured once more, albeit more prominently in this smaller space (Figure 96). The replication of images at the decorated doors of San Giovanni and the octagonal ceiling that towered over the heads of visitors reinforced the importance of the saints honored inside. Their relationship echoed the connections forged through the repetition of images at San Miniato al Monte, where the representation of the monastery's patron saint was fixed in the minds of viewers who ventured up the hill to the church named for him. While the labor expended on behalf of that journey made the mini-pilgrimage to San Miniato al Monte a special event, the ritual of Baptism made the trip to San Giovanni a truly memorable one. Every time

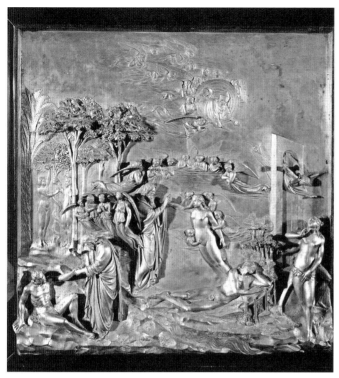

96. Lorenzo Ghiberti, *Scenes from Genesis (Gates of Paradise)*, ca. 1430–1452, San Giovanni, Florence. Photograph courtesy Erich Lessing/Art Resource, New York.

they passed by the reliefs on the south and, after 1424, the east portals of the Baptistery, common viewers could be reminded of the identical scenes illustrated in the mosaics on the interior – of *Genesi* and Giuseppe and Giovanni and Gesù and even of Giuda – and thus relive the experience of the baptism of their own children, godchildren, and grandchildren.

ANDREA DI CIONE'S *LAST JUDGMENT* AND *HELL* IN SANTA CROCE

Most churches in Italy found ways to celebrate their dedicatees through the visual arts. As we have seen, the church across the Arno inserted images of Saint Miniato on its facade, apse, nave wall, and subsidiary altars; the mosaics on the ceiling of San Giovanni contained panels detailing the story of John the Baptist; and the cathedral of Santa Maria del Fiore featured prominently the figure of the Virgin Mary at the most important entrance and egress of the facility. The same was true of the enormous Franciscan church of Santa Croce, rebuilt in 1295 over a smaller prototype that obviously did not suit the needs of the increasingly popular order. It would take the friars some ninety years to get around to employing the rather arcane story of the *Legend of the*

True Cross in the chancel of their church, where portions of it could be seen from the congregation's side of the *tramezzo* after Agnolo Gaddi's project was completed. Before that, though, the Franciscans promoted the name of their church by hanging from the ceiling, over the rood screen, the famous painted *Crucifix* that Cimabue produced at the time of Santa Croce's initiation – and that the waters of the Arno almost destroyed entirely in 1966.

Not surprisingly, some of the most involved and entertaining mural pictures in Florence were located in the mendicant seat of the Franciscans. The Preachers Minor famously employed fresco cycles in their churches that told stories, explained theories, and propagated the importance of the order. The church of Santa Croce was among its most important, and its enormous, barn-like structure cried out for decorations thanks to an architectural design that intentionally emphasized large expanses of curtain walls punctuated by comparatively slender lancet windows on the ground floor. The south wall was in particular need, for the pulpit stood there, affixed to a pier halfway down the nave, just before the *tramezzo* that barred the laity access to the transept (Figure 97). The absence of visual aides, cues, and distractions would have placed an unusually heavy burden of responsibility on the shoulders of the preachers who wished to hold the attention of all those commoners who came into the church. Both the preachers and their listeners clearly wanted, and may even have needed, images to enhance the experience.

And have them they did. Unlike the iconic saints rendered side by side in the church of San Miniato, the pictures in Santa Croce's nave were large and involved, focused on narrative sequences, featured stories that contained a variety of plots and sub-plots, and were ripe with intimidating (and titillating) messages that provided endless themes for elaboration by preachers from the nearby pulpit. On the north side of the nave, on the layman's left upon entrance, viewers encountered a lengthy series of images dedicated to the life and Passion of Christ. The cycle was enormous, extending some ten meters high and stretching from the entrance wall all the way down to the rood screen – more than four bays long (ending where the late-nineteenth-century monument to Donatello now stands). Remnants of these decorations still survive, although most of the fourteenth-century frescoes were destroyed when Vasari cleansed Santa Croce of its medieval decorations in his project of 1566. Near the entrance viewers today can see portions of the *Crucifixion, Noli me Tangere* – with the Magdalene clearly reaching out toward Christ's resurrected body – and *Ascension* above (Figure 98). These frescoes were destroyed when the monument to Galileo was installed on the wall there in 1737. But beyond this cluster of Passion scenes appeared an extensive group of other frescoes, as indicated by the faint appearance along the north wall of horizontal incisions that continue the uppermost border of the surviving images all the way down the nave to

97. Santa Croce, nave and pulpit, Florence. Photograph courtesy Scala/Art Resource, New York.

where the *tramezzo* began. What we see today in Santa Croce's nave was only a fraction of its original decoration.

Based on the organization of those frescoes that have survived, it is clear that this late-fourteenth-century cycle began chronologically at the *tramezzo* and then moved visitors back toward the exit at the church's west end. This, in turn, created a right-to-left reading on the north wall that was best seen from deep within the nave – not only at the mouth of the *ponte*, but just across from the place where the pulpit was located in Santa Croce's nave. Whereas common viewers might need to jostle one another for position to see the grand cycle in its proper order, the preacher who delivered the sermon from his elevated position in the pulpit attached to the third pier in the nave – facing north from its position on the south side of the church – had an unobstructed view of the sequence at its starting point near the *tramezzo*. From there he could scan the entire curtain wall before him, pick out scenes and vignettes that appealed to him, and then make his points to the audience below. And they, in turn, could follow his line of argumentation by turning their heads to focus on whichever bit of the story their guide was reviewing that day from his lectern. In this setting, the directional movement of scenes from right to left was selected to

98. *Crucifixion, Noli me Tangere, Ascension*, Santa Croce, Florence. Photograph courtesy Scala/ White Images/Art Resource, New York.

facilitate the dramatic and edifying presentation of Franciscan themes by some of the day's greatest orators.

But this narrative illustration of New Testament scenes was not the only set of pictorial illustrations available to preachers and viewers in Santa Croce. The south wall of the basilica, behind the preacher as he delivered his sermons, was also decorated with an expansive fresco cycle that similarly extended for almost two full bays, starting at the *tramezzo* and extending from left to right, well beyond the pulpit that contained the preacher.[20] Similarly damaged by Vasari's extensive scrubbing of the nave in the sixteenth century and the grad- ual accretion of monuments attached to the wall in subsequent periods, only fragments of the original fresco that decorated the space have survived. That

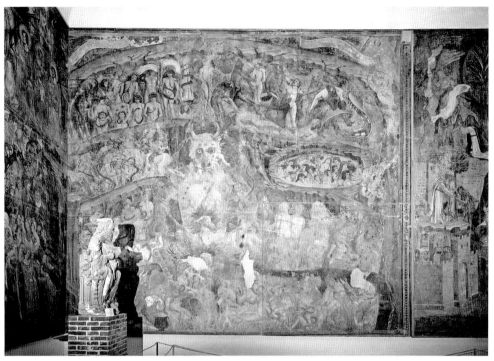

99. *Triumph of Death*, ca. 1333, Camposanto, Pisa. Photograph courtesy Scala/Art Resource, New York.

which remains reveals a subject that was connected thematically to the narrative of the Passion on the opposite wall and that provided preachers with a raft of opportunities for allegorical and admonitory referencing during their sermons.

This selection of frescoes included, but was not limited to, sections painted by Andrea di Cione in the middle years of the 1340s and dedicated to the themes of the *Last Judgment* and *Hell* (Plate XXXVI).[21] Derived from Dominican interpretations of the theme of the Triumph of Death, the theological traditions associated with the subject matter immediately connected the fresco with a literary foundation that spoke to a learned audience.[22] The fragments from this massive picture, now displayed piecemeal in the museum of Santa Croce's former refectory, built upon some of the compositions employed by the painters of the Pisa Camposanto during the early 1330s (Figure 99).[23] Like that earlier cycle, the Santa Croce pictures form a progressive crescendo of themes, beginning on the far left with what was probably a collection of saints and angels surrounding the Judging Christ and then ending at the right with explicit illustrations of the pains awaiting those consigned to the depths of hell for eternity. Here we see elderly and ragged commoners – generalized representations of the very people who crowded into the church to listen to preachers deliver their sermons in front of these pictures – point accusatory

100. Andrea di Cione, *Hell*, detail, ca. 1345, Santa Croce, Florence. Photograph courtesy Gabinetto Fotografico del Polo Museale Regionale della Toscana.

fingers toward what was probably a scene of the *Last Judgment*. Although these figures echo those from Pisa, it must be noted that Andrea did not merely copy them verbatim. The Florentine painter stacked his figures in a more vertical arrangement, and then painted directly on the wall their verbalized sentiments that in Pisa appeared within a banderole next to the group of onlookers. Moreover, small references to natural omens of disaster (an earthquake and a solar eclipse) that appear in the border have no precedent, and suggest that the artist had the freedom to elaborate on the Camposanto prototype (Figures 100 and 101).[24] Some liberties were taken by Andrea di Cione, and the Santa Croce fresco must be considered more of a variation on a theme than a direct copy of its Pisan predecessor.

The same can be said for the grisly image of the underworld that followed, which is also based in part on the Pisan template, but also deviates from it in

101. Andrea di Cione, *Hell*, detail, ca. 1345, Santa Croce, Florence. Photograph courtesy Gabinetto Fotografico del Polo Museale Regionale della Toscana.

significant ways. Like that earlier interpretation, Andrea's fresco of *Hell* similarly employs a partitioned landscape in which sinners occupy specific pockets delineated by ridges and flames painted in red. But the damned in the Camposanto painting stand rigidly in place, wrapped up individually or in groups by writhing serpents – the animalistic demon of choice in Pisa – that essentially prevent them from actively tormenting each other. Andrea's vision of the End of Days, on the other hand, employs physical action in addition to the appearance of demons to depict the violence and suffering awaiting sinners in hell. At its gates we see a bird figure – Andrea's animalistic demon of choice – opening its jaws to caw out the phrase "LASCIATE OGNI SPERANZA"

102. Andrea di Cione, *Last Judgment*, detail, ca. 1345, Santa Croce, Florence. Photograph courtesy Gabinetto Fotografico del Polo Museale Regionale della Toscana.

(written backward and upside down), the famous inscription over the portal of Dante's *Inferno* (Plate XXXVI). Figures huddle together, watching warily as those who have died before them meet their fate at the hands of demons and devils. Beaked torturers cart off the ill-gotten gains of the greedy and usurious; men and women struggle with each other in attempts to vanquish rivals; the depraved lay horizontally at the feet of Satan's guardians (Figure 102). Vestiges of peace, tranquility, and serenity have no place in this vision. While Andrea di Cione surely knew the cycle in Pisa, and obviously referenced the scenes there in his works for Santa Croce, he used an entirely new set of figures and vignettes within this broader compositional format in ways that made the fresco his own.[25] These changes similarly must have been motivated by the popularity a new interpretation of this scene.

Neither Andrea di Cione nor the author of the Camposanto frescoes were the first to partition the landscape of hell into specific chambers located on horizontal or diagonal levels. The Pisan painter clearly knew Giotto's depiction of the *Last Judgment* in Padua, and Giotto's rendering of hell followed a pattern that

103. Andrea di Cione, *Last Judgment*, detail, ca. 1345, Santa Croce, Florence. Photograph courtesy Gabinetto Fotografico del Polo Museale Regionale della Toscana.

had been established in miniature paintings from the late thirteenth century.[26] But Andrea crafted specific pockets, or *bolge*, created by rocky caverns that are more pronounced than the tongues of flame used by Giotto in Padua. He also employed specific pictorial details and various inscriptions that demonstrate Andrea's familiarity with Dante's popular and widely read book of the *Inferno*, written by 1310 and widely disseminated (along with *Purgatorio* and *Paradiso*) soon after the poet's death in 1322. At various locations, Andrea demarcated his *bolge* with Dantesque signifiers, as single words appear as inscriptions to help explain the mortal sins of the figures who now occupy each cave in hell. In the upper left corner appears a flag emblazoned with "LV(SS)VRIA" (Figure 103). A banner held by a demon bears the word "AVARITIA" to designate the band of clerics and potentates at its feet by the sin that has deposited them in hell (Plate XXXVI). Specific characters from Dante's epic also appear here. In the area where Satan perches in his icy kingdom, popping into his jaws three condemned souls, Andrea identified the central figure with the word "GIUDA," regarded by Dante as one of history's three greatest traitors. And next to him, just to the left, appears a centaur that Richard Offner identified

as Cacus, bearing two arrows and a bow, and mentioned by name in Dante's vision of The Thieves from *Inferno* XXV:16–25.[27] While the basic theme was derived from traditional interpretations of hell, the specific characters, their actions against one another, and the torments they endure based on the crimes they committed in this life all speak directly to the vision of the Other World crafted by Dante. Andrea di Cione clearly believed that his audience was just as familiar with it as he was, and that they were probably more interested in the poet's account of hell than in the theological ones that had driven artistic representations of this scene for decades.

Andrea was wise to have done so. More than any other book of the fourteenth century, *La Commedia* was a popular sensation on the streets of Florence. Frequent public readings, combined with Dante's famously memorable phrasing, cemented into the minds of common people and scholars alike the observations and admonitions of the city's most famous son (and, embarrassingly enough, its most important *persona non grata*). Still, by the time of the fresco's production in the middle of the 1340s, only the image of Satan in the chapel of the Magdalene on the Piano Nobile of the Palazzo del Podestà bore an image that referenced Dante's *Inferno*, and even that version – intended for condemned criminals – was not terribly specific. By the time of its execution sometime around 1345, Andrea's enormous painting was the only monumental artistic account of Dante's *Inferno* in all of Florence – and that would have made it an attractive draw for visitors and city-dwellers eager to see Dante's vision illustrated by a painterly interpreter. Andrea struck a nerve with this painting, and the friars at Santa Croce, about whom we shall speak more momentarily, must have been enormously pleased by this.

This is not to say that the work was merely a slavish illustration of the great poet's fantasy. As Gert Kreytenberg has observed, the linear composition of Andrea's *Inferno* contradicts the architectonic construction of hell that Dante described so vividly, in which the pathway toward Satan's pit funnels downward and ends in a central core below the nine levels that precede it. Were Andrea to follow Dante's design accurately, Judas and Satan would have appeared in the center of the composition rather than the far right. Instead, the painter chose to follow the visual prototype employed so effectively in Pisa rather than the literary structure that Dante designed, probably to conform both to standard approaches to narrative image progressions that viewers would have expected to see on a nave wall and to match the progression of images moving from right to left on the wall opposite Andrea's *Last Judgment* and *Hell* – thus creating a kind of parallelism between those two sides of the nave that Andrea's predecessors and contemporaries often employed. Memorable items like the River Styx and the burning Tombs – prominent features that Nardo di Cione would later emphasize in his representation of *Hell* in Santa Maria Novella's Strozzi Chapel – have no place here. Moreover, the *bolge* in this fresco that have

been demarcated with inscriptions end not with the Traitorous, as they do in the poem, but rather with the Avaricious and, if the centaur in fact represents Cacus, with the Thieves. Either the painter omitted a large number of *bolge* comprising the entirety of Dante's *Inferno* due to spatial constraints or he and his advisors intentionally wished to emphasize these particular sinners in this illustration of hell.[28]

This deviation from Dante's text extends to the *tituli* that accompany Andrea's figures, for the verses in the inscriptions in Andrea's fresco reference those found in the Pisan Camposanto rather than those in Dante's poem (Figure 100). At the left edge of the composition, for example, where Andrea painted beggars and hags standing in condemnation of those acquiescing to death, a painted placard bears the words:

> Schermo di savere e di ricchezza,
> Di nobiltà e ancor di prodezza,
> Val niente ai colpi di costei,
> Ed ancor non si truova contro a lei,
> O lettore, niuno argomento
> Or non avere l'intelletto spento
> Di stare sempre s'apparecchiato,
> Che non ti giunga in mortale peccato.[29]

> Neither learning, nor riches,
> nor nobility, nor courage are protection
> against the blows of death,
> and no reasoning can be found to stop her.
> Oh, reader, direct your mind
> so that you are always prepared
> and will not be caught in mortal sin.[30]

None of these lines borrow phrases from Dante's epic poem, even though the basic thrust of their commentary echo his conclusions. Instead they posit in vernacular language the themes and concepts often associated with images dedicated to the subject of Andrea's fresco. Indeed, above the head of one of the elderly commoners at the far left of the fresco appears an inscription that was copied directly from a scroll held by peasants in the Pisan version of the *Triumph of Death*:

> Dacchè prosperitade ci à lasciati,
> O Morte, medicina d'ogni pena,
> Deh vieni a dare omai l'ultima cena.[31]

> Since prosperity has left us,
> Oh death, medicine to all pains,
> Do come and give us now our last supper.[32]

These lines refer to the temptations of earthly wealth, the vice of avarice, the importance of penitence, and the desire for absolution, and they fit perfectly with the painted subject matter of the fresco. Although they were based on the more expansive and sophisticated themes embedded in Dante's complicated vision, none were taken directly from the text of *La Commedia*. They avoid entirely the language and cadence of learned philosophy and highly specialized poetics. The message is instead straightforward and clearly presented, and no comprehensive understanding of medieval theology is needed to understand it. Instead these verses were here simplified to present a more coherent and easily digestible message to a viewership not nearly as well versed in the theological components of the poem as an educated, clerical audience would have been. The painter seems to have felt confident that his viewers knew the message and even the approach that Dante imparted in his text; but he also seems to have doubted their understanding of Dante's architectonic structure of hell.

The deviation from a purely Dantesque approach to the design of *Hell* was surely intentional, which naturally raises the question: why did Andrea di Cione emphasize the sins of Avarice and Lust in this fresco, rather than the one of Treachery that Dante had featured in his poem?

The answer may well lie in the specific concerns of the friars in Santa Croce and their audiences inside the church during the middle years of the 1340s, when Andrea appears to have painted the fresco. In 1345 a new Inquisitor named Fra Piero d'Aquila was appointed to handle the threat of heresy in the growing, overcrowded, and wealthy city of Florence.[33] In contrast to previous inquisitors and heresy fighters, like the famous Peter of Verona whose stance against the *Patarini* and subsequent martyrdom in Lombardy had become the stuff of legends, Fra Piero d'Aquila focused his attentions not on theological or even political opponents of the status quo, but rather on the most blatant and pervasive vice thought to beleaguer this city of merchants. This new Inquisitor selected as the main focus of his investigations the linked sins of Usury and Avarice. Fra Piero decried the city's mercantile underpinnings, accused its wealthiest and most prominent citizens of fraud and extortion, and then demanded that they pay exorbitant financial penalties or face the ultimate punishment of excommunication.

On the face of it, Fra Piero's denunciation of the fiscal foundations of the city's lenders had some merit. The economic and political calamity of 1342 and 1343 had been driven largely by the failures of some of the city's major banking houses, among them the companies owned by the Bardi and Peruzzi families, whose burial chapels lay deep within the transept of Santa Croce. Only a few years removed from those unstable times and, in 1345, during a period still reeling from famine and political unrest, those who made their money "unnaturally" through the usurious practice of charging interest on loans were

easy targets. But Fra Piero, a recent addition to the community at Santa Croce, was not without ulterior motives in his quest to cleanse the city of its usurers. One of his ecclesiastical supporters was a church official named Cardinal Sabina, who had recently lent money to Angelo Acciaiuoli, the Bishop of Florence. The loan had not been repaid in a timely manner, and Cardinal Sabina and Fra Piero had a score to settle.

The Inquisitor initially sought to force the bishop's remuneration to Cardinal Sabina by going through legal channels, and Fra Piero beseeched the Florentine government to intervene on his behalf. But this lay body was unwilling to interfere in a clerical matter, which only fueled the Inquisitor's passions. Unable to convince the secular authority to assist him in his quest to settle accounts for his Cardinal, Fra Piero set upon a course of action that caused him to haul before his tribunal court an array of Florentine citizens, who wound up paying the Inquisitor a total of some seven thousand florins in fines.[34] When, in March 1346 (1345 o.s.), Fra Piero jailed Salvestro Baroncelli, a business partner of the Florentine Bishop Acciaiuoli, the government responded as though its own sovereignty had been challenged. Baroncelli was freed by the commune against the wishes of the Franciscan friar, who now held the city in contempt of the Inquisition – which was, by all accounts, a bad thing. Fra Piero placed all of Florence under Interdiction, effectively withholding from its citizenry access to the clergy it craved, but simultaneously withdrew to Siena for the sake of personal safety.[35] Within a matter of weeks the commune convinced the papal court in Avignon to lift the friar's clerical boycott and install a new Inquisitor in his place. The scandal dissolved without further incident, albeit not without a simmering sense of anticlericalism that would ultimately boil over into the infamous, and ill conceived, War of the Eight Saints in 1375. But it did serve to remind leaders in the government and those in the clergy of the tension caused by the enormous amount of wealth pouring into Florence during those years and the problems the church (and the mendicants in Santa Croce) had always had with those who found ways to reap rewards in greater amounts than others. Nearly everyone in Florence knew that the city and the churches inside it were fighting over money.

Perhaps this helps explain the selection of the words "LV(SS)VRIA" and "AVARITIA" in Andrea di Cione's painting, and their singling out as the sins of choice in Santa Croce's nave. The timing of the picture's production in the mid-1340s coincides directly with the arrival of the Inquisitor in Santa Croce, as well as his crusade against avarice that consumed conversations in the church and across the city during its brief encounter with interdiction. For the interval of time during which both Andrea's fresco was being painted and the hearings of the Inquisition were being held, the preachers who captured the imaginations of its listeners and the lay audience who flocked to Santa

Croce to hear them could have gazed upon the images of wealthy sinners and understood the connection between the painted message and the ferreting out of the guilty among them. Fra Piero d'Aquila prosecuted the crimes of luxury, greed, and avarice, and their designation as particularly heinous sins worthy of notation on the nave wall of Santa Croce connected the images there to ideas percolating among the Franciscan inquisitors who wielded so much power then.

LARGE-SCALE, MONUMENTAL PICTORIAL CYCLES RARELY GRACED THE congregation's side of church naves. Most of the elaborate frescoes and altarpieces that we identify with early Republican painting decorated spaces on the clergy's side of the *tramezzo*. But when churches attempted to address the visual needs of their clients, the results were equally stunning. The mosaics in the Baptistery formed the earliest cohort of monumental public imagery in an ecclesiastical setting. Due to the vibrancy of materials, or to the skillsets of the city's best artisans, or perhaps to the prestige attached to the medium thanks to its extensive employment in fashionable cities like Rome, Venice, and Constantinople, gold tesserae covered Florentine mural spaces long before pigments in egg tempera did. The apsidal mosaic at San Miniato al Monte was crafted with the vibrancy of San Giovanni's images clearly in mind. Cimabue, Giotto, Taddeo Gaddi, and Maso di Banco looked to the forms there for inspiration, and borrowed from mosaic programs their figural approaches, compositional innovations, and thematic impulses. Dante may well have been directly inspired by the image of the *Giudizio universale* in the Baptistery when he conceived of his own version of the *Inferno*. And the subjects, stories, and stylistic choices made by Andrea Pisano and Lorenzo Ghiberti for their famous bronze reliefs were either lifted directly from the mosaics in the Baptistery or supplemented them in ways that expanded upon a program that addressed, at one time or another, the entire population of Florence – one infant and one family at a time.

But this great age of mosaic quickly ran its course, and near the middle of the fourteenth century, again perhaps due to materials, skills, or prestige attached to famous practitioners, fresco painting came into vogue. One is tempted to attribute this shift to an intentional move by early Republican Florentines to distinguish their communal system from that of the Republic of Venice (and its autocratic figurehead, the Doge), the Empire in the East (with its Imperial head of state), and – for most of the fourteenth century – the discredited Royal papacy and its former capital in Rome. Mosaics were old-fashioned by the time Andrea di Cione began painting in Santa Croce: they were opulent and ostentatious and symbolic of autocratic states that did not share the same values as the citizens of Florence. Fresco painting – cheap, colorful, and easy

to produce – was an art form more appropriate for a common viewership. By the end of the early Republican period, the tradition of monumental mosaic decorations had all but died out, and in its place came an emphasis on pictorial illusionism, gestural expressionism, and naturalistic figural representation that never could have been replicated in gold leaf tiles.

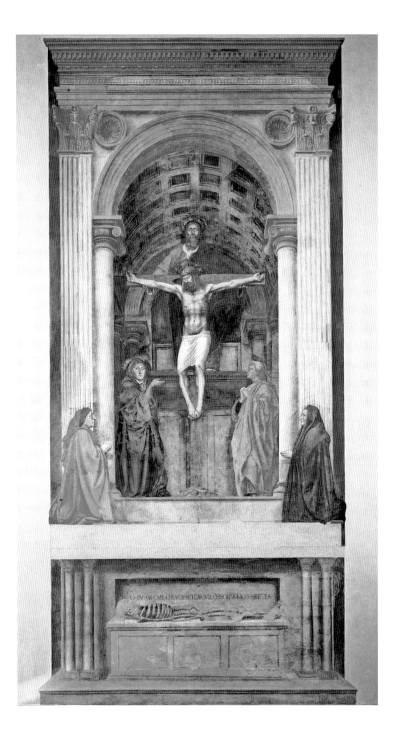

CHAPTER SEVEN

MASACCIO'S *TRINITY* AND THE TRIUMPH OF PUBLIC PAINTING FOR COMMON PEOPLE IN EARLY REPUBLICAN FLORENCE

P AMPINEA SITS QUIETLY WITH SIX OTHER WOMEN INSIDE THE FLORENTINE church of Santa Maria Novella. These friends, unrelated by birth but connected by both age and circumstance, have come to hear services in the largely empty Dominican space. Much weighs on their shoulders, for they have come here on a Tuesday to mourn the loss of thousands of fellow residents who have succumbed to the mysterious epidemic that cloaked all of Europe in the summer of 1348.[1] Their choice of venue makes a great deal of sense, for Santa Maria Novella's cemetery in the east cloister received its fair share of corpses during that plague year – as it would throughout the remainder of the fourteenth century. Yet the precise location in which Pampinea and her friends mourn within the church remains a mystery, for Giovanni Boccaccio does not place his protagonists in a specific spot there. However, we can be quite sure that the loose circle they have formed is situated on the congregation's side of the nave, and probably not far from the side door leading to and from the tombs that hold the dead for whom they grieve. That was where women like these seven were supposed to meet, and that was where the friars who lived and worked in Santa Maria Novella tended to them on a daily basis.

This was also the place where friars and lay patrons placed images for common viewers. Some eighty years after the events that Boccaccio described, one of the most famous works of public painting for Florentine audiences was produced on the west wall of this church. Sometime between 1425 and 1427, the young Masaccio produced his revolutionary fresco of the *Holy Trinity*, a work

of such extraordinary innovation that it effectively redirected the trajectory of western painting for generations to come (Plate XXXVII). The painting's setting, composition, message, and intended audience all distinguish this ground-breaking image as one of the most successful public paintings for common people ever produced during the early Republican period.

Spread upon the surface of the nave's third bay, the vertically oriented picture carves out two spatial boxes that recede naturalistically to a definitive conclusion, thanks to the artist's employment of the newly devised perspectival system that was only then coming into use. At the picture's base we find a skeleton laid flat across a painted sarcophagus in a shallow niche that seems to extend back only a meter or so.[2] The image of the crucified Christ looms above it, with the martyred figure supported by the Father, who stands on a platform. Between their heads, appearing almost as a collar or scarf around God's neck, floats a white dove that visually connects the two. A symmetrically balanced triangle descends from this core, marked by the standing figures of Mary and John the Evangelist, and continues in the form of two kneeling donors who press their hands together and gaze directly at one another. These lay donors occupy a time and space completely different from that of their celestial advocates, for they do not share the coffered chapel space occupied by the figures who stand behind them.[3]

Predictably, the key figure in this composition is the Virgin Mary, who turns her head to engage viewers with a frank gaze and hand gesture that implore our consideration. As her hand points directly at the form of her son's broken body, her direct glare beseeches us to consider the idea of the sacrifice and its implications for the future: she serves as the fulcrum of the composition, the conduit through which the barrier of the solid wall and its image can be penetrated by the viewer's imagination. By addressing us directly, the Virgin prods us to consider the sacrifice represented before us. Masaccio adds to this meditational invitation the exemplary figures of the two kneeling donors, who have conjured up in their minds the vision that Masaccio has revealed to them – and to us – in his painting. Their inability to fix their gazes on the figures behind them suggests that the holy entourage is but a figment of their imagination, mystically produced as a result of proper devotional behavior.[4] They enjoy a visionary experience invoked through prayer, which has in turn allowed them to imagine the broken body of the Savior. And we, in turn, have been granted access to their vision through the power of Masaccio's extraordinarily naturalistic rendering of it, as though the artist has informed us that if we adopt their pose and replicate their mental states, we too may experience this personal mystical revelation. The artist has provided those relegated to the congregation's side of the nave the instructions needed to profit fully from this devotional painting. It is no wonder that Masaccio chose as his model for this instructional image a pictorial motif that common people could

have accessed easily during their daily perambulations through the streets of Florence.

The compositional and iconographic choices that Masaccio made suggest that his fresco's inspiration emanated from the forms and formats he saw in Florentine street tabernacles that decorated public spaces for common people. Masaccio surely knew his trade well, and as a student of the traditions that had come before him he must have known Giottino's street tabernacle that we have come to know as the *Madonna della Sagra* (Plate II). Originally occupying the corner niche at the Via Leone near Santo Spirito when it was painted in 1356, the fresco features the unified composition commonly employed in street paintings. We recall that the focus of Giottino's painting revolves around the traditional grouping of the Virgin and Child Enthroned, with angels and saints closing in on the Holy Couple from each side. But the placement and gesture of John the Baptist – who stands to the lower left, gazes out at the viewer, and gestures with palm raised toward the central protagonists – distinguishes Giottino's tabernacle from the others in Florence, and marks the image as a communicative one intended to edify and instruct. This gestural choice, while not entirely unique for the age, was rare enough to suggest that Masaccio intentionally quoted it when he designed and painted his fresco of the *Holy Trinity* in the nave of Santa Maria Novella: its placement in a setting designated for public access made his selection of Giottino's *Madonna della Sagra* as the model for his fresco a perfectly logical one.

SETTING, CIRCUMSTANCE, AND MESSAGE

No records from the period confirm either the identities of its patron or the circumstances surrounding the commission of Masaccio's *Holy Trinity*. Until recently, the picture was believed to commemorate the memory of an otherwise unknown linen merchant named Domenico di Lenzo. The earliest references to Masaccio's fresco appear in two sixteenth-century documents that describe work done at the end of the 1420s under the direction of the convent's prior, Fra Lorenzo Cardoni, to direct construction of a chapel and altar in the west aisle dedicated to the Holy Trinity.[5] A second source confirms that the chapel of the Trinity was located in the nave's third bay on the west wall (to the left as one enters through the facade), directly across from a large portal on the opposite side of the nave that once led to the cemetery.[6] A third document reveals that, typical of the period, a tombstone was placed near the chapel's altar, in the floor by the foot of the fresco, and that the marker bore the words "Domenico di Lenzo et suorum," or "In Memory of Domenico, son of Lenzo, and his family members."[7] The floor tomb, moreover, was inscribed with the year of 1426, a date which corresponds to the time of the fresco's production and the architectural work sponsored by Fra Lorenzo Cardoni. Recent

evaluations of the evidence, however, call into question the identity of the red-clad kneeling donor and the woman in blue to his right, as a trail of wills and testaments dating to the late fifteenth century have led Rita Maria Coman-ducci to connect the chapel of the Trinity not to Domenico di Lenzo, but to members of the Berti family instead.[8] Still, Comanducci cannot demonstrate the Berti's ownership of the chapel in the 1420s, and until new evidence comes to light we can say nothing conclusive about the identity of its lay patrons.

The circumstances of the painting's production are among only a few of the numerous problems associated with it. The chapel and altar in which it was encased were removed during the Vasarian cleansing of the 1560s, and the ren-ovations inside Santa Maria Novella in 1860 and 1861 included the detachment of the upper half of the *Holy Trinity* from the nave wall and its relocation on the church's entrance wall. Only in 1952 was the painting returned to what we believe was its original location on the west wall of the nave, directly above the haunting skeletal form that lies horizontally across the painted tomb below (and which has never been moved). Indeed, the horizontal crease that sepa-rates this *momento mori* from the Crucifixion and Trinity above it creates more headaches than tonics for art historians. Do these two images belong together, one over the other? If both parts were painted by Masaccio as an ensemble, what portion of the fresco was hidden by the altar table placed in front of it? Why was only the top part – that representing the *Trinity* and its donors – moved during the nineteenth century? And when it was moved back in 1952, did it take up exactly the same position it held back in the 1420s when Masac-cio painted it on the nave wall of the Dominican friary? With no evidence to the contrary, we must assume that the current location of the *Holy Trinity* approximates its original setting, and that the way we see it today corresponds roughly to the way it was seen at the time of its completion. Accordingly, we must acknowledge that Masaccio's fresco, while unquestionably a transforma-tive image in the history of art, was also, at its core, a new interpretation of a fairly traditional approach to making public pictures for common people in early Republican Florence.

A variety of interpretations have offered compelling explanations for the image's intellectual thrust. At a very basic level, the Eucharistic reference to the body and blood of Christ connects the forms in Masaccio's *Holy Trinity* both to the Holy Scriptures of the New Testament and to ritual performances enacted at altars all across Christendom. The oozing wounds and contorted limbs of the martyr make this allusion quite clear. However, a group of modern schol-ars have appended to this core notion a number of additional themes – each based on highly sophisticated theological readings – that have encouraged us to see the image as a much more complex statement on the nature of Chris-tian devotional practices in the early Renaissance. In a series of learned essays, Ursula Schlegel, Otto von Simson, Rona Goffen, and Timothy Verdon have

alternatively interpreted the picture as a commemoration of its lay patrons, as an iconographic reference to the *Gnadenstuhl*, as an illustration of Paul's epistles, and as an Augustinian image expounding upon the theological principle of love.[9] Individually, and even collectively, these interpretations help us understand Masaccio's painting as an intellectual *tour de force*, and one is hard-pressed to select one of these suggestive themes over the others. Indeed, I rather prefer to embrace all of them simultaneously, with the understanding that the painting was always intended to be read on multiple levels according to liturgical practices, seasonal necessities, and – of course – the educational level of the viewers standing before it.

But these readings, all grounded in well-reasoned arguments that take as a point of departure Masaccio's dependence on specialized texts familiar only to a smattering of the city's intellectual elite, overlook a very basic premise. It seems highly unlikely that an audience of commoners would have had even the slightest inkling of complicated texts or symbolic connections to them, even if Masaccio did in fact embed them in his painting. Subtle references to the Greek and Latin writings of the Early Church Fathers would have been utterly lost on the carder with calluses on his fingers, the street-walker from the Mercato Vecchio, or the clerk working in the offices of the Florentine Mint underneath the large painting of the *Zecca Coronation*. And it is important to keep these common viewers in mind as we consider the painting's message, for the image was physically situated in a place that addressed both those elite viewers who knew their Pauline exegesis and those lay viewers who did not. The picture, after all, was situated directly at a key nexus in the church where everyone, from all walks of life, could have seen it. The *Holy Trinity* was not hidden behind the *ponte*, in the zone of the clerics and their elite benefactors. Rather, it appeared just behind the pulpit on the congregation's side of the nave, in the midst of a heterogeneous audience that was not expected to know or understand any of the learned texts that today seem to enrich it (Plate XXXVIII).

Masaccio's fresco must have been seen with frequency and by a multitude of viewers from a wide array of educational and social backgrounds, for Santa Maria Novella was an extremely popular religious center. This popularity was due to many things, but two salient issues in particular demand our consideration. First, the church was operated by the highly respected Dominicans, who trained their members to deliver sermons with an eloquence and dramatic presence that made them entertainers as well as moral guides. Fourteenth- and fifteenth-century commoners wanted to be edified, certainly; but they also wanted to be impressed by the wit and wisdom of men who knew more than they did. Commoners often, even regularly, flocked to hear sermons in much the same way that we rush to hear musicians perform or sit for hours to laugh and weep with actors on a theatrical stage. One of the best places to hear the most interesting sermons in Florence, delivered by the most

entertaining preachers in the region, was Santa Maria Novella, and these ser-
mons were delivered from the pulpit on the west side of the church nave.
Surrounded by scores, even hundreds, of listeners, the preacher who mounted
the pulpit's steps knew he could use pictures as illustrations to supplement his
remarks: as we have seen, the Franciscans in Santa Croce used the paintings
of the *Last Judgment* and *Hell* that decorated the nave walls which framed the
pulpit in their church in precisely this manner. And located literally next to
and directly behind the pulpit in Santa Maria Novella's nave stood Masaccio's
fresco of the *Holy Trinity* (Figure 104). Here the preacher had at his disposal
an image that celebrated a healthy roster of key exemplary figures and holy
advocates, and did so with a naturalistic accuracy that made them believable
co-occupants of his audience's space. God the Father, the Crucified Christ, the
Virgin Mary (gazing directly at listeners!), and John the Evangelist were avail-
able to be used referentially. The painting must have become a centerpiece of
Dominican preaching the day it was unveiled in the late 1420s, and those in
the audience whose eyes wandered from the preacher who stood above them
in the pulpit to the brilliant picture of the crucified Christ painted on the wall
directly behind him were rewarded with a visual treat of enormous innovation
and power.[10]

Among the first things Masaccio needed to consider as he began the designs
for his fresco was the vantage point his lay viewers would have of it when
they ventured inside the church. To a large extent, of course, its location was
pre-determined. As a decoration for the chapel of the Trinity built under the
direction of Fra Cardoni, the fresco's placement was obviously fixed in that
spot. But Masaccio must have been free to use the space allotted to him as he
wished. The painting's setting inside a chapel along the side aisle of the nave,
positioned within a presumably shallow wall construction that permitted view-
ers to consider it from the oblique, helped Masaccio make decisions about sight
lines, depth, figural proportions, and spatial relationships. Just as important, the
fresco's placement on the congregation's side of the *tramezzo* and across from
a prominent entrance into the church surely influenced the painting's com-
position, its content, and the messages Masaccio chose to impart to different
viewers simultaneously.

In 1988, John Shearman argued that the primary viewing spot for the *Trinity*
was in the middle of the nave, directly in front of the third bay where the chapel
was located (Figure 104). This is unquestionably a logical place to view the
image, as viewers there would have been able to consider it centered beneath
the arch of the arcade that forms the side aisle along the western edge of the
church. Moreover, if the altar table had been positioned directly before the
image on four free-standing legs, the skeleton at its base would have been
visible to viewers who considered it from enough of a distance to provide
them a visual path underneath that tabletop. But this could not have been

104. West side wall, with bay containing *Trinity*, Santa Maria Novella, Florence. Photograph ©
George R. Bent.

the only vantage point Masaccio considered as he painted his fresco. With the
congregation fanned out in a semicircle around the pulpit, only a fraction of the
audience would have had the luxury of seeing the picture from the preferred
position in the center of the nave, directly in front of the altar table, with an
unobstructed view of the fresco's upper and lower parts and the open table that
divided them. The best time to see the painting would have been during off-
hours, when there were no sermons or ceremonies under way and no clusters
of listeners or devotees cluttering up sight lines.

For many visitors to Santa Maria Novella, the first visual contact they would
have had with the *Holy Trinity* would have been immediately upon entering
the nave from the side door on its eastern flank. In its setting as a tomb marker

at the right of the pulpit, the fresco was positioned directly across from the only portal that led to and from the cemetery of Santa Maria Novella (Figure 105 and Plate XXXVIII). And this fact leads us to the second reason this particular church was so popular among common people during the early Republican period: the cemetery in this mendicant complex was a popular and prominent resting place for a large number of Florentines during this era. The emphasis on the dead and dying was everywhere. With tombs inserted in the walls, the floor, burial chapels along the side aisles and in niches built into the *tramezzo*, and in the *avelli* that lined the cemetery on its eastern flank, the church entertained visitors throughout the day who – like Pampinea and her friends – came to contemplate the lives of their loved ones without the mediation of priests or confessors. The pictures and objects that decorated the burial markers and tombs on the congregation's side of the nave, where Masaccio's *Holy Trinity* appeared, helped them do this, and the subject matter of an important portion of his fresco clearly alluded to this intimate type of viewing experience. In fact, the painting, then as now, was perfectly framed by the portal that permitted mourners to pass from the cemetery into the nave: Masaccio's painting could be seen from the space in the east cloister reserved for both the dead and the living who came to commemorate them (Plate XXXIX). Just as the large and poignant fresco of the *Abandonment of Children and the Reunification of Families* on the north facade of the Misericordia was framed by the south portal of the baptistery (Plates XII and XIII), the equally large and poignant fresco of the *Trinity* was perfectly framed by the portal that punctured the wall separating the cemetery from the church. It was the cloister of the dead that provided viewers an optimal vantage point for seeing Masaccio's innovative fresco.

Timothy Verdon has emphasized the relationship between the fresco's location and the east doorway that connected this cemetery to the church, just on the congregation's side of the *ponte*.[11] Since its construction in 1301, the portal had served as the entrance that allowed visitors to move from the graves of loved ones, where they could mourn the passing of their ancestors privately, into the nave where rites, sermons, and ceremonies were performed. When Boccaccio introduced readers to the main female characters in *The Decameron*, he carefully noted that they had come there to pray for their dead. Their private acts of mourning, we may imagine, included a visit to the cemetery in the east cloister, which was abuzz with activity during the summer of 1348 as bodies were buried inside its walls. Visitors who congregated in Santa Maria Novella would have completed their visit by leaving the cemetery and moving directly into the church, where they could pray for their ancestors in the presence of images that, as we now know all too well, had the capacity to see them, hear them, and advocate for them in the celestial court. By 1430, this transition of moving from the cemetery – the place of the dead – into the nave – the place

105. Cemetery, east cloister, Santa Maria Novella, Florence. Photograph courtesy Alinari/Art Resource, New York.

of the living awaiting death – included the pristine view of Masaccio's *Holy Trinity*.

And here, and for these viewers in particular, a very specific message was offered. Whereas priests, friars, and educated viewers might have read Pauline or Augustinian themes into the painting, and while lay worshippers milling about the nave may have interpreted it as an instructional device to help them communicate with their holy advocates through the intermediary power of the image, viewers from the cemetery got a subtly different message. At the base of the picture appeared the image of the decomposing corpse, defined by the inscription just above it, "IO FU[I] G[I]A QUEL CHE VOI S[I]ETE: E QUEL CH' I[O] SONO VO[I] A[N]C[OR] SARETE" (I was as you are: and what I am you soon will be). Mourners who saw this message as they entered the nave from the cemetery understood this passage as a commentary on penance and eternity, shrouded in an ominous warning of the unavoidable fate that awaits us all. It is no coincidence that the words accompanying the grisaille painting of the skeleton were written in Italian rather than Latin. The audience was comprised of lay viewers, and the text of the inscription – despite its location in one of the most learned and dogmatic clerical institutions in Florence – was directed not

at the friars and theologians who packed the cells of the friary's cloisters, but at common people who wandered into the nave after a thoughtful visitation to the cemetery next door. Italian was the language they spoke, and Masaccio's decision to write his inscription in that language enabled him to reach as many common viewers as possible. Viewers were asked to turn their thoughts from the memory of the deceased to their own mortality and the fate awaiting them. It was a perfect way to pivot away from the past and to begin thinking about the future.

ACCESS GRANTED

The early Republican artists who produced images on the congregation's side of naves repeatedly alluded to forms and figures that ornamented spaces reserved for elite audiences on the cleric's side of the *tramezzo*. This was, we have seen, a way to bring to common audiences a sense of what they were missing in the restricted zone of the church. Masaccio was no different. The young painter learned from those who preceded him, and adopted from them this mechanism of visual communication with an audience less familiar with imagery reserved for elites. But he did so in a more effective way. Whereas earlier painters had presented for common viewers simplified or abbreviated references to altarpieces by way of isolated effigies of standing saints (as had been done at Orsanmichele, San Miniato al Monte, and the Duomo), Masaccio instead created a holistic composition formed by a pastiche of images that appeared in various places inside Santa Maria Novella's transept. The fresco of the *Holy Trinity* made accessible to viewers standing on the congregation's side of the nave some of the most salient pictorial themes they were unable to see on the other side of the *ponte*.

At the most basic level, the *Holy Trinity* directly, overtly, and immediately replicated a core visual theme of the church's decorative program: that of the crucified Christ. At least two such images adorned the inner sanctum behind Santa Maria Novella's transept by the time Masaccio began the fresco's design in the 1420s. Giotto's *Crucifix* that had been installed somewhere inside the church by 1312, and may even have been placed atop the *tramezzo* facing common viewers who clustered around the pulpit and its flanking fresco in the nave's third bay (Figure 106). Brunelleschi's wooden sculpture of the same figure and scene, now in the Gondi Chapel, was carved roughly a century later, and provided viewers with an eerily naturalistic three-dimensional representation to consider (Figure 107). The sculptural quality of Masaccio's Christ emanates directly from Brunelleschi's template, as the painter borrowed from the sculptor the facial structure of his martyred figure, the naturalistically rendered hands and feet, and the tightly muscled limbs that hang from the cross. From Giotto's painting came the weightier handling of the torso, the representation of the hanging, brown-haired head, and the figures of Mary and John,

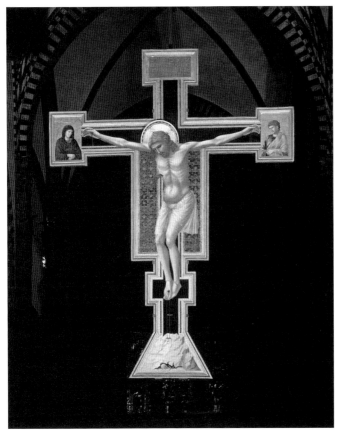

106. Giotto, *Crucifix*, ca. 1310–1312, Santa Maria Novella, Florence. Photograph courtesy Scala/Art Resource, New York.

respectively, at the two sides of Christ's body. These were, of course, fairly standard representations that could be found in churches far and wide, all across western Christendom – and, we must note, Santa Maria Novella undoubtedly possessed and displayed many more images of the crucified Christ than these two famous ones. But the emotional interaction between these three figures connects Masaccio's painting to Giotto's in very specific ways. And this was not the only pictorial reference from the church that Masaccio included in his fresco.

More subtly, Masaccio plucked from the decorative themes that ornamented Santa Maria Novella's Strozzi Chapel some of his more compelling compositional and thematic elements. Built in the 1340s and decorated by Nardo and Andrea di Cione in the following decade, the locked chapel – off-limits at all times, save for only a few days each year – was something of a mystery even to the friars who lived and worked there.[12] However, some of the images inside it were known to both Masaccio and the elites who were allowed to congregate in the transept. At the chapel's base, supporting the staircase that leads up to its main floor, appears an open tomb marked as the resting place

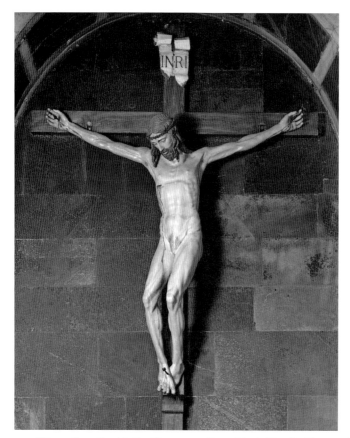

107. Filippo Brunelleschi, *Crucifix*, ca. 1415, Santa Maria Novella, Florence. Photograph courtesy Scala/Art Resource, New York.

of Rossi Strozzi and his descendants.[13] Inside this niche appears a fresco of the *Deposition of Christ*, painted during the decade of the 1340s, which features the body of the Dead Christ laid out on an open slab and mourned by male and female followers who contemplate his broken body (Figure 108). Not unlike the subject employed later by Fra Angelico for his painting at Santa Maria alla Croce (Figure 1), the horizontal composition emphasizes both the death of the Savior and the piety of those followers who mourn him. This same theme surely informed Masaccio's highly unusual addition of the human skeleton that stretches out across the painted tomb at the base of the *Holy Trinity*. The corpse enshrouded at the base of the Strozzi Chapel is now decomposed and confronts us in its final physical state: it's as though Masaccio has taken the image of the *Deposition*, with its emphasis on the process of burial, and extended the narrative and temporal sequence to its logical conclusion – the ultimate fate of the body after its interment. Aimed at viewers traversing the space between cemetery and nave, his fifteenth-century painted skeleton referred back to both the

108. *Lamentation of Christ*, ca. 1340, Santa Maria Novella, Florence. Photograph © George R. Bent.

composition and subject of the earlier fresco that adorned the burial niche at the ground floor level of the Strozzi Chapel.

Masaccio also selected for his fresco elements that he saw in the pictures placed above the niche and its image of the *Deposition*, inside the chapel proper. Within the inner sanctum of the Strozzi Chapel appears a vivid, highly original set of fresco paintings produced during the 1350s by Nardo di Cione and dedicated to the theme of the *Last Judgment* – the same theme as that crafted by his brother, Andrea, a decade earlier in the nave of the rival Franciscan church of Santa Croce. Set squarely in the chapel's center, Andrea's altarpiece illustrates the unusual theme of the *Ordination of the Keys and the Rule* (Figure 63) – a concept elaborated upon by Andrea di Bonaiuto in his depiction of the *Supremacy of the Dominican Order* in the Spanish Chapel only a few years later. Here, with a distinct interest in the vertical axis that moved from the chapel's altarpiece to the pinnacle of the lunette directly behind it, Masaccio borrowed key forms and poses for his *Holy Trinity*. Andrea's altarpiece features a centrally oriented Godhead – maybe Christ, maybe the Father, maybe a conflation of both – flanked by the kneeling figures of Saint Peter and Thomas Aquinas who look not at him, but rather across the picture plane, directly at one another. Masaccio borrowed all three of these poses for his composition. His depiction of God the Father, supporting the crucified Christ, depends on the spread-eagled

Godhead at the core of Andrea's altarpiece. The facial characteristics of Masaccio's Father derive in part from the Strozzi Chapel's paintings, as the God who holds the cross in the *Holy Trinity* bears the same features – and the same hand gesture – of Nardo di Cione's *Christ* at the very top of the chapel's central wall (Figure 109). The genuflecting saints that kneel to either side of that Godhead were transformed into donors who similarly gaze past the celestial apparition that transpires behind them. The Virgin Mary appears as holy advocate on the left side of both images, and shares her honorific position with a civic patron name John – the Baptist in Andrea's panel and the Evangelist in Masaccio's fresco. Even the dove that connects these two central characters in Masaccio's picture derives from Andrea's panel, as the small compartment directly over the presiding Godhead in the *Strozzi Altarpiece* contains that same white bird, which in turn explains the potential duality of that Godhead figure who dominates the center of the panel; indeed, Andrea's altarpiece contains within it a Trinitarian message, too. And by way of exclamation point, all of Masaccio's figures, from the skeleton at the fresco's base to the image of God the Father above, sit within an architectonic structure that conveys the notion of a burial chapel, just as do the figures and forms produced by Nardo and Andrea di Cione during the decade of the 1350s. The main difference, of course, is that Masaccio constructs his chapel as a Roman edifice, complete with a rounded barrel vault, tightly aligned coffers, and pristinely reproduced representations of ancient architectural elements.

Masaccio's pastiche is not an outright act of plagiarism, of course, for the young painter refrained from quoting directly the exact forms he knew decorated spaces in the transept. No one could ever mistake his painting for a mere copy of Giotto's *Crucifix*, Brunelleschi's wood sculpture, or the paintings that comprise the decorative program of the Strozzi Chapel. But it is equally true that the artist elaborated on pre-existing images in the church, just as he leaned heavily on the street picture of the *Madonna della Sagra* that had been painted by Giottino in 1356. Masaccio knew his art history, and he went to great lengths to quote passages from earlier visual texts in this, the greatest public painting of the early Republican period.

LIKE THE STREET TABERNACLES THAT BEGAT IT, THE *HOLY TRINITY* IN Santa Maria Novella had to speak to multiple audiences simultaneously. Preachers used it as they addressed listeners from the pulpit. Congregations saw it as they listened. Commoners were told by the gesture of Mary to think of the Passion as they prayed, and the positioning of lay donors kneeling outside of the imaginative world showed them the pose to strike as they went about the process of imagining and projecting onto themselves the suffering and sacrifice of their Lord and Savior. And those who ventured into the church from

109. Nardo di Cione, *Last Judgment, Christ*, ca. 1357, Strozzi Chapel, Santa Maria Novella, Florence. Photograph courtesy Gabinetto Fotografico del Polo Museale Regionale della Toscana.

the cemetery, where they thought deeply about loved ones from the past, were confronted by a stark reminder that their souls, too, were under scrutiny. Now was the time to begin preparations for their own mortality.

What makes Masaccio's *Trinity* so important and so unusual for its age is the way the artist (and, perhaps, his Dominican advisors) sought to engage both the learned viewers who periodically ventured forth to consider its forms and the unenlightened masses who frequented the nave of that mendicant cultural center. Educated preachers saw in its forms representations of scholastic discourse, while lay visitors went to Santa Maria Novella to hear preachers preaching and then sought solace through their private meditations and prayers, just as Pampinea and her six friends did in the opening of Boccaccio's tales.

Masaccio's design for the *Trinity* was the culmination of public painting for common people in early Republican Florence, and in many ways it served as the triumph of this form of communicative art. All of the ingredients we

have come to expect from paintings aimed at lay audiences were adopted by the artist, and in some cases were replicated with great fidelity. Yet Masaccio mixed them together with new ones that signaled both the twilight of one kind of painting and the dawn of a new one. Now a street picture was brought into an ecclesiastical setting, its qualities enhanced to make both field and figures more lifelike than anything that had ever come before it, and its viewers invited to replicate inside this setting the personalized expressions of devotion that they normally enacted on their own before street tabernacles and in public oratories – usually without the aid of official clerical intermediaries. The setting, audience, and message of his picture allowed Masaccio the luxury and the liberty to experiment with new things like linear perspective, earthy bodies, and classical references. Perhaps this mixture of modernity and familiarity helped Masaccio's stylistic innovations gain such traction among both artists and lay patrons. Within two decades, the pictorial decisions that shaped Masaccio's image on the congregation's side of Santa Maria Novella's nave became the standard by which all modern painting would be judged. In exceptionally important ways, the visual traditions that informed Renaissance art and culture emerged from the lengthy history of public painting for common people in early Republican Florence.

NOTES

INTRODUCTION

1. For a discussion of the rituals practiced by condemned prisoners while awaiting their fate in the Bargello, see Edgerton, 1985, 45–58; and Terry-Fritsch, 2010, 49–53. For a brief reference to the use of *tavolette* during processions of the condemned, see Edgerton, 1985, 165–192; and Freedberg, 1989, 5–9.

2. For the route and rituals of the prisoner's procession, see Biblioteca Nazionale, Firenze, II, I, 138: *Libri di varie notizie e memorie della Venerabil Compagnia di Santa Maria alla Croce al Tempio*, 171v–173v.

3. Another processional route taken by condemned prisoners moved south from the Palazzo del Podestà to the Via de' Neri and then east toward the facade of the church of Santa Croce before passing along the Borgo dei Malcontenti toward the Porta alla Croce. Holmes, 2013, 76, 299n61.

4. Biblioteca Nazionale, Firenze, II, I, 138, fols. 71–81. Between 1420, when records began to be kept, and 1500, members of the Neri accompanied 619 people to their deaths, nearly all of them men, at an annual rate of 7.7 processions.

5. Marchionne di Coppo Stefani, *Cronica*, R. 680a, in Zervas, 1996a, 50–51. Andrea's sculpted tabernacle was the only work of art mentioned in Stefani's lengthy and unusually thorough chronicle of Florentine life in the late fourteenth century.

6. Vasari does not explicitly indicate that the *Lamentation* faced the congregation, but the context of his remarks suggests it. After lauding him for his studiousness, Vasari wrote of Giottino's painting, "Questa tavola è posta nel tramezzo di detta chiesa a man destra, et èvvi dentro un Cristo morto, con le Marie intorno e co' Niccodemi, accompagnati di altre figure, le quali con amaritudine et atti dolcissimi et affettuosi piangono quella morte, torcendosi con diversi gesti di mani e battendosi di maniera che nella aria del viso si dimostra assai chiaramente l'aspro dolore del costar tanto i peccati nostri." His indication that "this painting is in place in the *tramezzo* … on the right hand side" suggests that Vasari was trying to lead readers to the picture, and took for granted that they would consider his directions from their point of entrance at the main portal of the church. Vasari did not advise them to pass through the *tramezzo*'s doors, but rather to find the painting directly at their right as they looked at the *ponte* from the only entrance to the church of San Remigio: the front door. For a recent analysis of the *tramezzo* at San Remigio and the placement of Giottino's *Lamentation*, see Bandini, 2010–2012, 211–30.

7. Belting, 1991.

8. Trexler, 1972b; and Trexler, 1980, 63–68.

9. This panel has traditionally been attributed to Bernardo Daddi and his workshop. Offner, 1934, 50–54; and Cole, 1975, 9–15.

10. Jones, 2003, 31–55.

11. Solberg, 2010, 53–74.

12. Solberg, 2010, 70.

13. Hall, 1974a, 325–41; and Hall, 1974b, 157–173.

14. For the difficulty of seeing beyond the *tramezzo*, see Hall, 1979, 2–3, 158; and Cannon, 2013, 51.

15. Cannon, 2013, 43.

16. Cannon, 2013, 43; and Cooper, 2011, 102–4.

17. Maginnis, 2008, 5–7; and Lisini, 1903, 398–99.

18. Maginnis, 2008, 5; and Durandus, 1906, 27–28. Durandus notes that sometimes women were seated on the south side of the nave and men on the north side. At others, men were seated closest to the *tramezzo* and women closest to the entrance wall. As Maginnis notes, "we do not know whether this was common or just hopeful."

19. Orlandi, 1955, 403; Pitts, 1982, 278; and Hall, 1974b, 165.

20. Naturally, there are exceptions to this general rule. Giotto's altarpiece for Santa Croce's Baroncelli Chapel, probably installed at the end of the 1320s, depicts the narrative scene of the *Coronation of the Virgin*. The altarpieces painted during the 1330s and 1340s for the spaces flanking the choir of the Siena cathedral were dedicated to moments from Christ's infancy rather than the iconic rendering of the Madonna and Child. By the middle of the 1360s, altarpieces with an exceptionally diverse selection of subjects (like those for Florentine monastic institutions by Orcagna, Nardo di Cione, and Giovanni del Biondo) were being painted and installed in churches all across Italy. Van Os, 1988, 77–89.

CHAPTER 1

1. The monastery of San Salvatore, operated by Romuald's Camaldolese order, was situated only fifty meters from this picture.

2. The painting was removed from this location and reinstalled on the corner of Via Leone and Via della Chiesa and for centuries looked out onto the small square there called Piazza Gusciana. See Arthur, 1991, 39; and Guarnieri, 1987b, 170.

3. Guarnieri, 1987b, 9–14.

4. For a discussion of the tradition of framing cult images with architectonic tabernacles, see Holmes, 2013, 215–18.

5. Holmes, 2013, 14; and Sabbatini and Invernizzi, 1991, 5.

6. The *Madonna of Humility* originally measured 225 × 98 centimeters, which made it fairly large by the day's standards. Bietti, 1991, 95–100.

7. The street formerly known as the Via di Trevigi is now known as the Via delle Belle Donne, whereas the Borgo San Pancrazio is today called the Via della Spada. Both run between the church of Santa Maria Novella and the Via Tournabouni. The Piazza Piattellina, just beyond the Piazza del Carmine to the east, was known in the fourteenth century as the Piazza degli Orpellai.

8. Cappellini, 1949, 21.

9. Bailey, 2001, 19–21.

10. Bargellini, 1971, 15. Bargellini offers no documentation for this suggestion, which makes his claim interesting but problematic, as street tabernacles did not have consecrated altars attached to them.

11. Marchini, 1973, 301–6.

12. Marchini (1973, 301–6) scoured fourteenth-century legends of the *Madonna of Orsanmichele* and came away empty-handed.

13. Biblioteca Nazionale Firenze, II, I, 138: *Libri di varie notizie e memorie della Venerabil Compagnia di Santa Maria alla Croce al Tempio*, fol. 3.

14. Muir, 1989, 29; Trexler, 1980, 111–12.

15. Muir, 1989, 29.

16. Muir, 1989, 25.

17. Muir, 1989, 33–35.

18. The power of these public Madonnas occasionally provoked violent attacks from those critical of the imposition of her presence. Trexler, 1980, 118–24.

19. Wolfgang, 1956, 311–30.

20. Ladis, 1987, 1.

21. Ladis, 1987, 1.

22. Holmes, 2013, 183–88.

23. Trexler, 1972b; and Trexler, 1980, 63–68.

24. Trexler, 1980, 68–69.

25. Holmes, 2013, 98–99, 198–99.

26. Freedberg, 1989, 5–9.

27. Bertani, 1991, 69.

28. Bertani, 1991, 69–87.

29. See Carocci, 1884, 97–98. Bertani (1991, 69), following del Migliore (1684, 518), tentatively suggested that the oratory was initially built and used by the Wool Guild, which ceded the rights of the oratory (and the *Madonna della Tromba*) over to the Guild of Doctors and Apothecaries in 1361. I have found no evidence to confirm this claim and thus must abide by the declarations in the *Provissioni* of 1361, which state quite clearly that the Arte dei Medici e Speziali was to be responsible for the oratory's construction and decoration.

30. A.S.F., Consigli Maggiori, *Provissioni* 48, 27 Agosto 1360 al 10 Luglio 1361, fol. 209v. "Item cum hoc sit quod olim quidem vicus vocatus il chiassode la tromba situs super angulo fori veteris in quo multa turpia et inhonesta fieri solebant de consensu comunis Florentie clausus fuerit et ibidem ad laudem et honorem virginis gloriose posita fuerit quedam tabula ipsius ymaginis devota et pulcra et ibidem factum fuerit oratorium cui tabule ob ipsius virginis gloriose reverentiam per homines et personas transeuntes apponuntur candele. Et quod pro conservatione et augmentatione dicte devotionis dicta ars et universitas [medicorum spetiariorum et merciariorum Porte Sancte Marie civitatis Florentie] suis expensis manutenuerit

tectum et porticum dicti vici et dicti oratorij et ibidem lampadem de nocte ardere fecerit et custodem et guardianum ibidem posuerit quod dicta ars (105) et universitas libere sine impedimento et contradictione alicuius persone eccleasiastice vel secularis collegij officij et universitatis habeat et habere intelligatur custodiam guardiam administrationem et regimen deinceps perpetuo dicti vici oratorij et tabule et oblationum et pertinentiarum eiusdem. Et quod consule dicte artis presentes et qui pro tempore fuerint et due partes eorum etiam alio vel alijs absentibus et inrequisitis vel presentibus tacentibus vel contradicentibus possint eisque liceat teneantur et debeant ibidem pro dicta arte ponere et deputare custodem et guardianum qui ibidem stet et stare possit et debeat de die et de nocte ad custodiendum accendendum et extinguedem lampades candelas ad honorem laudem et reverentiam dei genitricis eo modo et forma quibus prout et sicut eisdem vel maiori parti eorum et dictum est videbitur et placebit libere et sine alicuius contradictione non obstantibus [etc.]." Horne, 1909, 104–5.

31. Guarnieri, 1987b, 183. Santa Maria della Tromba was not the only public street picture maintained by the Guild of Doctors and Apothecaries. In the same year they received permission to maintain the oratory at the Mercato Vecchio, the Arte dei Medici e Speziali were also mandated to care for two other spaces, one on the Via Cavalieri and the other, probably, at the Piazza Santa Maria Novella. When we consider that the guild also commissioned the dossal panel of the *Madonna*, attributed to Bernardo Daddi, and the sculpture of the *Madonna della Rosa* for their niche on the exterior of Orsanmichele during the fourteenth century, it becomes clear that the Doctors and Apothecaries invested deeply in the figurative arts at a moment when guild politics drove the political system in early modern Florence.

32. For two disparate accounts of Jacopo del Casentino's career, see Horne, 1909, 95–112; and Offner, 1923, 248–84.

33. Marcucci, 1965, 52–53; and Boskovits and Tartuferi, 2003, 104–8.

34. Guarnieri, 1987b, 154.

35. Jacopo del Casentino is listed as one of the founding members of the Company of San Luca in 1339: see A.S.F., *Accademia del Disegno*, I, fol. 1; and Horne, 1909, 98–99.

36. For the notice of Jacopo del Casentino's death in 1349, see A.S.F., *Accademia del Disegno*, I, fol. 10. For the notice of his death in 1358, see *Annali Camaldolensi* VI, 52 (1358).

37. With this set of circumstances in mind, we may wonder whether the image had been originally painted by Jacopo del Casentino as far back as 1339 to celebrate the creation of the Compagnia di San Luca, the organization of painters (members of the Arte dei Medici e Speziali) for whom he served as an early consul. This would explain the appearance of the white-haired saint standing below the Virgin Mary in the painting's lower right corner, who we may now recognize as Luke the Evangelist, patron saint of Christian painters everywhere and the namesake of the artists' confraternity in Florence. See Cappellini, 1949, 18.

38. Jacopo del Casentino's *Madonna della Tromba* was removed from its tabernacle in 1785 and initially repositioned in the nearby church of San Tommaso, where a number of nineteenth-century itineraries noted its presence. But when that church was razed during the demolition of the Mercato Vecchio in 1885, the commune moved the picture to a newly built annex to the old palace of the Wool Guild, adjacent to the church of Orsanmichele. Upon completion of this project, the picture was fitted into the tabernacle space in 1905 and can be seen there today. Bertani, 1991, 71–82.

39. Bertani, 1991, 87.

40. Horne (1909, 109) suggested a date between 1337 and 1347. Marcucci (1965, 53) proposed a date between 1330 and 1340. Boskovits (1986, 413) placed the image closer to 1330, a date accepted by Bertani (1991, 69).

41. Horne, 1909, 107–8; Berenson, 1963, 382–83; Fremantle, 1975, 323–25; Boskovits, 1975, 98, 227, and 408; and Bertani, 1991, 84–87.

42. The word *tromba* has also been associated with the tubes or pipes that conveyed water from one end of the city to the other, and which ran beneath the piazza where the oratory of Santa Maria della Tromba stood.

43. This is not to say that Florentines superstitiously depended only on images for their personal protection. Those guilds that were quartered in the Mercato Vecchio – and there were many of them there – took up the responsibility of assigning small groups of members to patrol the area during nocturnal hours, when

the darkness covering the city prevented the *Madonna della Tromba* from seeing acts of villainy performed below her. The Silk Guild posted ten men around the Por Santa Maria every night. The Arte dei Rigattieri guarded their area of the Mercato Vecchio with four of their guildsmen. The Ponte Vecchio and the Via Calimala, leading from the river to the old market, were under the protection of the Guild of Doctors and Apothecaries. See Carocci, 1884, 165–66.

44. A.S.F., Consigli Maggiori, *Provvisioni* 48, 27 Agosto 1360 al 10 Luglio 1361, fol. 209 verso. Horne, 1909, 104–5.

45. Mazzi, 1984, 343–44.

46. Mazzi, 1984, 340.

47. Mazzi, 1984, 341.

48. Mazzi, 1984, 341; and Brackett, 1993, 277.

49. See Brackett, 1993, 273–300.

50. Trexler, 1981, 984.

51. Trexler, 1981, 984. This obviously rendered obsolete the law of 1325, which had required a distance of two hundred *braccie* from religious sites like Santa Maria della Tromba.

52. Welch, 2005, 32.

53. "You will meet the sweet Elena, the blond Matilde …. You will see Gianetta followed by her little dog …. Then will come Clodia with her naked painted breasts, Clodia a girl whose caresses are priceless." For the complete translation of *L'ermafrotido*, see O'Connor, 2001; and Brackett, 1993, 286.

54. Niccola Zingarelli, *Vocabolario della Lingua Italiana* (Bologna, 2006), 1942: Trombare – (fig., volg.) possedere sessualmente una donna.

55. Zingarelli, 2006, 1942. "Tromba – 4. Divulgatore. Persona pettegola, ciarlina, maldicente: 'è la tromba del quartiere.'" An Italian comic book intended for adult readers after World War II was titled *La Tromba* and chronicled the sexual exploits of off-duty soldiers.

56. This connection between *tromba* and *trombetti*, or "tramps," was noted by Bertani, 1991, 69; and Cappellini, 1949, 5.

57. Welch (2005, 33–35) proceeds to describe the problematic nature of more upstanding lower-class women who sold fruit and vegetables in the Mercato Vecchio, not far from the brothel there that offered a different kind of commodity for sale.

58. Trexler, 1980, 68–69. Taking them to task, Fra Savonarola thundered, "I tell you that the Annunciation doesn't want to see them dressed like that!"

59. A.S.F., *Archivio dell'arte dei Medici e Speziali*, 201, Libro di Testamenti e Contratti, 1347–1611, fol. 20r. "1408 AD. In Dei nomine … anno ab eius incarnationis millesimo quadrigentesimo octavo indicatione secunda, die vigesimo nono mensis novembris … ars et universitas medicorum, spetiariorum et mercaiorum civitatis Florentie ingombrabat et occupabat quemdam vicum vocatum 'il Chiasso della Tromba' in MCCCLX primo indictione XIV, die XXV, mensis junii … considerantes quod in dicto vico multa turpia et inhonesta solebant fieri … clauses fuerit … ad laudem et honorem Virginis gloriose posita fuerit quedam tabula ipsius Virginis Mariae imagines, et ibidem factum fuerit oratorium." Horne, 1909, 105.

60. The full text of this prayer states, "Gloriosa Vergine Maria, gloriosa e piena di pietade e di grazia, adornata di tutte le virtù, tu se' rosa bianchissima piena di carità, tu se' viuola aulentissima amorosa di vera e profonda umilitade, tu se' giglio bellissimo d'ottima e netta castità. Tu se' imperatrice nobilissima di grande excellenzia. Tu se' reina di somma potenzia, tu se' fontana di sapienza, tu se' degna di riverenzia, tu se' istella del mare, tu se' guida e conforto degli navicanti. Tu se' consolazione de' tribolati, tu se' consiglio degli sconsigliati, tu se' advocata e aiutatrice de' peccatori e sempre davanti a Cristo intercedi che elli ci faccia cotali figlioli come egli ci desidera e vuole e sempre viviamo nella sua lode: dolcissima madre graziosa la tua misericordia t'addomanda questa grazia che sia pe' lei buona advocata dinanzi a Cristo tuo figliolo, che mi guardi da pena e da dolo; e ancora priega il Salvatore che ci conformi nel suo amore e diece pacie e consolazione: e guardici di ogni persecuzione e da male temptazione e intenzione e da tutti i peccati mortali e nella fine a' beni di vita eterna a contemplare la santa Trinità. Amen." Biblioteca Seminario Maggiore, Florence, *Codex Rustici*, fol. 22; and Cappellini, 1949, 21–22.

61. Supino, 1905, 269.

62. Holmes, 2013, 76–79 (and the illustration on page 78), 166, 211.

63. Holmes, 2004, 110.

64. For a recent account of the picture's status as a cult image, see Holmes, 2013, 227–38.

65. Zervas, 1996b, 12.

66. Sorsa, 1902, 11.

67. "Nel detto anno (1292), a dì III del mese di luglio, si cominciarono a mostrare grandi e aperti miracoli nella città di Firenze per una figura dipinta di santa Maria in uno pilastro della loggia d'Orto Sammichele, ove si vende il grano, sanando infermi, e rizzando attratti, e isgombrare imperversati visibilmente in grande quantità. Ma i frati predicatori e ancora i minori per invidia o per altra cagione non vi davano fede, onde caddono in grande infamia de' Fiorentini. In quello luogo d'Orto Sammichele si truova che fu anticamente la chiesa di Sammichele in Orto, la quale era sotto la badia di Nonantola in Lombardia, e fu disfatta per farvi piazza; ma per usanza e devozione alla detta figura ogni sera per laici si cantavano laude; e crebbe tanto la fama de' detti miracoli e meriti di nostra Donna, che di tutta Toscana vi venia la gente in peregrinaggio per le feste di santa Maria, recando diverse 'magine di cera per miracoli fatti, onde grande parte delle loggia dinanzi e intorno alla detta figura s'empiè, e crebbe tanto lo stato di quella compagnia, ov'erano buona parte della migliore gente di Firenze, che molti beneficii e limosine, per offerere e lasci fatti, ne seguirono a' poveri … e seguissi a' dì nostri, sanza aquistare nulla possessione, con troppa maggiore entrata, distribuendosi tutta a' poveri." Villani, 1991, VIII, clv, 628.

68. Cassidy, 1992, 191.

69. Bargellini, 1969, 22; and Bergstein, 1991, 689.

70. La Sorsa, 1902, 185; and del Prete, 1859, 3. Chapter IV of the Statutes of 1294 states, "E siano tenuti i detti capitani di far fare le vigilie di queste feste cum candelotti aciesi in mano di quelli de la Conpagnia in tanto quanto si cantano le laude la sera, in prima in tutte le feste de la decta Donna nostra Madonna santa Maria, e di meser santo Michele, ne la Pasqua de la Nattivitade del nostro Segnore Gesu Cristo, e nella sua Risurrezione, e ne la sua Asensione, e ne la Pentecoste, e ne la festa di messer santo Giovanni Battista, et ne'XII Apostoli, e di meser santo Zenobio, e di Madonna santa Reparata, e di meser santo Lorenzo, et in quella d'Ongne santi due vigilie: l'una per tutti li Santi, e l'altra in comemoratione de'morti de la Conpagnia."

71. Cassidy, 1992, 180n3.

72. Compagni, 1818, 109–10. "In Orto S. Michele era una gran loggia, con un Oratorio di Nostra Donna, nel quale per divozione eran molte immagini di cera, nelle quali appreso il fuoco, aggiugnendovisi la caldezza dell'aria, arsono tutto le case, che erano intorno a quel luogo, e i fondachi di calimala, e tutte le botteghe, che erano intorno a Mercato vecchio fino in Mercato nuovo, e le case dei Cavalcanti, e in Vacchereccia, e in Porta S. Maria fino al Fonte vecchio, che si disse arsono più che millenovecento magioni, e niuno rimedio vi si potè fare." See also Villani, 1991, IX, lxxi, 134. "E fu sì empito e furioso il maladetto fuoco col conforto del vento a tramontana che traeva forte, *che in quello giorno arse le case degli Abati e de' Macci, e tutta la loggia d'Orto Sammichele.*" For the expulsion of Neri Abati, see Berghini, 1974, 180: "Messer Neri Abati messe fuoco che arse il più e il meglio di Firenze, che rovinò molti gentiluomini che mai più si potessino revere, e i Gherardini furono cacciati come rubella, né mai più ebbono polso."

73. Diane Zervas and Bruce Cole have argued that the original picture was a fresco, but Cohn and Bellosi have argued that it was a panel, a position that Richa took in 1754 (vol. 1, 5–6). It must be noted that the other picture in Orsanmichele before the fire of 1304, the painting of Saint Michael, was on panel. Indeed, the granary's piers were made of wood rather than brick and mortar, which would have been an unstable support for wet plaster and pigments. Cohn, 1957, 335–38; Cole, 1972, 91–96; Bellosi, 1977, 152–56; and Zervas, 2006, 20.

74. Villani, 1991, IX, lxxi, 134.

75. Bellosi (1977, 152–56) argued that the original *Madonna of Orsanmichele* survived the fire of 1304, although in a damaged state, and was used as a copy for the now-mutilated fresco of the Virgin and Child with Angels appearing in the audience hall of the Palazzo Arte della Lana.

76. Cassidy, 1992, 180.

77. Wilson (1992, 193) notes that "the Madonna 'image' could survive the destruction of a material image, for its efficacy derived less from any quality inherent in the image than from the relationship conducted through it by means of devotional exercises."

78. Even copies of miracle working pictures located in other places were often positioned in the same parts of buildings as the original. See also Holmes, 2004, 110.

79. Kreytenberg, 1990, 37–57. This might be a bit of an anachronism, as the reliefs for the marble shrine were sculpted by Giovanni di Balduccio in 1333, some four years after the events illustrated in the manuscript. These reliefs were

preserved and set into the exterior walls of Orsanmichele, where they are currently on view.

80. Cohn and Cole agreed that this type of composition was unique to confraternity paintings, and to that in Orsanmichele in particular. Bellosi (1977, 152–56) remarked that this type was borrowed by the artist who decorated the audience hall of the Palazzo della Lana sometime around 1320–1330. It should now be noted that these pictures were all based on Duccio's picture for the Compagnia dei Laudesi in Santa Maria Novella.

81. Cassidy, 1992, 190–91, 195; and Kreytenburg, 1990, 44–46.

82. Cassidy, 1992, 190. The appearance of the framework surrounding this version of the *Madonna of Orsanmichele* in the *Biadaiolo Manuscript* suggests that the entire shrine was originally created as a common street tabernacle. As Brendan Cassidy has noted, the design of the original frame that protected it until 1359 conformed to types normally seen on the hundreds of street tabernacles marking the Florentine urban landscape during the period. The arch surmounting the pictures inside repeats the same decorative detailing that the Biadaiolo Master painted on his depiction of the shrine in the granary, and the placement of the panels within the niche suggests that the shrine on the side of the granary conforms to the appearance of other street tabernacles of the period. The fact that this one actually performed miracles made it the most important street tabernacle in Florence.

83. Del Prete, 1859, 6 (Statue XI), 14 (Statute XI), and 26 (Statute XX).

84. Del Prete, 1859, 26 (Statute XX).

85. Villani, 1991, VIII, clv: 628.

86. Del Prete, 1859, 7 (Statutes XIII and XIIII).

87. Del Prete, 1859, 22; and La Sorsa, 1902, 194. "L'uficio di coloro che stanno a piè dell'oratorio della imagine della Donna nostra a ricevere l'offerta e l'entrata de la detta Compagnia essere debba di stare al decto loro uficio continuamente, di feriali e festerecci e solepnni, di dì e di nocte; e accendere e governare le lanpane che sono dirinpetto al decto oratorio: e obedire ciò che fia loro imposto e conmandato per gli rectori e capitani intorno al decto loro uficio, di dì e di nocte. Ciascuno possa stare l'una nocte l'uno, e l'altra nocte l'altro. Vero è che 'l dì vi debano stare continuamente dentro

a l'oratorio, e non uscire se l'altro non v'entra dentro. E quando v'entra o escie, debbia serrare l'uscio colla chiave, sì che continuamente stea serrate. E non vi debbiano giamai per le feste de la nostra Donna tenere denari fuor delle casse, o in scodella o in altro, per cambiare, o per alcuna cosa; ma incontanente che saranno offerti, gli facciano mettere ne la cassa a quelle cotagli persone che gli offerano. E quando fossono offerti panni o altra cosa (fuori che cera o danari) al decto oratorio, il debiano incontanente notificare al notaio; e 'l notaio gli debia scrivere nel registro della Compagnia e dirlo a' capitani e a' camerlinghi che saranno pegli tempi. E non possano vendere candelocti e cera, o alcuna altra cosa che si desse alla decta Compagnia. E a chi fallasse nelle predecte cose i camerlighi debbano tenere di suo salario per ciascuna volta soldi cinque. E che i proveditori della Compagnia, e 'l notaio in secreto e in palese, di dì e di nocte, debbano provedere sopra quelle cose c'anno a osservare quegli dell'oratorio e le guardie e gli altri oficiali, e rapportare a' capitani ogni difecto che trovassono."

88. The most famous discussion of this era within the context of fourteenth-century art historical studies, of course, is Meiss, 1951.

89. Boskovits, 1971, 239–51.

90. Villani, 1991, XIII, lxxiii, 466: "Onde avenne che già sono più di cento anni passati non fu sì pessima ricolta in questo paese di grano e biada, di vino e d'olio e di tutte cose, come fu in questo anno."

91. Villani, 1991, XIII, lxxxiv, 485: "In di grosso si stimò che morissono in questo tempo più di IIIIm persone, tra uomini e più femmine e fanciulli."

92. Villani, 1991, XIII, lxxxiv, 485–86: "Ma noi diveni credere e avere per certo che Idio promette le dette pestilenze e l'altre a' popoli, cittadi e paesi per pulizione de' peccati, e non solamente per corsi di stelle, ma talora, siccome signore dell'universo e del corso del celesto, come gli piace."

93. Cohn, 1957, 335–38.

94. For arguments supporting the suggestion that the Beta *Madonna* was replaced to update the old-fashioned and outdated picture, see Bellosi, 1977, 156.

95. A.S.F., *Archivio de' Capitani della Compagnia d'Orsanmichele, Libri di Elemosine fatte dai Camerlinghi di Or San Michele*, 244, fol. 8; and 245, fol. 6; and A.S.F., *Archivio de' Medici e*

Speziali, Cod. VIII. Frey, 1885, 61, 329–30; and Offner, 1930b, 3.

96. Villani, 1991, XIII, lxxiii, 471. "Avenne come piacque ad Dio, per la festa di san Giovanni Battista MCCCCXLVII, sforzandosi delle primaticce ricolte, subitamente calò il grano novella di soldi XL in XXII, e il Vecchio del Comune in soldi XX lo staio; e l'orzo in soldi XI in X."

97. A.S.F., *Orsanmichele*, 1, fols. 17v–20v. See La Sorsa, 1902, 219–20; and Zervas, 1996a, 26.

98. Crum and Wilkins, 1991, 133–35.

99. Matteo Villani, *Cronica*, I, vii; Fabbri and Rutenburg, 1981, 390.

100. Villani accused the Captains of Orsanmichele of embezzlement, a claim that has never been confirmed.

101. March 6, 1350 [1351]. The confraternity gave f. three hundred toward the construction of the vault above the Virgin's tabernacle in the grain loggia. "A Pierozzo di Bancho di Ser Bartolo dì detto per convertilli a ffare la volta sopra il tabernacholo … … f. 300 d'oro." A.S.F., *Orsanmichele*, 255, fol. 4; La Sorsa, 1902, 107; and Zervas, 1996a, 31.

102. Cassidy, 1992, 186–89. The ciboria produced by Arnolfo di Cambio in Rome during the last quarter of the thirteenth century represent monumentally important moments in the history of Italian sculpture. But still, they pale in comparison to Orcagna's achievement in Orsanmichele.

103. Cassidy, 1992, 186.

104. Fabbri and Rutenburg, 1981, 404.

105. Del Migliore, 1684, 534; and Richa, 1754, vol. 1, 12.

106. "Erasi presa dalla Repubblica per Avvocata speciale la Madonna d'Orsanmichele a voce di tutto il popolo, convocato in Piazza ne' 13 d'Agosto nel 1365 al suono della Campana grosta, com'era solito farsi in rutte le resoluzioni gravi, cagionò da lì in poi una gran devozione, e insiememente rispetto grandissimo verso dell'Oratorio nelli Statuali Uomini di governo, de' quali nessuno, attestano i ricordi que' tempi, vi si sarebbe accostato con livida coscienza, per farvi giuramento, privato, o solenne, secondo il costume indottosi in essi statuali, giurare su quell'Altare venerabile, di rettamente amministrare le cose della Repubblica, tenendosi per certo, se la intenzione loro non fosse stata sincera, che lì si sarebbero veduti subito que' gran gastighi, che seguivano in altri luoghi, e particolarmente in Turone al dir di. Gregorio Turonense, nel giurarsi il falso sull'Altare, pur d'una Madonna venerabile." Del Migliore, 1684, 534.

107. Richa, 1754, vol. 1, 11–12. By way of introduction, Richa says that the stories surrounding the government's interest in the cult of the *Madonna of Orsanmichele* are too numerous to recount individually, which suggests that the eighteenth-century priest had access to now-lost archival materials describing similar events. His description of the move to make the painting the city's advocate then recalls Del Migliore's text almost verbatim.

108. These stories, written hundreds of years after the fact, did not come with specific archival references attached to them, which has caused some confusion about the declaration of the Virgin's advocacy. Del Migliore's account mentions a fourteenth-century document, but does not specify which one he used as a source. Luigi Passerini (1853, 435–36) echoed, yet significantly modified, this story in his archival history of Florence, writing, "Ora mi resta a parlare della divozione della Signoria e del popolo verso il simulacro che si venerava nel tabernacolo, e di tutto ciò che reguardo al culto della Vergine mi è stato concesso di trovare nei libri pubblici. Già fino dal 1349 erasi incominciata la festa commemorativa della cacciata del Duca di Atene; ed in segno di solennità, ne dì vigesimosesto di luglio ogni Arte doveva mandare la propria bandiera la quale restava appesa per tutto il giorno ad uno dei pilastri: e se ne a riprova dal vedersi nei libri delle Deliberazioni stanziare una somma pel servo che collocava codeste bandiere. Nel 1365, allorquando la Madre di Dio fu dichiarata Avvocata speciale della Repubblica, fu ordinato che in ciascun anno, nel giorno in cui la chiesa festeggia l'Assunzione della Vergine al cielo, la Signoria nel maggiore apparato di pompa, o (siccome allora dicevasi) in maestà, dovesse portarsi all'Oratorio di Or San Michele e farvi offerta di cera; ma il Gonfaloniere, invece di cera, offriva un canestro di frutte, che depositava sull'altare di Maria. In seguito poi furono obbligati ad andarvi nel giorno stesso ad offerta anche i rettori delle varie chiese della città, e i superiori delle molte case monastiche; e ciò per una deliberazione emessa nel 1386. E, per vie maggiormente onorare la Vergine, ordinava la Signoria nel 1388, che in tutti i sabati, e nei giorni dedicate a Maria, i suonatori

di pifferi e viole che stavano al servigio dei Priori, dovessero andare a suonare alle Laudi che si cantavano nell'Oratorio, e farvi mattinata." La Sorsa (1902, 50n3) noted with exasperation that he could find no archival item to support these claims. Fabbri and Rutenburg (1981, 404) followed Del Migliore's story and noted that the picture in Orsanmichele was named the protective image of Florence, but erroneously cited Passarini's passage as the source for this.

109. Fabbri and Rutenburg, 1981, 404; and Holmes, 2013, 237–38.

110. Zervas, 1991a, 749. One of the Captains of Orsanmichele responsible for approving this project in 1366 was Giovanni Boccaccio: see Bargellini, 1969, 71.

CHAPTER 2

1. The panel of *Mary Magdalene* in the Accademia may have been produced for a confraternity, but there is no hard evidence to prove the point. Cannon, 2003, 302, 307.

2. For an overview of the identities of these figures, see Cannon, 2013, 83.

3. See Hueck, 1990, 33–46, esp. 41–44. An alternative suggestion posits that the large panel was originally produced for the use of the church friars, and perhaps moved onto the *tramezzo* of Santa Maria Novella when that interior structure was completed. Bellosi, 2003, 153. For a variety of options surrounding the possible location of the *Rucellai Madonna*, see Cannon, 2013, 83–89.

4. Cannon, 2013, 86.

5. Henderson, 1994, 465; and Davidsohn, 1908, 440 (who cites a testament of 1300 in which the so-called Societas S. Trinitatis is mentioned). For a suggestion of the panel's placement in Santa Trinita, see Hueck, 1992, 37–50.

6. For an overview of the growth of confraternities during the early Republican period, see Henderson, 1994, 38–46.

7. The rise in popularity of the Laudesi Company in Santa Maria Novella was perhaps due to the fact that women were equally invited to join in the ritualistic singing that went on every afternoon at roughly 5:00 P.M. beyond the barrier of the rood screen that prevented nearly everyone else from approaching the nave's inner sanctum.

8. Henderson, 1986, 73. The content of the verses sung by the Laudesi had political overtones as well as religious ones: lay worshippers in the transept of Santa Maria Novella sang about the glory and power of the Virgin Mary and the miracle of the human birth of Jesus, two themes that directly contradicted the main thrust of the Patarini heresy that challenged both the dual nature of Christ as man and God and the authority of the Church and the communal government. See also Weissman, 1982, 46.

9. Zervas, 1991a, 754. Zervas transcribes the agreement from A.S.F., *Capitani di Orsanmichele* 61, fol. 56v.

10. The choir books that Lorenzo Monaco illustrated for Santa Maria Nuova appear to have been intended for liturgical celebrations performed at the high altar of the Church of Sant'Egidio, which was located inside Santa Maria Nuova. The entire hospital complex, it should be noted, was a dependency of Santa Maria degli Angeli, Lorenzo's former monastic home and long-standing institutional partner, which abutted Santa Maria Nuova to the north. But we must also recognize that Lorenzo's connections to the hospital extended beyond this association: by 1406, the Confraternity of St. Luke (to which Lorenzo belonged) met in a Chapel dedicated to the company's patron saint that was also located inside Santa Maria Nuova (see Gaye, 1840, 34 and 41). The artist's ties to the hospital were quite strong and came from at least three important activities – one artistic, another professional, and a third privately devotional.

11. Arthur, 1988, 521; and A.S.F., Compagnie Religiose Soppresse, 910, vol. 6 (Compagnia di Gesu Pellegrino in S. Maria Novella, Vol. 6), fol. 73v. "MCCCXLII ... Rademmo a di xviiii di Gennaio Andrea di Cione dipintore per molti defetti e falli che fece e di non volere ubidire."

12. For a narrative account of this movement, see Bornstein, 1993.

13. Henderson, 1986, 71.

14. For a history of the Misericordia's origins, see Saalman, 1969, 4–19; and Earenfight, 1999, 50–53.

15. Earenfight, 1999, 203.

16. Passerini, 1853, 483–84.

17. A.S.F., *Bigallo* 3, 2 (1395–1400), fols. 93, 96v, 100v, 105v, and 129; A.S.F., *Bigallo* 1668 (1436–1584), fol. 3; Poggi, 1904, 201, 237–38; and Eisenberg, 1989, 210.

18. Eisenberg, 1998, 31–66, esp. 58n11, where the dimensions of the now-dispersed panels are recorded.

19. A.S.F. *Comp. Rel. Sopp.* 2170, Z 1–4, fol. 20.

20. Bailey, 2001, 19–29.

21. See A.S.F. *Comp. Rel. Sopp.* 2170, Z 1–4, fol. 20. "In prima, uno gonfalone con figure dipinto dal'uno lato la nostra donna che anunziata et dal'altro la Maestà."

22. A.S.F., *Comp. Rel. Sopp.* 2170, Z1–4, fols. 20–21.

23. A.S.F., *Comp. Rel. Sopp.* 903, G, fols. 2–2v.

24. A.S.F., *Comp. Rel. Sopp.* 903, G, fol. 3.

25. Arthur, 1990, 337–40.

26. Arthur, 1990, 340.

27. Biblioteca Nazionale, Firenze, II, I, 138 (*Libro di varie notizie e memorie della Venerabil Compagnia di Santa Maria alla Croce al Tempio*), 3.

28. Cappelli, 1927, 25. Although Cappelli prefers to identify this important street tabernacle as the one on Via dei Malcontenti, he also notes that the image venerated by the founders of the Company may have instead been located on the Via di San Francesco de'Macci.

29. Scudieri, 1993, 82. The triptych may have featured in its center a panel with the image of the *Annuciation of the Virgin*, currently in the collection of the Museo Bandini, Fiesole. Two other panels have been connected to this ensemble: *Saint Anthony Abbot* (Munich, collection of Alexander Rudigier) and *Saint Julian* (Metropolitan Museum of Art). Skaug, 1994, I, 93; and Tartuferi, 2008, 21, 120–23.

30. For the famous description of the ritualistic use of images by members of the Neri, see Freedberg, 1989, 5–9.

31. The painting is in the collection of the Museo Poldi Pezzoli in Milan. Boskovits (1991, 382) has dated the picture to the early 1340s and has suggested it was one of the earliest pictures owned and used by the Neri. See also Di Lorenzo, 2005, 11–30; and Di Lorenzo, 2013, 182–84.

32. Di Lorenzo, 2005, 15–16.

33. Di Lorenzo, 2005, 16. The appearance of the two Dominican saints has not been explained satisfactorily. Whereas Peter of Verona had a clear connection to the city of Florence, the civic interest in Thomas Aquinas seems to have been limited to the Dominican church of Santa Maria Novella. Although he prefers to situate the crucifix in the church of Santa Maria alla Croce al Tempio, Di Lorenzo (2005, 19–21) also provides a variety of alternative patrons for the cross.

34. Boskovits, 1991, 382; Richa, 1755, 132.

35. The combination of the Coronation in the main compartment and the scenes from Stephen's life in the predella surely represents a compromise between the two confraternities: members of Santa Maria del Desco got to see an image of the Virgin in the center of the picture, while those in Santo Stefano could focus on the works and miracles of their patron saint in the same altarpiece. We should not be surprised that two of the three predella pictures at the picture's base revolve around themes of death and burial, for confraternity members were commonly guaranteed proper (and even elaborate) burials as a perquisite of their participation.

36. Tacconi, 2005, 107–10. Folios 7r and 7v of the cathedral's *Mores et consuetudines* describe this processional route in some detail; see Tacconi, 2005, 107.

37. Ciatti, 2003, 21; and Boskovits, 1993, 700–703.

38. Davidsohn, 1908, 440; and Henderson, 1994, 444. Judging by the stylistic features of the earlier of the two wooden *tavolette*, a fair claim may be made for that company was active at least by the late 1290s, and probably much earlier than that.

39. Arthur, 1990, 337–38; and Marcucci, 1965, 114–15.

40. Arthur (1990, 339) has demonstrated that Gerini's *Vir Dolorum* was seen in conjunction with a now-lost altarpiece of the *Madonna and Child with Saints* (commissioned in 1346) and linen banners, installed no later than 1351, which protected it during non-feast days.

41. A document from the confraternity's registry, dated January 19, 1343, states: "Rademmo a di xviiii di Gennaio Andrea di Cione dipintore per molti defetti e falli che fece e di non volere ubidire." A.S.F., *Comp. Rel. Sopp.*, 910, vol. 6 (Compagnia di Gesù Pellegrino in S. Maria Novella, Vol. 6), fol. 73v.

42. For the banners used by the company of San Giovanni Decollato, see Aldrovandi et al., 2000, 14–17. For a description of those for the Company of San Zanobi, see Weissman, 1982, 84. For the restoration of a group of paintings on cloth that were probably used as processional banners, see Villers, 2000, 1–5. The four pictures fetched £950,000 when sold at auction by Sotheby's London in 2012.

43. Alternately, one could make the opposite argument – that viewers looked down on the

skewed perspective – so harsh is the splaying of space both above and below.

44. Zervas, 2003, 33–64.

45. See Poggi et al., 1904, 198.

46. For a chronology of the building's construction phases, see Saalman, 1969, 10.

47. Levin, 2004, 15, 49–50.

48. See Kreytenberg, 1976, 397–403; and Procacci, 1973, 312–14, 316.

49. For an excellent review of the competition between Orsanmichele and the Misericordia, see Earenfight, 2009, 15–32.

50. See Kreytenberg, 1976, 397–403; and Levin, 2004, 251–53.

51. The commission appears to have been (or to have become) intensely personal for Nardo di Cione: when he died in 1365, his survivors were directed to bequeath to the Company of the Misericordia a sum of thirty florins – no small amount at the time, especially for a painter. Either Nardo was a member of the confraternity near the end of his life, which would explain why he was hired to produce the fresco in the loggia in 1363, or he was so moved by the mission of the membership that he felt compelled to reward the Misericordia with his generous donation. See Milanesi, 1893, 58, no. 2.

52. For various interpretations of the *Allegory of Mercy*, see Offner, 1958, 159–63; Levin, 2004, 43ff.; and Earenfight, 1999, 138–233.

53. The inscription reads: OMNIS MISERICORDIA FACIAT LOCUM UNICUIQUE SECUNDUM MERITUM OPERUM SUORUM ET SECUNDUM INTELLECTUM PEREGRINATIONIS ILLIUS. ANNO MCCCXLII DIE II MENSIS SEPTEMBRIS.

54. Levin, 2004, 49.

55. Levin, 2004, 43.

56. Among them, in the position of honor to the immediate left of Mercy, kneels a man dressed entirely in red: this figure may represent the leader of the confraternity's decorative project committee, as Philip Earenfight has suggested. Ellen Schiferl has correctly argued that most acts of corporate patronage were led by individuals who commanded special deference in both archival records and in the images they helped commission. It must be noted, however, that donor portraits in monumental Florentine art are quite rare, and few appear on altarpieces painted during the fourteenth century. The figure may just as easily be a symbolic reference to the officers of the confraternity who held

office for only a few months' time before stepping down in favor of a new leader: the man in red may well honor an office rather than a specific officer. Earenfight, 1999, 186; and Schiferl, 1991, 121–22.

57. Earenfight, 1999, 176. Earenfight also notes the importance of this civic portrait as the pictorial ancestor of the circular representation of the city in the Florentine Guild of Judges and Notaries, described in Chapter 3 of this study.

58. One is tempted to consider these representations of men and women as references to actual members of the confraternity; but, alas, no signifiers in the image unequivocally support this identification.

59. An eighteenth-century inscription, created when the fresco was removed from its original location on the facade of the Bigallo and paired with the painting in its new setting inside the loggia, states: "Florentini orphanotrophii monumentum | externae aedis huiusce parieti | graphice a veteribus consignatum | huc in nuperrima eiusmet restauratione | arte translatum anno MDCCLXXVII | Petro Leopoldo I archid." Poggi et al, 1904, 208.

60. An entry in the records for the Confraternity of the Misericordia states: "MCCCLXXXVI v di Luglio. Giovanni Federighi, Nuto di Francesco, Giusto di Coverello, Soldo di Lippo Soldani, Francesco di Lutozzo, e Iacopo del Riccio fabro, Capitani della Misericordia … a Niccolò di Piero e Ambrogio di Baldese dipintori, a dì XXII giugno, per resto del lavorio della dipintura della faccia dinanzi della casa della Misericordia, come apare al dicto quaderno, fiorini diciassette doro." Archivio di Stato, Firenze, *Bigallo*, Filza II, fasc. 3, 27. See Passerini, 1853, 457.

61. Bloch, 2009, 35, 37. After 1300, baptisms could be held in S. Giovanni on a daily basis. The primary locus of the celebration was the south door, which was referred to during the fourteenth century as the "porta baptismale" (37n56).

62. Bloch, 2011, 134–37. Bloch notes that documents do not require the presence of mothers at baptismal ceremonies, but acknowledges that there was nothing to prevent them from attending. It is impossible to say with certainty whether both parents stood together inside the Baptistery during the ritual.

63. This type of image, which normally featured Mary seated on a pillow and often nursing the

Christ child, seems to have been introduced by Simone Martini in a lunette fresco painted in the Papal palace of Avignon before the first appearance of the Black Death. Its popularity increased rapidly during the second half of the century, and the earliest known Florentine example decorated an altar in Santa Maria Novella that was dedicated the Virgin of Humility in 1361. See Meiss, 1951, 144; Williamson, 2009, 20–24, 53–54; and Schmidt, 2014, 52.

64. For the sculpted relief of the Madonna of Humility for the Duomo, see A.S.F., *Comp. Rel. Sopp.*, 2170, Z 1–4, fol. 22. The altarpiece by Mariotto di Nardo is described in company records as a Madonna "cum Christo Jesu Domino Nostro in bracchiis." See Passerini, 1853, 112.

65. See G. E. Burci and A. Mazzanti, *Catalogo dei quadri ed altri oggetti d'arte esistenti nella galleria del R. Archispedale di Santa Maria Nuova di Firenze*, reprinted in Diana, 2005, 313–51.

66. For a variety of differing views on the scriptorium at Santa Maria degli Angeli, see Levi D'Ancona, 1959, 3–37; Freuler, 1997; Kanter, 1994, 220; and Bent, 1992, 507–23.

67. Boskovits and Parenti, 2010, 153–55.

68. For an examination of the practice of wet-nursing, see Klapisch-Zuber, 1985, 132–64.

69. As no archival records of this commission have survived, the names of the patrons and artist are not known to us, although twentieth-century scholarly attributions have pointed toward a member of Santa Maria degli Angeli named Don Silvestro dei Gherarducci, who has been touted as a monastic painter by some. See Levi D'Ancona, 1959, 3–37. See also Bent, 1992, 507–23, who rejected both the attribution to Don Silvestro and the argument that monks in Santa Maria degli Angeli had the proper training (let alone adequate workshop facilities) needed to produce such intricate works of art. Indeed, the very reason for Don Lorenzo Monaco's departure from the cloister in 1396 appears to have been the lack of artistic opportunities for him in that setting.

70. The panel has also been attributed to Jacopo's older brother, Andrea di Cione, and dated to the years 1363–1365. Kreytenberg, 2000, 164–66.

71. Meiss, 1954, 302–17.

72. Williamson, 2000, 48–54.

CHAPTER 3

1. For a recent interpretation of the picture and the literature dedicated to it, see Camelliti, 2013, 120. One hypothesis places the fresco in the Magdalene Chapel of the Palazzo del Podestà, where prisoners spent their last hours before processing to the executioner's ground outside the city walls. Another places it on the ground floor of the palace, where all visitors would have seen it. A third places the fresco near one of the gates of the city walls, the Porta della Scala.

2. For a comprehensive review of the *pittura infamante* in Trecento Italy, see Ortalli, 1979; Edgerton, 1985, 74–90; and Freedberg, 1989, 248–57.

3. Edgerton, 1985, 77.

4. Edgerton, 1985, 85; and Freedberg, 1989, 256–57.

5. Edgerton, 1985, 88.

6. Freedberg, 1989, 248–49; and Ortalli, 1979, 61n82.

7. Edgerton, 1985, 76.

8. Vasari, 1832–1838, 176 [Life of Giottino]: "L'anno 1343 a dì 2 di luglio, quando dal popolo fu cacciato il Duca d'Atene e che egli ebbe con giuramento renunziata e renduta la signoria e la libertà ai Fiorentini, fu forzato dai dodici Riformatori dello Stato e particolarmente dai preghi di messer Agnolo Acciaiuoli, allora grandissimo cittadino che molto poteva disporre di lui, dipingere per dispregio nella torre del Palagio del Podestà il detto Duca et i suoi seguaci." Giottino's holdout may have worked to his advantage, as the fee paid by the commune to the artist of this fresco to paint the damning image of Walter and his allies came in at twenty gold florins, a very high price indeed. See Edgerton, 1985, 80.

9. Freedberg, 1989, 249; see also Ortalli, 1979, 87–88.

10. Lorenzo Ghiberti, *I commentarii*, II, 1, 3.

11. Vasari, 1832, I, 400 [Giotto]: "Nella sala grande del palazzo del Podestà dipinse il Comune rubato da molti: dove, in forma di giudice con lo scettro in mano lo figurò a sedere: e sopra la testa gli pose le bilancie pari, per le giuste ragioni ministrate da esso; aiutato da Quattro virtu." Edgerton, 1985, 51.

12. The earliest attribution of these frescoes to the hand of Giotto appears in Ghiberti, II, 1, 3. For a modern interpretation of the chapel and its dating, see Elliott, 1998, 509–19.

13. For a compelling argument centering on the importance of Mary Magdalene for the condemned, see Terry-Fritsch, 2010, 45–62.

14. See Raimond van Marle, III, 1924, 6; Davidsohn, 1901, 783; and Wieruszowski, 1944, 20n3.

15. See Freedberg, 1989, 253.

16. At the time of its removal in 1432, the picture was attributed to Bernardo Daddi and, perhaps due to an inscription, dated to 1335. The *Inventario delle Masserize del Palazzo della Signoria di Firenze, 1432* states, "Feciono nettare e ripulire la tavola … dell'altare di San Bernardo … la quale trovano fu dipinta nel 1335 per maestro Bernardo dipintore." It should be noted that the timing of its removal from the palace corresponds to the earliest record of the Accademia's *Vision of Saint Bernard*, which was transferred to the Badia in 1434 from a small and struggling monastery called Santa Maria delle Campora, located just outside the Florentine Porta Romana. There is a possibility that the Accademia's picture was the altarpiece originally installed in the Chapel of Saint Bernard in the Palazzo della Signoria, moved to Santa Maria delle Campora briefly, and then moved again to the Badia. Palmeri, 2003, 180.

17. Rubenstein, 1995, 51.

18. Rubenstein, 1995, 50.

19. Hankey, 1959, 363–65; and Rubenstein, 1995, 51–52.

20. Hankey, 1959, 364. The inscription accompanying the painting of Brutus, for example, stated:

> Lucretie vindex sapiens non brutus ut ante
> Regibus expulsis in libertate quirites
> Asserui. pro qua virgis iustaque secure
> Percussi natos, hostemque cadendo peremi.

21. For an account of the crisis of 1342–1343 and the reign of Walter of Brienne, see Najemy, 2006, 135–38.

22. For excellent accounts of the alterations to the composition of the Florentine Signoria, see Becker, 1967, 205–33; Brucker, 1962, 116–31; and Najemy, 1982, 126–65.

23. Belting, 1985, 157; and Crum and Wilkins, 1991, 138.

24. Edgerton, 1985, 83–84; and Crum and Wilkins, 1991, 138.

25. See Vasari, 1832, 176 [Life of Giottino]: "Intorno alla testa del duca erano molti animali rapaci e d'altre sorti, significanti la natura e qualità di lui; ed uno di que' suoi consiglieri aveva in mano il Palagio de' Priori della città,

e come disleale e traditore della patria glie lo porgeva: e tutti avevano sotto l'arme e l'insegne delle famiglie loro, ed alcune scritte, che oggi si possono malamente leggere per essere consumate dal tempo."

26. Edgerton, 1985, 78–85; and Freedberg, 1989, 255.

27. Crum and Wilkins, 1991, 140. The inscription was recorded by Filippo Baldinucci two hundred years ago, before its destruction.

28. Edgerton, 1985, 85. See also Villani, 1991, XIII, xxxiv: "E fecionlo per suo dispetto e onta dipignere nel palagio del podestà a lato alla torre con messer Cerrettieri Visdomini, e con messer Meliadus d'Ascoli, e col suo conservadore messer Guglielmo d'Asciesi e il figliuolo, e messer Rinieri di Giotto da Sangimignano col suo fratello stati traditori, e sue aguzzette e consiglieri a mal fare, a memoria e esempio de'cittadini e de'forestieri che gli vedessono. A cui piacque, ma i più de'savi la biasimarono; perocchè fu memoria di difetto e vergogna del nostro comune, ch'l facemmo nostro signore."

29. Kreytenberg, 2000, 34–38 and note 54. While most specialists agree that the *Expulsion* represents some form of Pittura imfammata/Pittura damnata, few can agree on the authorship of this highly unique fresco. Andrea di Cione's name has most recently been attached to the image, but Taddeo Gaddi, Maso di Banco, Bernardo Daddi, and even Cennino Cennini have been connected to the picture originally installed inside the Stinche.

30. Villani, 1991, XIII, xxxiv: "A cui piacque [the fresco], ma i più de' savi la biasimarono; perocchè fu memoria di difetto e vergogna del nostro comune, che 'l facemmo nostro signore."

31. Fraticelli, 1834, 10–11; and Geltner, 2008a, 18.

32. See Geltner, 2008a, 18.

33. See Edgerton, 1985, 76.

34. Debt was the most common offense among prisoners in the Stinche (see Geltner, 2008a, 50–51), which speaks volumes about the emphasis Florentines placed on the concept of economic responsibility as a civic virtue. Even still, roughly 80 percent of the sentences meted out to prisoners lasted fewer than twelve months (see Geltner, 2008a, 74–75).

35. Fraticelli, 1834, 27. "Nello stesso cortiletto esisteva un Tabernacolo, con una dipintura, che si dice essere della scuola di Giotto, rappresentante S. Reparata in atto di benedire le insigne della Milizie della Repubblica fiorentina, che vanno ad espugnare vari paesi."

36. Fraticelli, 1834, 27n1. Fraticelli had heard that the painting may have been produced by the elusive Cennino di Cennini. "Non ho potuto esaminare da per me questa Pittura, essendo presentemente coperta da delle tavole, onde preservla dal soffrir detriment in occasione della demolizione di quest'edifizio; e perciò ho questo dovuto riportare quella descrizione, la quale mi è stata favorita. Nel momento peraltro che pongo sotto il torchio questo libretto, giunge a mia notizia, che una persona di tali materie intelligente, avendo già veduto la suddetta pittura, sospetta che possa essere di quel Cennino Cennini."

37. For a rich review of the criminal justice system in early modern Florence, see Wolfgang, 1956, 311–30.

38. Geltner, 2008b, 13.

39. Today, the offices of the old Zecca are occupied by the Gabinetto Fotografico of the Soprintendenza Speciale per il Polo Museale Fiorentino, just across the alley from the main entrance of the Uffizi Galleries.

40. The actual minting of coins took place along the banks of the Arno River, to the east, beyond the site of Santa Croce.

41. Spilner, 1987, 452–53, note 104.

42. A.S.F., *Zecca* 58, fol. 45 (October 30, 1372): "Simoni filio [blank] Niccholaio filio [blank] pictoribus civibus Fiorentinis pro eorum salario et labore picture unius tabule in qua pingere debent imaginem gloriose Virginis Marie matris Christi et etiam imagines quorundam aliorum sanctorum dei cum certis modis et condicionibus secundum pacta et conventiones factas inter dictos dominos offitiales dicte monete et dictos Simonem et Niccholaum pictures, que tabula esse et stare debet … in domibus dicti offitii monete in eo loco ubi placuerit dominis et offitialibus dicte monete pro tempore existentibus in summa lb. 134 fp." Siren, 1908, 101–2; and Offner, 1965, 89.

43. A.S.F., *Zecca* 59, fol. 43v (October 31, 1373): "Iacobo Cini, pictorii, pro eius pretio et labore pro complemento picture tabule gloriose Virginis Marie matris Christi et aliorum sanctorum Dei que tabula posita est in domibus dicti offitii Zecche Communis Florentie Flor auri quadraginta reductos ad monetam valent lib. centum triginta otto fp. ultra summam et quantitatem pecunie libr. centum triginta quactor olim stantiatam et solutam Simoni et Niccholaio, pictoribus civibus Florentinis, pro parte

solutionis picture dicte tabule." Gaye, 1840, 432; Siren, 1908, 102; and Offner, 1965, 90.

44. A.S.F., *Zecca* 59, fol. 39v. (October 15, 1373): "Iohanni Ambrosii, magistro lapidum, pro eius salario et labore pro eo quod laboravit fecit et altavit tres becchatellos in muro domus dicti offitii Zecche prope turrim dicti offitii pro sustinendo et ponendo super eis tabulam gloriose Virginis Marie matris Christi et aliorum sanctorum dei, in quibus becchatellis sculta intagliata et figurate sunt arma communis Florentie et artis Kalismale et Cambii in Summa lb. xxvi fp." Siren, 1908, 102.

45. A.S.F., *Zecca* 59, fols. 44v and 46v. These important references were first noted in Labriola, 2003b, 132.

46. Labriola, 2003b, 128; and Monnas, 1990, 45, 49, 55, and 58.

47. These inscriptions glorify the incarnation of Christ, as Isaiah's text features his celebrated verse predicting the Messiah's virgin birth. Isaiah holds a scroll that reads, "YSAIAH. ECCE VIRGO CHONCIPIET EPARIET PARI EFILIUM" (7:14), an appropriate statement reminding viewers of Mary's key role in the miraculous birth of Jesus. Ezekiel's inscription, "EZECKIEL. PETE TIBI A DOMINO DEO TUO IN PROFV … SIGU … DU …" (Isaiah 7:11. "Ask thee a sign of Jehovah thy God") further underscores the importance of Christ's virgin birth.

48. For the status of these saints as communal patrons, see Labriola, 2003b, 127. By 1375, the nave walls of the cathedral had been completed and the final portions of the church it surrounded, Santa Reparata, were being demolished. The project to remove the last sections of the early Christian basilica that remained inside the nave of the new cathedral was initiated in 1379. Toker, 1975, 161–90; and Verdon, 2001, 138.

49. Offner, 1965, 88n3.

50. Codell, 1988, 583–613. Codell argues that the appearance of architectural forms in this cycle identified John the Evangelist as a protector of the city, and therefore pronounced him a civic saint. More recently, Paula Spilner has persuasively proposed (in an unpublished paper delivered in 1996 at the Italian Art Symposium in Athens, Georgia) that the so-called San Pancrazio Altarpiece was originally commissioned to decorate the high altar for the Florentine Cathedral. If this was so, then the appearance of the Evangelist to the Virgin's immediate right,

just opposite the image of the Baptist on her left, confirms that this Saint John was given a highly visible position in arguably the most important (and most frequently seen) liturgical picture in Florence. It should also be noted that Saints Zenobius and Reparata also appear as flanking saints in this polyptych, the former at the far left and the latter at the far right of the composition. For mention of Professor Spilner's findings, see Bergstein, 1991, 690n39; Padoa Rizzo, 1993, 213–14; and Lavin, 2001, 674 and note 9.

51. Neither Matthew, Catherine, nor Anthony have been identified as patrons of the city by modern historians, yet it must be noted that all three were honored inside the Florentine cathedral as it was being built around the exterior of the original seventh-century basilica (formerly dedicated to Santa Reparata). Matthew was commemorated in a chapel bearing his name that had been constructed in the Duomo in 1365. Offner, 1965, 88n3. By 1372, the Duomo contained at least three pictures of Saint Catherine, which suggests a cult following there. Offner, 1947, 93–96; and Offner, 1968, 108. Interest in Anthony Abbot grew in the fourteenth century, and on January 12, 1383, the Parte Guelfa – the only officially sanctioned political party in the city – celebrated a festival in his honor and soon thereafter rededicated their chapel space in the Duomo to both Saint Victor and Saint Anthony. Bicchi and Ciandella, 1999, 7; and Leoncini and Bicchi, 2001, 306.

52. Offner, 1965, 88n6. This format had been used by Jacopo di Cione in the past: In his *Coronation of the Virgin* for the nuns of San Pier Maggiore, he had painted in the hands of Saint Peter a replica of the Church in which his altarpiece was installed, thus connecting the namesake of the nunnery to the celestial court painted for the high altar of the church, and invoking the saint's protection of that space in perpetuity. In the Zecca panel, though, the image of the church facing the Baptistery was no longer recognizable to contemporary viewers, as the facade of Santa Reparata had been replaced by the new one of Santa Maria del Fiore decades earlier.

53. See Crum and Wilkins, 1991, 143.

54. Each florin was worth roughly four silver *lire* in this period, and each lire was usually the equivalent of twenty silver *soldi*. These *soldi* were represented by a number of coins, including the *grosso* (worth five *soldi*), *quattrino* (four *soldi*), and *denaro* (one *soldo*).

55. For an examination of monetary units used in Florence during the mid-Trecento, see Cipolla, 1982, 20–29. While the Mint's board comprised leaders from the city's major guilds, which surely desired a strong gold standard, official monetary policy could not be brokered completely by the *popolo grosso*. Dramatic shifts in exchange rates or noticeable alterations in the value of silver and gold could not be kept secret, since wage earners were particularly interested in the value of silver (their currency of common use) and paid attention to the valuation of their *lire* in relation to gold. Exchange rates of different currencies, including those of both Florentine gold and silver, were posted daily outside the Mint. Unacceptable policies could result in popular unrest, as happened in Bologna in 1352, in Bergamo in 1371, and even in Florence periodically between 1351 and 1365. Workers in the Zecca went so far as to go on strike in 1351 to protest the reduced value of their wages (Cipolla, 1982, 56). It behooved the directors of the Mint to respect the needs of laborers who depended on the buying power of silver *soldi*, as an angry populace could destroy the city's stability.

56. Cipolla, 1982, 66–68.

57. Cipolla, 1982, 68.

58. Cipolla, 1982, 67–73.

59. Cipolla, 1982, 68–74.

60. Cipolla, 1982, 71–73.

61. Cipolla, 1982, 75. Some estimates suggest that as many as 40 million new coins were minted during this thirty-nine-month period.

62. As with the *stemmi* at the picture's base, figures have been paired on opposite sides of the panel. The prophets above, the enthroned figures in the center, and the two Johns standing at either edge of the panel begin this pairing. Victor and Zenobius, two ecclesiastical officials, are matched together in the center, as are Matthew and Barnabas, the latter of whom was considered to be one of Christ's apostles. Catherine and Reparata, kneeling at either end of this saintly line, serve as crowned bookends to the composition. Only Saints Anne and Anthony Abbot seem to be oddly paired.

63. Silver coins also bore the imprint of the lily, but in this context, with the lily painted gold

by Jacopo di Cione, the reference is clearly to the florin.

64. For a discussion of the coats of arms at the base of the Zecca picture, see Offner, 1965, 90–93; and Labriola, 2003b, 128.

65. That the Alberti and Davanzati family arms appear here suggests that the shields affixed to the picture were added late in the project, as these directors only attained their position in September 1373, a few weeks before the *Coronation* was installed.

66. Those *stemmi* appearing beneath the columns of the frame at the very outside edges of this strip were only added in the nineteenth century and are therefore beyond the scope of this discussion. See Labriola, 2003b, 128, 132.

67. Marcucci, 1965, 99; and Offner, 1965, 90, who states, "The old ground on which the shields were painted has been freed from the repaints. The coats-of-arms were originally painted on dark ground and given a narrow silver border. Above and below, the dark areas are edged with silver stripes."

68. Cennini's commentary on working with gold (and, on occasion, silver) appears in chapters CXXXIV–CLXII. See Cennini (2003, 156–65) for the painter's detailed advice on how to apply gold to panel paintings.

69. In 1987 Giorgio Bonsanti briefly noted that the richly decorative nature of the image indicated that the *Zecca Coronation* was intended to celebrate the power of the Florentine florin, the preferred monetary unit of international trade. "Il quadro risulta così, nella preziosità dei suoi ornate e nella profusione dell'oro, un inno di fiducia nella Zecca della città; potremmo chiamarlo un peana al fiorino, la famosa moneta di Firenze che aveva corso nel mondo." Bonsanti, 1987, 61–62.

70. As had been the case with Simone and Niccholaus, Jacopo di Cione did not receive for his efforts the forty gold florins promised to him in the contract he signed in 1372. Rather, the entry for October 31, 1373, indicates that Jacopo instead accepted the silver equivalent: "Flor. auri quadraginta reductos ad monetam valent lib. centum triginta otto" – or, "40 florins, reduced to the value of 138 lire." Surely the Directors knew that the latter was more valuable than the former and that parting with silver denari would be a wiser financial move than spending their gold florins, which they knew were bound to appreciate in value. Lest we think, however, that our painters were somehow duped by their patrons, we must remember that this method of payment may well have been preferred by our artists at that stage in their careers. Silver could be used to pay off small debts and wages to assistants, suppliers, and other creditors while the larger denominations could only be used for larger purchases or significant investments.

CHAPTER 4

1. A.S.F., *Arte di Por San Maria*, 32, XVIIII: "In quo sint ad minus ipsius Virginis ymago picta eiusdem filium tenentis in bracchis, et alii duo sancti quos voluerint consules." The consuls presiding over the guild seem to have been granted authority to select appropriate figures. Surely one of them must have been Saint John the Evangelist, the patron saint of the Arte della Seta. Slepian, 1987, 166.

2. Slepian, 1987, 158–59.

3. Carocci, 1884, 142; and Slepian, 1987, 162–63.

4. Scudieri, 2011, 16.

5. Scudieri, 2011, 16. A.S.F., *Arte dei Rigattieri, Linaioli, e Sarti*, 20, fol. 98v.

6. Scudieri, 2011, 17.

7. Staley, 1906, 404.

8. Staley, 1906, 354.

9. Staley, 1906, 310.

10. For a brief review of restrictions placed on various guilds, see Wolfgang, 1956, 327–30.

11. Villani, 1991, X, cclvii; and Slepian, 1987, 60.

12. Saalman, 1969, 3–4.

13. Lorenzo Monaco was hired in this capacity by the Company of Orsanmichele in 1412. Zervas, 1991a, 754.

14. Ladis, 1980, 230.

15. Wool and silk were often used together when producing tapestries during the fourteenth and fifteenth centuries. The use of silk as a fabric bearing distinctions of dignity and social prominence was a time-honored tradition, but in fact the city of Florence lagged behind other European centers in its production until the middle of the fifteenth century. Before then, wool was textile of prominence in the city. Monnas, 2008, 6; and Burke et al., 2013, 78–103.

16. The destruction of the old city was most poignantly lamented by Guido Carocci, who almost single-handedly worked to preserve the memory of what had been lost during the cleansing of the medieval center. Fittingly, his

most pointed homage to Old Florence was titled *Firenze Scomparsa* (Florence erased; Florence, 1897).

17. The rest of the city seemed to agree with them. As members of one of the seven major guilds, these lawyers and magistrates and record keepers regularly placed their leaders in positions of political prominence, for the governmental system put in place by the Ordinances of Justice in 1293 reserved spaces for them whenever elections for the priorate were held.

18. A basement underneath this *piano terreno* still survives and was apparently decorated in 1366 with frescoes painted by the young Jacopo di Cione, still an apprentice in the workshop of his older brother, Andrea. Borsook, 1982, 86–88.

19. A.S.F., *Giudici e Notai*, 28, fol. 7r; Slepian, 1987, 18; and Borsook, 1982, 87 (Appendix, Doc. I).

20. A.S.F., *Giudici e Notai*, 748, fols. 24v and 26r; and Borsook, 1982, 88 (Appendix, Doc. V).

21. A.S.F., *Giudici e Notai*, 91, fol. 9r; and Borsook, 1982, 87 (Appendix, Doc. III).

22. A.S.F., *Giudici e Notai*, 101, fol. 180; Slepian, 1987, 20, 26; and Borsook, 1982, 86. Payments in 1406 were directed to Ambrogio di Baldese, to whom the figure of Coluccio Salutati in the southeastern lunette must be attributed.

23. Staley, 1906, 155–56; and Hoshino, 1983, 184–204.

24. Staley, 1906, 152.

25. Brucker, 1971, 235–36; and Najemy, 2006, 157–58.

26. A.S.F., *Arte della Lana* 4, fol. 6.

27. Villani, 1991, XI, clxxxiii. "E poi a dì XVI di luglio vegnente s'apprese nel palazzo dell'arte della lana d'Orto San Michele, e arse tutto da la prima volta in su, e morivi uno pregione, che 'l vi mise credendo scampare, e la sua guardia; poi per l'arte della lana si rifece più nobile e tutto in volte infino al tetto." Spagnesi, 1992, 5–6.

28. Spagnesi, 1992, 5–6.

29. On occasion, those *sottoposti* whose practices threatened the status quo were permitted to participate in proceedings here.

30. Villani, 1991, XI, clxxxiii.

31. "O dulcissima semper Virgo Maria, in te angeli recipiunt laetitiam, inveniunt justi gratiam, peccatores in eternum veniam consecuntur. In gremio matris residet sapientia Patris." Slepian, 1987, 82.

32. Slepian, 1987, 82n71; and Morpurgo, 1933, 163, who connects this image to an historiated initial in the guild's statute book from 1333. See also A.S.F., *Lana*, Statuti, no. 4. For the texts of laude hymns sung before images of the Virgin, see Bailey, 2001, 19–29.

33. Despite a heavily damaged surface that prevents a clear reading, those surviving and legible portions of *The Madonna della Lana* reveal enough information to encourage some stylistic analysis. Clearly, the anonymous artist responsible for its production used a composition that borrowed heavily on both Duccio's *Rucellai Madonna* and the BETA *Madonna of Orsanmichele* of ca. 1305–1310, the latter picture being the more important of the two. The painting in the Palazzo della Lana ought to be dated ca. 1310.

34. Bellosi, 1977, 152–56; and Slepian, 1987, 82.

35. Villani, 1991, XI, clxxxiii: the new vaults in the audience hall were "più nobile e tutto in volte infino al tetto."

36. Spagnesi, 1992, 5–8, who argues for a dating of the vaults to ca. 1335–1345 but does not attach a date to the *Madonna della Lana*. Slepian (1987, 62) dates this to the period 1315–1318.

37. Slepian, 1987, 82–83.

38. Although dressed in fine garments, these figures wear long gowns with tight-fitting sleeves: the prevailing style of the decade of the 1340s (and beyond) featured short tunics, multiple buttons, and loose sleeves that could be tucked inside for flexible uses. These male figures, by virtue of their style of dress (which includes none of these items), have been depicted as conservative, perhaps older, members of Florentine society. For a discussion of style and wool garments produced during the fourteenth century, see Stuard, 2006, 24–26.

39. The few surviving archival references from the fourteenth century that pertain to guildhall decorations in Florence reveal that elected officials were entrusted with the job of consulting with artists about subject matter, negotiating prices, and making the final decision whether to proceed with projects. In 1358 consuls of the Guild of Judges and Notaries initiated the first decorative program in their headquarters on the aptly named Via Proconsoli: "Item quod presens camerarius dicte Artis posit eique liceat dare et solvere et expendere ad mandatum et deliberationem dicti domini preconsulis pro faciendo depingi figuram

Virginis gloriose in ea parte domus artis de qua sibi vedebitur." A.S.F., *Giudici e Notai*, no. 28, fol. 7, in Borsook, 1982, 87, Doc. I. The agreement with Andrea di Cione to paint a triptych of *Saint Matthew* for the pilaster in Orsanmichele maintained by the Bankers' Guild was crafted in 1367 by the consuls of the Arte del Cambio: "Andreas vocatus Argagnus sive Arcagniolus, quondam Cionis pictor de Florentia convenne con i Consoli dell'Arte del Cambio il di' 15 Settembre 1367 di dipignere la tavola di San Matteo per mettere in un pilastro d'Orto San Michele con 2 alie a lato per dipignervi 2 santi per alia o piu' come convennono, per fior. 40." Florence, Biblioteca Nazionale, Cod. Magl.-Stroz. II, IV, 378, fol. 436, in Siren, 1908, 99.

40. Vasari, 1832, 400. "Nella sala grande del palazzo del Podestà dipinse il Comune rubato da molti: dove, in forma di giudice con lo scettro in mano lo figurò a sedere: e sopra la testa gli pose le bilancie pari, per le giuste ragioni ministrate da esso; aiutato da Quattro virtu."

41. Orcagna's earliest appearance in the archives forms a small portion of a list of faults recorded in the proceedings of the Compagnia di Gesù Pellegrino in 1343. A.S.F., *Compagnie religiose soppresse* 910, 6, fol. 73v; and Offner, 1969, 7.

42. Archivio di Stato, Pistoia. *Patrimonio Ecclesiastico, Libri di Entrata ed uscita dell'Opera di S. Giovanni Fuorcivitas*, 1320–1376, No. C, 449, fol. 1; and Offner, 1969, 7. Of the six painters listed in this document, three came from the same workshop: along with Andrea di Cione and his brother, Nardo di Cione, a painter named Francesco was identified as a being member of this *bottega*. For an updated compilation of documents pertaining to both Andrea and Nardo di Cione, see Kreytenberg, 2000, 183–202.

43. For a recent reconstruction of Andrea di Cione's early career, see Kreytenberg, 2000, 32–61.

44. Similarities may also be found in the repetition of curved drapery folds extending down the sleeve of Gabriel's cloak in the *Annunciation* of 1346 and the knees of Brutus.

45. Bent, 2006, 231–44.

46. Rodolico, 1968, 20–27; and Najemy, 2006, 179–80.

47. Marchionne di Coppo Stefani, 1903, 202–3; Najemy, 2006, 179–80; and Brucker, 1971, 52.

48. Brucker, 1962, 110.

49. Becker, 1967, 170–71.

50. Villani, 1991, XIII, xxxii. "E poi a dì VIII d'agosto la notte s'aprese il fuoco nel popolo di San Martino presso ad Orto San Michele in botteghe di lanaiuoli, accendendosi in alcuno panno riscaldato per l'untume e soperchio caldo, onde arsono XVIII tra case e botteghe e fondaci di lanaiuoli con grandissimo danno d'arsione di panni e lane e altri arnesi e masserizie, sanza il danno delle case."

51. A.S.F., *Statuti* 7, 67. For a transcription of this document, see Rodolico, 1968, 99–100.

52. Ciuto Brandini's laboring comrades quickly recognized his arrest as an overt act of repression orchestrated by leaders of the Wool Guild, who in turn were fearful of insurrection and a weakening of their economic and political position. Ciuto's friends immediately demanded his release, and threatened a general work-stoppage to leverage their position. But the Capitano del Popolo, bolstered by some of the city's most influential aristocrats (including the consuls of the Wool Guild and the priors in the Signoria), refused to acquiesce. A.S.F., *Capitano del Popolo* 17, 72. For a transcription of proceedings against Ciuto Brandini, see Rodolico, 1968, 102–4. For excerpts of this hearing, see Brucker, 1971, 235–36.

53. Brucker, 1971, 236.

54. For other accounts of the case of Ciuto Brandini, see Brucker, 1962, 110–11; and Najemy, 2006, 157–58. For a list of priors in May 1345, see Marchionne di Coppo Stefani, 1903, 226. For the list of consuls in the Wool Guild in 1345, see A.S.F., *Arte della Lana* 32, fol. 10v.

55. "While the symptoms of unrest and opposition were visible in these years, discontent did not erupt into overt action.… References to plots and conspiracies, or insults and aggressions against communal authorities, which filled the judicial records of the 1340s, are almost entirely absent in this period. For the lower classes the general prosperity resulting from the labor shortage kept revolutionary ferment at a minimum." Brucker, 1962, 149–50.

56. Morpurgo, 1933, 142; and Slepian, 1987, 85. The texts of these inscriptions appear in Florence, Biblioteca Nazionale, *Magliabechiano*, II, II, 146, fol. 53a; *Riccardiano* 1070, fol. 25a; and *Marucelliana* c. 155, fol. 57a.

57. "Da Bruto, primo Consol de Romani/ prudente, giusto, temperato, forte/essenpro prenda ogni rettor di corte." The inscription

was found in *Marucelliana* C. 155, fol. 57a. See Morpurgo, 1933, 148; and Slepian, 1933, 87–88 and note 84.

58. See Livy, 1959, Vol. 1, Books 58–60.

59. Livy, 1959, Vol. II, Book 4. Livy does not mention whether the father grieved for his sons, but he makes clear Brutus's dedication to the state and to its defense at all costs.

60. Dante II, 1996, 13, 42. Passages in Dante's earliest works essentially amount to scattered sentences of text in books otherwise packed with laudatory passages about other, more obvious, heroes and role models that stretch on for pages. In the *Inferno*, Brutus's appearance in Limbo, the zone reserved for praiseworthy notables unable to follow Christ due to the vicissitudes of time, is embarrassingly short, as Dante states simply, "I saw that Brutus who drove Tarquin out, Lucretia, Julia, Marcia, and Cornelia" ("Vidi quel Bruto che cacciò Tarquino, Lucrezia, Iulia, Marzia e Corniglia"), hardly a stirring account of the virtues possessed by this symbol of unimpeachable justice. See Dante, *Inferno* IV:127; and Dante, *Il Convivio* IV, V, 12.

61. Petrarca, *Africa*, Book III, 1016–23; and *Petrarch's Africa*, 1977, 68.

62. Petrarca, *De viris illustribus*, Book V, 1, in Petrarca, 1964, 24.

63. For an account of the heroic status of Brutus during the Middle Ages, see Morpurgo, 1933, 150ff.

64. Slepian, 1987, 84. "Non tenner questo luogo mai alcuni per vertu come voi degni di loda onde il ver mio da voi prego che s'oda."

65. Slepian, 1987, 84. "Lusinghe e prieghe nelle menti folli operan molto et entran di leggero ma come tu non parla chi ama il vero."

66. Slepian, 1987, 84. "Io posso meritar ben chi mi serve onde se giudicate quell ch'io cheggio non ne verrà alcun di voi di peggio."

67. Slepian, 1987, 85. "Tu se' di morte vergognosa degno! Qui giudicio per oro non si vende ma quell ch'è suo a ciaschedun si rende."

68. Slepian, 1987, 85. "Io veggio ben com'io ricevo torto, ma se per caso Morte non m'affretta, questo non passerà senza vendetta."

69. Slepian, 1987, 85. "Se tu sapessi come fa per nulla qui ogni furia e ogni minaccia sapresti che'l dir tuo te solo impaccia."

70. Slepian, 1987, 86. "Io temo di sequir dinanzi a voi la ragion mia, perchè già forse avvene ch'offeso alcun di voi a mal si tenne."

71. Slepian, 1987, 86. "Non temer torto qui ricever mai ben che ci fosse singular offesa che quell bilancia dritta mai non pesa."

CHAPTER 5

1. This letter, written in 1984, is currently stored in the curatorial file for the Washington *Saint Paul* in the National Gallery's archives. I am grateful to the staff at the National Gallery and to Kay Arthur for making this unpublished document available to me.

2. For an extensive list of panels considered to have decorated church piers, see Offner, 1947, 94n1.

3. Occasionally a panel might extend beyond the contours of its support: the rather large picture of *John the Evangelist* installed in Orsanmichele by Giovanni del Biondo sometime around 1380 extends some 115 centimeters from side to side, which suggests that it extended past its supporting column by about 5 centimeters on either side. By way of comparison, Andrea and Jacopo di Cione's triptych of *Saint Matthew* for the same church has three equal-sided panels, each with the width of eighty-eight centimeters, which give it a much tighter fit around its pier.

4. Boccaccio, 1982, 12–13.

5. Richa, 1757, vol. VI, 173. The Medici family was keen to assert their prominence in the city by finding ways to erect tomb markers inside the cathedral well before Cosimo's ascent to power. Paoletti, 2006, 1117–63.

6. Offner, 1947, 94–96.

7. Becherucci and Brunetti, 1970, 2:284. There is some question as to the exact nature of worship spaces inside the Duomo. Paatz and Paatz, 1952, vol. II, 385ff.

8. A.S.F., *Sepoltuario Fiorentino* II (Florence, 1657), 1116; and Offner, 1947, 95.

9. Richa, 1757, vol. VI, 132.

10. Becherucci and Brunetti, 1970, 2:284.

11. Becherucci and Brunetti, 1970, 2:284.

12. Becherucci and Brunetti, 1970, 2:284.

13. Becherucci and Brunetti, 1970, 2:285.

14. Cohn, 1992, 263–64. Cohn saw the second appearance of plague in 1363 as an important moment in the collective psychology of central Italy, when survivors came to realize that this particular epidemic was more than an anomaly. His nuanced analysis of artistic

patronage during the second half of the four-teenth century suggested that the number of commissions for decorations did not increase substantially but that the types of commissions selected by patrons changed subtly. Cohn noted that between 1363 and 1400, more donors than ever before requested portraits of themselves or deceased relatives and that this kind of request diminished in frequency during the fifteenth century.

15. Becherucci and Brunetti (1970, 2:285) argue that this altar was located in the Tribune of Santa Maria del Fiore. Indeed, del Migliore (1684, 65–68) noted the presence of a confraternity dedicated to Saint Zenobius in Santa Reparata as early as 1281 and went on to confirm that the company met in front of a pilaster in the cathedral throughout the fourteenth century.

16. Cornelison, 2002, 437–45.

17. For the construction of the chapel of San Zenobius, see Ahl, 2000, 57.

18. The panel has been attributed to the hands of Jacopo di Cione and Giovanni del Biondo. Offner, 1969b, 91–96.

19. Offner, 1960, 68–72.

20. See the catalog entry by Daniela Parenti in Donato and Parenti, 2013, 126.

21. Offner, 1960, 68–72.

22. The *Enthroned Madonna Lactans* was moved periodically during its history (it once adorned an altar near the cathedral font) and was venerated at times as a mini-cult image due to miracles associated with it. Cohn, 1956/58, 52–53; and Archivio dell'Opera del Duomo, *Deliberazioni e Stanziamenti*, LV (a. 1408), c. 8v: Feb. 4, 1407 (1408). "Suprascripti offitiales etc. deliberaverunt quod mag. Nicholas medicus posit ponere et sue ponere potuerit in pilastro quod est in ecclesia s. Reparate iuxta portam per quam itur per viam Cocomeri ex latere dextro exeundo porte predicte unum tabernaculum cum tabula quam facere fecit ad reverentiam s. Blaxii omnibus suis sumptibus et expensis. Et quod dictus magister teneatur etiam tabulam Crucifissi que in ipso pilastro erat poni facere suis expensis in alio pilastro seu loco deliberando per Johannem Ambroxii caputmagistri opera, ita quod opera nullam expensam facere habeat pro predictis." The date of the picture's commission and execution have been disputed by Ana Labriola, who has attributed the painting to Jacopo del Casentino and ascribed to it a date of 1335–1336. Labriola, 2003, 333–44.

23. Cohn (1956/58, 57) transcribed this document from the Archivo dell'Opera del Duomo, *Deliberazioni* 1425–1435, c. 127v: "Item prefati operarii audita quadam postulatione facta per Antonium Ghezzi della Casa per quam dixit ipsum Antonium per perpetuis temporibus ob reverentia Dei et sanctorum Cosimi et Damiani deputasse in maiori ecclesia Florentiae unam cappellam ad offitiandum in dicta ecclesia et quod ob reverentia dictorum sanctorum vellet apponi facere in quadam pilastro dicte ecclesie unam tabulam pitture sanctorum prefatorum in uno ex pilastris dicte ecclesie existentibus versus pergamum predicationis et a pergamo inferiori versus portam platee s. Johannis. Idcirco volentes eidem ob predicta de dicta tabula complacere, deliveraverunt quod dictus Antonius posit dictam tabulam in dictis locis vel in uno ipsorum per eum eligendorum apponi facere suis expensis cum hoc quod nullum jus cappelle nec aliquod aliud jus acquiretur per eum in dicta ecclesia et cum hoc quod prefati operarii ad eorum beneplactium ipsam de dicto loco removeri facere possint sine consensu dicti Antonii."

24. A.S.F., *Orsanmichele* 14, 46r–47r; Zervas, 1996a, 96, Doc. 201 (April 30, 1381); Passerini, 1853, 900–901; and Cohn, 1956, 173.

25. A.S.F., *Orsanmichele* 14, 47r; Zervas, 1996a, 97, Doc. 202 (April 30, 1381); Passerini, 1853, 901–2; and Cohn, 1956, 173.

26. In an entry written in 1351, guild members were said to venerate the memory of their patron saint by worshiping at its pier in Orsanmichele that was decorated with a painting of Bartholomew: "si faccia … nella festa di san bartolomeeo del mese d'aghosto una solenne offerta per tutta la detta arte appresso al pilastro dorto sanmichele nel quale e' dipinta la sua fighura." See A.S.F., *Arte dei Pizzicagnoli*, 2, c.s.n.; and Cohn, 1956, 172.

27. A.S.F., *Arte della Lana* 88, fol. 14r; and *Arte della Lana* 47, fol. 67r; Zervas, 1996a, 110, Doc. 245 (September 23, 1390) and 111, Doc. 250 (March 6, 1392).

28. A.S.F. *Provvisioni*, 86, fols. 330r–v; Horne, 1909, 168–69; and Zervas, 1996a, 113.

29. A.S.F., *Orsanmichele* 60, fol. 7r; Zervas, 1991a, 758, Doc. 2; and Zervas, 1996a, 122, Doc. 292

(January 9, 1410). The precise amount spent on these decorations is actually unclear from the documents from 1410, as the captains were soon allowed to spend up to 20 percent of the confraternity's annual income on the oratory's decorations. A.S.F., *Orsanmichele* 18, fol. 12r; and Zervas, 1996a, 123, Doc. 295 (January 22, 1410).

30. Van Os, 1988, 11–20.

31. Bellosi, 1977, 152–56.

32. For the most recent analysis of this picture, see the catalog entry by Margherita Romagnoli in Boskovits and Tartuferi, 2003, 104–8.

33. Offner, 1965, 4.

34. Jacopo had, as we have seen, worked in the Guild of Judges and Notaries in 1366.

35. Van Os, 1988, 77–89.

36. Bent, 2006, 231–44.

37. The opportunities created by this new design were not lost on Orcagna's contemporaries, although they were also not entirely exploited as much as they could have been. Giovanni del Biondo, in particular, clearly recognized the possibilities opened by his former master, and he responded to the very public image of *Saint Matthew* by producing liturgical triptychs that appropriated Orcagna's prototype. The panel of *Saint John the Baptist* for Santa Croce and the triptych of *Saint Giovanni Gualberto* both look to the *Saint Matthew* picture for inspiration, as the dimensions and large format of narrative scenes flanking the iconically rendered central saint recall the pier panel in Orsanmichele. When Giovanni del Biondo was later commissioned to paint panels for piers in the city's cathedral, these projects would serve as guides.

38. Cannon, 2003, 291–313.

39. Niccolò di Pietro Gerini, a busy and popular painter of public pictures, was employed to produce a number of these figures, including the images of *Saint Mary Magdalene* and *Saint Nicholas of Tolentino*, the latter of which earned him six florins between January and July 1408. A.S.F., *Orsanmichele* 213, fols. 13v and 19r; and Zervas, 1996a, 122, Doc. 289 (January 27–July 11, 1408).

40. Eisenberg, 1989, 3–12 and 98–99.

41. This author is no exception. In 2006, I suggested that Lorenzo Monaco's *Agony in the Garden* may have been intended for an altar in Santa Maria degli Angeli, the former cloister of its maker. Bent, 2006, 147–49.

42. Eisenberg, 1984, 280–84.

43. Marchionne di Coppo Stefani, 1903, 171.

44. The Linen Guild also maintained a niche on the exterior of Orsanmichele – on the southwest corner – that corresponded to this internal pier. Donatello famously filled that niche with his figure of *Saint Mark* in 1413.

45. It is important to remember that two campaigns to upgrade and refurbish Orsanmichele's interior occurred within fifteen years of the completion of the *Agony in the Garden*. First in 1398 and again in 1408, panels were removed from their columns and replaced with frescoes of individual saints painted in their stead. Most of the fourteenth-century pictures that originally filled the church were removed and relocated, but without written records citing the destination of those pictures. Zervas, 1996a, 113.

CHAPTER 6

1. The bearded face of Christ in San Miniato has formal connections to Sicilian apsidal mosaics in Cefalu and Monreale, in the Hagia Sophia of Constantinople, and in the Byzantine monasteries of Chora, the Hosios Lukas and Daphne. The formal relationships between the mosaics in San Miniato and their Byzantine counterparts suggest the presence of artists who were, at the very least, cognizant of the types of images popular in apses of churches across the northeastern rim of the Mediterranean Sea. Demus, 1970, 121–31; and Demus, 1976, 64–73.

2. Boskovits, 1975, 203n108.

3. Boskovits, 1975, 418.

4. The pier on the north wall, opposite the one bearing the image of the Magdalene, was decorated with a fresco of John the Baptist and was probably produced at the same time, that is, sometime around 1410. The appearance of two female worshippers suggests that women were permitted to enter this portion of the church.

5. Another saintly intercessor was added to this group later in the fifteenth century, as a niche containing the black-clad form of Saint Anthony Abbot was crafted next to the prototypical fresco of Saint Christopher from ca. 1300.

6. Holmes, 2013, 80; and Kent, 2000, 202–10. Piero de' Medici rather famously inscribed on the facing of the shrine at the Annunziata the amount of money he had spent on the structure. This rather crass and self-adulatory celebration of personal piety serves as an example

of the distinctive approach to patronage taken by individuals during the Medicean period (as opposed to that preferred by their ancestors during the early Republican era).

7. The image of the Coronation had been recognized as a symbol of Ecclesia since the twelfth century. Among the earliest surviving monumental renditions of this scene on Italian soil were Duccio's circular stained glass window on the facade of the Siena Cathedral, installed in 1288, and the apsidal mosaic produced for the Roman Church of Santa Maria Maggiore in the middle of the 1290s by Jacopo Toritti at the behest of Pope Nicholas IV. The mosaic in Santa Maria del Fiore followed soon thereafter and served as the prototype for fourteenth-century representations of the subject in Florence. For a thorough account of the Florentine iconography of the *Coronation of the Virgin*, see Boskovits, 2001, 531–39.

8. The votive Mass of the Holy Angels includes a hymn with the text "Angeli, Archangeli, Throni et Dominationes, Principatus et Potestates, Virtutes caelorum, Cherubim atque Seraphim, Dominum benedicte in aeternum." See *Liber Usualis*, 1934, 1277.

9. Donatello contributed to this theme by producing the stained glass for the window in the east end of the Duomo. Its subject, yet another *Coronation of the Virgin*, linked it directly to the mosaic at the west end of Santa Maria del Fiore.

10. Tacconi, 2005, 101–5.

11. Tacconi, 2005, 101–5.

12. Tacconi, 2005, 106–7.

13. Candidates for authorship include Coppo di Marcovaldo and Francesco Magister, which suggest an early date of execution, sometime in the 1270s and 1280s. Boskovits, 1986; and Boskovits, 2003, 487–98. However, two scenes in the cycle, the *Visitation* and *John in the Wilderness*, appear to have been based on an early-fourteenth-century Italian text titled *La vita di San Giovambatista*, suggesting that the lower (and therefore last) sections of the ceiling were completed sometime between 1300 and 1310. Dunford, 1974, 96–98.

14. Notable exceptions are Heuck, 1994, 229–63; Giusti, 1994, 265–361; and Boskovits, 2000, 329–40.

15. Bloch, 2009, 24–37.

16. Bloch, 2009, 24–37. In a city of more than one hundred thousand people, the number of infants born and individually baptized must have surpassed the five thousand mark annually, a number too great to be accommodated over only three days each spring.

17. Dunford, 1974, 96–98. Conventional wisdom would contend that the appearance of the manuscript served as the textual source for the mosaics, which in turn would suggest a date of production for the latter of ca. 1305. Yet it may be argued with equal passion that the mosaics may have influenced the Florentine author of the text.

18. For important observations about the redemptive themes in the story of Joseph, see Boskovits, 2000, 332–33.

19. Hueck, 1994, 229; Davidsohn, 1896, vol. I, 685; and Davidsohn, 1908, vol. IV, 183.

20. de Marchi, 2011, 58.

21. The frescoes have been convincingly dated to the years 1344 and 1345. Boskovits, 1971, 244; and Kreytenberg, 2000, 39–61. For Andrea di Cione's activity in the mid-1340s, see Arthur, 1988, 521–24.

22. See Kreytenberg, 2000, 47. The program of the Triumph of Death has been connected to the writings of Simone Saltarelli (1262–1342), a Dominican friar who served as prior of Santa Maria Novella in 1305–1306 before being named Bishop of Pisa.

23. Polzer, 1964, 463–67.

24. Smart, 1977, 403–14.

25. For a recent and thorough interpretation of these murals, see Kreytenberg, 2000, 43–55.

26. Kreytenberg, 2000, 47n45.

27. Offner, 1962, 53. Kreytenberg has dismissed Offner's identification of the centaur as Cacus based on the addition of the weapons he carries, noting that Dante does not mention arrows or bows in his passage.

28. Offner, 1962, 45.

29. Kreytenberg, 2000, 43 and note 22. The damaged section reveals only the following text: B DI PDEZZA V … // LPI DICOSTEI EDAC … NO // SI TRUOVA CONTRO ALLEI // OLECTORE NIVNO ARGOMETO // HORNONA VERE LINTELLECTO // SPENTO. DISTARE SENPRE // SIAPPARECCHIATO. CHENO // TI GUNGHA INMORTALE PEC …

30. dal Poggetto, 1968, 78.

31. See Kreytenberg, 2000, 43.

32. dal Pogetto, 1968, 78.

33. Villani, 1991, XIII, lviii, 429–33.

34. Brucker, 1962, 133n125.

35. Villani claims that Fra Piero was soon run out of town by the Florentines, who recognized a good fleecing when they saw one (having perpetrated a good number of them, no doubt).

CHAPTER 7

1. Boccaccio, 1982, 14–15. Writes the author, "As our city was … almost emptied of inhabitants, it happened … that one Tuesday morning in the venerable church of Santa Maria Novella there was hardly anyone there to hear the holy services except seven young ladies.… Not by any previous agreement, but purely by chance, they gathered together in one part of the church and were seated almost in a circle, saying their prayers."

2. The skeleton was already obscured by Vasari's day. Procacci, 1956, 213n4.

3. Brunelleschi's chapel for the Barbadori Family in Santa Felicita, then the only structure by the architect finished and available for inspection, or the side chapels lining the nave of the church of San Lorenzo almost certainly inspired Masaccio's setting. Saalman, 1993, 82–105; and Radke, 2002, 49–50.

4. Schlegel, 1963, 30.

5. Documents with two competing sets of information were published in Orlandi, 1950, 194, 605; One states that the chapel and altar were erected under the direction of Santa Maria Novella's prior in the 1420s, Fra Lorenzo Cardoni: "Fecerat illud frater Laurentius Cardonius, et Sanctissimae consecraverat Trinitati, quando coenobio praesidebat" (Modesto Biliotti, "Chronica pulcherrimae aedis magnique coenobii S. Mariae cognomento Novellae florentinae civitatis," *Analecta Sacri Ordinis Fratrum Praedicatorum,* I–III and XII–XIII [1839–1898 and 1915–1918], 168). The other provides the date of 1430 (Vincenzo Borghiani, *Cronaca annalistica del convent di S. Maria Novella in 3 volumi,* III, 330–40). Schlegel, 1963, 19–20; and Comanducci, 2003, 14.

6. Records of the Vasarian demolition and reconstruction of Santa Maria Novella (preserved in Borghigiani, III, 391–92) contain references to the chapel of the Trinity and the portal across from it. Hall, 1979, 167 (Doc. 2, #4) and 168 (Doc. 2, #14).

7. This reference appears in *Il Sepultario di Santa Maria Novella* (Archives of Santa Maria Novella, Florence), 1617, fol. 64v. "Mon. di quelli di Lenzo. Fra l'Altare del Rosario, et la Colonna di lungo il muro verso la Piazza al principio del terzo arco monumento con chiusino quadro di marmo, con armé e lettere di quelli di Lenzo. – Domenico di Lenzo, et Suorum 1426." Goffen, 1998, 45 and note 14.

8. For an alternative interpretation of the *Trinity's* patron, see Comanducci, 2003, 14–21.

9. For a richly rewarding, and diverse, set of interpretations, see Schlegel, 1963, 19–34; von Simson, 1966, 119–59; Verdon, 2003, 105–29; and Goffen, 1998, 43–64.

10. One wonders whether Antoninus, the Dominican friar and future bishop, referred to images inside Santa Maria Novella when he delivered the Lenten sermons in Florence in 1427. Neither the subject of those sermons nor the setting of the performance have been determined, but Peter Howard and David Peterson have, in private conversation, affirmed that they most probably were conducted in either the Piazza Santa Maria Novella or the Piazza della Signoria.

11. Verdon, 2003, 119–24.

12. Hall, 1974b, 165. For the proposed date of the Strozzi Chapel's construction, see Giles, 1977, 37–52 and Arthur, 1983, 369–79.

13. Arthur, 1983, 378–79.

BIBLIOGRAPHY

Aldrovandi, Alfredo, Marco Ciatti, and Chiara Rossi Scarzanella. "The Decollation of St. John the Baptist: The Examination and the Conservation of a Fourteenth-Century Banner, initial comments." In *The Fabric of Images: European Paintings on Textile Supports in the Fourteenth and Fifteenth Centuries*, ed. Caroline Villers, London, 2000, 11–18.

Aldrovandi, Alfredo and Silvano Gabbrielli. *Orsanmichele in Firenze* (Florence, 1982).

Agnoletti, Anna Marie. *Statuto dell'Arte della Lana di Firenze (1317–1319)* (Florence, 1938).

Ahl, Diane Cole. "'In corpo di compagnia': Art and Devotion in the Compagnia della Purificazione e di San Zanobi of Florence." In *Confraternities and the Visual Arts in Renaissance Italy*, eds. Barbara Wisch and Diane Cole Ahl, Cambridge, 2000, 46–101.

Alighieri, Dante. *Il Convivio*, ed. Maria Simonelli (Bologna, 1966).

———. *Inferno*, ed. and trans. Allen Mandelbaum (Berkeley, 1980).

———. *De Monarchia*, ed. and trans. Prue Shaw (Cambridge, 1996).

Antal, Frederick. *Florentine Painting and Its Social Background* (London, 1948).

Arthur, Kathleen Giles. "The Strozzi Chapel: Notes on the Building History of Sta. Maria Novella." *The Art Bulletin* 65 (1983): 367–86.

———. "A New Document on Andrea Orcagna in 1345." *Mitteilungen des Kunsthistorischen Institutes in Florenz* 32 (1988): 521–24.

———. "Cult Objects and Artistic Patronage of the Fourteenth-Century Flagellant Confraternity of Gesù Pellegrino." In *Christianity and the Renaissance: Image and Religious Imagination in the Quattrocento*, eds. Timothy Verdon and John Henderson, Syracuse, 1990, 336–60.

Artusi, Luciano. *Tabernacoli fiorentini: immagini di devozione nel territorio nel Quartiere 3* (Florence, 1999).

Atwell, Adrienne. "Ritual Trading at the Florentine Wool-Cloth Botteghe." In *Renaissance Florence: A Social History*, eds. Roger Crum and John Paoletti, New York, 2006, 182–215.

Bailey, Elizabeth. "Marian Lauds and Madonna Images: An Early Quattrocento Street Tabernacle." *Medieval Perspectives* 16 (2001): 19–29.

———. "The History of the Tabernacle: Form, Function, and Meaning." *Medieval Perspectives* 17 (2002): 61–84.

Bandini, Maria. "Vestigia dell'antico tramezzo della chiesa di San Remigio a Firenze." *Mitteilungen des Kunsthistorischen Institutes in Florenz* 54 (2010–2012): 211–30.

Bandini-Piccolomini, F. "L'effigie di Bruto console segno degli ufficiali di Mercanzia." *Miscellanea storica senese* II (1894): 124.

Bargellini, Piero. *Orsanmichele a Firenze* (Milan, 1969).

———. *Cento tabernacoli a Firenze* (Florence, 1971).

Bargellini, Piero and Ennio Guarnieri. *Le Strade di Firenze VII* (Florence, 1987).

Barzellotti, Pier Luigi. *I beni dell'Arte della Lana* (Florence, 1880).

Beccadelli, Antonio. *Hermaphroditus*, trans. and ed. Eugene O'Connor (Oxford, 2001).

Becherucci, Luisa and Giulia Brunetti. *Il Museo dell'Opera del Duomo di Firenze I and II* (Milan and Florence, 1969–70).

Becker, Marvin. *Florence in Transition, I and II* (Baltimore, 1967).

Bellosi, Luciano. "Una Precisazione sulla Madonna di Orsanmichele." *Scritti di storia dell'arte in onore di ugo Procacci* I (Milan, 1977): 152–56.

———. "The Function of the Rucellai Madonna in the Church of Santa Maria Novella." In *Italian Panel Paintings of the Duecento and Trecento, Studies in the History of Art* 61, ed. Victor Schmidt, New Haven and London, 2003, 147–59.

Belting, Hans. "The New Role of Narrative in Public Painting of the Trecento: Historia and Allegory." *Studies in the History of Art, National Gallery of Art, Washington* 16 (1985): 151–68.

———. *Likeness and Presence* (Chicago, 1991).

Bent, George. "The Scriptorium at S. Maria degli Angeli and Fourteenth-Century Manuscript Illumination: Don Silvestro dei Gherarducci, Don Lorenzo Monaco, and Giovanni del Biondo." *Zeitschrift für Kunstgeschichte* 55 (1992): 507–23.

———. "A Patron for Lorenzo Monaco's Uffizi Coronation of the Virgin." *Art Bulletin* 82 (2000): 348–54.

———. *Monastic Art in Lorenzo Monaco's Florence: Painting and Patronage in Santa Maria degli Angeli, 1300–1415* (Lewiston, NY, 2006).

Berghini, Vincezio. *Storia della nobilità Fiorentina* (Pisa, 1974).

Bergstein, Mary. "Marian Politics in Quattrocento Florence: The Renewed Dedication of Santa Maria del Fiore in 1412." *Renaissance Quarterly* 44 (1991): 673–719.

Bertani, Licia. "Tabernacolo di Santa Maria della Tromba." In *Arte, storia e devozione: Tabernacoli da conservare*, Florence, 1991, 69–87.

———. *La Madonna di Bernardo Daddi negli 'horti' di San Michele* (Livorno, 2000).

Bicchi, Alessandro and Alessandro Ciandella. *Testimonia Sanctitatis: Le reliquie e i reliquiari del Duomo e del Battistero di Firenze* (Florence, 1999).

Bietti, Monica. "Tabernacolo di Croce di Via." In *Arte, storia e devozione: Tabernacoli da conservare*, Florence, 1991, 95–99.

Bloch, Amy. "Baptism and the Frame of the South Door of the Baptistery, Florence." *Sculpture Journal* 18 (2009): 24–37.

———. "Baptism, Movement, and Imagery at the Baptistery of San Giovanni in Florence." In *Meaning in Motion: The Semantics of Movement in Medieval Art*, eds. Giovanni Freni and Nino Zchomelidse, Princeton, 2011, 131–60.

Boccaccio, Giovanni. *The Decameron*, ed. and trans. Mark Musa and Peter Bondanella (New York, 1982).

Bomford, David. *Art in the Making: Italian Painting before 1400* (London, 1989).

Bonsanti, Giorgio. *La Galleria della Accademia* (Florence, 1987).

Bornstein, Daniel. *The Bianchi of 1399: Popular Devotion in Late Medieval Italy* (Ithaca, 1993).

Borsook, Eve. *The Mural Painters of Tuscany* (Oxford, 1980).

———. "Jacopo di Cione and the Guild Hall of the Judges and Notaries in Florence." *Burlington Magazine* 124 (1982): 86–88.

———. "Painting for 'the Most Noble City in the World.'" In *Florence at the Dawn of the Renaissance: Painting and Illumination 1300–1350*, ed. Christine Sciacca, Los Angeles, 2012, 11–23.

Boskovits, Miklós. "Orcagna in 1357 – and in Other Times." *Burlington Magazine* 113 (1971): 239–51.

———. *Pittura Fiorentina alla vigilia del Rinascimento* (Florence, 1975).

———. *The Mosaics of the Baptistery of Florence* (Florence, 1986).

———. *A Corpus of Florentine Painting, Volume IV, Section III: Bernardo Daddi, His Shop and Following* (Florence, 1991).

———. *A Corpus of Florentine Painting, Section I, Volume I* (Florence, 1993).

———. "La storia di Giuseppe e dei suoi fratelli nel Battistero di Firenze." *Arte Cristiana* 88 (2000): 329–40.

———. *A Critical and Historical Corpus of Florentine Painting, Volume V, Section III* (New York and Florence, 2001).

———. "Florentine Mosaics and Panel Paintings: Problems of Chronology." In *Italian Panel Paintings of the Duecento and Trecento*, ed. Victor Schmidt, New Haven and London, 2003, 487–98.

Boskovits, Miklós and Daniela Parenti, *Dipinti, Volume Secondo: Il Tardo Trecento* (Florence, 2010).

Boskovits, Miklós and Angelo Tartuferi, *Dipinti, Volume Primo: Dal Duecento a Giovanni da Milano* (Florence, 2003).

Brackett, John K. "The Florentine Onestà and the Control of Prostitution, 1403–1680." *Sixteenth Century Journal* 24/2 (1993): 273–300.

Brucker, Gene. *Florentine Politics and Society, 1343–1378* (Princeton, 1962).

———. *The Society of Renaissance Florence* (New York, 1971).

———. *Florence in the Golden Age, 1138–1737* (Berkeley, 1998).

Brundage, James A. *Law, Sex, and Christian Society in Medieval Europe* (Chicago, 1987).

Burke, Julia M., Lisha Deming Glinsman, John K. Delaney, Suzanne Quillen Lomax, Kathryn M. Morales, Michael Palmer, Christina Lynn Cole, and Paola Ricciardi, "Technical Study of *The Triumph of Christ* (The Mazarin Tapestry)." *Facture* I (2013): 78–103.

Burnam, R. "Medieval Stained Glass Practice in Florence, Italy: The Case of Orsanmichele." *Journal of Glass Studies* 30 (1988): 77–93.

Calleri, S. *L'arte dei Giudici e Notai di Firenze nell'età comunale e nel suo statuto del 1344* (Milan, 1966).

Camelliti, Vittoria. "Madonna con Bambino, la Civitas Florentiae e intercessore. La Caritas." In *Dal Giglio al David: Arte civica a Firenze fra medioevo e rinascimento*, eds. Maria Monica Donato and Daniela Parenti, Florence, 2013, 120.

Cannon, Joanna. "Beyond the Limitations of Visual Typology: Reconsidering the Function and Audience of Three Vita Panels of Women Saints, ca. 1300." In *Italian Panel Paintings of the Duecento and Trecento, Studies in the History of Art* 61, ed. Victor Schmidt, New Haven and London, 2003, 291–313.

———. *Religious Poverty, Visual Riches: Art in the Dominican Churches of Central Italy in the Thirteenth and Fourteenth Centuries* (New Haven and London, 2013).

Cappelli, Eugenio. *La Compagnia dei Neri: L'archiconfraternita dei battuti di Santa Maria della Croce al Tempio* (Florence, 1927).

Cappellini, Icilio. "L'oratorio di S. Maria della Tromba in Firenze: L'immagine 'devota e pulcra' e l'arte dei Medici e Speziali." *Rivista di Storia delle scienze mediche e naturali* 2 (1949): 3–22.

Carocci, Guido. *Il Mercato Vecchio di Firenze* (Florence, 1884).

———. *Studi storici sul Centro di Firenze* (Florence, 1889).

———. "Le arti Fiorentine e le loro residenze." *Arte e Storia* X, n.s. II (1891): 153–55, 177–79.

———. *Firenze Scomparsa* (Florence, 1897).

———. "I Tabernacoli di Firenze." *Arte e Storia* XXIII (1904), XXIV (1905).

———. "La sala d'udienza dell'Arte dei mercatanti e la sua suppelettile." *L'Illustratore Fiorentino* IV (1905): 27–28.

Cassidy, Brendan. "The Financing of the Tabernacle of Orsanmichele." *Source* 8 (1988a): 1–6.

———. "The Assumption of the Virgin on the Tabernacle of Orsanmichele." *Journal of the Warburg and Courtauld Institutes* 51 (1988b): 174–80.

———. "Orcagna's Tabernacle in Florence: Design and Function." *Zeitschrift für Kunstgeschichte* 55 (1992): 180–211.

Cennini, Cennino. *Il libro dell'Arte*, ed. Fabio Frezzato (Vicenza, 2003).

Chierici, Regina. "Tabernacoli stradali dipinti a Firenze nel XIV secolo." *Arte Cristiana* 95 (2007): 169–80.

Ciabani, R. *I canti. Storia di Firenze attraverso i suoi angoli* (Florence, 1984).

Ciasca, R. *L'arte dei medici e speziali nella storia e nel commercio fiornetino dal secolo XII al secolo XV* (Florence, 1927).

Ciatti, Marco. "The Typology, Meaning, and Use of Some Panel Paintings from the Duecento and Trecento." In *Italian Panel Paintings of the Duecento and Trecento, Studies in the History of Art* 61, ed. Victor Schmidt, New Haven and London, 2003, 14–29.

Cipolla, Carlo. *The Monetary Policy of Fourteenth-Century Florence* (Berkeley, 1982).

Cirri, A. "Dell'antico centro di Firenze e del mercato delle vettovaglie." *Illustrazione Toscana*, August, 1938: 319–24; December 1938: 441–44.

Codell, Julie. "Giotto's Peruzzi Chapel Frescoes: Wealth, Patronage and the Earthly City." *Renaissance Quarterly* 41 (1988): 583–613.

Cohn, Samuel. "Criminality and the State in Renaissance Florence, 1344–1466." *Journal of Social History* 14 (1980): 211–33.

———. *The Cult of Remembrance and the Black Death* (Baltimore and London, 1992).

Cohn, Werner. "Un quadro di Lorenzo di Bicci e la decorazione primitive della chiesa di Orsanmichele." *Bolletino d'arte* 41 (1956): 171–77.

———. "Notizie storiche intorno ad alcune tavole fiorentine del '300 e del '400." *Rivista d'Arte* 31 (1956/58): 41–72.

———. "La seconda immagine della loggia di Orsanmichele." *Bolletino d'arte* 42 (1957): 335–38.

———. "Franco Sacchetti und das ikonographische Programm der Gewolbemalereien von Orsanmichele." *Mitteilungen des Kunsthistorischen Institutes in Florenz* 8 (1958): 65–77.

Cole, Bruce. "On an Early Florentine Fresco." *Gazette des Beaux Arts* 80 (1972): 91–96.

———. "A Popular Painting from the Early Trecento." *Apollo* 101 (1975): 9–15.

Comanducci, Rita Maria. "'L'altare Nostro de la Trinita': Masaccio's Trinity and the Berti Family." *Burlington Magazine* 145 (2003): 14–21.

Compagni, Dino. *Cronaca fiorentina* (Pisa, 1818).

Cooper, Donal. "In loco tuttissimo et firmissimo: The Tomb of St. Francis in History, Legend and Art." In *The Art of the Franciscan Order in Italy*, ed. William Cook, Leiden, 2004, 1–37.

———. "Access All Areas? Spatial Divides in the Mendicant Churches of Late Medieval Tuscany." In *Ritual and Space in the Middle Ages: Proceedings of the 2009 Harlaxton Symposium*, Harlaxton Medieval Studies XXI, ed. Frances Andrews, Donington, 2011, 90–107.

Cornelison, Sally. "A French King and a Magic Ring: The Girolami and a Relic of St. Zenobius in Renaissance Florence." *Renaissance Quarterly* 55 (2002): 434–69.

Crum, Roger and David Wilkins. "In the Defense of Florentine Republicanism: Saint Anne and Florentine Art, 1343–1575." In *Interpreting Cultural Symbols: Saint Anne in Late Medieval Society*, eds. Kathleen Ashley and Pamela Sheingorn, Athens and London, 1991, 131–68.

dal Poggetto, Paolo. "Orcagna." In *The Great Age of Fresco. Giotto to Pontormo: An Exhibition of Mural Paintings and Monumental Drawings* (New York, 1968): 78.

Davidsohn, Robert. *Forschungen zur Geschichte von Florenz, Volumes I–IV* (Berlin, 1896–1908).

del Badia, Iodoco. *Miscellanea fiorentina di erudizione e storia* (Florence, 1902).

———. *Comizio Agrario. La nuova sede nei Palazzi della Condotta e della Mercanzia* (Florence, 1907).

del Migliore, Ferdinando Leopoldo. *Firenze: città nobilissima illustrata* (Florence, 1684).

del Prete, Leone. *Capitoli della Compagnia della Madonna d'Orsanmichele dei sec. XIII e XIV* (Lucca, 1859).

De Marchi, Andrea. "Relitti di un naufragio: affreschi di Giotto, Taddeo Gaddi e Maso di Banco neele navate di Santa Croce." In *Santa Croce: Oltre le apparenze*, Florence, 2011, 35–71.

Demus, Otto. *Byzantine Art and the West* (New York, 1970).

———. *Byzantine Mosaic Decoration: Aspects of Monumental Art in Byzantium* (New Rochelle, NY, 1976).

Diana, E. "Contributi sulla storia contemporanea della raccolta artistica dell'Ospedale di Santa Maria Nuova: i cataloghi di fine Ottocento." *Archivio Storico Italiano* CLXIII (2005): 313–51.

Di Lorenzo, Andrea. "La Croce astile di Bernardo Daddi del Museo Poldi Pezzoli." In *La Croce di Bernardo Daddi del Museo Poldi Pezzoli: Ricerche e conservazione*, ed. Marco Ciatti, Florence, 2005, 11–30.

———. "Croce astile." In *Dal Giglio a David: Arte Civica a Firenze fra Medievo e Rinascimento*, eds. Maria Monica Donato and Daniela Parenti, Florence, 2013, 182–84.

Donato, Maria Monica and Daniela Parenti, eds. *Dal Giglio a David: Arte Civica a Firenze fra Medievo e Rinascimento* (Florence, 2013).

Dorini, U. "La Cappella ed il Reliquiere della Parte Guelfa in S. Maria del Fiore." *Rivista d'arte* 7 (1910): 31–36.

Dunford, P. A. "A Suggestion for the Baptistery Mosaics at Florence." *Burlington Magazine* 116 (1974): 96–98.

Durandus, William. *The Symbolism of Churches and Church Ornaments: A Translation of the First Book of the "Rationale divinorum officiorum,"*

trans. and ed. J. M. Neale and B. Webb, 3rd ed. (London, 1906).

Earenfight, Philip. "The Residence and Loggia della Misericordia (Il Bigallo): Art and Architecture of Confraternal Piety, Charity, and Virtue in Late Medieval Florence." PhD dissertation (Rutgers University, 1999).

————. "Sacred Sites in Civic Spaces: The Misericordia and Orsanmichele in Post-Plague Florence." In *The Historian's Eye: Essays on Italian Art in Honor of Andrew Ladis*, eds. Hayden B. J. Maginnis and Shelley E. Zuraw, Athens, GA, 2009, 15–32.

Edgerton, Samuel. *Pictures and Punishment: Art and Criminal Prosecution during the Florentine Renaissance* (Ithaca, 1985).

Eisenberg, Marvin. "Some Monastic and Liturgical Allusions in an Early Work of Lorenzo Monaco." In *Monasticism and the Arts*, ed. Timothy Verdon, Syracuse, NY, 1984, 271–89.

————. *Lorenzo Monaco* (Princeton, 1989).

————. *The "Confraternity Altarpiece" by Mariotto di Nardo: The Coronation of the Virgin and the Life of Saint Stephen* (Tokyo, 1998).

Elliott, Janis. "The Judgement of the Commune: The Frescoes of the Magdalen Chapel in Florence." *Zeitschrift für Kunstgeschicte* 61 (1998): 509–19.

Fabbri, Lorenzo, Marica Tacconi, and Timothy Verdon, eds. *I libri del duomo di Firenze: codici liturgici e biblioteca di Santa Maria del Fiore, secoli XI–XVI*, Florence, 1997.

Fabbri, Nancy and Nina Rutenburg. "The Tabernacle of Orsanmichele in Context." *Art Bulletin* LXIII (1981): 385–405.

Franci, Andrea. "Orcagna e le ricerche recenti sulla scultura fiorentina trecentesca." *Arte cristiana* 90 (2002): 251–60.

Francioni, Domenico. *Notizie del Vecchio Mercato e del Ghetto di Firenze* (Florence, 1887).

Fraticelli, Pietro. *Delle Antiche Carceri di Firenze Denominate le Stinche* (Florence, 1834).

Freedberg, David. *The Power of Images* (Chicago, 1989).

Freemantle, Richard. *Masaccio: The Complete Paintings by the Master of Perspective* (New York, 1998).

Freuler, Gaudenz. *A Critical and Historical Corpus of Florentine Painting: Volume V, Section VII, Part II, Tendencies of Gothic in Florence: Don Silvestro dei Gherarducci* (Florence, 1997).

Frey, Karl. *Die Loggia dei Lanzi zu Florenz: eine quellenkritische Untersuchung* (Berlin, 1885).

Frojmovič, Eva. "Giotto's Allegories of Justice and the Commune in the Palazzo della Ragione in Padua: A Reconstruction." *Journal of the Warburg and Courtauld Institutes* 59 (1996): 24–46.

Frosinini, Cecilia. "Proposte per Giovanni dal Ponte e Neri di Bicci: due affreschi funerari del Duomo di Firenze." *Mitteilungen des Kunsthistorischen Institutes in Florenz* 34 (1990): 123–38.

Gamba, C. "Giovanni dal Ponte." *Rassegna d'arte* IV (1904): 177–86.

Gandi, G. *Le arti maggiori e minori in Firenze* (Florence, 1929).

Gaye, Giovanni. *Carteggio inedito d'artisti dei secoli XIV, XV, XVI, Volumes I–III* (Florence, 1839–1840).

Geltner, Guy. *The Medieval Prison: A Social History* (Princeton and Oxford, 2008a).

————. "Isola non isolata: le Stinche in the Middle Ages." *Annali di Storia di Firenze* III (2008b): 7–28.

Ghiberti, Lorenzo. *I commentarii*, ed. Lorenzo Bartoli (Florence, 1998).

Gilbert, Creighton and Jeanne Bouniort. "Saint Antonin de Florence et l'art: theologie pastorale, administration et commande d'oeuvres." *Revue de l'art* 90 (1990): 9–20.

Giles, Kathleen. "The Strozzi Chapel in Santa Maria Novella: Florentine Painting and Patronage, 1340–1355." PhD dissertation (New York University, 1977).

Giusti, Anna Maria. *Il Battistero di San Giovanni a Firenze*, ed. Antonio Paolucci (Modena, 1994).

Goffen, Rona. "Masaccio's Trinity and the Letter to the Hebrews." In *Masaccio's Trinity*, ed. Rona Goffen, Cambridge, 1998, 43–64.

Goldthwaite, Richard and G. Mandich, *Studi sulla moneta fiorentina (secoli XIII–XVI)* (Florence, 1994).

Gronau, Hans. "Notes on Trecento Painting, II: Some Unpublished Works by Jacopo del Casentino." *Burlington Magazine* 53 (1928): 78–84.

Guarnieri, Ennio. *I tabernacoli di Firenze* (Florence, 1987a).

———. *Le Strade di Firenze, VII: le immagini di devozione nelle strade di Firenze* (Florence, 1987b).

Haines, Margaret. "L'Arte della Lana e l'Opera del Duomo di Firenze, con un accenno a Ghiberti tra due istituzioni." In *Opera. Carattere e ruolo delle fabbriche cittadine fino all'inizio dell'età moderna*, proceedings of the Colloquium (Florence, Villa I Tatti, April 3, 1991), eds. Margaret Haines and Lucio Ricetti, Florence, 1996.

Hale, Charlotte. "The Techniques and Materials of the Intercession of Christ and the Virgin, attributed to Lorenzo Monaco." In *The Fabric of Images: European Paintings on Textile Supports in the Fourteenth and Fifteenth Centuries*, ed. Charlotte Villers, London, 2000, 31–41.

Hall, Marcia. "The Tramezzo in Santa Croce, Florence, Reconstructed." *Art Bulletin* 56 (1974a): 325–41.

———. "The Ponte in S. Maria Novella: The Problem of the Rood Screen in Italy." *The Journal of the Warburg and Courtauld Institutes* 37 (1974b): 157–173.

———. *Renovation and Counter Reformation: Vasari and Duke Cosimo in Sta Maria Novella and Sta Croce, 1565–1577* (Oxford, 1979).

Hankey, Teresa. "Salutati's Epigrams for the Palazzo Vecchio at Florence." *Journal of the Warburg and Courtauld Institutes* 20 (1959): 363–65.

Hartt, Frederick. "Art and Freedom in Quattrocento Florence." In *Essays in Memory of Karl Lehmann*, ed. Lucy Freeman Sandler, New York, 1964, 114–31.

Henderson, John. "Confraternities and the Church in Late-Medieval Florence." *Studies in Church History* 23 (1986): 69–83.

———. *Piety and Charity in Late Medieval Florence* (Oxford, 1994).

———. *The Renaissance Hospital* (New Haven, 2006).

Holmes, Megan. "The Elusive Origins of the Cult of the Annunziata in Florence." In *The Miraculous Image in the Late Middle Ages and Renaissance*, eds. Erik Thunø and Gerhard Wolf, Rome, 2004, 97–121.

———. *The Miraculous Image in Renaissance Florence* (New Haven and London, 2013).

Horne, H. P. "A Commentary upon Vasari's life of Jacopo del Casentino." *Rivista d'Arte* VI (1909): 95–112.

Hoshino, Hidetoshi. "The Rise of the Florentine Woollen Industry in the Fourteenth Century." In *Cloth and Clothing in Medieval Europe: Essays in Memory of Professor E. M. Carus-Wilson*, eds. N. B. Harte and K. G. Ponting, London, 1983, 184–204.

Hueck, Irene. "La tavola di Duccio e la Compagnia delle Laudi di Santa Maria Novella." In *La Maestà di Duccio restaurata*, ed. A. Petrioli Tofani, Florence, 1990, 33–46.

———. "Le opera di Giotto per la chiesa di Ognissanti." In *La 'Madonna d'Ognissanti' di Giotto restaurata*, ed. A. Petrioli Tofani, Florence, 1992, 37–50.

———. "Il programma dei mosaici." In *Il Battistero di San Giovanni a Firenze*, ed. Antonio Paolucci, Modena, 1994, 229–63.

Israëls, Machtelt. "Altars on the Street: The Wool Guild, the Carmelites and the Feast of Corpus Domini in Siena (1356–1456)." *Renaissance Studies* 20 (2006): 180–200.

Jacobus, Laura. *Giotto and the Arena Chapel: Art, Architecture and Experience* (London, 2008).

Jones, Lars. "Vision Divina? Donor Figures and Representations of Imagistic Devotion: The Copy of the 'Virgin of Bagnolo' in the Museo dell'Opera del Duomo, Florence." In *Italian Panel Paintings of the Duecento and Trecento, Studies in the History of Art* 61, ed. Victor Schmidt, New Haven and London, 2003, 31–55.

Kanter, Laurence. "Lorenzo Monaco." In *Painting and Illumination in Early Renaissance Florence 1300–1450*, eds. Laurence Kanter and Barbara Boehm, New York, 1994, 220–306.

Kent, Dale. *Cosimo de' Medici and the Florentine Renaissance* (New Haven and London, 2000).

Klange, Bente. "I mosaici della scarsella del San Giovanni a Firenze: l'iconografia." *Commentari* 26 (1975): 248–58.

Klapisch-Zuber, Christiane. "Blood Parents and Milk Parents: Wet Nursing in Florence, 1300–1530." In *Women, Family, and Ritual in*

Renaissance Italy, trans. Lydia G. Cochraine, Chicago and London, 1985, 132–64.

Krautheimer, Richard and Trude Krautheimer-Hess. *Lorenzo Ghiberti* (Princeton, 1956).

Kreytenberg, Gert. "Die Trecenteske Dekoration der Stirnwand im Oratorio del Bigallo." *Mitteilungen des Kunsthistorischen Institutes in Florenz* 20 (1976): 397–403.

———. "Un tabernacolo di Giovanni di Balduccio per Orsanmichele a Firenze." *Boletin del Museo Arqueologico Nacional* 8 (1990): 37–57.

———. "Das Oratorio di Santa Maria della Tromba in Florenz und der Bildhauer Jacopo di Piero Guidi." *Mitteilungen des Kunsthistorischen Institutes in Florenz* 35 (1991): 297–306.

———. *Orcagna (Andrea di Cione): Ein universeller Künstler der Gotik in Florenz* (Mainz, 2000).

Labriola, Ana. "Un dipinto di Jacopo del Casentino e alcuni appunti sull'antica cattedrale di Santa Reparata a Firenze." *Arte Cristiana* 91 (2003a): 333–44.

———. "Jacopo di Cione, Niccolò di Tommaso, Simone di Lapo." In *Cataloghi della Galleria dell'Accademia di Firenze, I: Dal Duecento a Giovanni da Milano*, eds. Miklós Boskovits and Angelo Tartuferi, Florence, 2003b, 127–35.

Ladis, Andrew. *Taddeo Gaddi* (Columbia, MO, 1980).

———. "Antonio Veneziano and the Representation of Emotion." *Apollo* 124 (1986): 154–61.

———. "An Old Picture in Florence." *Source* 7 (1987): 1–5.

Ladner, Gerhart. "The Gestures of Prayer in Papal Iconography of the Thirteenth and Early Fourteenth Centuries." In *Didascaliae. Studies in Honor of Anselm M. Albareda*, ed. Sesto Prete, New York, 1961, 245–75.

Landini, Placido. *Istoria dell'oratorio e della venerabile arciconfraternita di Santa Maria della Misericordia della città di Firenze* (Florence, 1779: reprinted with notes by Pietro Pillori, Florence, 1843).

Lansing, Carol. *The Florentine Magnates: Lineage and Faction in a Medieval Commune* (Princeton, 1991).

La Roncière, M. de. *Prix et salaire à Florence au XIVe siècle (1280–1380)* (Rome, 1982).

La Sorsa, Saverio. *La Compagnia d'Or San Michele* (Trani, 1902).

Lavin, Irving. "Santa Maria del Fiore: Image of the Pregnant Madonna. The Christology of Florence Cathedral." In *Atti del VII Centenario del Duomo di Firenze, I: la cattedrale come spazio sacro. Saggi sul Duomo di Firenze*, eds. Timothy Verdon and Annalisa Innocenti, Florence, 2001, 668–89.

Lenzi, Alfredo. "Il palagio della Parte Guelfa in Firenze." *Dedalo* I (1920): 250–62.

Leoncini, Giovanni. "I luoghi della devozione mariana a Firenze: Or San Michele." In *Atti del VII Centenario del Duomo di Firenze, II: la cattedrale come spazio sacro. Saggi sul Duomo di Firenze*, eds. Timothy Verdon and Annalisa Innocenti, Florence, 2001, 182–94.

Leoncini, Giovanni and Alessandro Bicchi. "Il culto dei santi in cattedrale." In *Atti del VII Centenario del Duomo di Firenze, II: la cattedrale come spazio sacro. Saggi sul Duomo di Firenze*, eds. Timothy Verdon and Annalisa Innocenti, Florence, 2001, 299–323.

Levi D'Ancona, Mirella. "Don Silvestro dei Gherarducci e il 'Maestro delle Canzoni.'" *Rivista d'arte* 32 (1959): 3–37.

———. *The Choir Books of Santa Maria degli Angeli in Florence, vol. II: The Reconstructed 'Diurno Domenicale' from Santa Maria degli Angeli in Florence* (Florence, 1993).

Levin, William. "Advertising Charity in the Trecento: The Public Decorations of the Misericordia in Florence." *Studies in Iconography* 17 (1996): 215–309.

———. "A Lost Fresco Cycle by Nardo and Jacopo di Cione at the Misericordia in Florence." *Burlington Magazine* 141 (1999): 75–80.

———. *The "Allegory of Mercy" at the Misericordia in Florence: Historiography, Context, Iconography, and the Documentation of Confraternal Charity in the Trecento* (Dallas, Lanham, Boulder, New York, Oxford, 2004).

———. "The Canopy of Holiness at the Misericordia in Florence and Its Sources, I." *Southeastern College Art Conference Review* 15 (2008): 309–25.

———. "The Canopy of Holiness at the Misericordia in Florence and Its Sources, II." *Southeastern College Art Conference Review* 15 (2009): 393–407.

———. *Liber Usualis* (Washington, DC, 1934).

Lisini, A., ed., *Il costituto del commune volgarizzato nel MCCCIX–MCCCX, Volumes 1–2* (Siena, 1903).

Livy. *History of Rome, Books 1–142*, trans. Benjamin Oliver Foster, Frank Gardner Moore, Evan Taylor Sage, and Alfred Cary Schlesinger (Cambridge, MA, 1959–1991).

Maginnis, Hayden B. J. "Lay Women and Altars in Trecento Siena." *Source: Notes in the History of Art* 28 (2008): 5–7.

Maginnis, Hayden B. J. and Andrew Ladis. "Sculpture's Pictorial Presence: Reflections on the Tabernacles of Orsanmichele." *Studi di storia dell'arte* 5–6 (1994): 41–54.

Marchini, G. "Miracoli d'Orsanmichele." *Mitteilungen des Kunsthistorischen Institutes in Florenz* 17 (1973): 301–6.

Marchionne di Coppo, Stefani. *Cronaca Fiorentina*, ed. Niccolò Rodolico (Città di Castello, 1903).

Marcucci, Luisa. *I dipinti Toscani del secolo XIV* (Rome, 1965).

Marshall, Louise. "Confraternity and Community: Mobilizing the Sacred in Times of Plague." In *Confraternities and the Visual Arts in Renaissance Italy*, eds. Barbara Wisch and Diane Cole Ahl, Cambridge, 2000, 20–45.

Martines, Lauro. *Lawyers and Statecraft in Renaissance Florence* (Princeton, 1968).

Mazzi, Maria Serena. "Il Mondo della Prostituzione nella Firenze Tardo Medievale." *Ricerche Storiche* 14 (1984): 337–63.

Meiss, Millard. *Painting in Florence and Siena after the Black Death* (Princeton, 1951).

———. "An Early Altarpiece from the Cathedral of Florence." *The Metropolitan Museum of Art Bulletin* 12 (1954): 302–17.

Melli, Lorenza. "The Documents." In *Giotto: The Santa Maria Novella Crucifix*, eds. Marco Ciatti and Max Seidel, Florence, 2002, 227–37.

———. *Nuovi documenti per la storia dell'arte Toscana dal XII al XVI secolo* (Rome, 1893).

Monciatti, Alessio. "L'Incoronazione della Vergine nella controfacciata della cattedrale di Santa Maria del Fiore e altri mosaici monumentali in Toscana." *Mitteilungen des Kunsthistorischen Institutes in Florenz* 43 (1999): 14–48.

Monnas, Lisa. "Silk Textiles in the Paintings of Bernardo Daddi, Andrea di Cione, and Their Followers." *Zeitschrift für Kunstgeschichte* 53 (1990): 39–58.

———. *Merchants, Princes and Painters: Silk Fabrics in Italian and Northern Paintings 1300–1550* (London and New Haven, 2008).

Moreni, Domenico. *Mores et Consuetudines Ecclesiae Florentinae* (Florence, 1794).

Morini, Ugo, ed. *Documenti inediti o poco noti per la storia della Misericordia di Firenze (1240–1525)* (Florence, 1940).

Morozzi, Guido. "La cattedrale di Santa Reparata." In *Atti del VII Centenario del Duomo di Firenze, I: la cattedrale e la città. Saggi sul Duomo di Firenze*, eds. Timothy Verdon and Annalisa Innocenti, Florence, 2001, 136–44.

Morpurgo, Salomone. "Bruto, 'il buon giudice,' nell'Udienza dell'Arte della Lana in Firenze." In *Miscellanea di Storia dell'Arte in Onore di I. B. Supino*, Florence, 1933, 141–63.

Muir, Edward. "The Virgin on the Street Corner: The Place of the Sacred in Italian Cities." In *Religion and Culture in the Renaissance and Reformation*, Sixteenth Century Essays and Studies 11, ed. Steven Ozment, Kirksville, MO, 1989, 24–40.

Najemy, John. *Corporatism and Consensus in Florentine Politics* (Chapel Hill, 1982).

———. *A History of Florence 1200–1575* (Malden, MA, 2006).

Nannelli, Francesca. *La Misericordia di Firenze: memorie, curiosità, tradizioni*, ed. Foresto Niccolai (Florence, 1984).

———. "L'affresco raffigurante Sant'Anna patrona di Firenze in Or San Michele." In *Sant'Anna dei Fiorentini: storia, fede, arte, tradizione*, ed. Anita Valentini, Florence, 2003, 149–54.

Offner, Richard. "Niccolò di Pietro Gerini." *Art in America* 9 (1921): 148–55, 233–40.

———. "Jacopo del Casentino. Introduzione alla sua opera." *Bolletino d'Arte* 3 (1923): 248–84.

———. *A Critical and Historical Corpus of Florentine Painting, Section III, Volume II* (New York, 1930a).

———. *A Critical and Historical Corpus of Florentine Painting, Section III, Volume III* (New York, 1930b).

————. *A Critical and Historical Corpus of Florentine Painting, Section III, Volume IV* (New York, 1934).

————. *A Critical and Historical Corpus of Florentine Painting, Section III, Volume V* (Florence, 1947).

————. *A Critical and Historical Corpus of Florentine Painting, Section III, Volume VIII* (New York, 1958).

————. *A Critical and Historical Corpus of Florentine Painting, Section IV, Volume II* (New York, 1960).

————. *A Critical and Historical Corpus of Florentine Painting, Section IV, Volume I* (New York, 1962).

————. *A Critical and Historical Corpus of Florentine Painting, Volume IV, Section III* (New York 1965).

————. *A Critical and Historical Corpus of Florentine Painting, Section IV, Volume IV* (New York, 1968).

————. *A Critical and Historical Corpus of Florentine Painting, Section IV, Volume IV, Part I* (New York, 1969a).

————. *A Critical and Historical Corpus of Florentine Painting, Section IV, Volume IV, Part II* (New York, 1969b).

Orlandi, Stefano. "Cronaca Annalistica del Convento di S. Maria Novella." In *"Necrologio" di S. Maria Novella, Volume II*, Florence, 1955, 397–404.

Ortalli, Gherardo. *Pingatur in palatio: La pittura infamante nei secoli XIII–XVI* (Rome, 1979).

Paatz, Walter and Elisabeth Paatz. *Die Kirchen von Florenz, Volumes I–III* (Frankfurt am Main, 1952).

Padoa Rizzo, Anna. "Bernardo di Stefano Rosselli, il 'Polittico Rucellai,' e il 'Polittico di San Pancrazio' di Bernardo Daddi." *Studi di storia dell'arte* 4 (1993): 611–22.

Palmeri, Michela. *Dipinti: dal Duecento a Giovanni da Milano*, eds. Miklós Boskovits and Angelo Tartuferi (Florence, 2003).

Paoletti, John. "Medici Funerary Monuments in the Duomo of Florence during the Fourteenth Century: A Prologue to 'The Early Medici.'" *Renaissance Quarterly* 59 (2006): 1117–63.

Passerini, Luigi. *Storia degli Stabilimenti di Beneficenza della Città di Firenze* (Florence, 1853).

Petrarca, Francesco. *De viris illustribus*, ed. Guido Martellotti (Florence, 1964).

————. *Petrarch's Africa*, ed. and trans. Thomas G. Bergin and Alice S. Wilson (New Haven and London, 1977).

Pinto, Giuliano. *Il Libro del Biadaiolo. Carestie e annona a Firenze dalla metà del '200 al 1348* (Florence, 1978).

Pisani, Rosanna Caterina Proto. "Tabernacolo in piazza del Carmine angolo Piazza Piattellina." In *Arte, storia e devozione: Tabernacoli da conservare*, Florence, 1991, 101–7.

Pitts, Frances. "Nardo di Cione and the Strozzi Chapel Frescoes." PhD dissertation (University of California, Berkeley, 1982).

Poggi, Giovanni. *Or San Michele* (Florence, 1895).

————. *Il Duomo di Firenze. Documenti sulla decorazione della chiesa e del campanile tratti dall'Archivio dell'Opera* (Florence, 1909).

Poggi, Giovanni, I. B. Supino, and Corrado Ricci. "La Compagnia del Bigallo." *Rivista d'Arte* 2 (1904): 189–209, 225–44.

Polzer, Joseph. "Aristotle, Mohammed and Nicholas V in Hell." *The Art Bulletin* 46 (1964): 457–69.

Procacci, Ugo. "Il Vasari e la conservazione degli affreschi della cappella Brancacci al Carmine e della Trinità in S. Maria Novella." In *Scritti di storia dell'arte in onore di Lionello Venturi, Volume 1*, ed. Mario Salmi, Rome, 1956, 211–22.

————. "L'affresco dell'Oratorio del Bigallo ed il suo maestro." In *Klara Steinweg: in Memoriam, Mitteilungen des Kunsthistorischen Institutes in Florenz* 17 (1973): 307–24.

Prosperini, P. *Capitoli della Compagnia dei Disciplinati della città di Firenze* (Padua, 1871).

Radke, Gary. "Masaccio's City: Urbanism, Architecture, and Sculpture in Early Fifteenth-Century Florence." In *The Cambridge Companion to Masaccio*, ed. Diane Cole Ahl, Cambridge, 2002, 40–63.

Ratté, Felicity. *Picturing the City in Medieval Italian Painting* (Jefferson, NC, 2006).

Ricci, Battaglia. *Palazzo Vecchio e dintorni. Studio sul Franco Sacchetti e le fabbriche di Firenze* (Rome, 1990).

Richa, Giuseppe. *Notizie istoriche delle chiese fiorentine, Volumes I–X* (Florence, 1754–1762).

Roberts, Perri Lee. "A New Late Fourteenth-Century Example of Florentine Civic Art: Mariotto di Nardo's Fresco for the Capitani of Orsanmichele." *Mitteilungen des Kunsthistorischen Institutes in Florenz* 30 (1986): 584–86.

Rodolico, Niccolò. *Il popolo minuto* (Florence, 1968).

Rubenstein, Nicolai. *The Palazzo della Signoria: 1298–1532* (New York, 1995).

Ruck, Germaid. "Brutus als Modell des guten Richters: Bild und Rhetorik in einem Florentiner Zunftgebäude." In *Malerei und Stadtkultur in der Dantezeit*, eds. Hans Belting and Dieter Blume, Munich, 1989, 115–31.

Saalman, Howard. "Michelozzo Studies: The Florentine Mint." In *Festschrift Ulrich Middeldorf*, ed. Antje Kosegarten and Peter Tigler, Berlin, 1968, 140–42.

———. *The Bigallo* (New York, 1969).

———. *Filippo Brunelleschi, the Buildings* (London, 1993).

Sabbatini, Oretta and Lia Invernizzi. *I Tabernacoli fiorentini* (Florence, 1991).

Salmi, Mario. "Il Palazzo della Parte Guelfa di Firenze e Filippo Brunelleschi." *Rinascimento* II (1951): 3–11.

Santi, Bruno. "Tabernacoli a Firenze: valenze storico-artistiche e problemi di tutela." In *Arte, storia e devozione: Tabernacoli da conservare*, Florence, 1991, 9–13.

———. *Tabernacoli a Firenze: i restauri (1991–2001)* (Florence, 2002).

Santoni, Luigi. *Diario Sacro e Guida Perpetua delle Feste Principali delle chiese della Città, Suburbio ed Archidiocesi Fiorentina* (repr., Bologna, 1974).

Schiferl, Ellen. "Italian Confraternity Art Contracts: Group Consciousness and Corporate Patronage, 1400–1525." In *Crossing the Boundaries: Christian Piety and the Arts in Italian Medieval and Renaissance Confraternities*, ed. Konrad Eisenbichler, Kalamazoo, 1991, 121–40.

———. "Caritas and the Iconography of Italian Confraternity Art." *Studies in Iconography* 14 (1995): 211.

Schlegel, Ursula. "Observations on Masaccio's Trinity Fresco in Santa Maria Novella." *Art Bulletin* 45 (1963): 19–34.

Schmidt, Victor. "The Lunette-Shaped Panel and Some Characteristics of Panel Painting." In *Italian Panel Paintings of the Duecento and Trecento*, Studies in the History of Art 61, ed. Victor Schmidt, New Haven, 2003, 83–101.

———. "La Vierge d'humilité de Niccolò di Buonaccorso." *La Revue des Musées de France* 4 (2014): 46–57.

Sciacca, Christine. "Reconstructing the Laudario of Sant'Agnese." In *Florence at the Dawn of the Renaissance: Painting and Illumination, 1300–1350*, ed. Christine Sciacca, Los Angeles, 2012, 219–81.

Scudieri, Magnolia. *Il Museo Bandini a Fiesole* (Florence, 1993).

———. "Il Tabernacolo dei Linaioli nel percorso dell'Angelico." In *Il Tabernacolo dei Linaioli del Beato Angelico restaurato*, eds. Marco Ciatti and Magnolia Scudieri, Florence, 2011, 15–26.

Siren, Osvald. *Giottino* (Florence, 1908).

Skaug, Erlang. *Punch Marks from Giotto to Fra Angelico: Attribution, Chronology, and Workshop Relationships in Tuscan Panel Painting, Volumes 1–2* (Oslo, 1994).

Slepian, Marcie Freedman. "Merchant Ideology in the Renaissance: Guild Hall Decoration in Florence, Siena, and Perugia." PhD dissertation (Yale University, 1987).

Smart, Alistair. "Taddeo Gaddi, Orcagna, and the Eclipses of 1333 and 1339." In *Studies in Late Medieval and Renaissance Painting in Honor of Millard Meiss*, eds. Irving Lavin and John Plummer, New York, 1977, 403–14.

Solberg, Gail. "The Painter and the Widow: Taddeo di Bartolo, Datuccia Sardi da Campiglia, and the Sacristy Chapel in S. Francesco, Pisa." *Gesta* 49/1 (2010): 53–74.

Spagnesi, Annalisa Bricoli. "Su alcune pitture nella Sala d'Udienza del Palazzo dell'Arte della Lana a Firenze." *Antichità viva* 31, 2 (1992): 5–10.

Spilner, Paula. "Ut Civitas Amplietur: Studies in Florentine urban development, 1282–1400." PhD dissertation (Columbia University, 1987).

Staley, Edgcumbe. *The Guilds of Florence* (London, 1906).

Statuti dell'Arte del Cambio di Firenze, ed. G. C. Marri (Florence, 1955).

Strozzi, Beatrice Paolozzi. "Tabernacolo di Monteloro." In *Arte, storia e devozione: Tabernacoli da conservare*, Florence, 1991, 89–93.

Stuard, Susan Mosher. *Gilding the Market: Luxury and Fashion in Fourteenth-Century Italy* (Philadelphia, 2006).

Supino, Igino Benvenuto. "Il Palagio dell'Arte della Lana in Firenze." *L'Arte* (1905): 266–70.

Tacconi, Marica. *Cathedral and Civic Ritual in Late Medieval and Renaissance Florence: The Service Books of Santa Maria del Fiore* (Cambridge, 2005).

Tartuferi, Angelo. "L'eredità di Giotto a Firenze." In *L'eredità di Giotto: Arte a Firenze 1340–1375*, ed. Angelo Tartuferi, Florence, 2008, 17–37.

Taylor-Mitchell, Laurie. "Images of St. Matthew Commissioned by the Arte del Cambio for Orsanmichele in Florence." *Gesta* 31/I (1992): 54–72.

———. "Guild Commissions at Orsanmichele: Some Relationships between Interior and Exterior Imagery in the Trecento and Quattrocento." *Explorations in Renaissance Culture* 20 (1994): 61–88.

Terry-Fritsch, Allie. "The Iconostasis, the Choir Screen and San Marco: The Veiling of Ritual Action and the Participation of the Viewer in Byzantium and Renaissance Florence." *Chicago Art Journal* 11 (2001): 14–32.

———. "Criminal Vision in Early Modern Florence: Fra Angelico's Altarpiece for 'Il Tempio' and the Magdalenian Gaze." In *Renaissance Theories of Vision*, eds. John Hendrix and Charles Carmen, Hampshire, UK, 2010, 45–62.

Toker, Franklin. "Scavi del Complesso Altomedievale di S. Reparata sotto il Duomo di Firenze." *Archeologia Medievale* 2 (1975): 161–90.

———. "Una visita di S. Ambrogio a Firenze, e la spiegazione delle origini della Cattedrale di S. Reparata." In *Atti del VII Centenario del Duomo di Firenze, II: la cattedrale come spazio sacro. Saggi sul Duomo di Firenze*, eds. Timothy Verdon and Annalisa Innocenti, Florence, 2001a, 377–95.

———. "On Holy Ground: Architecture and Liturgy in the Cathedral and in the Streets of Late-Medieval Florence." In *Atti del VII Centenario del Duomo di Firenze, II: la cattedrale come spazio sacro. Saggi sul Duomo di Firenze*, eds. Timothy Verdon and Annalisa Innocenti, Florence, 2001b, 545–59.

Trachtenberg, Marvin. *Dominion of the Eye: Urbanism, Art and Power in Early Modern Florence* (Cambridge, 1997).

Trexler, Richard. "By the Grace of the Lord Pope …" *Studies in Medieval and Renaissance History* 9 (1972a).

———. "Florentine Religious Experience: The Sacred Image." *Studies in the Renaissance* XIX (1972b): 7–41.

———. *Public Life in Renaissance Florence* (New York, 1980).

———. "La Prostitution Florentine au XVe Siècle: Patronages et Clientèles." *Annales ESC* 36 (1981): 983–1015.

Valentini, Anita. *L'iconografia fiorentina di Sant'Anna. La festa del 26 luglio* (Campi Bisenzi, 1998).

Van Marle, Raimond. *The Development of the Italian Schools of Painting, Volumes I–XIX* (The Hague, 1923–1936).

Van Os, Henk. *Sienese Altarpieces I* (Groningen, 1988).

Vasari, Giorgio. *Le Vite dei più eccellenti pittori, scultori, e architetti*, ed. Giovanni Maselli (Florence, 1832–1838).

Verdon, Timothy. "La Sant'Anna Metterza: reflessioni, domandi, ipotesi." *Gli Uffizi Studi e Ricerche* 5 (1988): 42.

———. "The Intercession of Christ and the Virgin from Florence Cathedral: Iconographic and Ecclesiological Significance." In *The Fabric of Images: European Paintings on Textile Supports in the Fourteenth and Fifteenth Centuries*, ed. Charlotte Villers, London, 2000, 43–54.

———. "The Intercession of Christ and the Virgin from Florence Cathedral: Iconographic and Ecclesiological Significance." In *Atti del VII Centenario del Duomo di Firenze, II: la cattedrale come spazio sacro. Saggi sul Duomo di*

Firenze, eds. Timothy Verdon and Annalisa Innocenti, Florence, 2001, 131–49.

———. "Masaccio's Trinity: Theological, Social, and Civic Meanings." In *The Cambridge Companion to Masaccio*, ed. Diane Cole Ahl, Cambridge, 2002, 158–76.

———. "La Trinità del Masaccio." In *Alla riscoperta delle chiese di Firenze: Santa Maria Novella*, ed. Timothy Verdon, Florence, 2003, 105–29.

Vestri, Veronica. "Le spese per la construzione della cappella di Sant'Anna in Via Calzaioli." In *Sant'Anna dei Fiorentini: storia, fede, arte, tradizione*, ed. Anita Valentini, Florence, 2003, 175–98.

Villani, Giovanni. *Nuova Cronica, Volumes I–III*, ed. Giuseppe Porta (Parma, 1991).

Villers, Caroline. "Paintings on Canvas in Fourteenth-Century Italy." *Zeitschrift für Kunstgeschicte* 58 (1995): 338–58.

———. "Four Scenes of the Passion Painted in Florence around 1400." In *The Fabric of Images: European Paintings on Textile Supports in the Fourteenth and Fifteenth Centuries*, ed. Caroline Villers, London, 2000, 1–10.

von Simson, Otto. "Uber di Bedeutung von Masaccios Trinitätfresko in Santa Maria Novella." *Jahrbuch der Berliner Museen* 8 (1966): 119–59.

Wackernagel, Martin. *The World of the Florentine Renaissance Artist*, trans. Alison Luchs (Princeton, 1981).

Watson, Paul. "The Spanish Chapel: Portraits of Poets or a Portrait of Christian Order." *Memorie domenicane* 11 (1980): 471–87.

Webb, Diana. *Patrons and Defenders: The Saints in the Italian City-States* (London, 1996).

Weinberger, M. "The First Façade of the Cathedral of Florence." *Journal of the Warburg and Courtauld Institutes* 4 (1940–1941): 67–79.

Weissman, Ronald. *Ritual Brotherhood in Renaissance Florence* (New York, 1982).

Welch, Evelyn. *Shopping in the Renaissance: Consumer Cultures in Italy 1400–1600* (New Haven and London, 2005).

Wieruszowski, Helene. "Art and the Commune in the Time of Dante." *Speculum* 19 (1944): 14–33.

Wilkins, David. "Donatello's Lost Dovizia for the Mercato Vecchio: Wealth and Charity as Florentine Civic Virtues." *Art Bulletin* 65 (1983): 401–23.

———. "Opening the Doors to Devotion: Trecento Triptychs and Suggestions Concerning Images and Domestic Practice in Florence." In *Italian Panel Paintings of the Duecento and Trecento, Studies in the History of Art* 61, ed. Victor Schmidt, New Haven and London, 2003, 371–93.

Williamson, Beth. "The Cloisters Double Intercession: The Virgin as Co-Redemptrix." *Apollo* 152 (November 2000): 48–54.

———. *The Madonna of Humility: Development, Dissemination and Reception, c. 1340–1400* (Woodbridge, 2009).

Wilson, Blake. *Music and Merchants: The Laudesi Companies of Republican Florence* (Oxford, 1992).

———. "Music, Art, and Devotion: The Cult of St. Zenobius at the Florentine Cathedral during the Early Renaissance." In *Atti del VII Centenario del Duomo di Firenze, III: la cattedrale come spazio sacro. Saggi sul Duomo di Firenze*, eds. Timothy Verdon and Annalisa Innocenti, Florence, 2001, 17–36.

Wolfgang, Marvin. "Socio-Economic Factors Related to Crime and Punishment in Renaissance Florence." *Journal of Criminal Law, Criminology, and Political Science* 47 (1956): 311–30.

Zervas, Diane Finiello. "The Parte Guelfa Palace, Brunelleschi and Antonio Manetti." *Burlington Magazine* 127 (1984): 494–99.

———. *The Parte Guelfa, Brunelleschi and Donatello* (Locust Valley, NY, 1987).

———. "Lorenzo Monaco, Lorenzo Ghiberti, and Orsanmichele, I." *Burlington Magazine* 133 (1991a): 748–59.

———. "Lorenzo Monaco, Lorenzo Ghiberti, and Orsanmichele, II." *Burlington Magazine* 133 (1991b): 812–19.

———. "The Building and Decoration of Orsanmichele before Verrocchio." In *Verrocchio's* Christ and St. Thomas, *a Masterpiece of Sculpture from Renaissance Florence*, ed. Loretta Dolcini, New York, 1992, 39–51.

_____. *Orsanmichele Documents 1336–1452, Volumes 1–2* (Modena, 1996a).

_____. *Orsanmichele a Firenze* (Modena, 1996b).

_____. "Niccolò Gerini's Entombment and Resurrection of Christ, S. Anna/S. Michele/S.

Carlo and Orsanmichele in Florence: Clarifications and New Documents." *Zeitschrift für Kunstgeschicte* 66 (2003): 33–64.

_____. *Andrea Orcagna: Il Tabernacolo di Orsanmichele* (Modena, 2006).

INDEX

Acciaiuoli, Angelo, bishop, 108, 269

Albania, 131

Alberti family, 131

Alberti, Bartolomeo di Caroccio, 122, 131

Alberti, Leonbattista, 211

Albizzi oligarchy, 142

Alighieri, Dante, 14, 114, 149, 169, 174, 240
 De Monarchia
 lessons of Brutus, 174
 Inferno, 117, 264, 265–268, 270
 La Commedia, 172, 266

Ambrogio di Baldese, 84
 Allegorical Winged Figure (Florence, Palazzo Arte dei Giudici e Notai), 151
 City of Florence (Florence, Palazzo Arte dei Giudici e Notai), 151
 frescoes in the Palazzo Arte dei Giudici e Notai, 147–151
 Uomini Famosi (Florence, Palazzo Arte dei Giudici e Notai), 149

Andrea di Bonaiuto
 frescoes in the Spanish Chapel (Florence, Santa Maria Novella), 285
 Madonna of Humility (Florence, Via delle Ruote and Via San Gallo), 20, 62, 100
 Spanish Chapel (Florence, Santa Maria Novella), 13
 Supremacy of the Dominican Order (Florence, Santa Maria Novella), 285

Andrea di Bonaiuto, circle of
 Annunciation of the Virgin (Florence, Accademia, ex-Orsanmichele), 204, 205

Andrea di Cione, 13, 61, 81, 165
 Annunciation of the Virgin (Milan, Gerli Collection, ex-San Remigio), 165
 Crucifixion (Florence, Santa Maria a Montughi), 166
 Expulsion of the Duke of Athens (Florence, Palazzo Vecchio, ex-Stinche), 114–121, 133, 165, 166, 181, 230
 frescoes in Santa Maria a Montughi (Florence, Santa Maria a Montughi), 165
 Hell (Florence, Museo dell'Opera di Santa Croce), 262, 263

Last Judgment (Florence, Museo dell'Opera di Santa Croce), 12, 15, 264, 265
Last Judgment and *Hell* (Florence, Museo dell'Opera di Santa Croce), 261–270, 285
 and inscription, 267
 Dante, 264–268
 inquisition, 268–270
paintings in Santa Maria a Montughi (Florence, Santa Maria a Montughi), 166
Pentecost (Florence, Accademia, ex-Santissimi Apostoli), 211
punishment, 72, 74
Strozzi Altarpiece (Florence, Santa Maria Novella), 5, 12, 166, 169, 283, 285, 286
Tabernacle of Orsanmichele (Florence, Orsanmichele), 4, 18, 52, 58–60, 61, 86, 202, 204, 205–206, 210, 214, 218

Andrea di Cione and Jacopo di Cione
 Saint Matthew (Florence, Uffizi Galleries, ex-Orsanmichele), 166, 204, 208–214, 217

Angelico, Fra (Guido di Piero), 211
 Deposition of Christ (Florence, Museo di San Marco, ex-Santa Maria alla Croce al Tempio), 2, 3, 284
 Madonna and Child (Florence, Museo di San Marco, ex-Palazzo Arte dei Linaioli e Rigattieri), 136–139

Anjou family, 131, 132

Anjou-Durazzo alliance, 131

Antonio della Casa, 200

Aquinas, Thomas, 78

Ardinghelli family, 74

Aretino, Spinello
 frescoes of the Life of Saint Benedict (Florence, San Miniato al Monte), 226

Arnoldi, Alberto
 Madonna and Child (Florence, Museo del Bigallo), 85–88, 101

Arnolfo di Cambio
 Enthroned Madonna and Child (Florence, Museo dell'Opera del Duomo, ex-Santa Maria del Fiore), 233, 235

Arte della Lana, Archivio di Stato, Firenze
 Incipit Page, fol. 6, 154

Arthur, Kay, 75, 186
Assisi, 231
Assisi, church
 San Francesco, 10, 67
 Burial of Saint Francis, 10
 Miracle at Greccia, 10
Avignon, 269

Bardi family, 268
Baroncelli, Salvestro, 269
Beccadelli, Antonio
 L'ermafrodito, 41
Becherucci, Luisa, 196
Bellosi, Luciano, 204
Bernardino of Siena, 31, 43
Berti family, 276
Biadaiolo Manuscript, Biblioteca Laurenziana, 54
 Riot at Orsanmichele, fol. 79, 51–52, 53
Bischeri, Bartolommeo di Nofri, 194
Bischeri, Giovanni di Nofri, 194
Bischeri, Noferi di Giovanni di Bartolomeo,
 192–194
Black Death, 162, 165, 172, 190, 194, 211
Black Guelphs, 50
Bloch, Amy, 95
Boccaccio, Giovanni, 114, 148, 149
 Decameron, 10, 190, 280
 Pampinea in Santa Maria Novella, 273, 280,
 287
Bologna, 108
Bonaccorso di Lapo Giovanni, 107
Boskovits, Miklós, 77, 78
Brandini, Ciuto, 181, 253
 plot and arrest of, 171
Brooklyn
 Museum of Art, 198
Brucker, Gene, 172
Brunelleschi, Filippo, 84, 232
 Crucifix (Florence, Santa Maria Novella), 282,
 284
Brunetti, Giulia, 196
Brutus, Junius, 114, 156, 163, 169
 legacy of, 173–174
 sons (Titus and Tiberias), 173

Caesar, Julius, 114
Cannon, Joanna, 11
Cardoni, Lorenzo, Fra, 275, 278
Carocci, Guido, 33
Cato, 114
Cavalcanti, Guido, 30, 31, 118
Cennini, Cennino, 132
Chigi Villani, Vatican Library
 Flagellants, fol. 197v, 82
 Supplicants before the Madonna of Orsanmichele,
 fol. 152, 49
Cicero, 114

Cimabue, 84, 241, 270
 Crucifix, 258
 Santa Trinita Madonna (Florence, Uffizi
 Galleries, ex-Santa Trinita), 68–69, 160, 235
Claudian, 114, 149
Codice Rustici, Biblioteca Seminario Maggiore, 38,
 44
 Santa Maria della Tromba, fol. 22, 38
Comanducci, Rita Maria, 276
Compagni, Dino, 50–51
Constantine the Great, 114
Constantinople, 270
Council of Lateran IV, 1215, 204
crime, criminals, 106–114
Crum, Roger, 116, 127
cult, 45, 46, 57, 74
cult image, 18, 24, 46, 49, 50, 52, 55, 56, 58, 60, 61,
 62, 63, 65

d'Amelia, Carlo Ternibili, 107
d'Orlando, Bonsi, 172
Daddi, Bernardo, 9, 13, 37, 55, 58, 84, 199, 218
 Crucifix (Milan, Museo Poldi Pezzoli), 77–78
 death, 162
 Enthroned Madonna (Florence, Accademia,
 ex-Palazzo Arte dei Medici e Speziali), 140
 Madonna and Child (Florence, Accademia,
 ex-Palazzo Arte dei Medici e Speziali),
 135, 136, 182
 Madonna and Child Enthroned (Florence, Uffizi
 Galleries, ex-Santa Maria del Fiore), 204,
 232
 Madonna and Child with Saints (Florence, Museo
 dell'Opera del Duomo, ex-Santa Maria del
 Fiore), 199
 Madonna del Bagnuolo (Florence, Museo
 dell'Opera del Duomo), 6–7, 49, 186
 Madonna of Orsanmichele (Florence,
 Orsanmichele), 4, 18, 24, 46, 55–56, 114,
 127, 160, 175, 176, 204, 206
 payments, 56
 Saint Catherine (Florence, Museo dell'Opera del
 Duomo, ex-Santa Maria del Fiore),
 191–192, 193, 194
 stemmi, 192
 Saint Paul (Washington, D.C., National Gallery
 of Art), 185–186
 inscription, 186
Daddi, Bernardo (workshop)
 Allegory of Mercy (Florence, Museo del Bigallo),
 84, 88–93, 102, 236
Davanzati family, 131
Davanzati, Davanzato di Giovanni, 122, 131
Del Migliore, Ferdinando, 60
Domenico di Lenzo, 275, 276
Donatello, 218
 Marzocco, 217

Duccio di Buoninsegna, 84
 Rucellai Madonna (Florence, Uffizi Galleries,
 ex–Santa Maria Novella), 52, 65–68, 71, 74,
 140, 160, 191, 235
Durandus, Guglielmo, 12

Eisenberg, Marvin, 216

Falucci, Niccolò di Francesco Gialdi, 200
Fieravanti, Neri, 145
Fino di Tedaldi, 108
Florence
 education, 2
 magnate, 2
Florence, church, 231
 Badia, 91, 231
 nave decorations, 230–232
 Ognissanti, 231
 Orsanmichele, 4, 24, 46, 55, 69, 71, 127, 156, 157,
 158, 166, 182, 187, 202, 282
 Good Thief, 204
 pier panels, 202–218
 Saint Anne (Florence, Orsanmichele), 57, 61,
 205
 stained glass windows, 24–27, 61–62: *Miracle
 of the Hanged Thief*, 29, 61; *Miracle of the
 Ordeal by Fire at the Grain Market*, 27, 61;
 Renunciation of Worldly Goods, 26, 61
 Trinity, 204
 walls, 60–62
 San Bartolo in Corso, 72, 84
 San Felice, 186
 San Frediano, 18
 San Giovanni, 84, 88, 91, 94, 95, 96, 101, 127, 225,
 230, 233, 235, 237, 238, 257, 270
 bronze panels (Andrea Pisano and Lorenzo
 Ghiberti), 255–257
 mosaics in, 239–257: *Christ the Redeemer*, 241;
 crime, 253–254; crime and punishment,
 253–254; dates, 240; east vault, 247, 252; east
 vault, *John the Baptist Imprisoned*, 254; *Last
 Judgment*, 241–243, 253: *Heaven*, 242; *Hell*,
 243; north vault, 245, 252; northeast vault,
 244, 246, 252, 254; *Scenes from Genesis*, 244,
 253: *Apparition of the Dove*, 252; *Cain Killing
 Abel*, 252; *Creation*, 252; *God Ordering Noah
 to Build the Ark*, 252; *Joseph and the Chariot*,
 252; *Joseph Imprisoned*, 252; *Joseph Thrown
 Down the Well*, 252; *Joseph's Release from
 Prison*, 252; *Temptation*, 252; *Scenes from the
 Gospels*, 244–252: *Adoration of the Magi*, 244,
 252; *Annunciation*, 244; *Annunciation of the
 Virgin*, 252; *Annunciation to Zacharia*, 252;
 Dream of Joseph, 252; *Flight into Egypt*, 252;
 John Preaching at the River Jordan, 252; *The
 Dream of the Magi*, 244; *The Healing of the
 Paralytic*, 252; *The Last Supper*, 252; *Three

 Marys at the Tomb, 244, 252; *Scenes from the
 Life of John the Baptist*, 245: *Burial of John the
 Baptist*, 252; *John the Baptist Imprisoned*, 252;
 Scenes from the Gospels: Flight into Egypt,
 252; south vault, 249, 252; southeast vault,
 248, 252; tyranny, 254–255
 ritual of baptism, 95–96
 south doors, 248, 250, 280
San Giuseppe, 77
San Lorenzo, 231, 237
San Marco, 231
San Michele Bertoldi, 31
San Miniato al Monte, 162, 230, 231, 233, 237,
 238, 256, 257, 258, 282
 Christ Enthroned, 221, 223, 224–225, 270
 Christ with the Instruments of the Passion, 229
 *Christ with the Instruments of the Passion and
 Saints Julian, Miniato, and Catherine with
 Female Donors*, 227, 228
 *Christ with the Instruments of the Passion with
 Saints Julian, Miniato, and Catherine with
 Female Donors*, 228
 Christ with the Virgin and Saint Miniato,
 221–223, 226
 paintings in, 221–229
 Saint Anthony, 227
 Saint Christopher, 221, 226, 227
 Saint James the Minor, 227
 Saint Mary Magdalene, 227–228
 Saints John the Baptist, Reparata, and Zenobius,
 226
 *Saints John the Baptist, Reparata, Zenobius, and
 Benedict*, 227
 *Saints Mary Magdalene, Nicholas, Andrew, and
 Christopher*, 227
 Saints Nicholas, Miniato, and Andrew, 226, 227
 Saints on the South Wall, 224
San Pancrazio, 237
San Pier Maggiore, 36, 79, 231, 237
San Remigio, 5, 6, 230
Sant'Ambrogio, 2, 230
Santa Croce, 4, 5, 9, 12, 15, 48, 79, 165, 230, 231,
 233, 259
 Assumption of the Virgin, 12
 Crucifixion, Noli me Tangere, and Ascension, 258,
 260
 frescoes in, 257–270
 Last Judgment and *Hell*, 261–270, 278
 monument to Galileo Galilei, 258
 pulpit, 259
 Stigmatization of Saint Francis, 12
 tramezzo, 258–261
Santa Felicita, 237
Santa Maria alla Croce al Tempio, 2, 77, 78, 284
Santa Maria degli Angeli, 11, 71, 98, 166, 211,
 216, 225
Santa Maria del Carmine, 18, 74, 231

Florence, church (*cont.*)

Santa Maria del Fiore, 46, 74, 75, 79, 82, 84, 88,
91, 97, 99, 101, 102, 127, 191, 196, 198, 199,
200, 206, 210, 217, 225, 230, 237, 238, 257,
282
Chapel of Saint Zenobius, 196
Coronation of the Virgin, 232–239, 241
façade, 238, 239
nave, 238
panels in, 191–202
Pecori Chapel, 102
Santa Maria della Tromba, 34, 38, 40, 41, 43, 44,
62, 136, 157
Santa Maria Maggiore, 187, 230
Santa Maria Novella, 5, 9, 10, 12–13, 43, 65–69,
71, 75, 79, 165, 166, 230, 231, 233
Cappella dei Morti, 13
Cappella Maggiore, 12
cemetery, 273, 275, 279, 280, 281, 286
Chapel of Saint Gregory, 74, 191
Chapel of Saints Simon and Thaddeus, 81
Chapel of San Niccolò, 75
Deposition of Christ, 284
façade, 99
Gondi Chapel, 282
Masaccio's *Holy Trinity*, 273–288
nave wall, 279, 281
pulpit, 277, 278, 279
renovation of 1860 and 1861, 276
Rucellai Chapel, 74
sermons in, 277–278, 280
Spanish Chapel, 13, 285
Strozzi Chapel, 12, 166, 267, 283, 284, 285:
Lamentation of Christ, 285
tramezzo, 277, 278, 280, 282
transept, 282
Santa Reparata, 127, 191, 196, 232, 235
Vir Dolorum, 232, 233
Santa Trinita, 68, 231
Santissima Annunziata, 1, 225
Annunciation of the Virgin, 19, 31, 46, 225, 230
Santo Spirito, 74, 231, 275
Santo Stefano, 237
Santo Stefano in Pane, 74, 79
Florence, city centers
Arno River, 61, 123, 129, 152, 157, 221
Bigallo, 84
Bishop's Palace, 84, 138
Borgo, 105
Foro Romano, 33
Loggia dei Lanzi, 123
Mercanzia, 114, 122
Mercato Nuovo, 46, 138, 157
Mercato Vecchio, 1, 31, 32–34, 39, 40, 44, 45, 46,
62, 99, 135, 138, 142, 145, 157, 231, 236, 277
brothel in, 41–42
Mugnone, 41

Palace of the Executor of the Ordinances of
Justice, 107
Palazzo del Podestà, 32, 45, 91, 106–112, 114, 117,
118, 119, 120, 138, 145, 164, 170, 174
Magdalene Chapel, 1, 109, 254, 266
Palazzo della Signoria, 91, 106, 112–114, 116, 117,
118, 120, 122, 127, 169, 171, 217
Audience Chamber, 113
Chapel of Saint Bernard, 113
Piazza della Repubblica, 32, 135, 142
Piazza della Signoria, 122, 138, 142, 145
Piazza Orsanmichele, 61
Piazza Piattellina, 21
Piazza San Giovanni, 1, 72, 84, 88, 92, 93, 101,
102, 138, 199, 235, 238
Piazza Santa Maria Novella, 186
Piazza Santo Spirito, 18, 21
Ponte Santa Trinita, 25
Ponte Vecchio, 105, 138, 157
Porta alla Croce, 2, 21, 28, 32, 61, 74, 77, 109
Porta Romana, 138
Porto San Gallo, 138
San Giovanni, 105
San Pancrazio, 105
San Pier Maggiore, 105
San Pier Scheraggio, 105
Stinche (prison), 106, 114, 117, 118–121, 127, 138,
145, 166, 181, 230
Florence, confraternity, 70–84, 100
Bigallo, 72, 74, 84
Compagnia della Misericordia, 70, 72, 74,
84–96, 101, 102, 230
Audience Hall, 85, 88, 91, 92, 102
façade, 236, 250, 280
headquarters, 74
loggia, 84, 86, 88, 199, 225
Compagnia di San Luca, 37, 38, 71
Compagnia di San Zanobi, 74, 82, 196
Compagnia di Santa Maria del Desco, 74
Compagnia di Sant'Agata, 79, 80
Compagnia di Santo Stefano, 74, 78
Compagnia Santa Maria alla Croce al Tempio
(Neri), 1, 28, 31, 72, 74, 75–78, 82
Libri varie, 28
Confraternity of Saints Zenobius and Reparata,
199
Flagellants (*Disciplinati*), 71, 80, 83, 101, 103
Gesù Pellegrino, 72, 74, 75, 81, 82, 84, 165
San Giovanni Decollato, 82
Frati della Penitenza, 186
interests of, 72
Laudesi Company, 24, 69, 70–71, 101, 103, 185
Orsanmichele, 47, 48, 51, 52, 56, 58, 60, 71, 72,
74, 84, 86, 191, 202, 208: bequests to, 57;
captains, 55, 56, 57; statutes, 52–54
Santa Caterina, 74
Santa Maria delle Laude, 68

Santa Maria Novella, 52, 65, 66, 191
Santa Reparata, 74
Pinzocheri del Terz'Ordine di San Francesco, 186
Saint Zenobius, 191
Santa Maria del Desco, 78
Florence, events
banking crisis of 1342, 54, 92, 127, 268
Battle of Benevento, 1266, 255
Battle of Campaldino, 1289, 126
Battle of Cascina, 1364, 126, 128
bubonic plague of 1347 and 1348, 54, 57, 172, 190, 196, 273, 280
bubonic plague of 1363, 196
bubonic plague of 1375, 190
bubonic plague of 1399, 72
Ciompi Revolt, 172
creation of the Office of the *Onestà*, 1403, 41
epidemic of 1340, 54
Expulsion of the Duke of Athens, 1343, 54, 56, 57, 116, 181
famine of 1328 and 1329, 52, 54
famine of 1345 and 1346, 54–55, 56, 58
Feast of Saint Anne, 1345, 56
financial crisis of 1370–1373, 128–130
fire in Wool guild headquarters, 1331, 154, 156, 158, 160
fire of 1304, 50–51, 55, 61, 74, 204
fire of 1344, 171
flood of 1333, 25, 53
flood of 1966, 258
Inquisition of 1345 and 1346, 54, 268–270
renovation of ghetto, 142–143
Risorgimento, 141, 231
Statute of 1355, 41
Sumptuary Law, 1384, 41
War of the Eight Saints, 107, 269
Florence, government, 112
Florence, guild, 2
Bakers, 202
Bankers (Arte del Cambio), 122, 124, 126, 127, 131, 132, 204, 208, 210, 211, 217
residence, 138, 142
Blacksmiths, 138
Butchers and Bakers, 135
Carpenters, 204
Cheesemongers, 202
Delicatessen Owners (Arte dei Pizzicagnoli), 36, 140, 202, 206, 210, 214, 217
Doctors and Apothecaries (Arte dei Medici e Speziali), 34, 35, 37, 38, 40, 41, 42, 135, 140, 147, 182, 210
Painters, 137
residence, 138
Sala d'Udienza, 135
Dyers, 24, 116, 170–171
Harness Makers, 202

International Cloth Merchants (Arte della Calimala), 122, 124, 126, 128, 131, 138, 158, 202, 239, 255
residence, 142
Judges and Notaries (Arte dei Giudici e Notai), 140, 157
residence, 138, 141, 143, 145: *Allegorical Figures*, 148; *Allegorical Winged Figure*, 151; *Allegorical Winged Figure* (Florence, Palazzo Arte dei Giudici e Notai), 150; *City of Florence*, 151; *City of Florence* (Florence, Palazzo Arte dei Giudici e Notai), 150–151; *Cleric*, 147; construction, 145; paintings in, 144–152; Sala d'Udienza, 182; *Uomini Famosi*, 149; *Uomini Famosi* (Florence, Palazzo Arte dei Giudici e Notai), 148–150; *Uomini Famosi* (Florence, Palazzo Arte dei Giudici e Notai), 182
responsibilities, 144–145
Linen Merchants (Arte dei Linaioli e Rigattieri), 138, 217
Residence, 40: Sala d'Udienza, 137
Locksmiths, 202
organization and function, 137
residences of, 138–142
design and decoration of, 138–142
Saddlers
Bookbinders and Glove Makers, 138
Shearers and Tailors, 202
Silk Merchants (Arte della Seta), 135, 202, 207, 210
Goldsmiths, 138
residence: Sala d'Udienza, 135
Vintners (Arte dei Vinattieri), 202, 207, 208
Wool Merchants (Arte della Lana), 32, 38, 88, 116, 141, 142, 152–182, 194, 202
lanaiuoli, 153, 157, 168, 170, 171, 176, 178, 180
membership, 152
organization and procedures, 152–156
rebellion, 154, 168–172, 181
residence, 138, 142, 143, 155, 182: bottega, 157; design of, 156–159; fire, 154, 158, 160; Sala d'Udienza, 4, 109, 158, 159, 230, 236: frescoes in, 157–182; *Judgment of Brutus*, 162, 167, 177, 179; *Judgment of Brutus* (Florence, Palazzo Arte della Lana), 161, 163–182; *Madonna della Lana* (Florence, Palazzo Arte della Lana), 99, 159–161, 175: date, 160; inscription, 160; *Saints Martin, Pancras, Peter, and Frediano*, 161; *Saints Martin, Pancras, Peter, and Frediano* (Florence, Palazzo Arte della Lana), 161–163, 175
sottiposti, 153–154
Statute Book, 154–156, 161: *Agnus Dei*, 154–156
statutes and bylaws, 154–156
stemmi, 202

Florence, guilds, 3
Florence, hospital
 San Paolo dei Convalescenti, 186
 Santa Maria Nuova, 71, 97–100
 Via San Gallo, 100
Florence, merchants, 4
Florence, museum
 Accademia, 17, 75, 97, 99, 100, 113, 122,
 216
 Museo del Bigallo, 84
 Museo dell'Opera del Duomo, 79, 186,
 191
 Museo Nazionale del Bargello, 105
 Uffizi Galleries, 123, 124
Florence, office
 Capitano del Popolo, 106, 171, 172
 Executor of the Ordinances of Justice,
 106
 Guelph Party, 131, 132
 Office of the Night, 106
 Onestà, 41, 106
 Signoria, 129
 Zecca (mint), 106, 122–125, 126–133
 Book of Statutes, 126
 construction of, 123
 currency and monetary policy, 127–130, 132
 responsibilities, 122
Florence, street
 Borgo degli Albizzi, 36, 62
 Borgo San Lorenzo, 20
 Borgo San Pancrazio, 20
 Chiasso della Tromba, 34, 38
 Via Adimari, 84, 85, 87, 101
 Via Antonino, 20
 Via Calimala, 34, 154, 157
 Via Calzaiuoli, 73, 84
 Via Corso, 34
 Via dei Malcontenti, 21
 Via del Sole, 20, 43
 Via della Cella di Ciardo, 20
 Via delle Casine, 21
 Via delle Ruote, 20, 62
 Via di Trevigi, 20
 Via Ghibellina, 106, 114
 Via Giraldi, 36
 Via Leone, 18, 275
 Via Palazzuolo, 186
 Via Pandolfini, 138, 145
 Via Proconsolo, 138, 145, 182
 Via San Gallo, 20, 62, 100
 Via Tournabuoni, 43
format, painting, 13–15, 79, 101–102, 103, 140, 142,
 162–163, 181–182, 204, 206, 211
 pier panels, 187
 Saint Matthew, 214
Fraticelli, P.I., 118
Freedberg, David, 31, 108

Gaddi, Agnolo, 162
 Legend of the True Cross (Florence, Santa Croce),
 257
Gaddi, Gaddo, 233
Gaddi, Taddeo, 9, 77, 233, 270
 Madonna and Child (Florence, Accademia,
 ex-Palazzo Arte dei Giudici e Notai), 140,
 141, 182
 Madonna and Child (Florence, Via Antonino),
 20
Galilei, Galileo, 258
Gerini, Niccolò di Pietro, 83–84, 211, 218
 Coronation of the Virgin (Florence, Palazzo Arte
 della Lana), 39
 Flagellation of Christ (private collection), 83
 Lamentation of Christ (Florence, Orsanmichele),
 83
 linen paintings, 82–83
 The Betrayal of Christ (private collection), 83
 The Flagellation of Christ (private collection),
 83
 The Mocking of Christ (private collection), 83
 The Washing of the Disciples' Feet (private
 collection), 83
 Saint Mary Magdalene (Florence, Orsanmichele),
 214, 215
 Saint Nicholas of Tolentino (Florence,
 Orsanmichele), 214, 215
 Vir Dolorum (Florence, Accademia, ex-Santa
 Maria Novella), 75, 76, 80–81, 84
Gerini, Niccolò di Pietro, and Ambrogio di
 Baldese
 *The Abandonment of Children and the
 Reunification of Families* (Florence, Museo
 del Bigallo), 93–96, 236, 250, 280
Gherarducci, Pseudo Don Silvestro dei
 Madonna Lactans (Florence, Accademia), 97–100
Ghibellines, 118, 255
Ghiberti, Lorenzo, 109, 136, 164, 218, 255, 270
 Baptism of Christ (Florence, San Giovanni), 256
 east doors (Gates of Paradise)
 Scenes from Genesis (Florence, San Giovanni),
 257
 San Giovanni
 east doors (Gates of Paradise): *Old Testament
 Scenes* (Florence, Museo dell'Opera del
 Duomo, ex-San Giovanni), 256
 north doors: *Adoration of the Magi* (Florence,
 Museo dell'Opera del Duomo, ex-San
 Giovanni), 256; *Annunciation of the Virgin*
 (Florence, Museo dell'Opera del Duomo,
 ex-San Giovanni), 256; *Arrest of Christ*
 (Florence, Museo dell'Opera del Duomo,
 ex-San Giovanni), 256; *Baptism of Christ*
 (Florence, Museo dell'Opera del Duomo,
 ex-San Giovanni), 256; *Crucifixion*
 (Florence, Museo dell'Opera del Duomo,

ex-San Giovanni), 256; *Last Supper*
(Florence, Museo dell'Opera del Duomo,
ex-San Giovanni), 256; *Nativity* (Florence,
Museo dell'Opera del Duomo, ex-San
Giovanni), 256
Tabernacle (Florence, Museo di San Marco,
ex-Palazzo Arte dei Linaioli e Rigattieri),
136
Giottino, 13, 18, 108
Lamentation of Christ (Florence, Uffizi Galleries,
ex-San Remigio), 5–6
Madonna della Sagra (Florence, Accademia,
ex-Via Leone), 17–18, 21, 22, 24, 62, 125,
275, 286
Giotto, 9, 18, 84, 109, 170, 240, 270
Charles of Calabria (lost), 112
Coronation of the Virgin (Florence, Santa Croce),
5
Crucifix (Florence, Santa Maria Novella), 282,
283, 286
death, 162
Enthroned Madonna with Symbols of Florence
(Florence, Museo Nazionale del Bargello),
105–106
in Santa Croce, 5
Last Judgment (Padua, Scrovegni Chapel),
264
Ognissanti Madonna (Florence, Uffizi Galleries,
ex-Ognissanti), 160
Peruzzi Chapel, 9
Robbed City (lost), 109, 164, 174
Scrovegni Chapel, 111
Giotto (workshop)
Hell (Florence, Museo Nazionale del Bargello),
111
Last Judgment (Florence, Museo Nazionale del
Bargello), 109–112
Scenes from the Life of John the Baptist
The Dance of Salome (Florence, Museo
Nazionale del Bargello), 110
Scenes from the Life of John the Baptist (Florence,
Museo Nazionale del Bargello), 109
Scenes from the Life of Mary Magdalene
Noli me Tangere (Florence, Museo Nazionale
del Bargello), 110
Penitent Magdalene in the Wilderness (Florence,
Museo Nazionale del Bargello), 110
Scenes from the Life of Mary Magdalene (Florence,
Museo Nazionale del Bargello), 109
Giovanni del Biondo, 162, 199, 211, 218
Martyrdom of Saint Sebastian (Florence, Museo
dell'Opera del Duomo, ex-Santa Maria del
Fiore), 187–191
Miracle of the Hanged Thief (Florence,
Orsanmichele), 29
Miracle of the Ordeal by Fire at the Grain Market
(Florence, Orsanmichele), 27

Renunciation of Worldly Goods (Florence,
Orsanmichele), 26
Saint Catherine (Florence, Museo dell'Opera del
Duomo, ex-Santa Maria del Fiore),
192–194
Saint Catherine with Noferi Bischeri (Florence,
Museo dell'Opera del Duomo, ex-Santa
Maria del Fiore), 195
Saint John the Evangelist (Florence, Accademia,
ex-Orsanmichele), 207–208, 217
Saint Sebastian (Florence, Museo dell'Opera
del Duomo, ex-Santa Maria del Fiore),
210
Scenes from the Life of Saint Sebastian (Florence,
Museo dell'Opera del Duomo, ex-Santa
Maria del Fiore), 188, 189, 190
Giovanni del Ponte, 194
Bartolommeo and Giovanni Bischeri (Florence,
Museo dell'Opera del Duomo, ex-Santa
Maria del Fiore), 194
Goffen, Rona, 276
Guelphs, 255

Hannibal, 114
Hawkwood, John, 230
Hercules, 14, 25
heretics
Albigensians, 71
Cathars, 71
Paterini, 71
Heuck, Irene, 253
Holmes, Megan, 31
Hungary, 131

iconostasis, 9
Incredulity of Saint Thomas (lost), 113, 114

Jacopo del Casentino, 13, 35–37, 38, 40, 42, 45, 207
Enthroned Madonna Lactans (Florence, Museo
dell'Opera del Duomo, ex-Santa Maria del
Fiore), 200–202
Madonna and Child with Saints Benedict and Peter
(Florence, Via Giraldi and Borgo degli
Albizzi), 36, 37, 62
Madonna and Child with Saints Stephen and Philip
(Florence, Palazzo Arte della Lana),
142–143
Madonna della Tromba (Florence, Palazzo Arte
della Lana, ex-Oratory of Santa Maria
della Tromba), 1, 32–45, 62, 99, 112, 125,
140, 236
Saint Agatha (Florence, Accademia), 79–80, 81
Saint Bartholomew (Florence, Accademia,
ex-Orsanmichele), 36, 140, 202, 203, 204,
206–207, 208, 211, 214, 217
Saint Miniato (Florence, San Miniato al Monte),
36

Jacopo di Cione, 13, 162, 199, 218
 Coronation of the Virgin (Florence, Accademia,
 ex-Zecca), 99, 121–133, 210, 277
 and Niccolò di Tommaso, 123, 128, 129
 and Simone di Lapo, 123–124, 128, 129
 commission, 122–124
 Federigho Benghi de Rubeis, 124
 Giovanni di Ambrogio, stone mason,
 124
 payments for, 123–124, 129
 stemmi, 131–133
 frescoes in the Palazzo Arte dei Giudici e Notai,
 146
 Madonna Lactans (Washington, D.C., National
 Gallery of Art), 98–100
 matriculation into guild of Doctors and
 Apothecaries, 146
 Saint Zenobius (Florence, Museo dell'Opera del
 Duomo, ex-Santa Maria del Fiore),
 194–196, 197
Jacopo di Cione and Giovanni del Biondo
 Saint Zenobius (Florence, Santa Maria del Fiore),
 196–198
Junius Brutus, 14

Kreytenberg, Gert, 266

La vita di Giambattista (1300–1310), 246
Lapo di Francesco, 202
Leeds Castle, 83
Leopold Hapsburg-Lorraine, Archduke,
 93
Livy, 173, 174
Lorenzetti, Ambrogio
 Allegory of Bad Government (Siena, Palazzo
 Pubblico), 120, 121
 Allegory of Good and Bad Government (Siena,
 Palazzo Pubblico), 119–120
 Allegory of Good Government (Siena, Palazzo
 Pubblico), 109, 163, 164, 165
Lorenzo di Bicci
 Madonnone (Florence, Via di San Salvi), 24,
 25
 Saint Martin (Florence, Accademia,
 ex-Orsanmichele), 207–208, 209
Lorenzo di Niccolò
 Saint Reparata (Florence, Museo dell'Opera del
 Duomo, ex-Santa Maria del Fiore), 199,
 200
Lorenzo Monaco, 13, 71, 98, 218
 Agony in the Garden (Florence, Accademia),
 216–218
 lost altarpiece, 74
Lorenzo Monaco (workshop)
 Double Intercession (New York, Metropolitan
 Museum of Art), 101–103, 199, 236
Lucretia, 173
Lupi, Bonifacio, 100

Madonna dei Chierici, 46
Madonna dei Malcontenti (Florence, Via dei
 Malcontenti), 21, 22, 23, 28
Madonna della Lana (Florence, Palazzo Arte della
 Lana), 160
Madonna of Impruneta (Impruneta, Santa Maria
 dell'Impruneta), 31
Madonna of Orsanmichele, 176
 Alpha version (lost), 48–51, 62, 99, 204
 Beta version, 51–56, 59, 140, 160, 206, 211
 veils, 54
 history of, 46–62
Madonna of Orsanmichele (Florence, Orsanmichele),
 65, 202, 206, 215, 218
 Omega version, 55, 210, 214
 civic patron, 60–62
Maestro di San Martino a Mensola
 Madonna and Child (Florence, Piazza Piatellina),
 23
 Madonna and Child (Florence, Piazza Piattelina),
 20
manual laborers, 3, 15, 18, 45, 152, 171, 176, 180, 181
Mariotto di Nardo
 *Coronation of the Virgin with Five Music-Making
 Angels* (Minneapolis, Institute of Arts,
 ex-Santo Stefano in Pane), 73, 74, 78
 *Madonna and Child with Saints Stephen and
 Reparata* (Florence, Accademia, ex-Palazzo
 Arte della Lana), 141, 182
Masaccio
 Holy Trinity (Florence, Santa Maria Novella),
 230, 273–288
 and Andrea di Cione's *Strozzi Altarpiece*, 285,
 286
 and Brunelleschi's *Crucifix*, 282
 and *Deposition of Christ*, 284
 and Giottino's *Madonna della Sagra*, 275, 286
 and Nardo di Cione's *Last Judgment*, 286
 Gnadenstuhl, 277
 inscription, 281–282
 restoration and relocation, 276
Maso di Banco, 9, 270
 death, 162
Masotti, Lionardo, 191
Medici, Cosimo de', 72, 230
Medici, Piero de', 19, 230
Medici, Vernis di Cambio, 192
merchants, 45, 48
Moricci, Giuseppe
 Santa Maria della Tromba (Florence, Galleria
 d'Arte Moderna), 34, 35
Morpurgo, Salomone, 172, 178
Muir, Edward, 28, 30

Nanni di Banco, 218
Nardo di Cione, 165, 211, 218
 Christ in Judgment with Angels (Florence, Museo
 del Bigallo), 85–88, 101

Hell (Florence, Santa Maria Novella), 266
Judgment of Brutus (Florence, Palazzo Arte della
 Lana), 4, 109, 162, 163–182, 230, 236
 inscriptions, 176–181
 Virtues, 176: Fortitude, 178; Justice, 177–179;
 Prudence, 176–177, 178; Temperance,
 178–180
Last Judgment (Christ) (Florence, Santa Maria
 Novella), 287
Last Judgment (Florence, Santa Maria Novella),
 13, 283, 285
Madonna and Child (Brooklyn, Museum of Art),
 198–199
Paradise (Florence, Santa Maria Novella), 166,
 168
Nelli, Pietro
 Saints Michael and Benedict (Florence, San
 Miniato al Monte), 226
New York, museum
 Metropolitan Museum of Art, 101, 199
Niccolò di Tommaso
 Saint Sixtus (Florence, Borgo San Pancrazio and
 Via del Sole), 20, 21, 43
 Saints Nicholas, Miniato, Andrew (Florence, San
 Miniato al Monte), 226

Octavian Augustus, 114
Offner, Richard, 127, 198, 266

Paatz, Elizabeth, 194
Paatz, Walter, 194
Padua, 111, 231
Parma, 108
patronage, female, 8
Pecori family, 101
Peruzzi family, 268
Peter of Verona (Saint Peter Martyr), 71, 74, 78, 81,
 268
Petrarch, Francesco, 114, 148, 149, 169, 174
 Africa
 Junius Brutus, 174
 De viris illustribus, 114
Piero d'Aquila, Fra, 54, 268–270
Pierozzo di Bancho di Ser Bartolo, 57, 60
Pisa, 128
 currency, 128, 129
Pisa, church
 Camposanto
 Triumph of Death, 261–265
 San Francesco, 8
 Santa Caterina, 11
Pisano, Andrea, 270
 Scenes from the Life of John the Baptist
 (Florence, San Giovanni), 250, 251, 255
 Baptism of Christ, 255
 Baptism of Followers, 255
 Birth of the Baptist, 255
 Imprisonment of John, 255

John Before Herod, 255
John in the Wilderness, 255
pitture infamante, 107–108, 119
procession
 banner, 79, 81, 83, 101
 Bishop of Florence, 237–239, 240, 241
 confraternity, 50, 75, 79, 80
 criminal, 1–2, 31, 45
 Duomo to Baptistery, 234
 Feast of Saint Anne, 127
 Feast of Saint John the Baptist, 170
 flagellants, 72
 relic of Saint Philip, 238
 route
 Duomo to Baptistery, 237–239, 240
 Ponte alla Carraia, 79
 Ponte Vecchio, 79
 San Pier Maggiore, 79
 Santa Maria del Fiore, 79
 Signoria, 60

Ranieri da San Gimignano, 117
Richa, Giuseppe, 60, 78, 192
Ridolfi, Neri, 75
ritual, 79
 Baptism, 249, 250, 256
 feast days, 50
 Easter, 237, 238
 Feast of Saint Agnes, 237
 Feast of Saint John the Baptist, 238, 240, 253
 Feast of Saint Pancrazio, 237
 Feast of Saints Peter and Paul, 237
 Feast of Saints Philip and James, 238
 Feast of the Ascension, 211, 238
 Feast of the Assumption, 60, 211
 Feast of the Pentecost, 211, 240
 Holy Saturday, 238, 240
 Litanies of April 25, 238
 Maundy Thursday, 217
 Octave of the Nativity, 238
 Purification of the Virgin, 238
 Rogation Day, 237, 238
ritual, hymns, 62, 68, 70, 71, 74, 75, 79
 baptisms in San Giovanni, 240
 Orsanmichele, 47, 49–50, 51, 53
 Santa Maria Novella, 66
ritual, Mass, 11, 12, 18, 24, 43, 71, 276
ritual, prayer
 Santa Maria della Tromba, 44
Rome, 137, 231, 234, 255, 270
 Santa Maria Maggiore, 233
Rosselli, Stefano, 192
Sabina, cardinal, 269
Sacchetti, Franco, 113
Saint Mary Magdalene (Florence, Accademia), 211,
 213
Saints Martin, Pancras, Peter, and Frediano (Florence,
 Palazzo Arte della Lana), 161

Salutati, Coluccio, 14, 114, 149
Sardi, Datuccia, 8
Savonarola, Fra, 31, 43
Schlegel, Ursula, 276
Scipio Africanus, 114
Seminetti, Bartolo di Giovanni, 122
sexes, segregation of, 12
Shearman, John, 278
Siena, 109, 211, 269
 laws of 1309 and 1310, 12
 Palazzo Pubblico, 119
Solberg, Gail, 8
Soldani, Tommaso Lippi, 122
Stefani, Marchionne di Coppo, 170
Steinweg, Klara, 194
Stradanus, Johannes
 Mercato Vecchio (Florence, Palazzo Vecchio), 34,
 36
Strozzi, Rossi, 283

tabernacle, 18–24, 25, 26, 27, 28–32, 60, 62, 65, 74,
 75, 84, 100, 137, 140, 159, 176, 204, 275, 286,
 288
 function of, 29–32
 illumination of, 30, 32, 35
Tacconi, Marica, 237
Taddeo di Bartolo, 8
Tarquinius, Lucius, 173
Tarquinius, Sextus, 173
tavolette, 2, 31, 77, 79
Tolentino, Niccolò da, 230
Torriti, Jacopo
 Coronation of the Virgin (Rome, Santa Maria
 Maggiore), 233
Toscani, Giovanni
 Incredulity of Saint Thomas (Florence, Accademia,
 ex-Mercanzia), 113, 115
tramezzo, 5, 9–13, 14, 18, 24, 29, 66, 79, 187, 206,
 223, 230, 232, 258–261, 277, 278, 280,
 282
Trexler, Richard, 30, 31
trombare, 42

Uomini Famosi (lost), 113–114

Val di Greve, 118
Varano, Ridolfo, 107
Vasari, Giorgio, 108, 109, 117, 164
 Giottino, *Lamentation of Christ*, 5
 renovation of Santa Croce, 10–11, 231, 258, 260
 renovation of Santa Maria Novella, 231, 276
veil, 75
Venice, 270
 Rialto, 28
Verdon, Timothy, 276, 280
Vice
 prostitution, 39–45
viewership, 8–13, 22, 30–32, 42, 43, 65, 68, 102,
 232
 confraternities, 103
 Expulsion of the Duke of Athens, 118–119
 female, 100
 frescoes in Santa Croce, 259
 Holy Trinity, 277–282, 286
 Judgment of Brutus, 175–182
 mosaics in San Giovanni, 239, 240, 241, 247–252
 pier panels, 187
 reception, 31–32, 43–45, 58–60, 61, 62, 94–96,
 100
Villani, Giovanni, 56, 117, 119, 138, 156, 158,
 171
 Nuova Cronica, 48–49, 51, 52
 famine of 1345 and 1346, 54
Villani, Matteo, 57
Villers, Caroline, 82
Vision of Saint Bernard (Florence, Accademia), 113,
 211, 212
von Simson, Otto, 276

Walter of Brienne, Duke of Athens, 14, 41, 54, 56,
 57, 88, 92, 108, 115–117, 127, 180
 Wool guild, 116, 168–171
Washington, D.C., museum
 National Gallery of Art, 98, 100, 185, 186
Wheel of Fortune (lost), 113
Wilkins, David, 116, 127
Wilson, Blake, 51

Zenobi da Strada, 114, 149